TREASURES
FROM
KOREA

This exhibition
is presented
in association with
THE DAILY TELEGRAPH
AND
**MIDLAND BANK
INTERNATIONAL**

TREASURES
— FROM —
KOREA
ART THROUGH 5000 YEARS

Introduction by
ROGER GOEPPER

Edited by
RODERICK WHITFIELD

With Contributions by
SOON-TAEK CHOI-BAE, EDITH DITTRICH,
ROGER GOEPPER, YOUNGSOOK PAK,
JI HYUN WHANG, RODERICK WHITFIELD,
ULRICH WIESENER

Published for the
Trustees of the British Museum by
British Museum Publications

© 1984 The Trustees of the British Museum

Published by British Museum Publications Ltd
46 Bloomsbury Street London WC1B 3QQ

British Library Cataloguing in Publication Data

Goepper, Roger
 Treasures from Korea.
 1. Art, Korean – History
 I. Title II. Whitfield, Roderick
 709'.519 N7360

ISBN 0-7141-1430-8

Designed by Harry Green

Set in Monophoto Photina
and printed in Great Britain
by Jolly & Barber Ltd, Rugby

Committee of Honour

UNITED KINGDOM

HRH The Duke of Gloucester GCVO
Patron

The Rt Hon Sir Geoffrey Howe PC QC MP
Secretary of State for Foreign Affairs

H.E. J. N. T. Spreckley
HM Ambassador to the Republic of Korea

W. S. Bates CMG
Chairman of the Anglo-Korean Centennial Committee

Sir Jeffrey Petersen KCMG
Chairman of the Anglo-Korean Society

J. A. L. Morgan CMG
formerly HM Ambassador to the Republic of Korea

The Rt Hon. the Lord Hartwell MBE TD
Chairman and Editor-in-Chief of the
Daily Telegraph *and* Sunday Telegraph

G. W. Taylor
Group Chief Executive, Midland Bank plc

The Rt Hon. the Lord Trend PC GCB CVO
Chairman of the Board of Trustees, British Museum

Sir David Wilson FBA
Director of the British Museum

REPUBLIC OF KOREA

The Hon. Chin Iee-Chong
Prime Minister

The Hon. Lee Won-Kyung
Minister of Foreign Affairs

The Hon. Lee Jin-Hie
Minister of Culture and Information

The Hon. Lee Hai-Won
Chairman of the Committee of Education, Culture and Public Information, the National Assembly

H.E. Dr Kang Young-Hoon
Ambassador to the United Kingdom

The Hon. Dr Kim Sang-Man KBE
Chairman, Korea-Britain Centennial Committee and Honorary Chairman Dong-A Ilbo, Daily News, Seoul

Dr Choi Sunu
Director-General of the National Museum of Korea, Seoul

The Hon. Dr Han Pyo-Wook
President, the Korean-British Society

Dr Kim Won-Yong
Chairman, Committee of Cultural Properties and Professor, Seoul National University

Editorial note

The general arrangement of the catalogue entries is chronological. The objects from each period are preceded by a short historical introduction and some groups of objects (ceramics and paintings) are also introduced by short essays. Buddhist and secular sculptures are placed within the catalogue according to their respective periods, and therefore the essay on sculpture will be found in the general introduction.

The following abbreviations have been used in the catalogue:

Contributors

STB Soon-taek Choi-Bae JHW Ji Hyun Whang
ED Edith Dittrich RW Roderick Whitfield
RG Roger Goepper UW Ulrich Wiesner
YSP Youngsook Pak

Measurements

D diameter TH thickness
H height W width
L length

Korean terminology has been used wherever possible, and a select glossary gives the Korean or Chinese characters for important techniques or proper names. Accordingly, Chosŏn has been used in preference to Yi for the name of the last dynasty (AD 1392–1910) following modern Korean usage. Considerations of space make it impossible to include every term used in the catalogue and introductions. The characters for the Glossary were written by Roderick Whitfield, who also prepared the maps. Korean names are given in the traditional form, surname followed by given names. In the case of painters who are well known by a studio name, this is also given. A modified version of the McCune Reischauer romanisation is used throughout. Bibliographical references are given for each item to scholarly articles and to good colour illustrations.

RODERICK WHITFIELD
January 1984

Contents

Acknowledgements *page 8*

Preface *page 9*

Chronology *page 10*

Maps *page 12*

Introduction *page 14*

1 The Prehistoric period *page 40*

2 The Three Kingdoms *page 51*
 (57 BC–AD 668)

3 Unified Silla *page 103*
 (AD 668–935)

4 Koryŏ Dynasty *page 128*
 (AD 918–1392)

5 Chosŏn Dynasty *page 153*
 (AD 1392–1910)

6 Paintings *page 182*

Glossary *page 221*

Bibliography *page 223*

Acknowledgements

This exhibition has been made possible by the concerted efforts of a great many persons. We are most grateful to Dr Sunu Choi, Director General of the National Museum of Korea, and to the other National Museums, Museums, and private collectors in Korea who have so generously lent their treasures.

The British Museum wishes to thank Professor Roger Goepper, Director of the Museum für Ostasiatische Kunst, Cologne, and his staff for their contributions to the text of the catalogue. Special thanks go to Dr Young-sook Pak through whom it has been possible to consult the latest studies by Korean scholars, and who has thereby contributed substantially to the whole catalogue as well as to those entries which bear her initials. Limitations on space, and the need for a consistent scholarly approach, have meant that it was not always possible to use the whole of the material contributed: all responsibility for the errors that remain lies solely with the editor.

Thanks are also due to His Excellency The Korean Ambassador and his staff, especially Mr Lee Chan-yong, Cultural Attaché, for help at all times. The British Museum is grateful to the Daily Telegraph and to Midland Bank International, in association with whom the exhibition is presented, particularly to the Daily Telegraph for publicity and to the Midland Bank for generous provision of colour plates in this catalogue. All the illustrations of exhibits are from photographs provided by the National Museum of Korea. Further colour photographs used in the exhibition were taken in Korea by Graham Harrison.

The exhibition would not have been possible without the dedication and expertise of Martin Pyant, Bob Baxter and Julia Walton in the British Museum Design office. Christopher Date of the Department of Oriental Antiquities, Jenny Chattington at British Museum Publications, and Harry Green, have worked long hours to ensure its success. Thanks are also due to David McLintock and Evelyn Dyson who undertook the preliminary translation of the German entries.

Preface

The present Korean art exhibition provides a comprehensive view of the culture of Korea beginning with comb-patterned pottery from archaeological sites carbon-dated to be five to six thousand years old – down through the Bronze Age, Early Iron Age, the Three Kingdoms period (Koguryŏ, Paekche, and Silla) and the subsequent Unified Silla, Koryŏ, and Chosŏn periods.

Accordingly, this exhibition includes objects from the unique Bronze Age of Korea (based on the ancient civilisation of North-east Asia in which Korean culture finds its origin) and works of art in gold and other precious metals from Silla, seldom paralleled in other Asian countries.

For many centuries in the Unified Silla and Koryŏ periods Korea produced some of the finest examples of Buddhist art. The exhibition includes distinctive Korean images such as the Buddha in meditation as well as important finds from recent excavations.

The art of ceramics has had a continuous development in Korea from the earliest times. In the Koryŏ period, as early as the eleventh century, celadon wares were perfected and renowned throughout the Far East. Ceramics continued to be an important cultural accomplishment over the five hundred years of the Chosŏn period.

In the field of painting, also, Korea has a long history. For the current presentation we have selected representative works from the Chosŏn period. We hope that out of the present selection the differences between Korean paintings and those of neighbouring China and Japan will emerge.

It is sincerely hoped that this exhibition will lead to a better understanding of the unique and original achievement and merit of the culture of Korea, a nation with one of the longest histories in Asia. I wish to take this opportunity to extend my deepest gratitude to the British Museum and other organisations and individuals whose co-operation has proved invaluable in the presentation of this exhibition.

SUNU CHOI
Director General
National Museum of Korea

Chronology

5000BC	**PALAEOLITHIC**	Sokjang-ni, Chŏngok-ni dwelling sites	

4000BC 3000BC 1000BC	**NEOLITHIC**	Amsa-dong dwelling site Plain pottery	

800BC 500BC	**BRONZE AGE**	Mugye-ri, Songguk-ri cist graves Earliest appearance of 'Liaoning' dagger	Stone daggers

300BC 200BC 100BC	**EARLY IRON AGE** 108 Establishment of the Lelang colony by Han dynasty China	Ritual bronzes with incised patterns

THREE KINGDOMS PERIOD

Kingdom of Koguryŏ (37 BC–AD 668) Capital at Kuknaesŏng (Tong'gou, now in China)	**Kingdom of Paekche** (18 BC–AD 660) Capital at Wiryesong near Seoul	**Kingdom of Silla** (57 BC–AD 935) 35 Traditional foundation of Kŭmsong (the Golden Fortress), Kyŏngju

100AD
200AD
300AD

313 Fall of the Lelang colony 357 Tongsu tomb, near P'yŏngyang 372 Adoption of Buddhism Foundation of state university (t'aehak) King Kwanggaet'o (391–413)	367 First Paekche envoy to Japan 384 Adoption of Buddhism 391 Japanese invasion of Paekche and Silla	

400AD

King Changsu (413–91)
Expansion of Koguryŏ to the north
414 Great stele of Kwanggaet'o erected by King Changsu recording expansion of Koguryŏ under King Kwanggaet'o and expulsion of Japanese by alliance of Koguryŏ, Silla, Kaya.
427 Capital moved from Tong'gou to P'yŏngyang

	475 Capital moved to Ungjin (Kongju) King Munyŏng (501–23) Paekche successes against Koguryŏ	Kyŏngju royal tombs (5th–7th century)
Tomb of the Dancers, near Tong'gou Tomb of the Wrestlers, near Tong'gou		
	525 Burial of King Munyŏng (d. 523) 527 Burial of his queen	King Pŏphŭng (r.514–40) 528 Adoption of Buddhism in Silla

500AD

539 The yŏnga dated gilt-bronze Buddha Numerous tombs with wall-paintings	Songsan-ni brick tomb, near Kongju 538 Capital moved to Sabi (Puyŏ) Introduction of Buddhism to Japan from Paekche	532 Foundation of Pulguk-sa, Kyŏngju King Chinhŭng (540–76)
	552 Buddhist sutras and images sent to Emperor Kimmei in Japan	562 Fall of Kaya to Silla 569 Completion of Hwangryong-sa King Chinp'yŏng (579–632)

600AD

612–3 Sui attacks on Koguryŏ Tomb of Four Guardians, Tong'gou Kangsŏ tombs, near P'yŏngyang Chinp'ari tomb, near P'yŏngyang 645 Koguryŏ repels Tang army	602 Monk Kwallŭk of Paekche visits Japan	634 Punhwang-sa pagoda completed 640 Ch'ŏmsŏngdae observatory built
668 Fall of Koguryŏ to Silla Establishment of Unified Silla	660 Fall of Paekche to Silla	

UNIFIED SILLA (AD 668–918)

State of Palhae in the north (699–926)	674 Construction of Anap-chi 679 Construction of Sach'ŏnwang-sa 682 Construction of Kamŭn-sa	Printed Dharani sutra in Śākyamuni pagoda, Pulguk-sa, Kyŏngju

700AD	King Sŏngdŏk (702–36)	751 Rebuilding of Pulguk-sa 751 Construction of Sŏkkuram	754–5 Avataṁsaka sutra with illustrations 755 Great Buddha of Medicine cast for Punhwang-sa 771 Pongdŏk-sa bronze bell cast
800AD	Chang Po-go's (d. 846) hegemony of sea-routes between China, Korea and Japan	802 Construction of Hae'in-sa Korean colonies on Chinese coast described by priest Ennin (794–864)	858 Iron Buddha of Porim-sa 865 Iron Buddha of Top'ian-sa

KORYŎ DYNASTY (AD 918–1392)

900AD	918 Koryŏ dynasty established 919 Capital established at Kaesŏng 935 Final surrender of Silla 958 Institution of state examinations 993 Khitan invasions (until 1018)		993 Inscribed proto-celadon vase (? earliest white porcelain)
1000AD	1010 Liao invasion of Korea	Ch'ŏnt'ae-jong (Tiantai sect) brought to Korea by Ŭich'ŏn (1055–1101)	1010 First carving of Korean Tripitaka begun
1100AD		1123 Visit of the Chinese envoy Xu Jing	1159 Inlaid celadon in tomb of Mun Kong-yu
	1196 Beginning of rule of Ch'oi family	Chogye-jong (Sŏn Buddhism) established by Chinul (1158–1210)	
1200AD	1231 Mongol invasion 1232 Court flees to Kanghwa Island		1234 First printing with metal types 1237–51 Carving of Koryŏ Tripitaka (now in Hae'in-sa)
1300AD			

CHOSŎN DYNASTY (AD 1392–1910)

			Decline of celadons
	1392 Chosŏn dynasty established 1394 Capital moved to Hansŏng (Seoul)	Establishment of Tohwasŏ (Painting Bureau)	
1400AD	King Sejong (1418–50)	1418 Establishment of Chiphyŏn-jŏn (Hall of Worthies) 1443–6 Invention of *Han'gul* writing system	1419 White porcelain used at court 1447 An Kyŏn *Dream Journey to Peach Blossom Land* 1464 First discovery of native cobalt
	Literati purges (1498, 1504, 1519, 1545)		
1500AD			Decline of *punch'ŏng* wares
	1592–8 Japanese invasions	Korean potters taken to Japan	
1600AD	Death of General Yi Sunsin	1625 Official kilns at Punwŏn recorded	
	1627–36 Manchu invasions		
1700AD	King Yŏngjo (1720–76) King Chŏngjo (1776–1800)	*silhak* (practical learning) movement 1776 Kyujanggak (Royal Library) established	Paintings of real landscape (*chingyŏng sansu*) by Chŏng Sŏn (1676–1759) Genre paintings by Sin Yun-bok (mid-18th-century) and Kim Hong-do (1745–after 1814) Kim Chŏng-hŭi (1786–1857), calligrapher and painter
1800AD			
	1863 Yi Ha-ŭng Prince Regent	1862 Demolition of most Confucian academies (*sŏwŏn*) 1883 Closure of official Punwŏn kilns	
	1910 Annexation by Japan 1945 Republic of Korea		

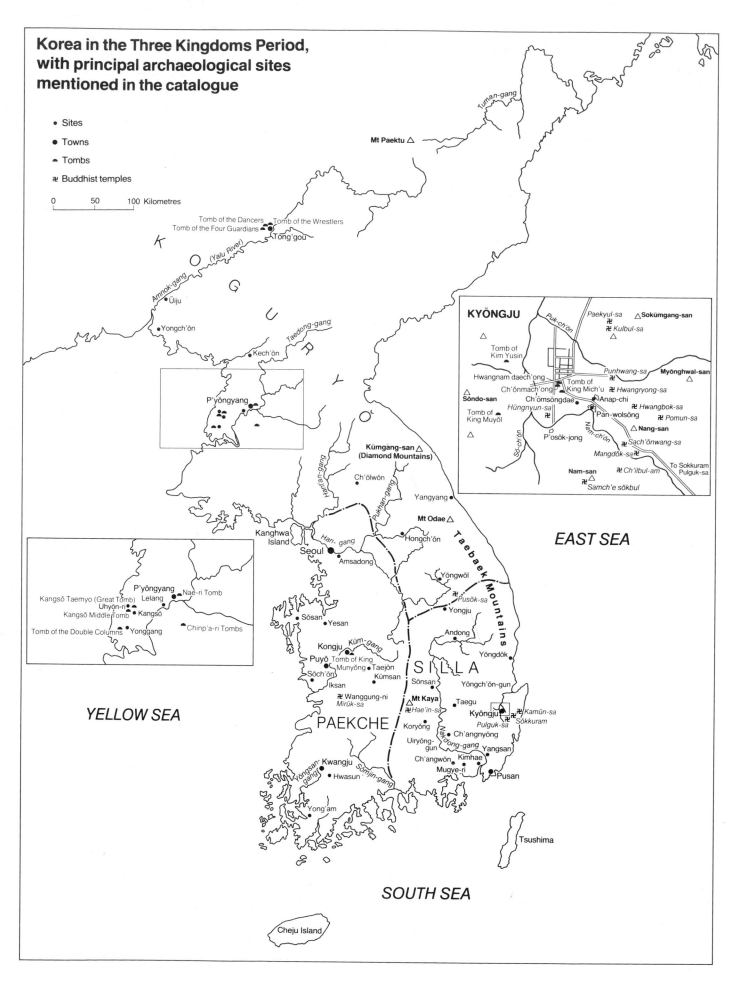

Korea in the Three Kingdoms Period, with principal archaeological sites mentioned in the catalogue

- • Sites
- ● Towns
- ⏶ Tombs
- 卍 Buddhist temples

0 50 100 Kilometres

KYŎNGJU

Puk-ch'ŏn

Paekyul-sa △ Sokŭmgang-san

卍 Kulbul-sa

Tomb of Kim Yusin

Hwangnam daech'ong *Punhwang-sa* **Myŏnghwal-san** △

Ch'ŏnmach'ong Tomb of King Mich'u 卍 Hwangryong-sa

Sŏndo-san Ch'ŏmsŏngdae Anap-chi 卍 *Hwangbok-sa*

Tomb of King Muyŏl *Hüngnyun-sa* 卍 Pan-wolsŏng 卍 *Pomun-sa*

Sŏ-ch'ŏn P'osŏk-jong Nam-ch'ŏn △ **Nang-san**

Mangdŏk-sa 卍 卍 Sach'ŏnwang-sa

To Sokkuram
Pulguk-sa

Nam-san △ 卍 *Ch'ilbul-am*

Samch'e sŏkbul

Mt Paektu △

Tuman-gang

K O G U R Y Ŏ

Tomb of the Dancers Tomb of the Wrestlers
Tomb of the Four Guardians ⏶
T'ŏng'gou

Amnok-gang (Yalu River)

• Ŭiju

• Yongch'ŏn

Taedong-gang

• Kech'ŏn

• P'yŏngyang

Kŭmgang-san △
(Diamond Mountains)

Han'tan-gang • Ch'ŏlwŏn

Pukhan-gang • Yangyang

Kanghwa Island **Mt Odae** △

Han-gang • Hongch'ŏn

Seoul ●
• Amsadong

Taebaek Mountains EAST SEA

• Yŏngwŏl

卍 *Pusŏk-sa*
• Yongju

P'yŏngyang Nae-ri Tomb
Kangsŏ Taemyo (Great Tomb) Lelang
Uhyŏn-ri
Kangsŏ Middle Tomb • Kangsŏ
Tomb of the Double Columns Yonggang
Chinp'a-ri Tombs

• Andong
• Yŏngdŏk

• Sŏsan • Yesan

S I L L A

Kongju Kŭm-gang
Puyŏ Tomb of King
Sŏch'ŏn Munyŏng Taejŏn
Kŭmsan • Sŏnsan
• Yŏngch'ŏn-gun
Iksan • Taegu
卍 Wanggung-ni **Mt Kaya** **Kyŏngju**
Mirŭk-sa 卍 *Hae'in-sa* 卍 *Kamŭn-sa*
Pulguk-sa 卍 Sŏkkuram
• Koryŏng • Ch'angnyŏng
PAEKCHE Uiryŏng-gun • Yangsan
Ch'angwŏn Kimhae

YELLOW SEA

Yŏngsan-gang Kwangju
• Hwasun Sŏmjin-gang Mugye-ri
Pusan

• Yong'am

Tsushima

SOUTH SEA

Cheju Island

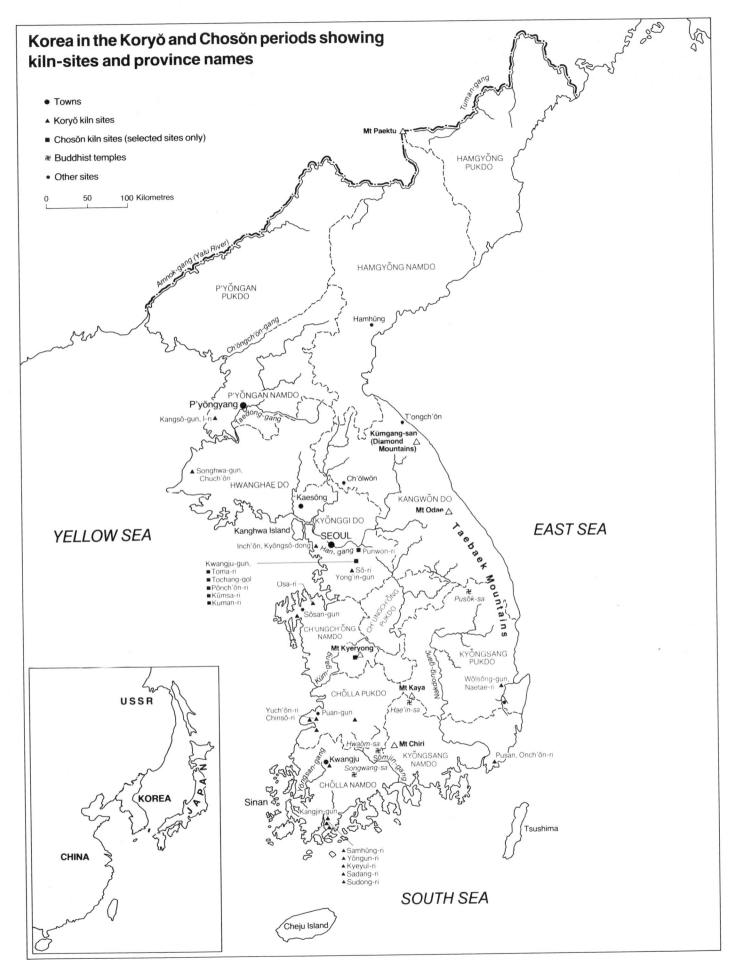

Korea in the Koryŏ and Chosŏn periods showing kiln-sites and province names

- ● Towns
- ▲ Koryŏ kiln sites
- ■ Chosŏn kiln sites (selected sites only)
- 卍 Buddhist temples
- • Other sites

0 50 100 Kilometres

Tuman-gang

Mt Paektu △

HAMGYŎNG
PUKDO

HAMGYŎNG NAMDO

Amnok-gang (Yalu River)

P'YŎNGAN
PUKDO

Ch'ŏngch'ŏn-gang

Hamhŭng ●

P'YŎNGAN NAMDO

P'yŏngyang ●

Kangsŏ-gun, I-ri ▲

Taedong-gang

T'ongch'ŏn ●

Kŭmgang-san △
(Diamond
Mountains)

▲ Songhwa-gun,
Chuch'ŏn

HWANGHAE DO

Ch'ŏlwŏn ●

Kaesŏng ●

KANGWŎN DO

Mt Odae △

KYŎNGGI DO

YELLOW SEA

Kanghwa Island

SEOUL ●

EAST SEA

Inch'ŏn, Kyŏngsŏ-dong ▲

Han-gang

■ Punwŏn-ri

Kwangju-gun,
■ Toma-ri
■ Tochang-gol
■ Pŏnch'ŏn-ri
■ Kŭmsa-ri
■ Kuman-ri

▲ Sŏ-ri
Yong'in-gun

Osa-ri ●

CH'UNGCH'ŎNG
PUKDO

卍
Pusŏk-sa

T
a
e
b
a
e
k

M
o
u
n
t
a
i
n
s

● Sŏsan-gun

CH'UNGCH'ŎNG
NAMDO

Kŭm-gang

Mt Kyeryong ■

KYŎNGSANG
PUKDO

Wŏlsŏng-gun, ▲
Naetae-ri

Mt Kaya △

CHŎLLA PUKDO

卍
Hae'in-sa

Nakdong-gang

Yuch'ŏn-ri ● Puan-gun
Chinsŏ-ri ▲ ▲

▲

卍
Hwaŏm-sa △ Mt Chiri

Pusan, Onch'ŏn-ri ●

Kwangju ●

卍
Songwang-sa

Sŏmjin-gang

KYŎNGSANG
NAMDO

Yŏngsan-gang

CHŎLLA NAMDO

Sinan

Kangjin-gun
▲ ▲

▲ Samhŭng-ri
▲ Yŏngun-ri
▲ Kyeyul-ri
▲ Sadang-ri
▲ Sudong-ri

Tsushima ●

SOUTH SEA

Cheju Island

USSR

KOREA

CHINA

JAPAN

13

Introduction

Korea – the Country and its People

The oldest name of Korea is Chosŏn ('morning freshness'), a name repeatedly revived throughout its history; today the republic is called Hanguk ('the State of the Han'). Korea is a peninsula on the eastern edge of the great Eurasian landmass. It protrudes into the sea from the north, stretching southwards for about 1000 kilometres and forming a barrier between the Yellow Sea and the Sea of Japan. The country covers an area of almost 221,000 square kilometres and is thus about the same size as Britain. The distance between Korea and Japan across the Tsushima Strait is only 206 kilometres; that between the west coast of the Korean peninsula and the mouth of the Huai River in central China is somewhat more than 500 kilometres. Korea is a relatively stable landmass which rarely experiences earthquakes and no longer has any active volcanoes, unlike Japan. Its northern frontier with China and Manchuria is formed by the great Yalu and Tuman Rivers.

More than 70 per cent of the country's total area consists of mountains, which vary in height; the T'aebaek range near the east coast rises to 1571m. In this respect the character of the landscape is very similar to Japan. The peninsula has a continental climate which extends from the landmass of northern Asia, but it is also reached by the monsoon. It has cold winters and a very hot summer, with a rainy period in June and July.

Korea's geographical position has been of great significance for its history and culture. In prehistoric and early historical times, when men hardly ventured out to sea, settlers followed by material culture entered the country by the land route from northern Asia. This was still the case in the early historical phase. The sphere of Chinese culture began to extend into the Korean peninsula only about 300 BC, when the northern Chinese state of Yan expanded to the north-western borders of Korea. Even later, when Chinese military colonies existed in Korea in P'yŏngan province under the Chinese Han dynasty between 108 BC and AD 313, the conquest of these colonies and their supply for more than four centuries was principally overland from the north.

Under the Three Kingdoms, Koguryŏ (37 BC–AD 668), which embraced large tracts of northern Korea and Manchuria, cultivated its contacts with Chinese civilisation by way of the land route. By contrast, Paekche (18 BC–AD 660), in the south-west of the peninsula, had no uninterrupted overland link with China and had to rely on the sea route. In fact, it had closer political and cultural contacts with the southern dynasties of the then fragmented Chinese Empire than Koguryŏ had with north China by the land route. The Unified Silla Kingdom (AD 668–935) seems to have favoured the sea link with the Empire of the Tang dynasty (AD 618–906), which was shorter and quicker than the journey by land, though more dangerous.

The brisk maritime trade of the ninth century and the shipping in the northern part of the China Sea was well established in Korean hands. In the travel journals of Japanese pilgrim monks, most notably the famous Ennin (AD 794–864) we possess detailed and lively descriptions of the Korean colonies along the Chinese coast and inland as far as the capital Chang'an. At that time it was virtually impossible to make a sea journey between China and Japan in either direction without the services of Korean middle-men.

In the eighth century the Tungusic state of Bohai (Korean Palhae), ruled by a

refugee intelligentsia from Koguryŏ, pushed its way between the Korean Silla Kingdom and the Tang State, and later, when northern China and Manchuria were ruled by the Liao dynasty of the Khitan and the Jin dynasty of the Manchurian Jurchen, there was no longer a direct land link between Korea and China, and most diplomatic and trading contacts depended on the sea route. Japan, which in the early phase of its history owed a great deal of its 'Chinese' culture to Korean mediation, could in any case be reached only by sea.

That Korea is a peninsular largely explains why the Koreans of today are among the very few peoples who have lived in the same geographical area for some two thousand years and have not been subject to waves of immigration from outside. The Chinese Mongolian and Japanese invasions have had no appreciable effect on the structure of the Korean nation.

Within the Altaic race the Koreans belong to the Tungusic group of peoples spread across Manchuria and Siberia. Probably as early as the neolithic period in the third millennium BC, they supplanted more or less completely the original Palaeo-Asiatic population of the peninsula. Since this period they have been in undisputed occupation of the area they inhabit today. This area is so narrow that the original tribal differences became progressively blurred. Finally the country's ethnic and cultural unity was decisively established by the first political unification which took place under the Unified Silla dynasty (AD 668–935); it was maintained under the Koryŏ (AD 918–1392) and Chosŏn dynasties (AD 1392–1910). This phenomenon explains the consistency of cultural development in Korea and which is clearly illustrated by the items illustrated in this catalogue.

The Language, Script and Literature of the Koreans

Korean belongs to the Ural-Altaic family of languages. Within this family it belongs to the Altaic group, and within this group to the Tungusic branch. The other two branches are Turkic and Mongolian, with which it shares certain characteristic features. Some of the features of the Korean language are also found in Japanese, but so far no generic relation has been established between the two languages. In early times there were two groups of dialects in Korean, the Puyŏ languages of the north, spoken in Koguryŏ, and the Han languages in the south, from which the standard language of the Unified Silla Kingdom evolved. Today six dialects may be distinguished in spoken Korean.

Like Japanese, Korean contains a large proportion of Chinese loan-words. It is estimated that rather more than half the present vocabulary comes from Chinese. Although these Chinese loans have been adapted to Korean pronunciation, at the same time they preserve a type of Chinese pronunciation current several centuries ago. This situation may be compared with that of English, whose vocabulary acquired many French elements after the Norman Conquest. However, while English and French are related as members of the Indo-European family, Korean and Chinese belong to quite different families.

Like Latin in the European Middle Ages, Chinese has remained the literary language of Korea from the earliest times almost up the present day. The very earliest document, a great stone stele of the nineteenth king of Koguryŏ, Kwanggaet'o, from the year AD 414, is in Chinese.

From the Unified Silla period (AD 668–935) more and more Chinese books were

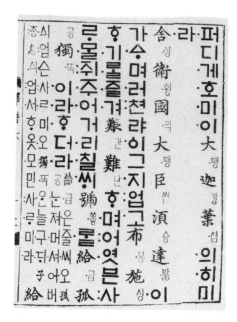

Page from a book printed in AD 1449, with *Han'gŭl* characters in three sizes for the text, commentary and notes. The types were cast in bronze; the Chinese characters used for proper names are from a font of AD 1434.

introduced, and the Confucian classics and the sacred texts of Buddhism (no 219; see colour illustration) became the basis of all education in Korea. Historical works, collections of biographies, even journals and poems, were written exclusively in Chinese, and this same foreign language was used in all state examinations. In the first half of the sixth century Korean songs began to be written down in Chinese characters, but these were used purely phonetically, without reference to their meaning (in the Chinese system of writing each character represents a syllable suggesting meaning rather than sound). To a Chinese these texts would have seemed like an extreme form of gibberish. This writing system is known as *Idu*, and it later influenced the Japanese in their so-called *Manyō-gana*.

King Sejong (reigned 1418–50), the fourth king of the Chosŏn dynasty, published his own extremely scientific writing system for Korean in 1446 in a book called *Hunmin chŏng'ŭm* ('Correct phonetic script for the instruction of the people'). This consisted of 28 simple graphic signs, later reduced to 24, which are still in use as a phonetic script in Korea. The King may have drawn his inspiration from Indian writing systems used for Sanskrit or from the *Phags-pa* script of the Mongols, which was invented by a priest. Angular shapes are used to represent consonants, horizontal or vertical strokes represent vowels; these are combined in box-like units representing syllables and placed underneath each other to form words, though with no spaces between the words. This script, known today as *Han'gŭl* ('Korean script'), is easily learnt and was intended as a popular alphabet. In fact, it was hardly able to establish itself in the fifteenth century, since it met with resistance from the civil service, which was used to Chinese. It was dismissed as a script for women because of its simplicity; this was also the fate in the Heian period in Japan of the syllabic script of *hiragana (onna-de,* 'women's style'). Since many words borrowed from Chinese sound alike but are written with different characters a text written solely in *Han'gŭl* is in practice often more difficult to read than one in which Chinese characters are used for the important words and concepts and *Han'gŭl* for the grammatical morphemes of Korean. After a long period during which there were attempts to abolish Chinese characters in the Republic of Korea, there is at present a strong movement for a return to a mixed system of writing. The *Han'gŭl* alphabet, however, offers the only solution to the problem of correctly representing all the sounds of present-day Korean. The difficulty of romanisation becomes clear when one learns that in August 1982 the periodical *Korean Journal* collected no fewer than twenty-five systems for the transcription of Korean into the Western alphabet, four of them used all over the world. In the present catalogue the system of McCune-Reischauer is used.

As early as 1403 movable metal type had been made from an alloy of copper and tin. This has been used for printing the Confucian classics, but, as in China in the eleventh century, such experiments did not meet with any large-scale success. Usually whole folios were printed from a single hand-carved wooden block. The earliest examples of Korean poetry are the *hyangga* ('native poems') of the Unified Silla period; only twenty-five examples are preserved as quotations in later works. They are written in the *Idu* system and were certainly sung. While these were relatively short works, the Koryŏ period produced 'long poems' known as *changga*; some of these were written by learned authors in court circles and were influenced by the Chinese poetry of the Song period (AD 960–1279), while others had the character of folk-songs (*sogyo*) and were composed by *kisaeng*, educated courtesans.

The late Koryŏ period saw the emergence of the *sijo*, which consisted of only three lines and which was very popular among Confucian scholars during the Chosŏn dynasty (AD 1392–1910), reaching its peak as an artistic form in the seventeenth century. From about 1500 onwards narrative poems known as *kasa*, which were lyrical in character, were composed by men of letters, but also, on occasion, by ladies.

Early prose works survive only in later collections of myths and legends in the historical works, *Samguk sagi* (dated 1145) and *Samguk yusa* (thirteenth century); tales of miracles and magic also survive. In the middle of the Koryŏ period anecdotes, satires and erotic narratives appeared as new literary genres, copied from Chinese models. Under the Chosŏn dynasty the scope of narrative literature became broader and Chinese novels were adopted. Among the works which have remained famous to this day are *Kŭmo-sinhwa* ('New Tales of Kŭmo') by Kim Sisŭp (AD 1435–93) and *Kuun-mong* ('Dream of Nine Clouds') by Kim Manchung (AD 1637–92).

Since 1700 there has been a flood of novels and novella literature. A classic example is *Ch'unhyang-jŏn* ('Story of Ch'unhyang'), a sentimental story about the love of a young man of the *yangban* élite for the daughter of a *kisaeng*, or courtesan. After a rapid decline of the classic literary genres towards the end of the Chosŏn period, modern writing began to develop in Korea under Western influence.

Religions in Korea

In most advanced early cultures art is rooted to a large extent in religion. Individual works of art have specific roles to play in ritual, and are thus subject to its requirements, so that religious conceptions come to determine not only the content of the works but also their form. This holds true for architecture, as well as sculpture, painting and cult objects. It will therefore be useful to give a brief account of Korea's traditional religions.

Popular belief and shamanism

Korean popular myths, which were often not recorded until a late date, and stories preserved in historical works of the Koryŏ period, enable us to reconstruct important features of early Korean popular religion. Like other areas of Korean culture, it had strong links with the northern Asiatic hinterland, particularly, of course, with Manchuria and Siberia. The myths relating to the founding of Three Kingdoms, Koguryŏ, Paekche and Silla, which point to totemism and a bear-cult in early Korean religion, are important sources. The mythical founder of Korea is Tan'gun, who sprang from the union between a god and a she-bear. The legendary year of his birth 2333 BC, marks the beginning of traditional Korean chronology.

The old nature religion, which is almost indistinguishable from shamanism and which shares many features with Japanese Shintō, recognises sky-gods such as Hananim and gods of the sun, the moon and the stars. Among the powers of the earth (*t'osin*), the local mountain-gods (*sansin*) play a specially important role, for example the god of Namsan, south of Kyŏngju. Demonic tigers (*horang'i*) assist them. At the entrances to villages one still finds tall poles of the local deities, with crudely carved human faces. Rivers and lakes are inhabited by water-gods (*susin*), symbolised by the dragon. Gods of crops and of the earth were worshipped at the

'land and harvest altars' (*sajik-tan*); their cults involved fertility rites, as may be inferred from the respresentations on the clay urn from a Silla tomb (no. 46). In the everyday life of the people, wandering ghosts (*kwisin*), the souls of unfortunate persons, cause disturbance and have to be propitiated by sacrifices. Some of the nature gods came partly to be identified with figures in the Chinese and Buddhist pantheon and acquired features indicating a degree of syncretism.

In Korea, as in China, the ancestor cult played a specific role. As in China, wooden tablets (*wip'ae*) with the name of the deceased were set up in ancestral shrines (*sadang*). At graves, the locations of which were selected with the aid of geomancy (*p'ungsu*), rites were performed for the dead on certain days of the year.

Primitive traits are preserved in Korean shamanism, although elements of Chinese popular religion have partly infiltrated its pantheon and ritual. As in northern Asia, shamanism in Korea was no doubt originally the religion of a clan, and the leader of the clan might be identical with the shaman. When organised states began to take shape in the period of the Three Kingdoms the former chiefs and magicians became state shamans who exercised considerable influence on political and military life, acting as a kind of oracle on behalf of the king. Perhaps a survival of this identification of the leader with the shaman is represented by the golden crowns from this period (nos 43, 93), as their motifs are partly drawn from shamanism. When the advanced religions – Buddhism and Confucianism – were established in Korea, the shamans were relegated to the lowest stratum of society.

Today the shamans of Korea are women (*mudang*); at one time men also performed this role. The profession of the shaman can be passed on by inheritance, but usually this difficult calling is taken up as a result of the so-called 'shaman sickness' (*mubyŏng*) which manifests itself in the form of dreams or hallucinations. At the start of her career the shaman, by a mystical and magic process, acquires her most important cult objects – her curved sword (*wŏldo*), mirror (*myŏngdo*) and drum (*changgo*) – before undergoing her initiation ceremony (*naerim-kut* or *kangsinkut*, 'the calling down of the gods') and being allotted her personal tutelary god (*momju*).

The principal ceremonies (*kut*) are designed to drive away evil spirits (*chapkwi*), call down the rain, give thanks for the harvest and ensure general protection. The shaman falls into a trance and speaks with the voice of the spirits (*kongsu* 'empty singing'). Such ceremonies take place mostly under spirit-trees (*tongsin-namu*) or by 'spirit-rocks' (*tongsin-bawi*), thought to be the residences of gods, and follow a traditional pattern.

A glossary of shamanistic terms is given in Cho Hung-youn 1982 (RW).

Buddhism

The Buddhist religion (*pulgyo*) reached Korea from China in the fourth century AD, but soon became a powerful current. It was officially recognised as the state religion in Koguryŏ around AD 372, in Paekche around 384 and finally in Silla in 528. As a cultural force, it made itself felt in all the arts: Buddhist priests are even portrayed among the subjects of the Koguryŏ mural paintings in tombs. The first flowering of Buddhist culture in Korea came in the sixth century in the Paekche Kingdom, and in the seventh and eighth centuries under the Unified Silla dynasty. Then, after a period of partial stagnation towards the end of this dynasty, it acquired a fresh impetus through the encouragement of the Koryŏ kings. Later it

Ceiling design of lotus, Koguryŏ wall-painting from the Ssangnyong-ch'ong (Tomb of the Double Columns), near Yonggang, South P'yŏngan province, early 6th century AD.

was forced into the background by Confucianism, and was even partially suppressed during the Chosŏn dynasty (AD 1392–1910).

Under the Unified Silla dynasty (AD 668–935), after Paekche and Koguryŏ had been finally integrated into the Kingdom, Buddhism came fully into its own as the religion of the state and was even exploited as means of propaganda for political purposes. One king even gave the members of his family names borrowed from the Indian princely family to which Śākyamuni, the historical Buddha, belonged, and though this was merely symbolic it is, nevertheless, telling. More significantly, great temples were built in and around Kyŏngju to provide, supposedly, supernatural defences against any threat from outside. In AD 679, some ten years after the unification of the kingdoms, Sach'ŏnwang-sa, the great 'Temple of the Four Heavenly Kings' (no. 125; see colour illustration) was built to prevent the armies of the Tang dynasty, which had been driven out of Korea in AD 671, from returning to Silla. Above all, the cult of the 'benevolent king' (*inwang*), and of the sutra of that name, played a part in consolidating the dynastic principle, as it did in Japan at a later date. A similar purpose lay behind the building of Kamŭn-sa next to the sea; here, after his death, King Munmu (reigned AD 661–81), who was venerated as a dragon-god, guarded the land against incursions by Japanese pirates (nos 118, 119). The welfare of the realm was thus felt to have been placed in the hands of powerful Buddhist divinities whose favour was to be sought by the founding of temples and erecting statues.

Tortoise and snake, Koguryŏ wall-painting from the north wall of the Great Tomb of Kangsŏ, Uhyŏn-ri, South P'yŏngan province, 6th–7th century AD.

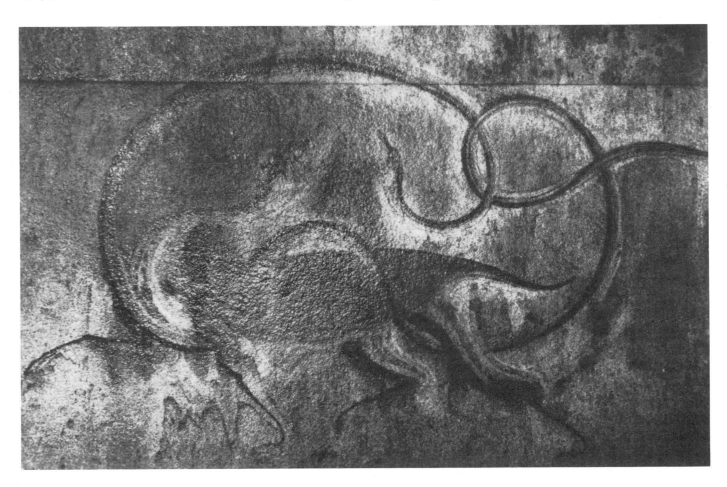

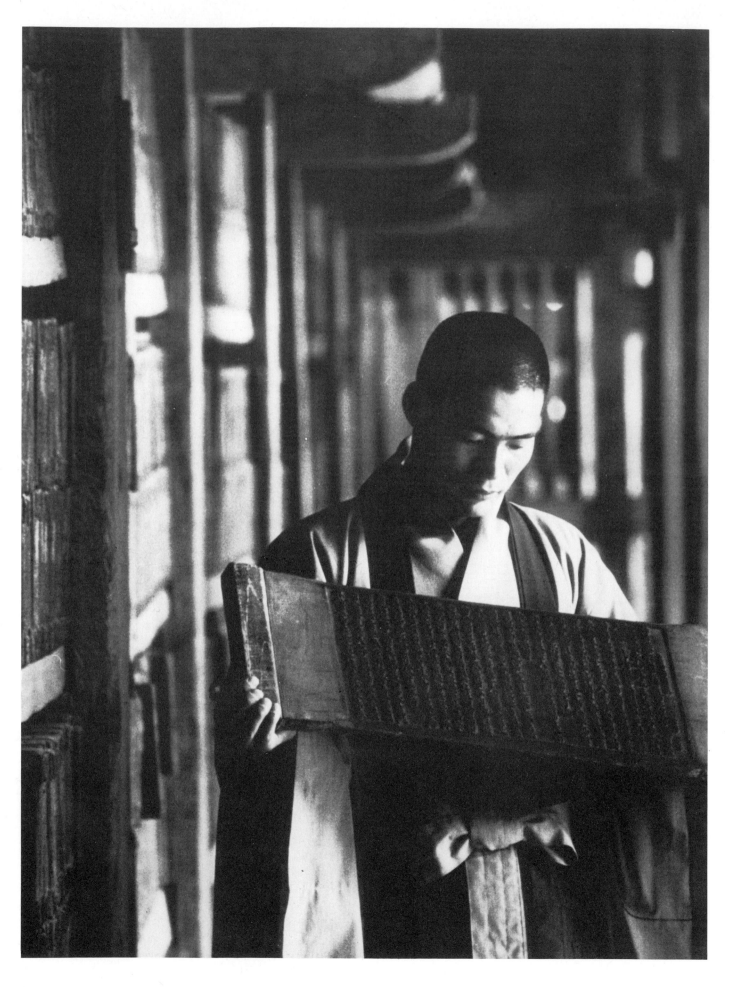

Monk holding a block from the Koryŏ
Buddhist Tripitaka, in the library of the
Hae'in-sa temple on Mt Kaya in South
Kyŏngsang province. (Photo Graham Harrison)

Despite political tension between Korea and China, numerous Korean monks
visited the monastic centres of the Tang capital, Chang'an, to study theology. One
of them, Hyech'o, who incidentally acquired a high reputation in China, even
travelled as far as India, and left a famous account of his journey.

All the forms of Buddhism which were popular in China during the Tang period
were transmitted to Korea, mainly by Korean priests who had studied in China.
Among them were the philosophically oriented Mahāyāna schools Samnon-jong
('School of the Three Treatises') Pŏpsŏng-jong ('School of Absolute Being') and
Yusik-jong (or Popsang-jong 'Dharmalakṣaṇa School'), Yul-jong and Kyeyul-jong.
The most influential, however, was Hwaŏm-jong ('Avataṁsaka School'), brought
to Silla by the influential priest Ŭisang (AD 625–702), this sect based its teaching
on the sutra of the same name and sought a synthesis of all Buddhist teachings. In
the seventh century came Esoteric Buddhism (Milgyo), which emphasised the
importance of ritual, Amitābha Buddhism (Chŏngt'o-jong, Pure Land School),
which laid stress on prayer (yŏmbul) as the means of redemption, and the Meditation
School (Sŏn-jong, Chinese Chan, Japanese Zen).

It was only under the Koryŏ dynasty that the eclectic-philosophical Ch'ŏnt'ae-
jong (the Tiantai School) was brought from Song China by Ŭich'on (AD 1055–
1101), the fourth son of King Munjŏng. However, it was soon pushed into the
background by the Chogye-jong, founded by Chinul (AD 1158–1210), who
successfully harmonised the Doctrinal and Meditation Schools. Thus Korean Sŏn,
by emphasising constant discipline, prayer and the study of sutras, as well as
meditation, is unique in the Far East. Since about 1200 the Chogye-jong School of
Sŏn has been predominant and still controls nearly all the monasteries.

The doctrines of redemption and the spectacle of the ritual exercised a fascination
over all the peoples of eastern Asia, including the Koreans. Above all, the often
pompous form of worship could be pressed into service by the royal house for
political ends, since it released patriotic forces. The kings of the Unified Silla period
(AD 668–935) employed Buddhism as a religion which would afford protection
against external enemies, and they regarded the great temples they built
(Hwangryŏng-sa, Sach'ŏnwang-sa) as bastions of national consciousness.

The pantheon of Buddhas and divinities corresponds in all essentials to that
found in China, but it is not as rich as the Japanese, since the Esoteric Schools did
not attain the same importance in Korea as they did in Japan. The greatest reverence
was accorded in Korea to the historical Buddha Śākyamuni (Sŏkkamuni), the
Buddha of Medicine, Bhaishajyaguru (Yaksa-yŏrae), the Buddha of Infinite Light,
Amitābha (Amita-bul); in the Koryŏ period the mystic Vairocana (Tae'il-yŏrae)
was also worshipped. Among the Bodhisattvas the Maitreya (Mirŭk-bosal), who
was expected as the future Buddha, had his own cult in the sixth and seventh
centuries (nos 94–96). Later the Compassionate Bodhisattva, Avalokiteśvara
(Kwanse'ŭm-bosal) and Kṣitigarbha (Chijang-bosal) became more prominent
(no. 122). An important aspect of religious activity was the proliferation of the
enormously extensive canonical literature (taejang-gyŏng). The texts were
originally copied by brush in Indian ink or in gold and silver on dark blue indigo-
coloured paper (no. 219; see colour illustration) as a means of attaining virtue. As
in Japan, there were large monastic scriptoria, for the mass of writing to be copied
required a high degree of organisation. From the eighth century onwards the
texts were also carved on woodblocks and printed. In the Śākyamuni pagoda of

Pulguk-sa, the oldest known printed text has been found, dating from the early eighth century AD. In Hae'in-sa the 81,137 blocks which were carved by order of the king between 1237 and 1251 as a magic defensive measure against the Mongol invasion are still preserved in a long hall of the monastery. A similar measure had been taken in the first half of the eleventh century against the invasions of the Khitan.

An equally important role was played by the cult of relics, which was similar to that found in medieval Europe. Many great monasteries owe their existence to a small, insignificant relic (*sari*) which was thought to be endowed with miraculous powers (nos 116, 118). Chinese emperors of the Tang dynasty sent such relics as gifts to the Silla king. When the priest Chajang returned from China in AD 643 he brought with him a fragment of skull, a back tooth and a costly garment said to have belonged to the historical Buddha Śākyamuni; these treasures were distributed among the great temples. Such relics, as vehicles of religion, were at least as valuable as the sacred writings brought back from China by monks.

Confucianism

Confucianism (*yugyo* or *yuhak*) is properly speaking not a religion, but a code of ethics and morals which was developed by the Chinese philosopher Confucius (551–479 BC) and was intended to guarantee the smoothest possible functioning of family, society and state. Even today the manners of the Koreans, down to the smallest details, bear the mark of Confucianism. If, for instance, a pupil gives something to his teacher or drinks to him, he supports his right hand, in which he holds the object, at the wrist with his left hand as a sign of special respect. In some families the son or son-in-law may not smoke in the father's presence without his permission.

Knowledge of Confucianism and the Confucian classics reached Korea together with the Chinese script between 108 BC and AD 313, when military colonies under Chinese rule were established in P'yŏngan province. In AD 372 the first state university (*t'aehak*) was founded in the kingdom of Koguryŏ, followed a little later by the first private schools (*kyŏngdang*). Paekche followed suit a short time after this. The Unified Silla dynasty in particular endeavoured to make the teachings of Confucianism the backbone of the state. To this end the king sent numerous scholars and officials to study in Chang'an, the capital of the Tang Empire, and in AD 682 he instituted a state university (*kukhak*). Men like Kim Inmum (AD 629–94) and Ch'oe Ch'iwon (born AD 875) are numbered among the greatest of Korean scholars.

Towards the end of the Silla period the Confucians split into feuding factions which began to interfere in politics, usually with disastrous results. The kings of the Koryŏ dynasty (AD 918–1392) began in 958 to hold yearly state examinations (*kwagŏ*) for candidates for civil office. These took place in their new capital of Kaesŏng (Seoul) and were meant in theory to enable any citizen to follow a civil career. In fact, the offices remained in the hands of a hereditary administrative élite (*yangban*, literally 'two categories', i.e., military and civil officials) which was inclined to nepotism and corruption. In the fourteenth century the Neo-Confucianism of Zhu Xi (AD 1130–1200) reached Korea from China under the name of Chuja-hak.

The rulers of the Chosŏn dynasty (AD 1392–1910) accorded exclusive favour

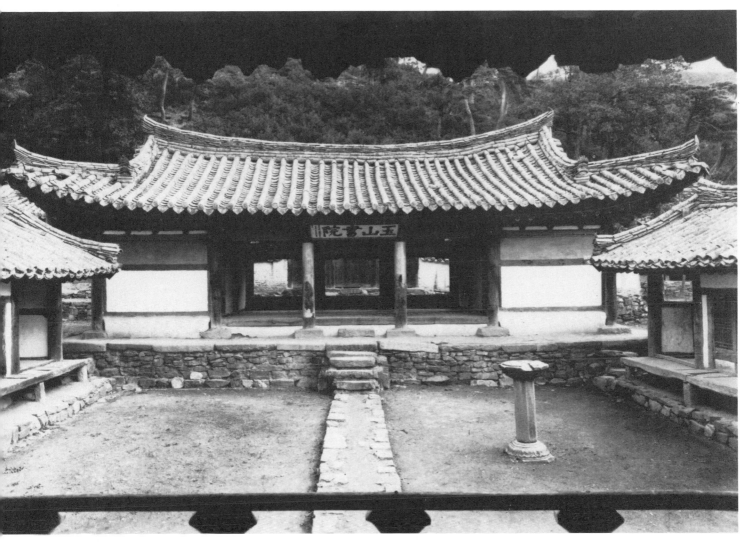

Sixteenth-century courtyard and main hall of the Oksan Sŏwŏn, in Kyŏngju. This famous *sŏwŏn* (Confucian academy) with a library of more than two thousand books, was the teaching place of Yi On-jŏk, Confucian scholar and minister, AD 1491–1553, and was dedicated as a shrine to his memory in AD 1610.

to Confucianism from the fifteenth century. In the sixteenth century factions developed (*pungdang*), which led to inter-factional killings and culminated in the so-called literati purges (*sahwa*).

A typically Korean phenomenon of positive intellectual significance, though of little importance in the sphere of politics, was the emergence in the late seventeenth century of 'Practical Learning' (*silhak*), possibly sparked off by the influence of Jesuit missionaries who were active at the court in Peking. *Silhak* was most influential in the field of literature. Its effect on Confucianism, oriented as it was towards practical living, may be discerned in the tendency among painters to portray real, existing Korean landscapes rather than ideal landscapes in the Chinese manner (no. 231), and perhaps also in the realism with which officials were portrayed (no. 226), but especially in genre-painting (no. 246c; see colour illustration), which was cultivated to a degree unknown in China.

Taoism

Chinese Taoism, a highly mystical form of philosophy and religion named after the universal principle of 'the way' (*dao*, Korean *do*), never acquired the same

foothold in Korea as the other religions which were imported from China. Nevertheless, it is claimed that Taoist influence may be seen in some of the motifs in the mural paintings in fourth- to sixth-century graves of the Koguryŏ kingdom. The book *Daode-jing*, which is attributed to Laozi, the legendary founder of the religion, was at all events known in Koguryŏ during the seventh century. Reportedly Gao Zu, the first Tang emperor, sent priests to Koguryŏ with a portrait of Laozi and some Taoist texts. As Buddhist temples began to be transformed into Taoist shrines and Taoist priests acquired a higher status than Buddhist priests, opposition arose among the Buddhist priesthood. The teaching of the Laozi reached Paekche and Silla, making its way into the ideology of the *hwarang*, the 'flower lords' of Silla, and infiltrating popular religion. Taoism flourished particularly in the Koryŏ dynasty, and the Chinese envoy Xu Jing described both Taoist temples and the images in them on his visit to Korea in AD 1123. Some of the popular deities have Taoist names. As in China, the natural striving for long life (*su*) and happiness (*pok*) was invested with a Taoist meaning and expressed in Taoist symbolism.

Korean Architecture

To give some idea of the surroundings and atmosphere in which many of the works of art illustrated here originally existed it will be useful to provide a brief account of the architecture of Korea. Korean architecture forms part of the great tradition which was shaped and dominated by China. Nearly all the types of building found in Korea have their origin in China.

The basic part of every sizeable architectural complex is the hall. There is usually a series of halls disposed along an axis, standing within courtyards enclosed by covered walks. This general plan is followed both in palaces and in Buddhist temples.

The hall (*tang* or *chŏn*) is rectangular, with the main entrance facing south in the centre of the long side. It usually stands on a raised terrace (*kidan*), paved with stone slabs, and is reached by one or more flights of steps. The construction is based on powerful wooden columns, on which is set a framework of beams to support the heavy tiled roof. The walls have no structural function. Doors and windows are of wooden lattice lined with opaque white paper. The eaves extend far beyond the walls, forming a verandah which usually runs round the whole building.

To support the projecting eaves a relatively simple but efficient system was developed in China and adopted, with very slight variations, in Korea and Japan. Each column supports a wooden bracket. This bracket is parallel to the wall and, by means of bearing-blocks at each end and in the middle, supports the actual beams of the frame. Other brackets project from the column at right angles to the wall; these support the roof purlins. As a rule there are two brackets, but later there are three or more. This whole bracket system is called in Korean *gongp'o* or *pojak*, and in Chinese *dou-gong* after its component parts.

In Korea the *gongp'o* system has two main types: in the older type (*chusim-p'o*) the brackets are all placed directly over the columns (*chusim*); in the later type (*ta-p'o*), taken over from China by the builders of the late Koryŏ period, the brackets are increased in number (*ta*) and are placed not only above the columns, but also between them, resting on the lowest beam of the frame, where they have a decor-

ative rather than a structural function. In the interior of the building the same bracket system supports large wooden beams forming the roof-frame. In the earlier period one could see through to the rafters, but from the Koryŏ period onwards there is usually a coffered interior roof.

The size of a building is governed by the number of inter-columnar spaces (*kan*). The use of wood as the building material imposes a limit on the size of buildings and the interiors. Consequently, palace and temple halls were essentially designed to house the throne and its immediate furnishings or the cult images and their altars. When the king held fairly large audiences, the body of officials assembled in front of the hall, as one can still see from the stone markings in the courtyard of the Dŏksu Palace, while the king sat inside the hall with his immediate household.

There were, however, a few hall structures of monumental proportions, as demonstrated by the ground-plan of the main hall of Hwangryong-sa in Kyŏngju; its vast scale can be reconstructed from the remaining stone bases on which the pillars once stood. The great 'owl-tail' (*ch'imi*), which adorned the roof-ridge and which is taller than a man, and the large floor-tile (no. 106) give some indication of the imposing dimensions of this hall.

In Buddhist temples there is, in addition to the hall, a second type of building which determines the lay-out of the whole complex, namely the pagoda (*t'ab*), which may be made either of stone or of wood. Pagodas, whether in fact of stone or wood, are not practical buildings in which to hold religious services, but are commemorative monuments built in honour of the relics (*sari*) deposited either in their foundations or above. The whole temple was often designed for the veneration of these relics, around which the faithful walked in procession in a clockwise direction.

The troubled history of Korea, with the Mongol invasions of the thirteenth century and the devastating Japanese campaigns of Hideyoshi from 1592 to 1598, led to the destruction of nearly all the older wooden pagodas. But in the case of the huge nine-storey pagoda of Hwangryong-sa, which dated from the sixth or seventh century, the stone bases for the pillars are still *in situ*, and from these one can deduce that these early pagodas must have resembled those of Japan, for instance the pagodas of Hōryū-ji or Yakushi-ji at Nara. Each storey had its own roof, so that the tower actually consisted of a number of single-storey buildings placed one on top of the other, the wall structure being in every case essentially the same as that of the halls. The oldest surviving example of a wooden pagoda is that of Wŏlchŏng-sa, which has nine storeys rising on an octagonal base and dates from the eleventh or twelfth century. The Buddhist stone pagodas (*sŏkt'ab*), of which a large number are still extant, go back to the seventh century. There are examples from Paekche (Mirŭk-sa and Chŏngnim-sa) and from Silla (Punhwang-sa, Kamŭn-sa).

The classical type is represented by the pagodas of Kamŭn-sa, built in AD 682, one of which contained shrines for the relics (nos 118, 119). It has a square base and rises to three storeys. The base (*kidan*) consists of a flat platform with steps and a higher zone with pilasters. The three-storey pagoda proper (*t'absin*) is built over this and, like the base, has a copious filling of stones and is faced with stone slabs. Each storey has four pilaster-like corner columns, between which the wall slabs are set. Each storey is smaller in breadth and height than the one below it, giving an illusion of greater height; the whole structure is in fact only about 13.4m high.

The Śākyamuni stone pagoda in Pulguk-sa (Temple of the Buddha Land), Kyŏngju, in which a printed sutra of the early eighth century in twelve sheets has been discovered.

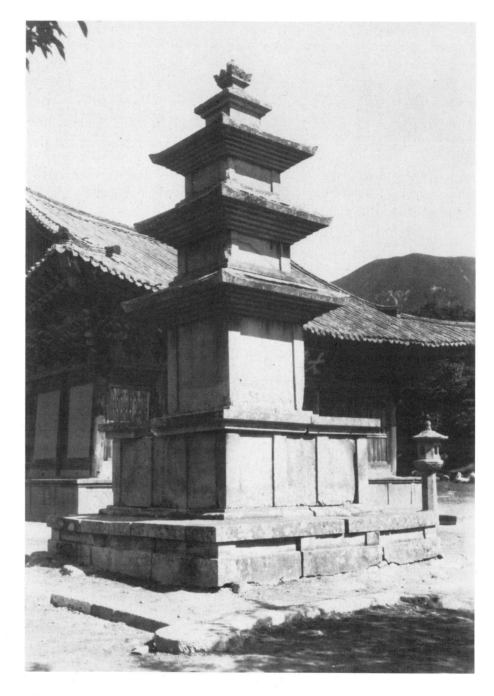

Opposite: General view in Hae'in-sa, on Mt Kaya, with monks returning to their quarters after prayer. (Photo Graham Harrison)

The sloping roofs are also of stone. The projecting eaves are supported underneath by five layers of stone slabs which corbel out like inverted steps. These are also found in similar form in Chinese tiled pagodas and are imitated from the roof-support system used in wooden structures. On the topmost roof rests a square block of stone from which an iron mast rises. On this the *chatras* (parasols or canopies) were placed, on top of one another. Beside this basic classical form are more complex special types, such as the pagodas of Mirŭk-sa and Pulguk-sa.

Unfortunately not a single city temple from the early period survived the wars that came later. Because of the growth of Chogye-jong (the Korean school of Sŏn Buddhism) as introduced by Chinul, it became more and more common for Buddhist monasteries to be sited in remote valleys or in the mountains, where they were guaranteed the quiet essential for meditation and the discipline of the monastic life. The disposition of the buildings consequently had to take account of the terrain, and as a result the strict ground-plan of the older temples was usually not observed.

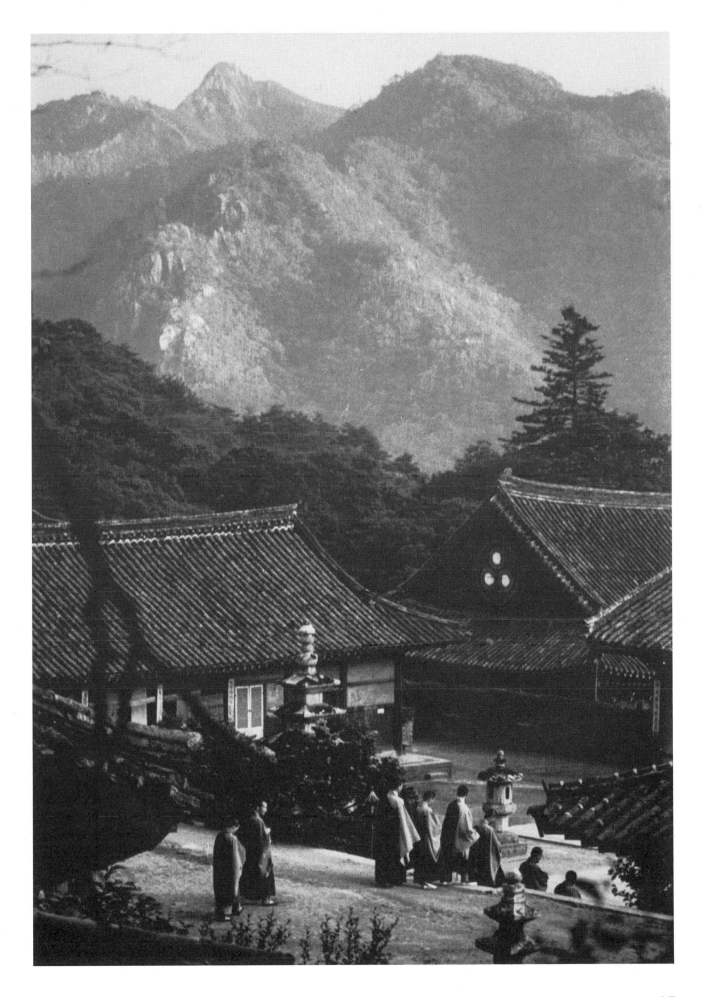

The classical lay-out of a temple, which was taken over from China and transmitted to Japan, was based on the axial arrangement of the buildings one behind another, each standing in a large rectangular courtyard enclosed by covered walks (*hoerang*). The large entrance gate (*chungmun*, 'middle gate') was let into the façade according to the same principle of construction as in a hall. The pagoda (*t'ab*) stood by itself in the courtyard, and behind it, also free-standing, was the main hall (*kŭmdang*, 'golden hall;) with the most important cult images. At the back of the courtyard, incorporated into the covered walk, was the lecture hall, used for preaching and instruction (*kangdang* or *musŏl-jŏn*). Less strictly determined were the positions of the bell pavilion and the library. The monks' quarters were as a rule situated outside the actual temple area. In the old temple plan there was only one pagoda situated on the axis; later there were often two, standing one on either side of the central axis.

Large cult images like no. 132 and perhaps some stone sculptures as well stood on the altars in the Buddhist halls. It was upon these that the ritual centred and the architecture had to afford a protective shield for the religious observances and the icons. The interior walls were often decorated with murals and with large hanging scrolls which complemented and supplemented the religious meaning of the sculptures. In fact, the building together with its contents might acquire a total symbolic sense, standing for the paradise world of the Buddha Amitābha, as in the case of the oldest surviving temple hall in Korea, Muryangsu-jŏn (The Hall of Infinite Life) of Pusŏk-sa (twelfth to thirteenth century). The architecture of Korea and other Far Eastern countries, however, never played the same role as the 'mother' of the other arts that was accorded to Western architecture. Essentially, the halls were shrines or depositories for the icons, and the sculpture was never integrated into the building with the same homogeneity as it was in, say, a Romanesque or Gothic cathedral. This becomes quite plain in those places where in recent times sculptures hewn from the natural rock are restored to their 'original condition' by being given a protective housing of the type seen in Korean timber constructions (Sŏkkuram).

Buddhist Sculpture and Grave Sculpture

Korean sculpture evolved in two important areas – in the cult images of the Buddhist religion and in the sculptures, some of them monumental, which adorned the graves of the upper class. Its origins lay in Chinese culture, and it continued to draw inspiration from that powerful source, yet it soon began to go its own way and take on a typically Korean character. The sculptures of the early period (no. 29), made for graves or associated with ancestor worship, are relatively simple. The introduction of Buddhism brought with it sculpture of greater artistic merit. The early Buddhist phase in the development of Korean sculpture is moreover of great significance for the transmission of Chinese influence to Japan, as the intensive investigations of recent years have shown. Further research will undoubtedly throw still more light on the important influence of early Korean Buddhist sculpture on Japanese sculpture.

As in the other countries of the Far East, Buddhist sculptures fulfilled various functions within the framework of religious observances; these different functions affected their format, the materials employed and the choice of iconographical

types. Small figures made of bronze or fired clay may have stood on the domestic altars of the great families and had a function in family worship. They were also deposited in the stone pagodas of temples as votive offerings; this is true, for instance, of the little golden Buddhas of Hwangbok-sa. Larger figures made of bronze – which was increasingly replaced by cast iron from the ninth and tenth centuries onwards – of stone or of some less durable material, such as wood and clay, were placed in temple halls or cave-temples as icons and were the focus of monastic and public ritual. Larger stone sculptures were frequently allocated to a particular architectural context; such are the figures of gate-keepers and lions on the pagoda of Punhwang-sa, where they have a symbolic function within the overall context of the building. Some of the greatest artistic achievements, inspired by the religious zeal of priests or nobles, are the monumental cult images carved on rock faces in the cave-temples which were often built on the outskirts of towns and villages in mountainous regions.

The style of Korean sculpture is often dependent to a very large extent on the material used. Bronze casts from wax models and figures made of soapstone had a certain smoothness and reproduced fine detail, while stone, especially the frequently used granite, produced simpler, block like forms in which much of the detail was suppressed. Other materials used in sculpture included fired and unfired clay, which was wrapped with hemp cloth and covered with gilded lacquer and wood. The troubled history of the Korean peninsula has unfortunately led to the loss of almost all objects made of these more sensitive materials.

The Buddhist religion began to penetrate the Korean peninsula in the fourth century AD and established itself as the state religion of the Three Kingdoms as it spread from north to south. Twenty years after its introduction into Koguryŏ in the late fourth century there were already nine temples in the capital, P'yŏngyang. No sculptures, however, survive from the first two centuries of Buddhism in Korea. The earliest bronze sculpture from Koguryŏ, dated to AD 539, is no. 19 in this catalogue (illustrated in colour). Like all Korean works of the sixth century it is completely under the influence of Chinese sculpture, in particular that of the northern dynasties of Northern and Eastern Wei (AD 386–550), whose figural sculptures are characterised by their comparatively large hands and heads, by the sharp points of the garments swinging out at the sides and by a few iconographic features, such as the position of the hands placed together on the breast and the back bent forward in a pose of meditation. It is known, on the basis of finds, that the figures were cast both with the lost-wax technique and from assembled part-moulds made of clay.

There was a particular flowering of Buddhist sculpture in the south-western kingdom of Paekche, which was separated from the Chinese mainland by about 500 kilometres of sea and no doubt received most of its Buddhist influence from the southern Chinese states of Eastern Jin and Liang. From the inscription on a stele of AD 642, shortly before Paekche was annexed by Silla, it can be seen how Buddhism in Paekche was also promoted by individual patronage. According to the inscription, a certain nobleman named Chijŏk, of the Sataek clan, being conscious of the vanity of human affairs, had a large Buddha hall built, together with a stone pagoda. The Paekche sculptures are distinguished by the softness of their execution and the impression of human warmth that they give. A typical feature is the so-called Paekche smile.

As is known from historical accounts, priests from Korea played an important part in the propagation of Buddhism in Japan in the second half of the sixth century, and the influence of Korean sculptors can be traced in many works of the Asuka period (AD 552–645) from the Nara area. In Korea itself there was a preference in the late sixth and early seventh centuries for a certain type of Bodhisattva, namely the one 'sitting pensively with half-crossed legs' (*banga-sayu*) who is usually identified with the future Buddha Maitreya (Mirŭk-bosal) who sits as a Bodhisattva on his throne in the Tushita heaven. In fact, at this period the cult of this Bodhisattva of Grace and the sutra texts concerned with him – both emanating from China – played an important part on the Korean peninsula. The examples of this iconographic type illustrated here (nos 94–96) are clear testimony to the Maitreya cult, which was practised above all by the nobility.

Almost all the active forms of Buddhism which were being taught at the time in China were transmitted to Korea by monks. The most influential was the Hwaŏm School, which was based on the extensive Avataṁsaka sutra (Korean, Hwaŏm-gyŏng), one of the most important texts of Mahāyāna Buddhism (no. 219). The lasting influence of Chinese sculpture on the Korean artists of the Unified Silla period is easy to understand against this background. Of course, one must not underrate the continuing artistic tradition of Paekche, especially in the early phase of the Unified Silla period. The highly developed artistic culture of this state, which was not only geographically but also intellectually closest to China, was integrated into the Unified Silla Kingdom without a break in its tradition.

Up to about the middle of the seventh century Korean sculpture was still predominantly influenced by styles from the Chinese Sui dynasty (AD 581–617) and the early Tang dynasty (AD 618–906), styles which were already a few decades old before their influence was felt in Silla. This time-lag in the transmission of artistic traditions from one country to the other can also be observed in the Buddhist art of Japan. It is equally true of large stone sculptures such as the triad in the rock-cave of Kunwi, as of works on a smaller scale (no. 97; see colour illustration). From the mid-seventh century the three-dimensionality and realism characteristic of Tang sculpture may be observed (no. 108). From the eighth century onwards the northern Chinese metropolitan school of sculpture from the temples of Chang'an, for instance the famous sculptures in the Shōdō Hakubutsukan from the Baiqing-si, Xian (Mizuno 1960, pls 76–9), exerts a marked influence, due no doubt to direct priestly contact with the religious centres of China.

A characteristic of Buddhist sculpture in Korea which distinguishes it from that of Japan is the carving of great rock sculptures in mountainous regions away from the urban centres. In the area to the south of the Silla capital of Kyŏngju the massif of Namsan ('Southern Mountain') supplied an opportunity for such carvings. The tradition of rock-carvings extends from India, across Central Asia to China and finally to Korea. Sculptures in the round were hewn from large rocks and a hall would be built to house them. Another form of rock sculpture consisted of enormous reliefs carved in the cliff-faces, which were then either partly covered with buildings or left in the open. Round them places of worship were established far away from the turmoil of the city; such peaceful rural settings come close to an ideal of the monastic life which had been a basic element of priestly existence in the early days of Buddhism in India.

Ch'ilburam was built in the Namsan mountains in the seventh century, and

just next to it, a good century later, Sinsŏn-am; both had reliefs carved in the natural rock. Sculptures in the round are to be found at Pori-sa and Yongjang-sa. The gigantic Buddha on the cliff-face of the valley of Samnŭng-gye goes back to the ninth century. There are also other places around Kyŏngju where such carvings are to be found, such as Kulbul-sa ('Temple of the Sculptured Buddhas') to the north, with its relief carved on an enormous boulder (samyŏn-sŏkbul) which now stands alone in the forest; these are still not satisfactorily classified. Another is Kolgul-am to the east, which has a giant Buddha from the second half of the ninth century.

In these rock-carvings certain peculiarities of Korean sculpture may be discerned which are unknown in either China or Japan and may be attributed to a combination of a fundamentally Korean sense of style and the limits imposed by the material. One of these peculiarities is the clear tendency towards two-dimensional treatment. The heads of the Buddhas of Samnŭng-gye and Kolgul-am are both sculptured almost in the round, while the lower parts of their bodies are executed in low relief, with no attempt to represent full detail, which is rendered simply by carved outlines in the rock. This striking and time-saving method of working remains a feature of Korean sculpture in later phases, too, as we can see from the rock Buddhas of Pukhan-san, Seoul and Pŏbju-sa.

The second characteristic is a highly abstract method of representing the folds of the clothing, which appear as ridges on the smooth surface of the garments. A similar treatment is to be observed in the flame patterns of the mandorlas. A prime example is a standing Buddha in granite, 201 cm tall, in the Kyŏngju National Museum. This tendency towards abstraction is closely connected with the occurrence of squat, almost block-like figures, largely lacking in finer detail, which were the inevitable outcome of the widespread use of granite as a material for sculpture in the Silla period. Examples can be seen in the stone sculptures of Kaman-sa from AD 720, and in the triad from the second half of the seventh century found in a cave-temple in the Sŏsan mountains, in what had been Paekche territory. This development was to continue in the later bronze sculpture of the Unified Silla period, as can be seen in the Buddha of Paegyul-sa.

The culmination of large-scale stone sculpture in the Unified Silla period, indeed in Korea generally, is found at the mountain site of Sŏkkuram on the T'oham-san to the south-east of Kyŏngju. The building of this cave-temple, together with an extension of the temple of Pulguk-sa further down the valley, was begun by the famous minister Kim Taesŏng in AD 751, partly in memory of his parents and partly to promote the peace of the state; however it was not completed until AD 774, after his death. Underneath the dome in the middle of the main chamber the Buddha sits enthroned in the attitude of 'touching the earth', while round him, on the walls of the domed chamber and the chapel in front of it, a whole pantheon of Buddhist divinities is represented in magnificent relief. Though there is no Chinese model for the complex as a whole, the tautness and fullness of the sculptural style are reminiscent of early Tang sculptures (no. 126). Here too, one may discern a tendency towards two-dimensional treatment, and this has led to the suggestion that the impetus came from Chinese pattern-drawings rather than from actual sculptures.

All in all, the early and middle eighth century represented the peak of Buddhist art in the Unified Silla Kingdom. King Sŏngdŏk (reigned AD 702–37) and to

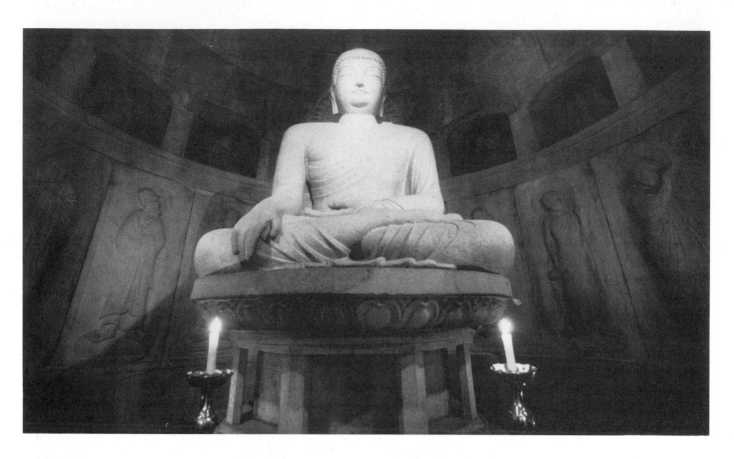

Seated figure of the Buddha in the Sŏkkuram granite temple built on Mt T'oham near Kyŏngju, AD 751–74. (Photo Graham Harrison)

an even greater extent his son Kyŏngdŏk (reigned AD 742–764) showed such religious zeal in their patronage of temples as to put all previous enterprises in the shade. Especially famous are the great bells; those of the state temple Hwangryong-sa are reputed to have weighed about 50,000 gǔn (pounds). The so-called Emille bell of Pongdŏk-sa, which still hangs today in the courtyard of the Kyŏngju National Museum, is said to weigh 12,000 gǔn. Unfortunately the great Buddha of Medicine (Yaksa-yŏrae) which King Kyŏngdŏk had made for Punhwang-sa in 755 has been lost, but it probably belonged, like so many sculptures of the eighth century, to the great 'international' style of Buddhist art with its genesis in the Chinese metropolis of Chang'an (cf. no. 108).

After AD 770 the state patronage of Buddhist art was blocked by power-struggles within the ruling Kim family. In these unsettled times contributions to the temples came largely from members of the more illustrious families. The result was a diminution of Chinese influence; the folds in the Buddhas' garments became more stylised in the second half of the eighth century, and from the beginning of the ninth a progressive Koreanisation is to be observed in the two-dimensional treatment of the body as well as in the broadening of the faces. Folds are now often represented by engraved lines (no. 121). In terms of iconography, the representation of Buddhas and divinities from the pantheon of Esoteric Buddhism becomes more common – a feature which is paralleled in Japan at precisely the same period. The insecurity prevailing shortly before the collapse of the Unified Silla dynasty is manifest in an obvious deterioration in the technical quality of Buddhist sculpture. Often bronze figures were cast as half-shells only, and it became more common for large figures to be made not of bronze, but of iron, which was less expensive but more difficult to work.

Under the Koryŏ dynasty (AD 918–1392) Buddhist sculpture visibly loses much of its vitality and magnificence. Although some sculptures of the Three Kingdoms and the Unified Silla period seem simple, almost like peasant art, they are nevertheless powerful and vital, while the works of the Koryŏ period – and to an even

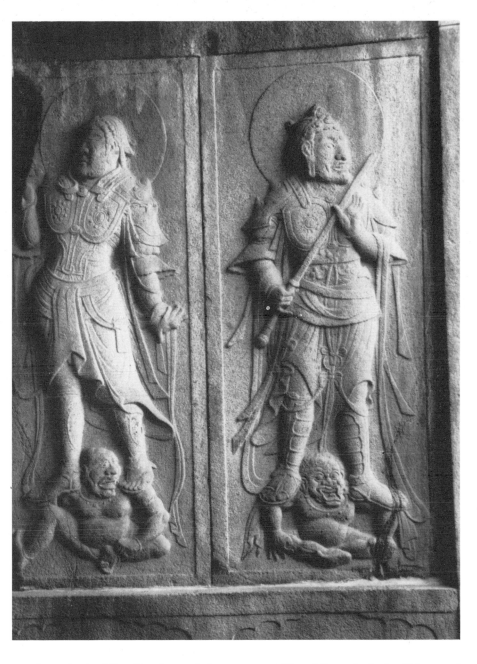

Panels with reliefs of the Heavenly Kings
Tamun-ch'ŏn and Chiguk-ch'ŏn
(Vaiśravaṇa, King of the North and
Dhṛtarāṣṭra, King of the East) in the
Sŏkkuram temple, AD 751–74.

greater extent of the Chosŏn period – appear stiff and formal. As in China and Japan, this is undoubtedly connected with a decline of intellectual creativity in the Buddhist religion, which came more and more under pressure from Confucianism. It is difficult to trace a clear line of development in the Buddhist sculpture of the Koryŏ period, since there are few works which can be dated. At first we may observe a continuation of the Silla traditions, but they are now infiltrated by influences from the China of the Song dynasty (AD 960–1279) and from the states of Liao and Jin established to the north of it. The faces of the Buddhas become more strongly Koreanised. Their half-closed eyes, which were at first almost horizontal, soon became clearly slanted, and the faces, with their high cheek-bones, appear altogether more two-dimensional.

The forms become even more mannered in the tenth and eleventh centuries. In the thirteenth and fourteenth centuries, under Koryŏ's forced vassalage to the Mongol rulers of China. Korea saw an upsurge of lamaist art, which was already widespread in China and Tibet. The sculptures of later times were often of huge proportions and totally formalised and expressionless.

Although Korean Buddhism was already largely exhausted as an influential force, the Japanese invasion under Toyotomi Hideyoshi (AD 1592–8) had calamitous results for Buddhist culture. Almost all the temples were razed to the ground, with the result that today there are only a few temple buildings left in Korea dating from before the sixteenth century. Works of art which could be moved were taken to Japan as booty, so that Korea itself has, for instance, hardly any paintings from the Koryŏ period. In the Chosŏn dynasty, with its single-minded emphasis on Confucianism, nothing could restore Korean Buddhism to its former glory.

In the field of grave sculpture, the second great area of the plastic arts in Korea, large-scale figures of officials and guard animals were created, influenced by Chinese models. These were set on both sides of the paths leading up to the grave-mounds of kings and important noblemen. As in China, they appear mostly block-like and rather crude. Peculiar to Korea are tomb-mounds incorporating the twelve signs of the zodiac (*sibi-ji*), carved as figures with human bodies and the appropriate animal heads (no. 129). These were chiselled on stone slabs and placed against the drum-shaped lower part of the tumulus. They symbolised the twelve double hours of the day, as well as the directions of the compass. In combination with the so-called ten celestial stems (*sipch'ŏn-gan*) they formed the sixty-year cycle of Far Eastern chronology. Placed around the grave, they reinforced the significance of its cosmological symbolism.

Kŭmsŏng – The Golden City

Since 1921 Kyŏngju has furnished some of the most spectacular archaeological treasures. It was the capital of Silla for almost a thousand years, yet Kyŏngju today hardly gives any impression of its original splendour, despite the remnants of the past that are scattered throughout the town and the surrounding area. In the eighth century Kŭmsŏng ('Golden City'), as Kyŏngju was called in the Silla period, was one of the largest and most splendid cities in the world.

According to legend, Kŭmsŏng was founded in 35 BC. In the second half of the third century AD the first king from the powerful Kim family ruled here. The name of the family also meant 'gold', which probably seemed a good omen to the kings who subsequently had their residence there.

Both during the Old Silla period (57 BC–AD 668) of the Three Kingdoms and during the Unified Silla period (AD 668–935) Kyŏngju remained the undisputed governmental, administrative and cultural centre of the state. During its heyday in the seventh and eighth centuries the city occupied an area several times larger than it does today. The Silla kings planned their city on the model of the Sui and Tang capital Chang'an and built a grid of roads. The walls enclosing the city measured 10 kilometres from north to south and 8 kilometres from east to west, and had twenty gates. According to an official census, in the period of its greatest affluence there were 178,936 houses in 1,360 sections of the city and 35 'great

houses', in other words properties of the nobility, as well as royal palaces and great Buddhist temples. It is estimated that the city had about a million inhabitants. One ancient source describes the impression it made under Hŏngang, the 49th Silla king (AD 875–86) in the following words:

Houses with tiled roofs extended in rows from the capital right to the four seas, and there was no longer a single straw roof to be seen. At every street corner one could hear soft music. Gentle, sweet rain brought harmonious blessings, and all the harvests were rich.

Like Heian (Kyōto) in Japan, another city modelled on Chang'an, Kyŏngju lay at the confluence of three rivers and was surrounded on three sides by mountains; thus the city was protected by supernatural as well as physical defences. Admittedly there were in addition extensive fortifications, such as the fortress on the Namsan, built in AD 591, which had a wall some 1000m long. In the city itself there was the Pusan fortress, and on the bank of the River Anpuk the long 'iron wall' (ch'ŏlsŏng) with its iron gates. In addition to all this, in the eighth century a dike some 2300 m long was built to the south of the city for protection against Japanese pirates. Almost 40,000 workers were employed on the project.

In the middle of the town, on the bank of the southern river (Namch'ŏn), lay the palace area, likewise enclosed by a wall; this was shaped like a half-moon and was consequently called the Moon Fortress (Wŏlsŏng). All that can be seen of it today is the terrace-like area where it stood. It is said to have been begun in AD 101.

From excavations carried out with great care in the last decade by Korean archaeologists, we are extremely well informed about a second palace complex, which was built as a complement to Wŏlsŏng. This is an irregular series of buildings, the main hall of which was called Imhae-jŏn ('Hall by the Sea'). The buildings were disposed along the shore of a large artificial lake, the Anap-chi ('Lake of Wild Geese and Ducks'), which was filled and drained by a skilfully constructed drainage system. The park, which was laid out round the lake like a landscape garden, had artificial hills and piles of rocks which were called Musan-sibi-bong (the 'Twelve Peaks of the Shaman Mountains'). There were three islands of varying size in the lake, and in the water were artificial stone formations which resembled dragons and turtles. This was the so-called 'detached palace area' (pyŏlgung), where the king held state banquets and receptions for foreign embassies – great feasts with wine and music' at which dances were performed by the palace ladies, and boat trips were made on the lake. During the excavations a wooden boat almost 6m long and made of pine planks was discovered in front of the buildings on the western shore.

Countless stone bases for pillars, as well as roof-tiles, floor-tiles with fine reliefs (no. 105) and items of wooden architecture have been discovered, but it has not yet been possible to reconstruct the exact form of the buildings. These were assembled according to an irregular and complex ground-plan, although in structure they must of course have conformed to the system throughout the Far East: wood-framed halls supported by wooden columns and built upon bases faced with slabs of stone. On the verandahs formed by the widely projecting eaves the guests would sit looking out on the artificial 'sea' of Anap-chi. There were similar complexes in Paekche about AD 500, but we now know little more than their names, Imryu-gak ('Pavilion by the Waterway') and Manghae-jŏng ('Pavilion of the Distant Sea-View'), and we know from texts that exotic animals ran about in the surrounding park to entertain the guests.

The name Anap-chi, 'Lake of Wild Geese and Ducks', has not yet been satisfactorily explained, and may have been coined after the fall of Silla, when the place had become a wilderness. At all events the rich finds from the lake and its surroundings afford an impressive insight into the courtly life of Silla. Mountings and ornaments from Buddhist altars, even figures of the Buddha, and a bronze wick-trimmer are amongst the finest of them (nos 108–111). Cutlery is represented by bronze knives and spoons. A little black lacquered die, with a saying composed of four Chinese characters on each of its fourteen angular faces, hints at the spirit of gaiety and festivity which reigned at such feasts. Among the sayings are: 'All participants hit themselves on the nose'; 'Three cups [to be drunk] in one draught'; 'Two cups, then you are free'; 'Perform a dance without a sound'; 'Pray sing as you will'.

Crudely carved wooden figures, which look like the great shamanistic ancestor totems, and a wooden phallus carved with considerable realism show that even in court circles the ancient Korean popular beliefs lived on beside Buddhism and Confucianism. Lacquerwork trays and pottery inkstones for grinding Indian ink reflect the standard of living of the Silla nobility. Further evaluation of the excellently published finds will certainly extend further our view of the cultural riches of the 'Golden City.'

Beside one of the arterial roads leading south from Kyŏngju one finds today, in a walled enclosure, the stone revetment of a narrow watercourse, which describes a series of irregular curves in the shape of an abalone shell before returning to its starting point. Here, in the Silla period, there was another detached palace, P'osŏk-jŏng (the 'Pavilion of the Abalone-shaped Stones'), of which today this is the only remnant. The palace and its pavilions were used by the Silla kings for picnics with the ladies of the court; on other occasions, following ancient Chinese custom, the educated nobility would assemble here to celebrate the spring festival beside the meandering watercourse by vying with each other in the composition

P'osŏk-jŏng. the Pool of the Abalone-shaped stones, in Kyŏngju. Wine cups were floated on the rill and poems composed as an elegant pastime for the court.

of poems. Servants would float cups filled with wine on the water, and the man before whom they came to rest against the stone revetment had to compose a poem or continue one already begun. If he failed he was obliged to drink the wine in the cup. King Hŏngang (reigned AD 875–86) once made an excursion to this spot to drink wine with the ladies of the court. In the middle of the festivities the god of the Namsan mountains was reported to have appeared – visible only to the king – and danced; the king and his ladies began to sing and joined in the dance. Court sculptors were commissioned to commemorate the occurrence in a work of art entitled 'The Dance of the Frosted Beard' (sang'yŏm-mu).

In the middle of Kŭmsŏng stood an observatory used by the court astrologers and belonging to the Wŏlsŏng Palace. As in China, astrology was an important factor in all government business, but it was also a way of communicating with the cosmic powers. Today, at the southern edge of Kyŏngju, the round stone tower of the Ch'ŏmsŏng-dae (the 'Terrace for the Contemplation of the Stars') still stands. It was built around AD 640 by King Sŏndŏk. It is 9m high and consists of 364 granite blocks in 27 courses, not counting the square base and the four great stones of the square lintel that crowns it. Probably in accordance with the laws of geomancy (p'ŭngsu, 'wind and water'), most of the great tombs of members of the royal family of Silla and its generals are in the western part of the city, near to the western river (Sŏch'ŏn) and by the 'Mountain of the Peach of the Immortals' (Sŏndo-san). Some of these are great round earth mounds, their lower parts revetted in stone and with stone figures of guards.

One can perhaps gain some idea of the splendour of Kyŏngju during the Silla period if one considers the many large gold objects – crowns, belts and ear-pendants – which were placed in the graves of kings and queens as early as the period of the Three Kingdoms (eg. nos 77, 92, 93; see colour illustrations). During its heyday in the seventh and eighth centuries the Golden City was pervaded by a cosmopolitan atmosphere similar to that of the Tang capital of Chang'an. There were certainly many foreigners there, just as there were large Korean colonies in China, with the Koreans controlling the shipping and overseas trade. There was a demand for imported foreign goods, such as glassware from the Near East; ornamental art sometimes employed Iranian motifs, for instance confronting birds on each side of a tree (no. 100b).

The government and administration of the state were based on the Chinese model, but the important offices of state remained firmly in the hands of the great nobles and the royal family; they were thus to a large extent hereditary and could not be obtained, as in China, by examination. On the advice of the priest Chajang, who had returned from China, Queen Chindŏk introduced Chinese dress for the court and the civil service in AD 649. In the following year she adopted the Chinese calendar and even used the Chinese reign-titles (nianhao). All the same, Korea felt itself to be the grandest of all the tributary states of the Tang Empire.

In addition to regular tribute, the two courts enjoyed exchanging gifts. King Kyŏngdŏk sent the powerful Tang Emperor Tai Zong a mountain 3m high made of colourfully dyed linen complete with watercourses, trees, flowers, palaces, temples, dancers and monks, even with tiny figures of the Buddha made of sandal-wood, gold and precious stones. When the wind blew, this ingenious device known as the 'Mountain of the Thousand Buddhas' (Manbul-san) began to move and to emit sounds like the music of the spheres.

The young noblemen studied in private and state-run schools and academies where they could be educated in all branches of Chinese learning. The élite organisation of the 'flower squires' (hwarang) was a special feature of the Silla kingdom. Boys from illustrious families who were especially handsome and gifted were selected to attend a kind of military academy which had probably evolved from early Korean young men's leagues. The fifteen- to sixteen-year-old hwarang wore costly and elegant clothes, as well as make-up and face-powder. They were instructed in the six traditional Chinese arts – etiquette, music, archery, riding, writing and arithmetic – and so were initiated not only into the business of war, but into the principal fields of culture.

Beside this Confucian side of the hwarang élite there was also a shamanistic aspect. The hwarang used to retire to the mountains round Kyŏngju, especially the Kŭmgang-san to the north, in order to practise ritual songs and dances and to communicate with the old Korean mountain-gods. The ideology of the 'Way of the Flower Squires' (hwarang-do) represented a syncretism of shamanism, Confucianism, Buddhism and Taoism. The Buddhist monk Wŏn'gwang (d. 630) formulated five commandments (ogye) for the commmunity, representing a code of behaviour: the first was 'Serve the prince loyally', the second 'Serve your parents with filial piety', the third 'Deal reliably with your friends', the fourth 'Never yield in battle', the fifth 'Choose properly the living creatures you kill'.

The élite troops of the hwarang, famous in literature from the sixth century, played a decisive role in the unification which brought about Unified Silla Kingdom. The famous general Kim Yusin (AD 595–673; see no. 127) had been a hwarang in his youth. Despite their somewhat feminine appearance they were much feared as warriors, sacrificing their lives unhesitatingly for the king. Towards the end of the Silla period, when all moral values became uncertain, even the code of honour of the hwarang suffered a decline, and there were stories in which they by no means distinguished themselves by conspicuous bravery. All the same, these powdered 'Flower Squires of Korea', who are in many respects reminiscent of the young men of Greece or the squires of medieval Europe, remained unique in the Far East.

In Kŭmsŏng, as in the ancient cities of China and Japan, the most conspicuous and architecturally distinguished buildings, after the palace complexes, were the Buddhist temples. The heavy roofs of their halls and above all their many-storeyed pagodas towered above the uniformly low roofs of the residential areas. Since Buddhism was the state religion, promoted by the royal family and the nobles, the temples developed into centres of intellectual life, each having a large community of monks.

In the centre of Kyŏngju, to the north of the palace complexes of Wŏlsŏng and Anap-chi, lay two great monasteries, Hwangryong-sa and Punhwang-sa. Both may truly be called national temples. The 'Temple of the Imperial Dragon', Hwangryong-sa, was originally meant to be a palace. However, in AD 533, while it was being planned, a dragon was said to have risen out of the earth at that spot, and so King Chinhŭng had a temple built there instead. In AD 569, seventeen years after building had begun, the great pagoda was completed, though it was not until AD 584 that the huge 'Golden Hall' (kŭmdang), the main religious building of the temple, was finished. For its altar a statue (chang'yuk-sang) of the Buddha nearly 5m high was cast in metal which was said to have landed miraculously by ship from South-East Asia. But the real marvel of the temple was the great nine-

storey wooden pagoda, which was begun at the instigation of the priest Chajang in AD 636, more than a century after the founding of the temple. The architect was a man from Paekche by the name of Abiji, who was aided by a further two thousand expert builders from the defeated state. Each of the nine storeys symbolised a people hostile to the Silla Kingdom; these peoples were, so to speak, to be imprisoned in the pagoda. This architectural marvel was badly damaged by lightning and fire at least five times, but each time it was restored, until it was finally burnt down, together with the other temple buildings, by the invading Mongols in AD 1238, during the Koryŏ period. Korean archaeologists have in recent years uncovered the whole area of Hwangryong-sa. From the observation hills made by the archaeologists the massive proportions of the buildings can be appreciated. The column bases and trenches, which mark the ground-plans, show Hwangryong-sa's vast scale. The huge 'owl's tail' tile (*ch'imi*) from the end of the roof-ridge gives an idea of the magnificent impression that the temple must have made. Hwangryong-sa need fear no comparison with the Tang temples in Chang'an.

Of the no less important Punhwang-sa, the 'Fragrant Imperial Temple' (or, written with another character, the 'Temple of the Fragrant Bamboo Grove'), which lay immediately to the north, all that is left today are the lowest three storeys of a stone pagoda which originally had seven. The pagoda, which is today 9m high and whose base is 13m square, was built in AD 634. It has stone doorways in the middle of each side, each doorway flanked by two gate-keepers (*vajrapaṇi*) of granite in high relief. At the four corners of the base sit stone lions sculptured in the round which are reminiscent of Chinese examples from the early Tang period.

The resources which the Silla kings spent – indeed squandered – on their Buddhist temples and cult figures is clearly revealed in the historical work *Samguk yusa*, where it is stated that in AD 764, for the regilding of a large image of the Buddha in the Yŏngmyo-sa temple, 23,000 *sŏk* [of rice] had to be found in order to meet the costs. This, at 60g per *sŏk*, amounts to 1,422,000kg of what is the staple food of Eastern Asia (*Samguk yusa*, chapter 3, p.25).

In general, of course, the picture which has been sketched here of the splendour of the 'Golden City' is essentially true for the nobility and the royal family. The common people no doubt had only the bare necessities of life and lived in simple, straw-roofed houses such as are still found in remote parts of the country. In ancient times, too, high culture was carried by a relatively small upper class and made possible ultimately by the toil of innumerable nameless peasants in the fields and the forced labour of unknown artisans.

A few years before the overthrow of Silla by Koryŏ an event occurred which seemed to portend the fate of the kingdom. It had been observed that the shadow of the pagoda was upside down. The people of Silla believed in miracles and judged this to be an evil omen. In AD 935 Wang Kŏn, the founder of the Koryŏ dynasty, occupied Kyŏngju with his army. Three holy objects of Silla were to be preserved on his orders – the 5m high gilded Buddha in Hwangryong-sa, the costly jade belt of Chinp'yŏng, king of Silla from AD 579 to 632, and the great nine-storey pagoda.

ROGER GOEPPER

1 The Prehistoric Period

The Korean peninsula was already occupied in the palaeolithic period, on the evidence of dwelling sites found at Sokjang-ni on the Kŭm-gang river and Chŏnguk on the Hantan River.

Comb-patterned pottery is found in the neolithic period about 4000–1000 BC. Present knowledge suggests that the ability to make pottery came from north-eastern Manchuria, spread to north-western Korea, and gradually made its way from there to the south. In the course of this southward movement local styles developed which may all be described as 'pottery with geometrical decoration'. A village of about twenty semi-subterranean pit-houses has been excavated at Amsa-dong on the Han River near Seoul. The vessels usually have a pointed base and are decorated with incised and impressed geometric patterns. Stone tools for hunting and fishing (including deep-sea fishing, on the evidence of fish-bones from a site near Pusan) have also been found, as well as spindle-whorls and evidence, towards the end of the period, of the cultivation of rice (Pearson 1982, p. 24).

The comb-patterned pottery was followed in the tenth century BC by plain coarse pottery. Early in the first millenium BC bronze technology was introduced from the north, and bronzes were made in the Liaoning region (now part of China). They include weapons (the Liaoning dagger with characteristic waist and projections), mirrors, and various rattles for possible ritual use, but no vessels. The decoration of the bronzes is principally of finely incised geometric patterns and bears no resemblance to contemporary bronze decoration in China.

Together with bronze technology, new burial practices were introduced, involving the construction of large cist graves and dolmens, similar to those of Western Europe. These impressive graves include an increasing array of funerary goods, and thus set the pattern for the large and richly furnished graves of later periods. Iron artefacts have been found in Korea from the third and second centuries BC onwards; however, bronze continued in widespread use until at least the first century BC. JHW/RW

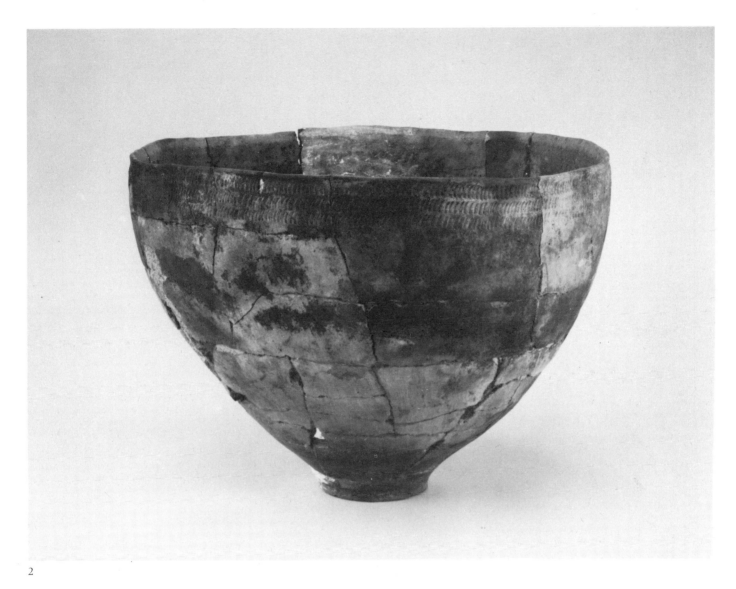

2

1 Storage jar *(colour ill.)*

Neolithic, *c.* 3000 BC
Pottery. H 40.5 cm; D (mouth) 35.1 cm
Excavated at Amsa-dong, near Seoul, 1968
Kyŏnghi University Museum, Seoul

Extensive neolithic settlements have been excavated along the banks of the Han River in Amsa-dong, which offered favourable living conditions and the clay needed for making pottery. This vessel, the largest to be found, is of characteristic pointed shape with comb decoration. Carbon-14 tests have provided a date of about 3000 BC for the dwelling-sites at Amsa-dong, and the comb-pattern pottery is assigned to the middle phase of the neolithic. Earlier pottery without comb decoration has been found at sites near Pusan in the south of the peninsula (Han Byong-sam 1981, p.165).

Neolithic pottery with geometric decoration usually contains a high percentage of mica; at some sites there is also a percentage of asbestos or steatite. The pottery from Amsa-dong was of a particularly 'sandy' nature. The vessels were built by hand, with relatively thin walls and a carefully smoothed surface.

The decoration is of rows of diagonal impressions above, and longer incised lines arranged in herring-bone pattern are below. Similar comb-patterned pottery is also found in the Yenisei culture in Siberia, and according to Kim Won-yong (1973, pp.60–2) there are undeniable links between the Siberian finds and those in Korea, paralleling the Ural-Altaic derivation of the Korean language itself. JHW/RW

Published Han Byong-sam 1981, pl. 2;
San Francisco 1979, no. 1

2 Bowl on narrow foot

Early neolithic, *c.*5000 BC
Pottery. H 28.0 cm; D (mouth) 37.5 cm
From Osan-ri, Yangyang, Kangwŏn-do province
Seoul National University Museum

This vessel is among the oldest neolithic pottery, but is different in shape and decoration from the comb-patterned ware. The three rows of diagonal incisions are confined to the top part of the vessel. On some pieces the decoration is impressed, and on others of slightly later date in the fifth millennium BC groups of regular raised horizontal lines run around the mouth.

The shape of this storage jar is broadly conical, like no. 1, but has a narrow flat base. Carbon-14 dating places vessels of this type about 5000 BC (Im Hyo-jae 1983) RW

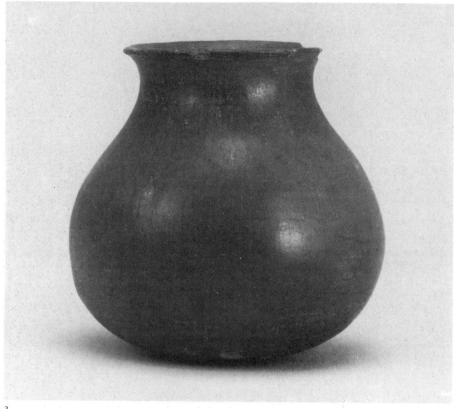

3

3 Small jar

Bronze Age, *c.* 500–300 BC
Pottery, painted red and burnished. H 12.4 cm
Provenance unknown
Seoul National University Museum

Besides the simple, undecorated pottery found in dolmens and cists there is often a finer type painted a reddish-orange and burnished. The vesels are light, thin-walled and generally have a bulbous shape, round base, narrow neck and a rim curving outwards.

Such pots have been found at dwelling-sites as well as in tombs, where they only occur singly. They are found in southern dolmens together with polished stone daggers, and it is possible that like them they served a cult purpose.

The vessels are carefully built from fine clay mixed with finely separated mica. Red ochre was applied as a colouring, and the walls were beaten with a wooden beater, before firing in an oxidising atmosphere, at a slightly higher temperature than usual. JHW

Published Kim Won-yong 1968, col. pl. 1. Cf. Han Byong-sam 1981, pl. 12

4 Long-necked jar

Bronze Age, *c.* 400–200 BC
Pottery, burnished black. H 22.0 cm;
 D (mouth) 9.2 cm, (foot) 6.7 cm
Found in 1967 in a cist at Koejŏng-dong,
 Taejon, South Ch'ungch'ŏng province
National Museum of Korea, Seoul

The Koejŏng-dong grave where this piece was found was a cist, a rectangular pit in the ground, lined with unhewn stone slabs placed on edge and sealed with several others. Around it were piled several cart-loads of stones. The cist also contained three bronze mirrors and a bronze dagger. Two of the mirrors had crude geometric decoration and possibly date before 400 BC; the dagger was of the slim Korean type (cf. no. 7b) and was probably made about 300–200 BC.

The black pottery probably derives from northern Chinese models. It was produced from very fine clay and has a thickness of between three and four millimetres, like the small red pot, no. 3. The dull black sheen of the ware was produced by smothering the fire with powdered dung to produce a sooty smoke which permeated the body and turned it black.

Both the form of the burial and the goods placed in the grave demonstrate a close affinity between the Bronze Age of Korea and that of Liaoning and southern Siberia. Similar jars with a long neck have been found at sites of the middle Bronze Age at Misŏng-ni, Ŭiju and Sinkok-ni, Yongch'ŏn, North P'yŏngan province, and at Hukbang-ni, Kech'ŏn, South P'yŏngan province (personal communication from Chi Kon-gil). JHW/RW

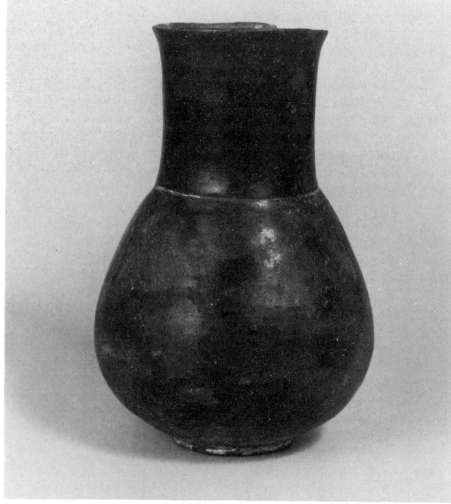

4

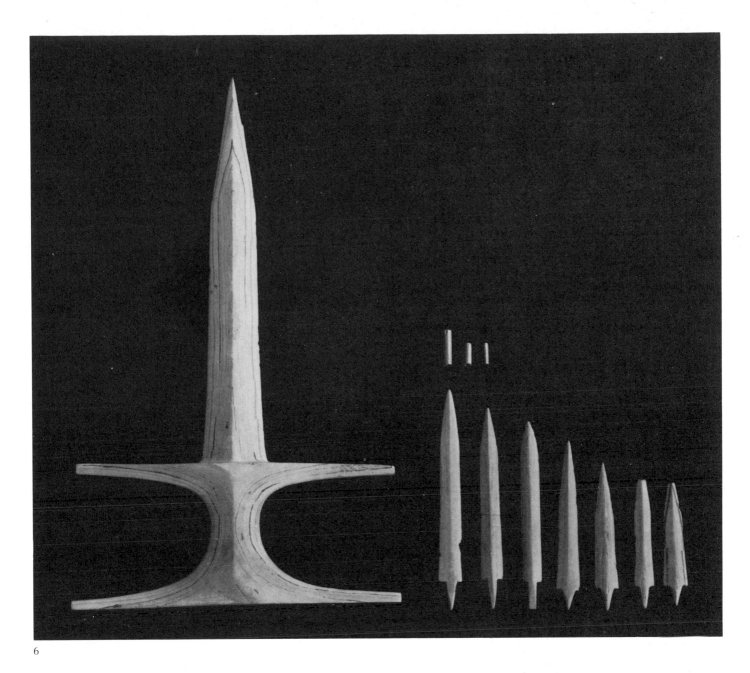

6

5 Songguk-ri cist contents
(colour ill.)

Bronze Age, *c.* 500 BC
Slate, bronze, jade. L (stone dagger) 34.1 cm,
 (arrowheads) 12.2–19.9 cm,
 (jades) 3.0–4.7 cm, (bronze dagger) 33.4 cm
Found at Songguk-ri, Puyŏ, in 1974
National Museum of Korea, Seoul

The bronze dagger from this grave is the earliest
form of the so-called 'Liaoning dagger' so far
found in Korea, showing the typical waisting or
lute shape with projections. Later Korean daggers
or short swords were descended from this form
but became more slender.

 Stone daggers are mostly made of finely veined
polychrome slate. This form, with a blade of
diamond cross-section and a narrow ridge divid-
ing it from the hilt, had evolved by the seventh
century BC.

 Bronze Age graves often contained cylindrical
and semi-lunar jades, which may have had a
ceremonial or religious significance. Particularly
interesting and mysterious are the curved jades,
which remained very important until the sixth
century AD. They have so far been found only in
southern Korea and in Japan. JHW

Published Kyōto 1976, no. 4

6 Mugye-ri cist contents

Bronze Age, *c.* 200–100 BC
Slate, jade. L (dagger) 46.0 cm,
(arrowheads) 11.0–18.8 cm, (jades) 1.8–3.0 cm
Excavated at Mugye-ri, Kimhae, in 1964
National Museum of Korea, Seoul

Stone daggers with an extreme widening of the
ends of the hilt are dated to the late Bronze Age.
This dating rests upon comparisons with other
sites where similar grave-goods have been found
together with individual iron artefacts. These
extreme forms represent a terminal stage in a
development which could go no further, and
they are found only in the southern part of the
country.

 The stone for such weapons was chosen not
for its hardness, but for the fineness of its vein-
ing. The colourful slate, here yellowish-white
with black veins, was the ideal material; the
different layers of colour could be brought out
by polishing and give a subtle emphasis to the
contour of the dagger. Such objects can only
have been intended for ceremonial use. JHW

Published San Francisco 1979, no. 2;
Kim Won-yong 1978a, pl. 46

7a Part of a scabbard

Bronze Age, *c*. 300–200 BC
Bronze. L 25.1 cm
Found in 1978 in a cist at Tongsŏ-ri, Yesan
Puyŏ National Museum

Various explanations have been offered for this bronze object, and two similar pieces, which were discovered in a cist at Tongsŏ-ri, along with nine daggers or short swords (one of 'Liaoning' type, the rest slim Korean ones), three dagger-hilts, a high-necked vessel of the shiny black ware, and numerous other finds.

At Koejŏng-dong, also in South Ch'ungch'ŏng province, three such pieces, each about 22 cm long, were excavated in 1967 (Kyōto 1976, no. 8; San Francisco 1979, no. 4). All have the same convex outer surface with incised decoration and rings of plaited rope form. When found, these three pieces were in alignment.

A possible explanation of the purpose of these objects is afforded by the illustration in Kim Won-yong 1968 (p. 32, fig. 3). This sole example of a complete assembly shows a short iron sword in its scabbard which is lined with wood and covered with four ornaments in electrum. They have exactly the same double-waisted shape as the present example. They were fastened to the wooden core of the scabbard with lacquer, and held in place by silk bindings. In view of the close association of these ornaments with daggers or short swords, and the lack of decoration on the back (see Kim Jeong-hak 1978, pls 65–7), it seems likely that all were in fact scabbard coverings. RW/YSP

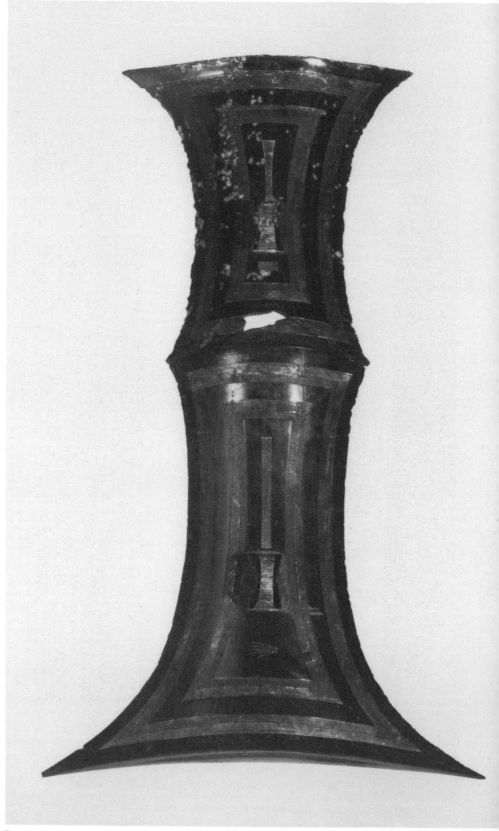

7a

7b Short sword

Bronze Age, *c.* 300–200 BC
Bronze. L 31.9 cm
Found in a cist at Tongsŏ-ri, Yesan, in 1978
Puyŏ National Museum

When compared with the 'Liaoning' type dagger from the cist at Songguk-ri (no. 5), the attenuation of the lute-shaped waist and projections can be clearly seen. The blade became longer as it became straighter and slimmer. A parallel development can be seen in north-eastern China and in Korea, the daggers with the most pronounced shape being dated to the late Western Zhou or early Chunqiu (eighth–seventh centuries BC), and the latest types to the beginning of the Han dynasty (third century BC). (Pearson 1982, p. 25, after Kim Jeong-hak 1978 and Lin Yun 1980, p. 154). JHW/RW

8 Two moulds for a short sword and a halberd

Bronze Age, *c.* 400–300 BC
Stone. L 35.5 cm; W 8.8 cm; depth 4.1 cm
From Yŏngam, South Chŏlla province
Sungjŏn University Museum

Sungjŏn University Museum has a fairly large collection of bronze weapons and stone moulds, all from Yŏngam, but lacking precise details of their excavation. Each of these half-moulds has the matching counterpart for the other on the reverse.

The short sword made from this mould had a round rib running all the way to the tip, indicating that it is a relatively early form of the type derived from the 'Liaoning' dagger. However, the end of the blade next to the hilt ends in a right angle rather than curving inwards as in no. 7b. JHW/RW

Published Kim Jeong-hak 1978, pl. 72

7b 8

9 Sword and fragments of scabbard

Early Iron Age, 2nd–1st century BC
Bronze. L 33.2 cm, (with hilt) 45.0 cm
From Pisan-dong, near Taegu, North
 Kyŏngsang province
Hoam Art Museum, Yongin;
 National Treasure no. 137

The site at Pisan-dong, at the foot of Mt Waryong, was a chance find, discovered in 1956 as a result of a storm. About fifty objects were found, out of which some fifteen were acquired by the Hoam Museum. The sword shown here, complete with hilt, blade and decorative fittings for the scabbard, is an especially rare find. Scabbards and hilts were commonly made of wood and hence do not survive. The scabbard for this sword was no doubt also of wood, but strengthened and decorated with a bronze tip and several oval rings.

The headpiece of the hilt is in the form of two realistically shaped geese with their heads turned to rest on their backs. This form of hilt spread to Japan, where the form became more abstract. It had its origin in the cushion-shaped stone hilts of Liaoning. JHW

Published Kim Jeong-hak 1978, pp. 153–5;
Kim Won-yong 1978a, pls 75–6;
San Francisco 1979, no. 7

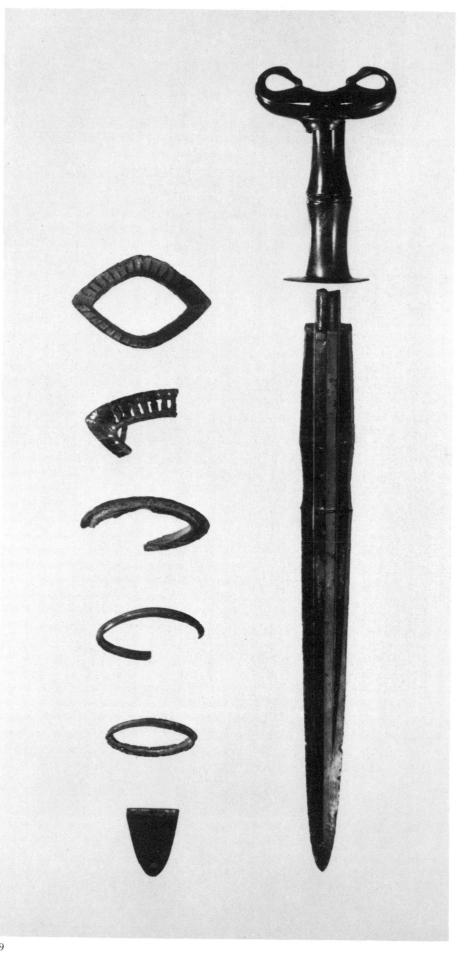

9

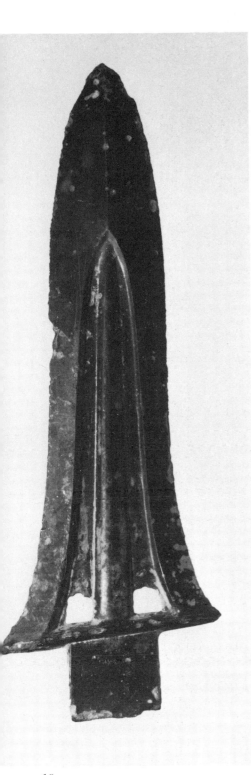

10

10 Halberd

Early Iron Age, *c.* 3rd–2nd century BC
Bronze. L 27.9 cm; W 9.4 cm
Provenance unknown
Sungjŏn University Museum

The halberd or dagger axe is found relatively late in Korean bronze culture, usually in association with iron artefacts. It first appears together with the short sword when the latter had already assumed its slim outline, as shown by the two moulds (no. 8). There the blade has a diamond cross-section. Later, as in this example, the central ridge and the lateral grooves become flatter. In its final form, intended only for ceremonial use, the point becomes broad and round. Such a piece was found at Manch'ŏng-dong, near Taegu (Kim Jeong-hak 1978, p. 156). JHW/RW

11 Ritual object

Bronze Age, *c.* 4th–3rd century BC
Bronze. L 17.6 cm; W 19.5 cm
From a cist at Namsŭng-ri, Asan,
 South Ch'ungch'ŏng province
National Museum of Korea, Seoul

In Korea there seem to have been three centres of bronze culture: the delta of the Nakdong-gang in the south-east, the area between Taejŏn and Iksan on the Kŭm-gang in the south-west, and along the Taedong-gang in the north. It seems as though the culture near the Kŭm River was especially rich in mysterious objects which have so far resisted all attempts at interpretation.

This bronze has long drawn-out tips. The upper arms end in small balls which are hollow and pierced at the back: they originally may have contained small pellets to serve as rattles.

The decoration consists of simple bands of hatching, which emphasise the unusual form of the piece very effectively. Although it was clearly designed with a front and a back, the back is also decorated and no less carefully shaped. On one side it has a semi-circular eyelet in which hangs a ring with rope pattern; on the other there are two such eyelets and rings. Like a similar object (Kyōto 1976, no. 15), it has one edge with a set of holes, clearly designed to ensure a solid attachment by means of pins or nails. JHW/RW

Published Ōsaka 1980, no. 5

11

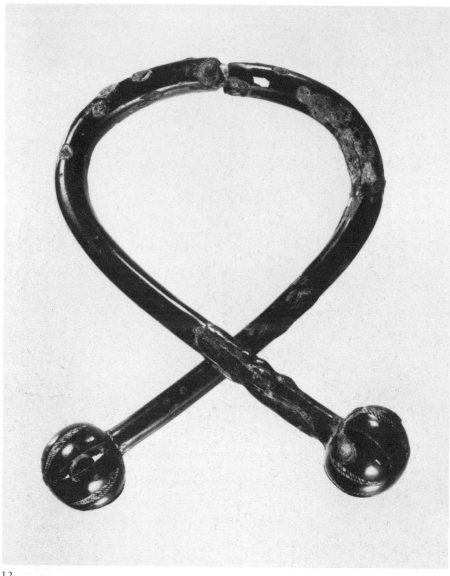

12

12 Ritual object

Late Bronze Age, *c.* 3rd century BC
Bronze. L 16.8 cm
Provenance unknown
Hoam Art Museum, Yongin (formerly
 Kim Dong-hyon Collection)

This small object consists of two parts with a
socketed join in the middle and each ending in
a hollow ball with pierced apertures enclosing a
bronze pellet, to serve as a rattle or jingle. It
might have belonged to the equipment of a
shaman. JHW

Published Kim Won-yong 1978a, pl. 92;
Nan Chōsen 1925, pls 39–40

13 Eight-armed ritual object

(colour ill.)

Late Bronze Age, *c.* 3rd–2nd century BC
Bronze. D 12.3 cm
Found at Daegong-ri, Hwasun,
 South Chŏlla province in 1971
National Museum of Korea, Seoul;
 National Treasure no. 143

This star-shaped rattle may have been a ritual
implement or musical instrument. It is one of a
pair. Other comparable objects have been found,
always occurring in pairs. The eight arms of the
star widen out into hemispheres, each with two
slits on the shallow convex back and containing
a small bronze ball. There is an eyelet in the

centre of the back, by which the rattle could be
held or fastened, possibly strapped to a shaman's
wrist. The decoration is of incised straight lines
and spirals, in the manner typical of early Korean
bronzes. JHW

Published San Francisco 1979, no. 5;
Nan Chōsen 1925, pls 38, 40

14 Pair of finials *(colour ill.)*

Late Bronze Age, *c.* 3rd–2nd century BC
Bronze. H 15.8 cm
From Kangwŏn province
Hoam Art Museum, Yongin;
 National Treasure no. 146

These two ornaments are socketed to serve as
finials for posts or staffs, but Kim Won-yong
suggests that as such pieces are always found in
pairs they may have been held in the hands and
shaken during rituals. Each has four slits in the
top, and a little bronze ball. The decoration
matches that on the star-shaped rattle (no. 13),
with incised straight lines and double spirals.

The similarities among such pieces point to a
fairly uniform development of Korean Bronze
Age culture in the south. JHW

Published San Francisco 1979, no. 6a–b, pl. 1;
Kim Won-yong 1978a, pl. 84

15 Mirror

Early Iron Age, *c.* 3rd–2nd century BC
Bronze. D 21.2 cm
From Kangwŏn province
Sungjŏn University Museum;
 National Treasure no. 141

Bronze mirrors appear in Korea about the middle
of the first millennium BC. They are round flat
discs with one side smooth and polished, and
the other decorated and provided with two or
more eyelets for a tassel to hold or hang the
mirror. The early mirrors have a diameter of
8–11 cm and the decoration on them consists of
very simple geometric patterns. Such mirrors
were cast in steatite moulds and have been
found in Manchuria and western Japan as well
as Korea (Kim Won-yong 1968, p. 33).

This mirror, the finest and best preserved of
its type, has extremely fine decoration arranged
in concentric circles, but derived from the cruder
geometric patterns of the early mirrors. There is
no sign of Chinese influence, and the pair of
asymmetrically placed eyelets are totally differ-
ent from the central knob of all Chinese mirrors.
This is in spite of the fact that Chinese mirrors
were known in Korea and are occasionally found
with Korean grave-goods. JHW

Published San Francisco 1979, no. 8, pl. 11

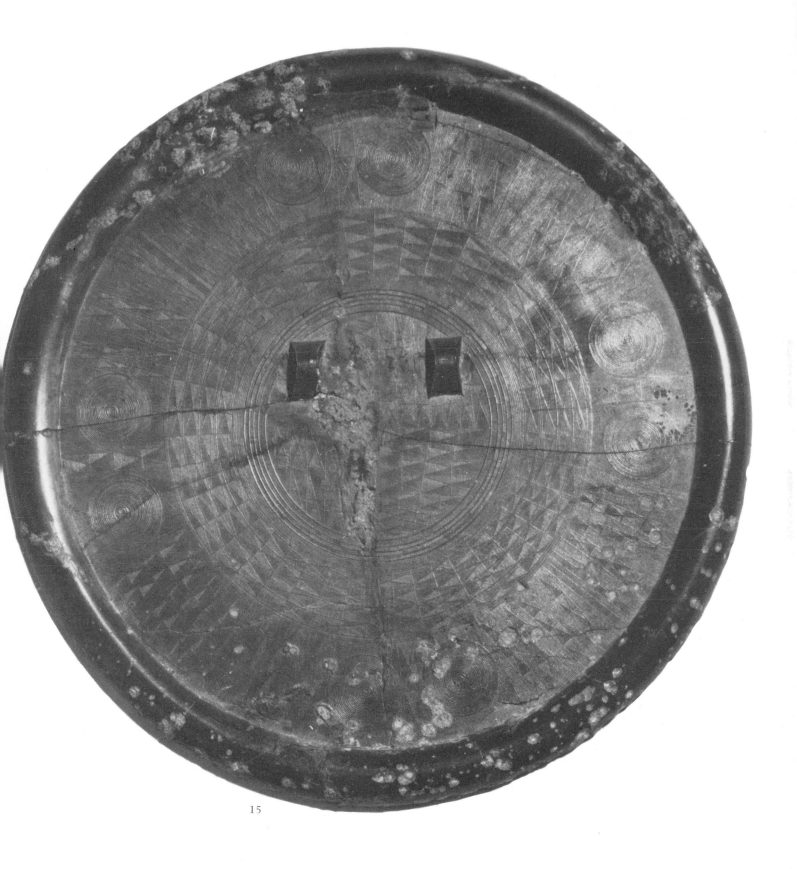

15

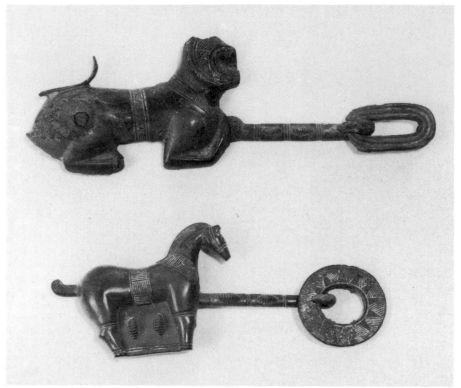

16

16 Belt buckles or garment hooks

Early Iron Age, *c.* 2nd–1st century BC
Bronze. L (tiger) 22.2 cm, (horse) 18.6 cm
Found in 1918 at Ŏŭn-dong, Yŏngch'ŏn,
 North Kyŏngsang province
Kyŏngju National Museum

Belt buckles in the form of tigers and horses
have been found in many places in Korea. They
display strong Siberian characteristics, especially
in the sturdy legs and compact shape, allied
with considerable northern Chinese influence
(Kim and Kim 1966, p.175). These two were
found together with Chinese and locally manu-
factured mirrors, and the star-shaped decoration
on the ring of the horse buckle is directly com-
parable to the decoration of the earlier type of
local mirror cast in steatite moulds (*ibid.* pp.24,
183). JHW/RW

Published San Francisco 1979, nos 9–10

17 Covered jar

Iron Age or early Silla,
 2nd–3rd century AD
Pottery. H 29.2 cm; D (foot) 20.0 cm
From Choyang-dong, Kyŏngju,
 North Kyŏngsang province
Kyŏngju National Museum

Lidded storage jars of this type have been dis-
covered in stone cists. This vessel was built by
hand and the clay was compacted by being
beaten with a wooden implement, usually wound
with cloth or hemp cords, or incised with lattice-
like designs, so that its pattern was transferred
to the clay. There is no other decoration, but the
flaring foot is characteristic of the time, and was
transmitted to Silla. Below the spreading mouth
there is a short straight cylindrical neck. The
body is of a yellowish-grey earthenware, with a
hardness between that of the prehistoric pottery
and Silla stoneware. JHW/RW

Published Han Byong-sam 1981, pl. 24

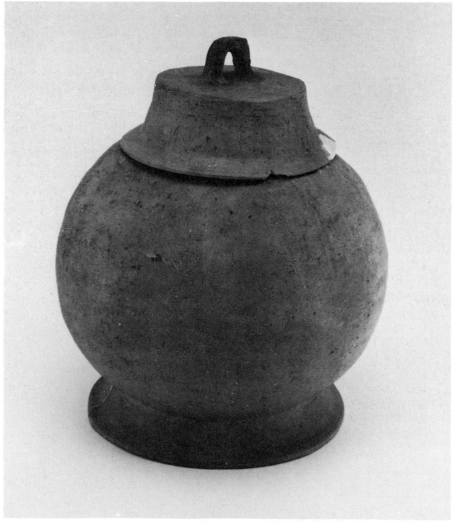

17

2 The Three Kingdoms
(57BC–AD 668)

The Three Kingdoms of the first millennium AD were Koguryŏ in the north, extending far into Manchuria, and Paekche and Silla in the south. A smaller group of clan villages in the south, known as Kaya, was absorbed by Silla in AD 562. The date of the foundation of Silla is traditionally given as 57 BC, but it is possible that Koguryŏ was in fact the oldest of the Three Kingdoms, and that the authors of *Samguk sagi*, the History of the Three Kingdoms, were anxious to improve the historical record by claiming primacy for their dynasty, following Silla's unification of the country in AD 668.

Koguryŏ (37 BC–AD 668)

The kingdom of Koguryŏ was the largest of the Three Kingdoms, established, according to *Samguk sagi*, in 37 BC, with its capital at Kuknaesŏng (Tonggu, now Tong'gou). Probably its people, who came from the north, from present-day Siberia and Manchuria, were already settled before that date along the Yalu River. Originally nomadic, it was these tribes who brought bronze culture to Korea. Koguryŏ culture was therefore strongly influenced by that of north-eastern China, and in addition by the presence of a Chinese colony at Lelang (Korean, Nangnang or Naknang) from 108 BC to AD 313. Chinese characters were used for writing historical records, and in AD 372 a Confucian school was established in Koguryŏ for the teaching of Confucian texts. Thereafter the Chinese classics were to remain the basis of Korean education until the nineteenth century.

In AD 427 the capital was moved to P'yŏngyang. Under the reigns of King Kwanggaet'o (reigned AD 391–413) and King Changsu (reigned AD 413–91) Koguryŏ expanded its territory far into Manchuria, posing a new threat to China. Early in the Tang dynasty Silla allied with Tang China to attack Koguryŏ, and the whole country was unified under Silla in AD 668.

The most impressive remains of Koguryŏ culture are the mural paintings of the great tombs, fourteen of which are near Tong'gou, and thirty-seven near P'yŏngyang. While the style of the paintings is clearly Korean, the subjects show strong influence from Han dynasty China. Cosmological symbols, such as the sun, moon and stars, appear on the vaulted ceilings, and the animals of the four directions on the walls. In addition, since Koguryŏ was, again in AD 372, the first area of Korea to receive Buddhism from China, Buddhist influence is evident in decorative motifs incorporating the lotus. Many of the tombs have vivid descriptions of daily life (Tomb of the Wrestlers, Tomb of the Dancers), including portraits of the deceased, and even a procession with a Buddhist monk (Tomb of the Double Columns).

With the downfall of Koguryŏ in AD 668 the tradition of mural painting in tombs was lost in Korea, but it had already been transmitted to Japan where the Takamatsu-zuka tomb shows the direct influence of Koguryŏ style and subject-matter (Takamatsu-zuka 1973). JHW/RW

18a-d Roof-tile and tile-ends with lotus and demon-mask decoration

Koguryŏ, 5th–6th century AD
Earthenware. (**a**) L 41.3 cm; D 15.0 cm;
 (**b-d**) D 18.2 cm, 13.6 cm, 13.8 cm
Provenance unknown
National Museum of Korea, Seoul

The practice of covering roofs with tiles bearing impressed decoration was adopted by Korea from the Chinese colony at Lelang during the Han period (206 BC–AD 220). The earliest Koguryŏ tiles follow the Chinese examples in taking Chinese characters as designs for the ends visible along the lower edge of the roof. Such tiles were only used for palace buildings and, after the introduction of Buddhism in the fourth century AD, for Buddhist temples. The Buddhist lotus, easily adapted to the circular shape, became a favourite motif. Its subsequent development provides valuable evidence for the spread of Buddhism within Korea and to neighbouring Japan. Chinese, Korean and Japanese examples were usefully compared in the exhibition The Origins of Japanese Buddhist Art at the Nara National Museum in 1978.

Five main types of tile are used on Korean roofs:

1. Shallow concave tiles (*am-maksae*, cf. no. 103)
2. Semi-cylindrical convex tiles with circular or oval ends (*sud-maksae*, cf. no. 18a)
3. Square or circular plaque with a central hole, nailed to the end of beams (*sŏkkarae-maksae*, cf. no. 21a)
4. Ridge-end tiles, commonly decorated with a demon mask (*kwimyŏn*, cf. no. 101)
5. 'Owl's tail' tiles, crowning the ends of the main ridge (*ch'imi*)

Demon masks used on building tiles to ward off evil spirits are known throughout Korea. The one shown here is close to a ridge-end tile excavated in P'yŏngyang: in both the principal features are in double outline and the ears are omitted altogether to give added prominence to the eyes and mouth (Nara 1978, no. 45). A later and more three-dimensional version of this type was made in Silla in the seventh and eighth centuries (see no. 101). JHW/RW

18b Published Chin Hong-sop 1978a, pl. 99

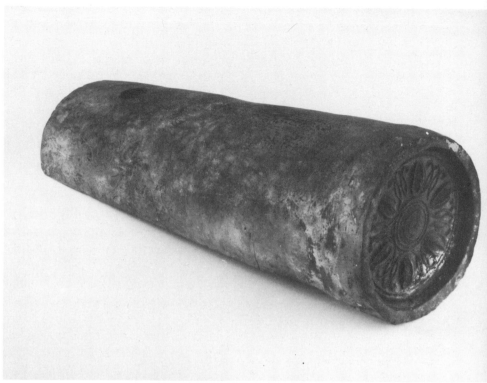

18a

18b

18c

18d

19 Standing Buddha *(colour ill.)*

Koguryŏ, probably AD 539
Gilt bronze. H 16.2 cm, H (figure only) 9.1 cm
Found in 1963 at Ŭiryŏng,
 South Kyŏngsang province, cast in
 P'yŏngyang
National Museum of Korea;
 National Treasure no. 119

This figure, cast in one piece with the mandorla, is the earliest datable Buddhist sculpture from Korea and hence of great documentary importance.

The Buddha stands on a pedestal consisting of a cylindrical lower part with a base-plate, a simple down-turned lotus and a wedge-shaped nucleus. The right hand is held forwards in the gesture of absence of fear (*abhaya-mudrā*), the left lowered in the gesture of blessing (*varada-mudrā*). The hands and head are comparatively large, and the narrow-shouldered body is hidden by the heavy robe. The face is narrow, with softly modelled details, and there are traces of dark blue colouring in the hair, which is tightly curled. The protuberance at the top of the head – the *uṣṇīṣa* – is relatively high. The feet are large and crudely executed.

The robe has a prominent collar-like neck lying over both shoulders, and one corner is pulled over the left arm. In front it falls in heavy U-shaped folds to form three angular ridges, while the hems splay out at either side. The treatment of the robe is highly reminiscent of Chinese examples from the late Northern Wei and the Eastern Wei period of the early sixth century. It is found in a rather more complex form on an altar from AD 524 in the Metropolitan Museum, New York.

The relatively large mandorla, curved forwards at the top, is incised all over with a flame pattern which appears somewhat irregular when compared with Chinese examples. On the back of the mandorla, which was broken and has been restored, is a Chinese inscription of forty-nine characters, incised in four lines before gilding. Since some of the characters are not easy to identify, it can be translated only tentatively as: 'In the seventh year, *kimi*, of the Yŏn'ga era the head-priest of the East Temple [Dong-sa] of Nangnang in the land of Ko[gu]ryŏ together with his respectful pupil Yŏn and another forty persons caused [figures of] the thousand Buddhas of the present age of the world to be made and distributed in the world. Of these this is the twenty-ninth. In the present year the Buddhist Bhikṣu Pobryu has performed the sacrifice.' Since up to now no era called Yŏn'ga is known from the Koguryŏ period, it is not possible to fix the cyclic date precisely; this is repeated every sixty years. Generally, however, it is presumed to be AD 539, above all on stylistic grounds.

At all events this sculpture is important evidence of how a Buddhist artist from Koguryŏ in the early sixth century tried to feel his way into the roughly contemporary Chinese form-language. RG

Published Hwang Su-yong 1973, pp. 29–44;
San Francisco 1979, no. 69;
Kim and Kim 1966, p. 112–13 (with rubbing of inscription).

20 Seated Buddha

Three Kingdoms, perhaps Koguryŏ,
 late 6th century AD
Gilt bronze. H 8.8 cm
Provenance unknown
Namgun Ryon Collection

The Buddha sits cross-legged in the posture of meditation. The excessively long robe hangs down in front over a pedestal, now lost. The hands are placed in front of the body with their backs turned outwards in the archaic gesture of meditation (*dhyāna-mudrā*). The head and hands are still relatively large. The detail of the trapeze-shaped face is powerfully executed. The hair and the distinct knob-like *uṣṇīṣa* are without curls. In this figure, too, the robe covers both shoulders, but the folds hang more naturally and are no longer as full as in no. 19. The same is true of the cascades of folds which loop in front of the pedestal.

Near P'yŏngyang in North Korea fragments of three clay models for Buddhist bronze figures have been found, one of which has folds not unlike those seen here. This allows us tentatively to classify this figure among the early works from Koguryŏ. The form of the *uṣṇīṣa* points in the same direction. The figure illustrates the reaction of Korean Buddhist sculptors to the more highly developed Chinese style of the late Northern and Eastern Wei dynasty in the early sixth century, so that one may suggest that there was a lapse of about half a century between the Chinese prototypes and the Korean variations. RG

Published Kang Woo-bang, 1982, p. 30;
San Francisco 1979, no. 72

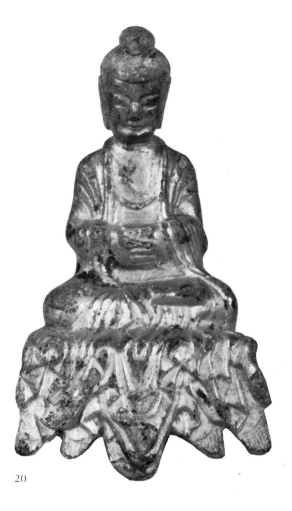

20

Paekche (18 BC–AD 663)

The kingdom of Paekche occupied territory in the south-west of Korea, where the former rulers of the kingdom of Puyŏ had withdrawn at the time of the foundation of Koguryŏ. The first capital of Paekche was at Wiryesŏng, south of present-day Seoul; thereafter it was sited successively at Hansan (Kwangju) until AD 475, and at Ungjin (now Kongju) from AD 475 to 538. These changes of capital reflected the varying success of Paekche's campaigns against Koguryŏ. In AD 538 it became necessary to move the capital even farther south. Recalling his people's descent from the former kingdom of Puyŏ, the king called the new capital Nam-Puyŏ (South Puyŏ) and the city has retained the name Puyŏ to this day. In AD 660 Paekche was conquered by Silla with the help of troops from the Chinese Tang empire and was incorporated into the Unified Silla Kingdom.

At the height of its power, however, Paekche enjoyed close relations with China, which was only about 500 km away by sea. Whereas Koguryŏ's contacts with China were with the north, Paekche was influenced by the southern dynasties, and particularly by the Liang dynasty (AD 502–57). The extent of cultural exchange at this time can be seen in the contents of the tomb of King Munyŏng (reigned AD 501–23), which contained handsome pieces of ceramics from China, as well as being itself constructed in every detail like the tombs of the Liang.

Buddhism was introduced to Paekche in AD 384, by a Central Asian monk, who came via China under the Jin dynasty. There were also frequent contacts with Japan, where Paekche scholars went as early as the fourth century to teach Chinese. During the reign of Songwang (AD 523–54) doctors, astrological and calendrical experts, monks and artisans were sent to Asuka Japan to found Buddhist temples. Their presence in Japan is still remembered in the name of the famous Kudara (Kudara = Paekche) statue of Kannon in the Hōryū-ji temple, Nara. In AD 552 Sŏngwang sent Buddhist images and sutras to Emperor Kimmei. Within Korea also it was a Paekche architect, Abiji, who went to Silla, the last of the Three Kingdoms to adopt Buddhism, to construct the famous nine-storey pagoda of the Hwangryong-sa in Kyŏngju. JHW/RW

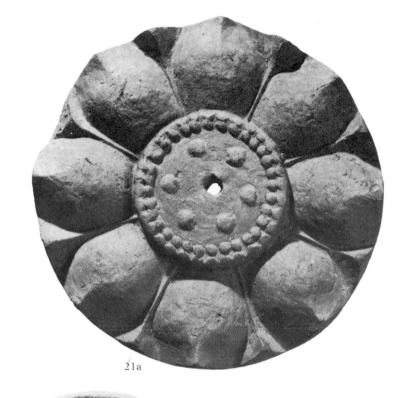

21a

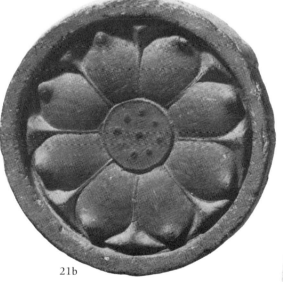

21b

21c

21a-c Tile-ends with lotus decoration

Paekche, 6th–7th century AD
Earthenware, D 16.5cm, 13.6cm, 14.5cm
a. Excavated from the temple complex of
 Kǔmkang-sa, Puyŏ, South Ch'ungch'ŏng
 province; Chin Hong-sop Collection
b. From Puyŏ, South Ch'ungch'ŏng
 province; collection of Miss Choi Su-chong
c. Excavated from the temple complex of
 Mirǔk-sa, Iksan, North Chŏlla province;
 Ch'ungnam University Museum

Roof-tiles from Paekche are less varied than those
from Koguryŏ, of which about three hundred
varieties have been counted. The principal motif
is the lotus blossom with six or eight petals
surrounding the ovary. Unlike the narrow petals
of Koguryŏ tiles with their intervening tendril
motifs, the petals on Paekche tiles are broad and
fleshy, with the tip turned up. In the plaques
nailed to the ends of beams there is no enclosing
border and the petals appear even larger, reach-
ing right to the edge. Nos 21a and b date to the
period AD 538–660 when the capital was at
Sabi (cf. Nara 1978, nos 9, 14). No. 21c has
additional decoration on each petal, and cannot
be earlier than the middle of the seventh cen-
tury AD, at the end of the Paekche period. The
decoration of tile-ends in the Unified Silla period
(late seventh–eighth centuries, see no. 102)
was to become much more complex, with super-
imposed rows of petals. Paekche tiles were not
glazed, although fragments with similar designs
and traces of yellowish-green glaze have been
found at the site of the Mirǔk-sa (Maitreya
temple). JHW/RW

55

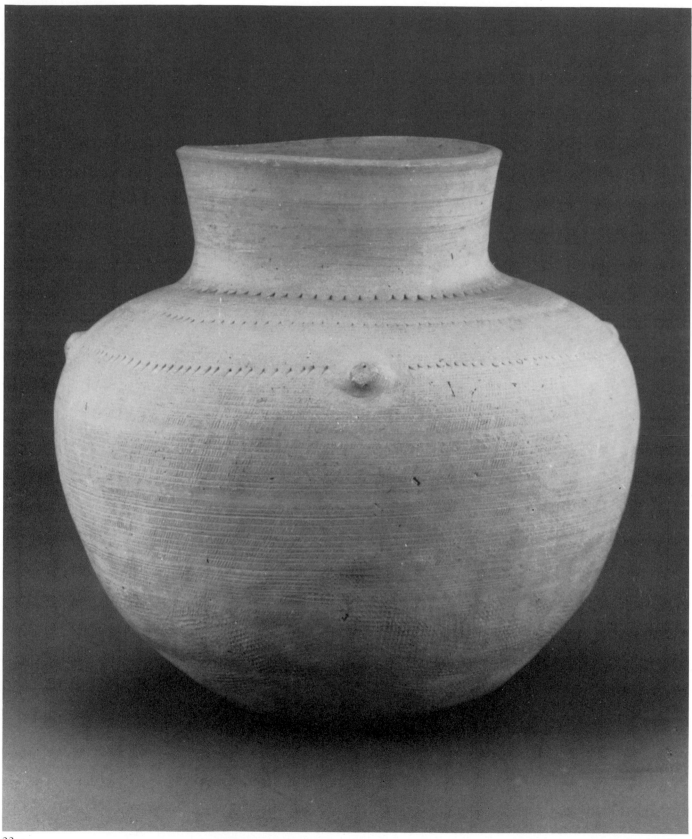

22

22 Jar with four ears

Paekche, 6th–7th century AD
Pottery with impressed mat decoration.
 H 26.0 cm
From Namsan-ri, Kongju,
 South Ch'ungch'ŏng province
Kongju National Museum

Two main kinds of pottery were made in Paekche:
a low-fired ware of the famous 'eggshell coloured'
Paekche clay, and pottery fired at a temperature
of about 1000°C, with a rather formal character
(no. 23).
 This vessel is of a very early Paekche shape,
with rounded base and swelling body (cf. Han
Byong-sam 1981, pl. 96). Four rudimentary
knobs adorn the shoulders near the widest point,
and the whole surface bears traces of mat or
cloth impressions from the beater used to com-
pact the clay body. There is every indication
that the piece was made with great care, and
the decoration of three bands of small triangles
around the base of the neck, on the shoulders,
and joining the four knobs, is elegant and crisply
impressed. JHW/RW

Published Chin Hong-sop 1978a, pl. 1.

23 Jar with four lug handles

Paekche, 6th–7th century AD
Grey stoneware with ash glaze. H 43.0 cm
Provenance unknown
Puyŏ National Museum

In contrast to the harmonious, swelling form of
the last piece, this example of grey stoneware,
with its abrupt transitions in shape, dates from
the end of Paekche. No other vessels of this
shape are known. The decoration, which com-
bines horizontal bands with incised arching
loops, is close to that of Silla ceramics. JHW/RW

Published San Francisco 1979, no. 64;
Han Byong-sam 1981, pl. 101.

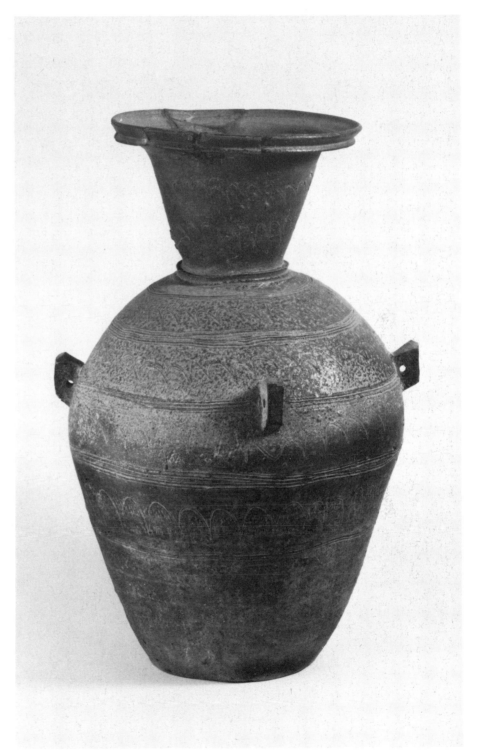

23

24 Cup with animal-shaped handle

Paekche, 6th–7th century AD
Grey stoneware. H 13.0 cm
From Sŏch'ŏn, South Ch'ungch'ŏng province
Puyŏ National Museum

Cups, bowls and pots with handles are seldom found in Paekche ceramics. On this cup a complete but unidentifiable animal with an enormous tail serves as the handle. The only other decoration is provided by a raised band which has appliqué beads at regular intervals.

JHW

Published San Francisco 1979, no. 63

25 Inkstone and cover

Paekche, late 6th–early 7th century AD
Grey stoneware. H 15.8 cm
Provenance unknown
National Museum of Korea, Seoul

Pottery inkstones have been found in large numbers on the sites of official buildings and temples in the Puyŏ area, evidence of Paekche interest in scholarship, and of the close relationship with the southern dynasties of China, from which this type of inkstone with multiple feet was directly derived (see *Wenwu* 1964, no. 3, pl. 9). In turn, Paekche scholars brought it to Japan, where it was very popular from the seventh century onwards.

To use the stone, a little water was poured on to the raised central portion, and a cake of ink (lamp black solidified with animal size) was rubbed on it. The more one rubbed, the darker the colour of the ink; it could be diluted again with water. The channel around the edge served both as a reservoir and to guard against spillage.

JHW/RW

Published Han Byong-sam 1981, pl. 107

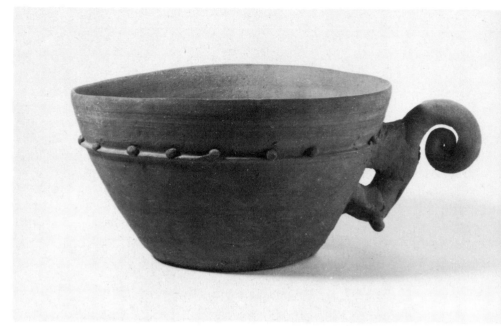

24

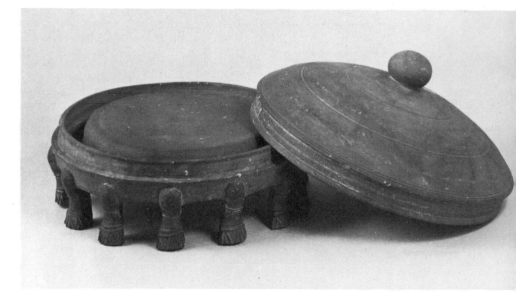

25

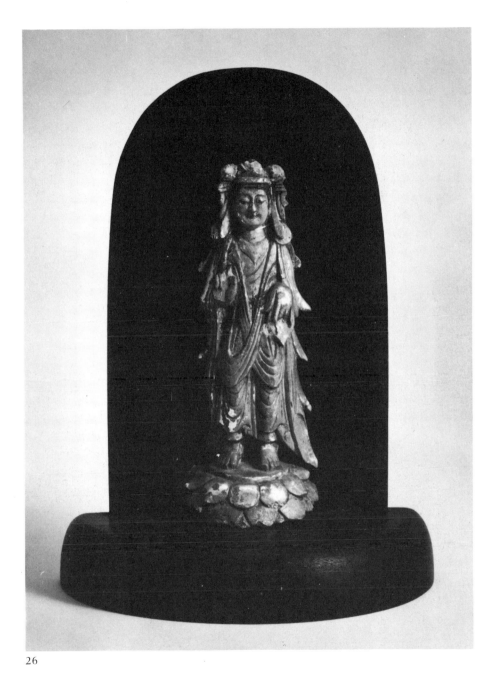

26

26 Standing Avalokiteśvara

Paekche, second half of 6th century AD
Gilt bronze. H 11.5 cm
Excavated in Kunsu-ri, Puyŏ,
 South Ch'ungch'ŏng province, in 1936
Puyŏ National Museum; Treasure no. 330

The figure was discovered, together with the soapstone Buddha (no. 27), within the grounds of a former temple of the Paekche Kingdom, on the site of wooden pagoda which has now completely vanished. The temple lay near the last capital of Paekche.

The surface of the figure, which from the side appears extremely flat, almost as if it were a bas-relief, is heavily patinated, and the gilding has largely disappeared.

The Bodhisattva stands on a double lotus with down-turned petals. The right hand is raised in a gesture which may be interpreted either as that of teaching (*vitarka-mudrā*) or of absence of fear (*abhaya-mudrā*). The attribute held in the left hand has not been precisely interpreted, but is similar to that held by the principal Bodhisattvas in Buddha triad groups, especially those from China during the Northern and Eastern Wei period (AD 386–534). The face is broad and has the typical mild 'Paekche smile'.

The head-dress consists of a diadem with richly intertwined bands and large discs over the shoulders. The dhoti and the shawls flowing from the shoulders splay out on either side like fins. The shawl falls symmetrically, criss-crossing in U-shaped folds which are echoed lower down in the incised folds of the robe.

On the back is a peg for fastening a mandorla (*kwangbae*). This Bodhisattva was one of the two figures accompanying a larger central Buddha, perhaps sharing a large mandorla (*ilgwang-samjon-bul*). The generally rather soft forms and modelling are characteristic of early Paekche sculpture, which is related to the Chinese Northern Wei style of the first half of the sixth century AD. RG

Published Kim and Kim 1966, pl. 55 and p. 116; Kang Woo-bang 1982, pp. 4–5; Hwang Su-yong 1983, pl. 12

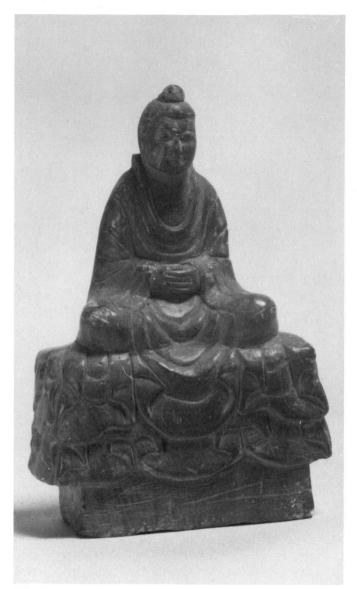

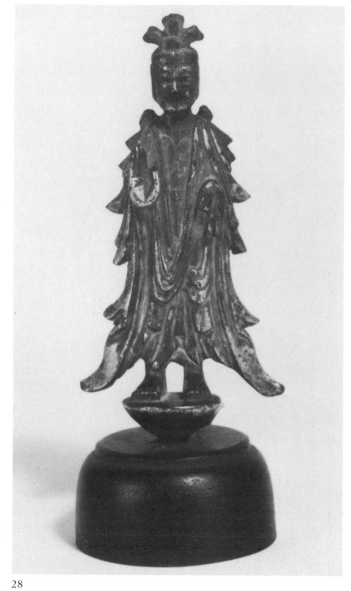

27

28

27 Seated Buddha

Paekche, second half of 6th century AD
Grey steatite. H 13.4 cm; W (pedestal) 7.4 cm
Excavated at Kunsu-ri, Puyŏ,
　South Ch'ungch'ŏng province, in 1936
National Museum of Korea; Treasure no. 329

This Buddha was discovered together with the bronze Bodhisattva (no. 26) at the site of a former Paekche temple. He sits cross-legged on a rectangular pedestal which is covered by his robe. His hands are placed together with their backs turned outwards in front of the body in the meditation position (*dhyāna-mudrā*). This early form, which was later abandoned, is characteristic of Chinese works of the fourth and fifth centuries, and of Korean works of the sixth and early seventh (cf. no. 20). The face is broad, with softly formed details and the typical 'Paekche smile'. The hair and the knob-like *uṣṇīṣa* have no curls. On the bare breast an almost invisible swastika is incised as a sign of good luck. The robe falls in large U-shaped folds from the narrow shoulders and forms a fairly thick collar round the neck and chest. In the front and at the sides it falls in three symmetrical cascades of folds over the pedestal. Their stylised forms are reminiscent of those of the bronze triad of AD 628 in the Hōryū-ji temple at Nara, which is probably also the work of a Paekche artist. The soft, 'relaxed' impression made by the figure as a whole is undoubtedly partly due to the ease with which steatite can be worked.　RG

Published San Francisco 1979, no. 73;
Kim and Kim 1966, pls 56–7, and p. 118;
Kang Woo-bang 1982, p. 4

28 Standing Bodhisattva

Three Kingdoms, first half of the
　sixth century AD
Gilt bronze. H 15.1 cm
Provenance unknown
National Museum of Korea

This slim Bodhisattva stands on the round wedge-shaped centre of a lotus flower, the petals of which are missing. Especially when viewed from the side, the figure appears fairly flat, reminiscent of the famous large Yumedono-Kannon in the Hōryū-ji temple at Nara. The feet are large and block-like. The right hand is stretched forward in the gesture of absence of fear (*abhaya-mudrā*), the left is turned downwards in the gesture of blessing (*varada-mudrā*) with two fingers bent. The face is angular, and the tripartite division of the hair has direct parallels in the roughly contemporary Chinese stone sculpture of Longmen and Gong Xian; altogether the figure has an unmistakable stylistic affinity to works of the Northern Wei dynasty of China.

Here too the robe and shawls swing out in fin-like points. The shawls, which seem to be held on the shoulder by a button-like ornament, cross in front of the thighs in large U shapes (cf. no. 26). On the back is a large eyelet onto which to attach the mandorla.

In all probability this fine sculpture, with its marked Chinese features, was once a side-figure in a triad. It is important because of its intermediate position between Chinese and Japanese Buddhist sculpture.　RG

Published Kim and Kim 1966, pl. 54;
Kang Woo-bang 1982, p. 25

The Tomb of King Munyŏng

In 1971 the unique discovery of an intact tomb of the Paekche Kingdom was made on a hill on the outskirts of Kongju, the former Paekche capital. While restoring the drainage system of a Paekche grave with wall-paintings, the archaeologists came upon an underground building of brick with an entrance sealed with decorated bricks. When it was opened it proved to be of great importance: not only were its contents intact, but it contained epitaph plaques identifying the king as one of the most famous rulers of Paekche. Born in AD 461, King Munyŏng (reigned AD 501–23) established close ties with the Liang dynasty (AD 502–57) in China. His victories in AD 521 against Koguryŏ in the north are recorded in the *Liang shu*, and he maintained friendly relations with Silla.

The plan of the tomb is closely based on contemporary Chinese tombs, with an entrance facing south and a narrow vaulted corridor leading to the rectangular chamber, also with a semicircular vault. The construction is entirely in brick; most of the bricks have moulded decoration of geometric patterns and lotus rosettes. In the north wall of the chamber, four horizontal courses alternate with a course of pairs of bricks standing on edge, their ends forming a larger lotus rosette (cf. Ōsaka 1980, no.91). A large flame-shaped niche in the centre housed a green-glazed stoneware bowl serving as a lamp. The east and west walls each have two such niches. These lamps must have been lit at the funeral ceremony and possibly went on burning after the tomb was sealed, leaving traces of soot on the tiles above them.

The grave contents were all costly and exquisite, although far less extensive than those of Silla tombs. Whereas one Silla tomb may contain a considerable amount of contemporary pottery, not one Paekche pot was found in the tomb of King Munyŏng. Instead there were two handsome proto-Yue green-glazed jars, which must have been gifts from Liang dynasty China, and the five lamps of the same ware, already mentioned. Chinese custom is also evident in the two epitaph tablets for the King and Queen, which were placed with the purchase money for the site in the entrance corridor, guarded by a fabulous animal (no. 29).

The tomb and its contents have been thoroughly published in an official report (Munyŏng 1974). JHW/RW

29 Tomb guardian

Paekche, *c.* AD 523
Hornblende and iron. H 30.0 cm; L 47.3 cm
Excavated from the tomb of King Munyŏng
in 1971
Kongju National Museum;
National Treasure no. 162

This fabulous creature, the only figure of a tomb guardian to have been found in a Korean tomb, stood in the entrance corridor. In front of it lay two stone epitaph plaques which provide important evidence. One of the them records the name of the King, with his Chinese title of Great General Pacifier of the East as well as King of Paekche, and the dates of his death (AD 523) and burial (AD 525). The second plaque bears an inscription with a contract for the purchase of the land for the tomb from the local earth spirits, according to a custom existing in China since the Han dynasty (Pak 1981, p. 47) and is dated AD 525. Part of the actual purchase money lay on the plaque, in the form of a string of coins from Liang China. The Queen died in AD 526 and was buried in AD 529; her epitaph was written on the other side of the contract plaque.

Although the idea of a guardian at the tomb entrance came from China, the only resemblance to Chinese animal figures of this period is in the tongues of flame on its flanks. It has a single antler or horn, and bears traces of red around its mouth, showing that it was originally coloured. Sturdily planted on all fours, it is an original creation with an aggressive, forbidding vitality.

JHW/RW

Published San Francisco 1979, no. 61

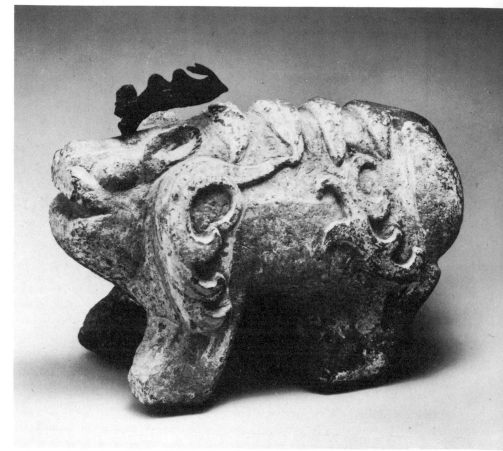

29

30 Wine cup with cover and stand *(colour ill.)*

Paekche, *c.* AD 523
Gold (lotus rosette round knob) and silver.
H (cup) 5.6 cm, (lid) 5.2 cm, (stand) 2.7 cm
Excavated from the tomb of King Munyŏng
in 1971
Kongju National Museum

This exquisite cup and stand is more than a hundred years earlier than silverwork made in the Sui and Tang dynasties in China. The engraved lotus on the cover closely parallels the painted lotus in the Tomb of the Double Columns (see p. 18), which suggests that it was produced in Korea. It has a counterpart in glazed stoneware (cf. Han Byong-sam 1981, pl. 125, there dated Unified Silla but surely earlier).

The cup has a high cylindrical foot which fits into a raised support in the centre of the stand. The stand bears traces of sixteen lotus petals surrounding the support, and animals in a landscape as the principal subject. The cup itself has an eight-petalled lotus around the base, and three long slim dragons around the sides. The cover has a continuous landscape of four hills with flying birds and a tree in the spaces between, in a vocabulary typical of Daoist thought in the period of the Three Kingdoms. It is crowned with another eight-petalled lotus in cut gold foil, with a gold lotus bud as the knob.

JHW/RW

Published San Francisco 1979, no. 60

31

31 Pair of bracelets

Paekche, dated AD 520
Silver. D 8.0 cm
Excavated from the tomb of King Munyŏng
 in 1971
Kongju National Museum;
 National Treasure no. 160

This pair of silver bracelets were found by the
Queen's left side. Each is inscribed with a cyclical
date corresponding to AD 520, the name of the
silversmith, Dari, and the weight. In Paekche,
as in the other two kingdoms, bracelets were
bands of solid gold with regular indentations on
the outer surface (two such pairs, of gold and of
silver, were also found in the tomb). This pair is
one of the few examples which has dragons
instead, two on each bracelet, their scales indi-
cated with incised lines.

According to the excavation report, the
character ri in the maker's name is distinctive
of Paekche, and is the same as the character
ri in the name of the Korean craftsman who
created the Śākyamuni triad in the Hōryū-ji,
Nara, and who must also have been from
Paekche. As the Queen died in AD 526, the
bracelets were clearly used by her and were not
simply funerary gifts. JHW

Published San Francisco 1979, no. 58, pl. X

32 Ornamental hairpin

Paekche, c. AD 523
Gold. L 18.4 cm
Excavated from the tomb of King Munyŏng
 in 1971
Kongju National Museum;
 National Treasure no. 159

This splendid ornament was found resting on a
Chinese bronze mirror which lay beneath the
King's head (another mirror lay at his feet,
probably to guard against evil spirits). It was
apparently worn at the back of the head, which
had been supported by a black-lacquered wooden
head-rest with cut gold-leaf decoration of flowers
on a pattern of hexagons. When in place, this
comb would have complemented the flame
ornaments at the sides (see no. 35), which are
broader at the base and curve upwards to a
point. JHW

Published San Francisco 1979, no. 56, pl. X.

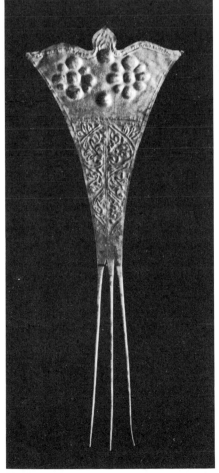

32

33 Ear-rings of the king *(colour ill.)*

Paekche, *c.* AD 523
Gold and jade. L 8.3 cm
Excavated from the tomb of King Munyŏng
 in 1971
Kongju National Museum;
 National Treasure no. 156

This splendid pair of ear-rings were found lying as if they had actually been worn by the King. Such ornaments always occur in pairs and evidently were an important element in the jewellery worn by the upper classes in all three kingdoms. The larger rings are of solid gold, and each hold two closely fitting smaller rings to which pendants are attached. These are constructed from tiny rings and petal-shaped spangles, with further decoration of granulation. Both the custom of wearing ear-rings, and the technique of granulation (minute grains of gold individually attached), are thought to have come to Korea through the Chinese colony at Lelang. The Chinese, however, wore glass ear-rings and it was the Koreans who seem to have introduced those in gold (Kim and Kim 1966, p. 183). The finest Korean goldwork using granulation invites comparison with the astonishing creations of Etruscan and Hellenistic goldsmiths from the seventh century BC onwards (cf. Greifenhagen 1974, p. 45), which may have been the ultimate source of inspiration for Chinese jewellers in the Han dynasty.

One of the pendants on each of these earrings is assembled in the same way as the beads of the necklace from Kyŏngju (no. 65), and ends with a curved piece of green and white speckled jade, capped with gold. The other pendant has a small articulated cylinder in two linked openwork halves, from which hang one large flat petal and two smaller concave petals, one on each side. JHW/RW

Published San Francisco 1979, no. 57, pl. X

34 Curved jades with caps

Paekche, first half of 6th century AD
Jade and gold. L 2.9–3.2 cm
Excavated from the tomb of King Munyŏng
 in 1971
Kongju National Museum

The flat semi-lunar jade ornaments of the Bronze Age (no. 5) continued to evolve until the period of the Three Kingdoms, when they appear in their characteristic form. The head is thicker and powerfully rounded, often adorned with a plain or granulated gold cap, with settings for semi-precious stones. The jades themselves are short and thick, and more sharply curved than those from Silla (cf. no. 52). Such curved jades were used, according to their size, as terminal elements in crown or girdle pendants, or quite

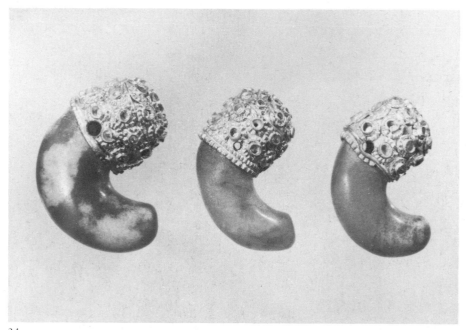

34

simply as personal jewels. Their symbolic significance is unknown. JHW

Published San Francisco 1979, no. 59a–c

35 Ornament from the King's head-dress *(colour ill.)*

Paekche, *c.* AD 523
Gold. H 30.3 cm
Excavated from the tomb of King Munyŏng
 in 1971
Kongju National Museum;
 National Treasure no. 154

This ornament and its exact counterpart were found one above the other near the King's head, and must have been worn one either side of his cap. The *Sui shu* records that the Koguryŏ aristocracy wore caps of purple silk with gold and silver ornaments, and other persons wore caps with bird's wing ornaments; according to the *Jiu Tang shu* (the official history of the Tang dynasty) the kings of Paekche wore silk caps adorned with gold flowers, and their officials caps with silver flowers (Kim Won-yong 1982, p. 184). Paintings of Koreans wearing narrow caps with side ornaments of feathers survive, notably the picture of an envoy in the recently excavated tomb of Zhang Huai near Xian (Zhang Huai 1974, pl. 25). This ornament and its twin show the accuracy of the Tang record.

The form of the ornament is like a flame, flowing upwards in rhythmic movement, the slight asymmetry exactly mirrored in the matching piece. The structure is very close to the tiny tree incised on the lid of the silver cup, but each of the branches begins as a half-palmette, such as is seen in the scroll borders of the Koguryŏ tomb-paintings. Near the top the central stem becomes a full-blown lotus. Numerous small leaves of gold foil emphasise the floral character of the whole. JHW/RW

Published San Francisco 1979, no. 55b, pl. IX; Kyōto 1976, no. 42

36 Ornament from the Queen's head-dress *(colour ill.)*

Paekche, *c.* AD 523
Gold. H 22.6 cm
Excavated from the tomb of King Munyŏng
 in 1971
Kongju National Museum;
 National Treasure no. 155

As with the King, two ornaments were found, one upon the other, close to the Queen's head. In this case, however, it would seem that they were worn not at the sides, but at the front and back. The one shown here, with the stem broken off short, is from the front; the one from the back, with a longer stem (9.5 cm), is some 7 cm smaller, though of the same width. The symmetry of the design also suggests that it was worn at the front: the same half-palmette leaves rise on either side, springing from a lotus blossom in the centre and enclosing another near the top. RW

Published Kim and Lee 1974, p. 187, pl. 167

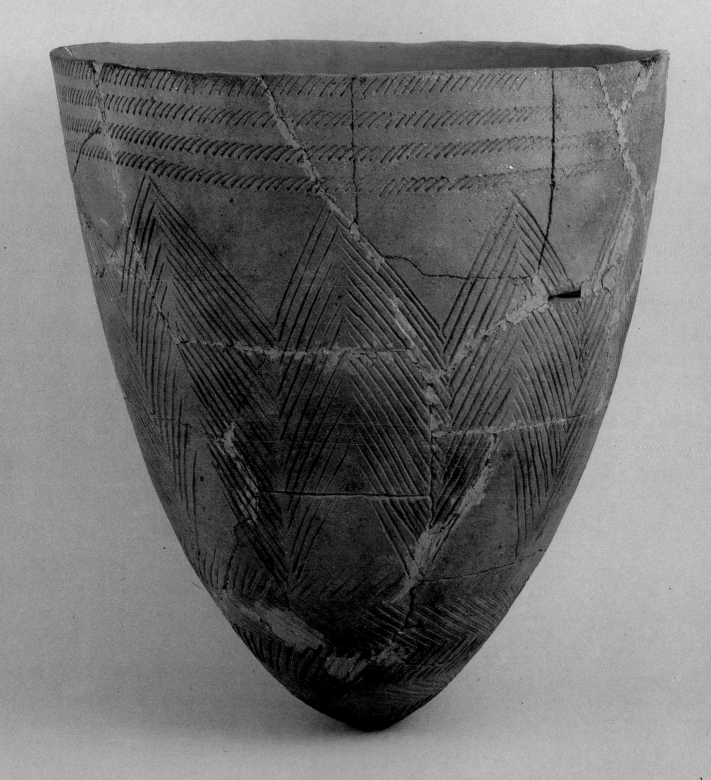

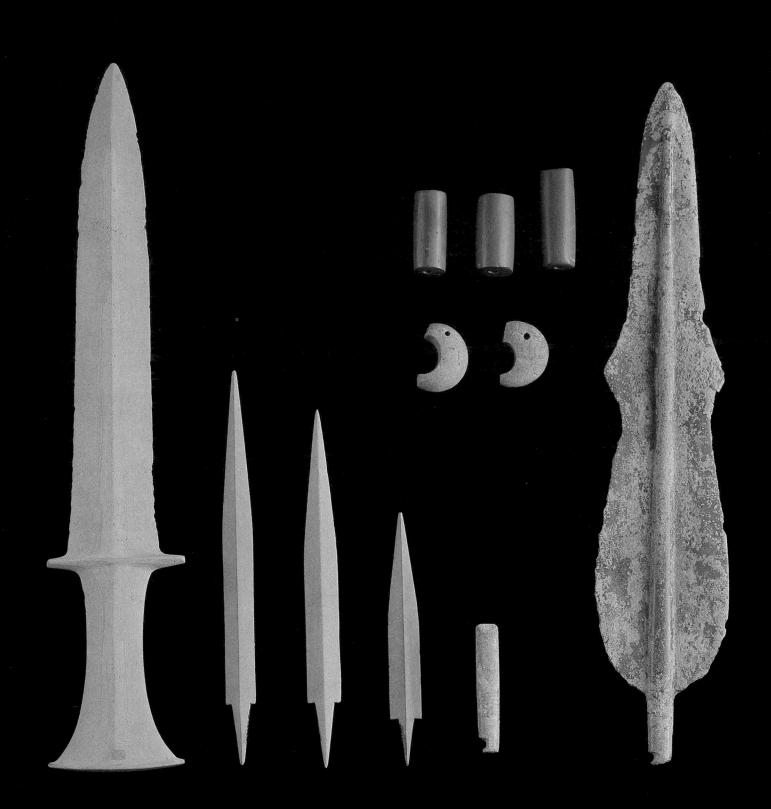

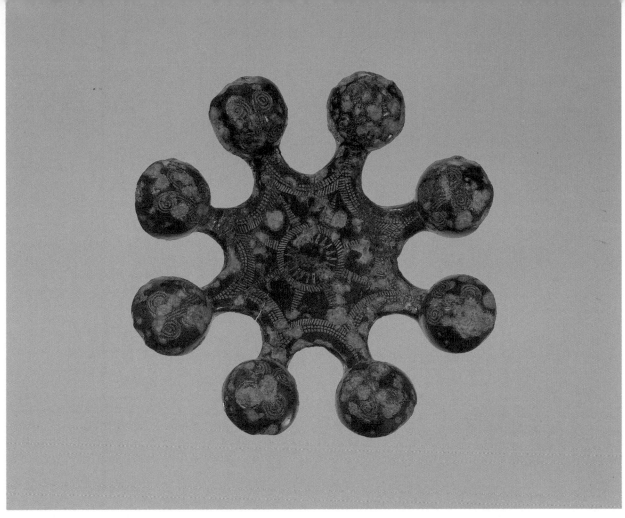

13 △

14 ▽

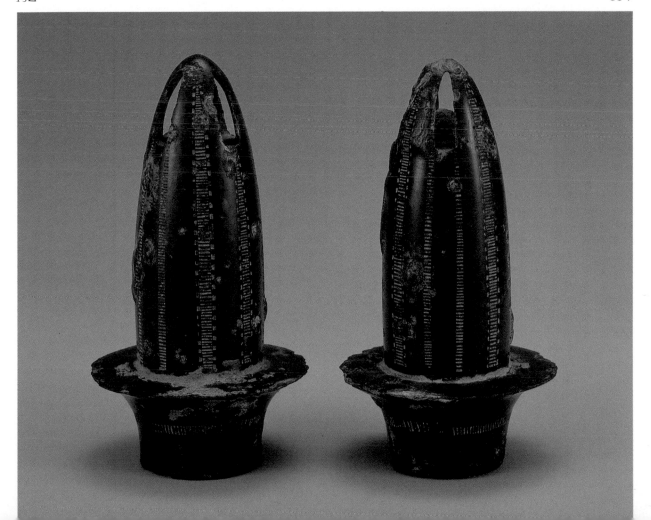

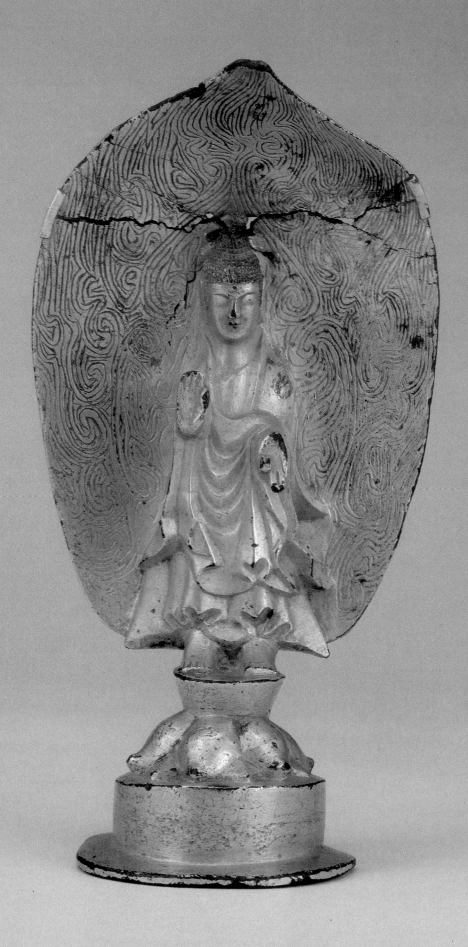

19

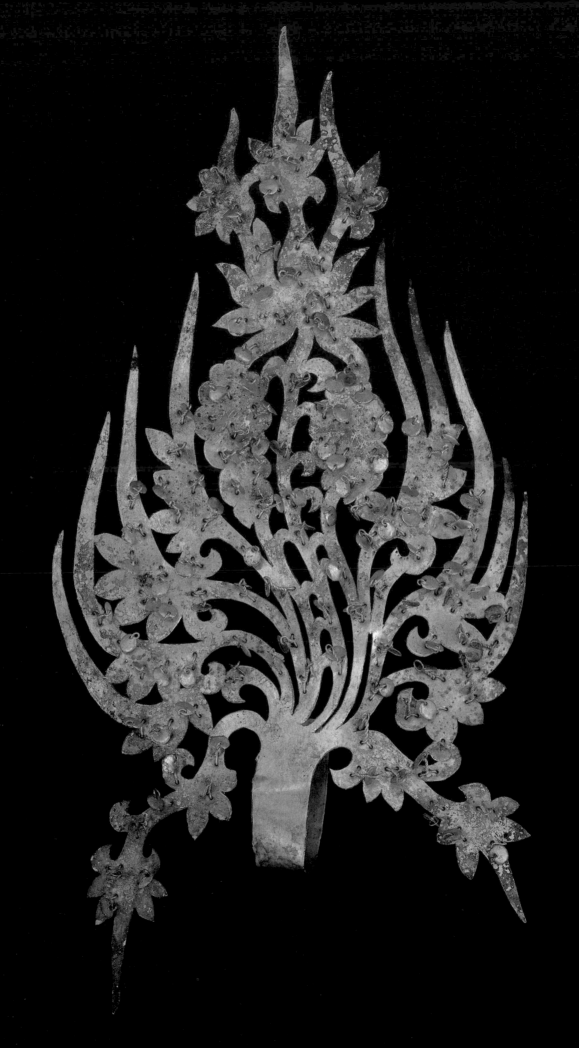

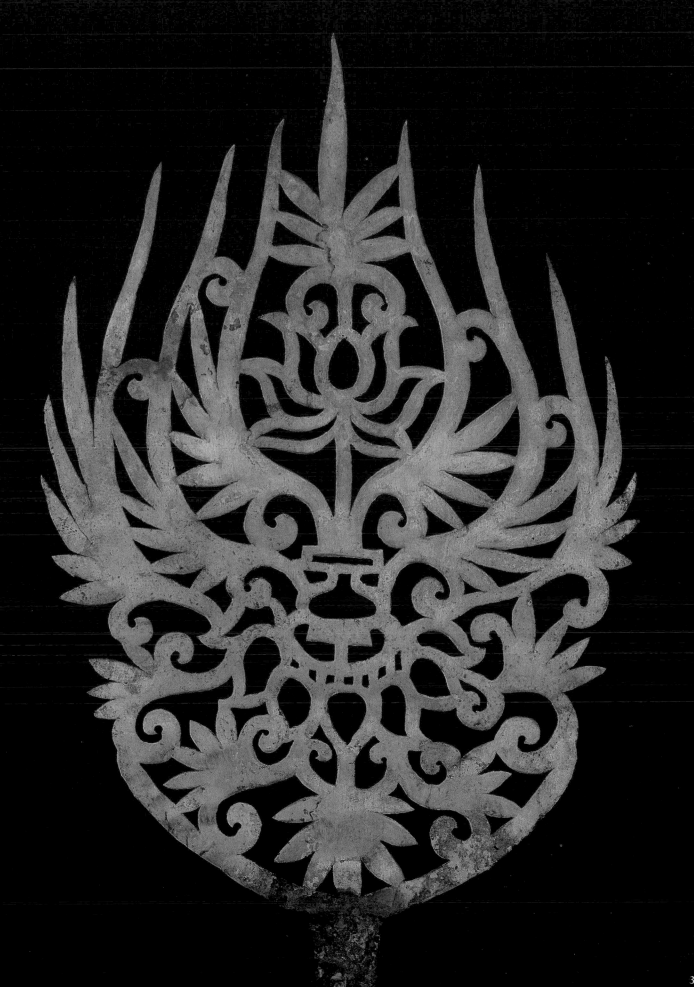

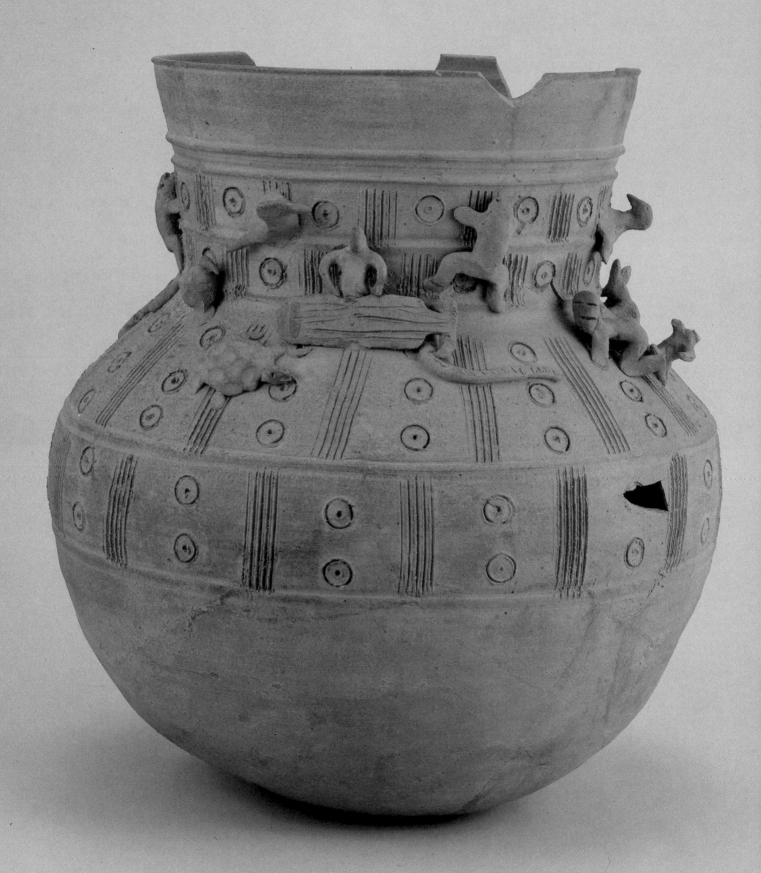

46

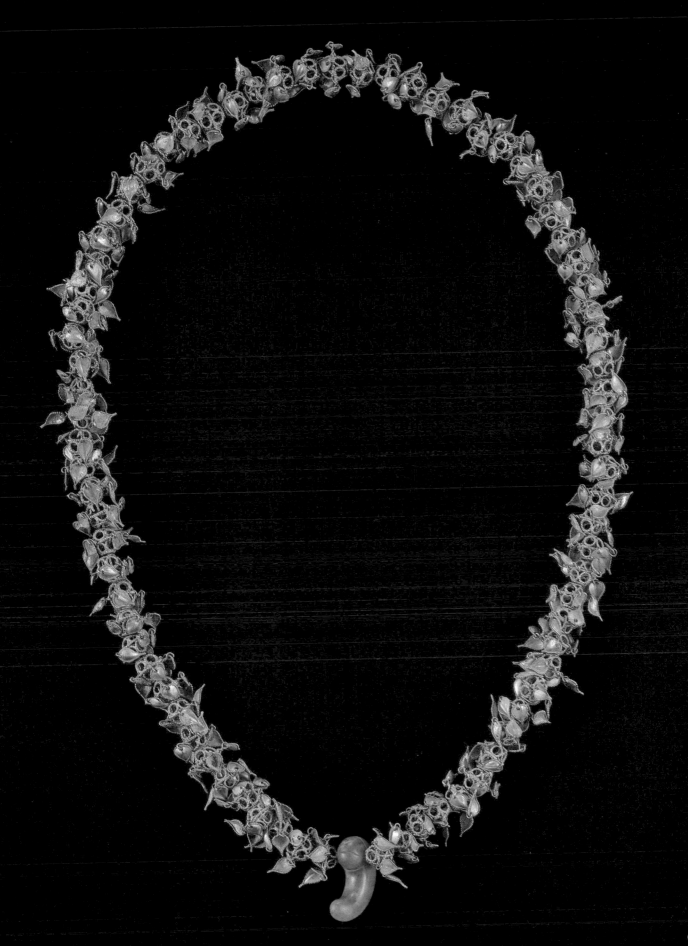

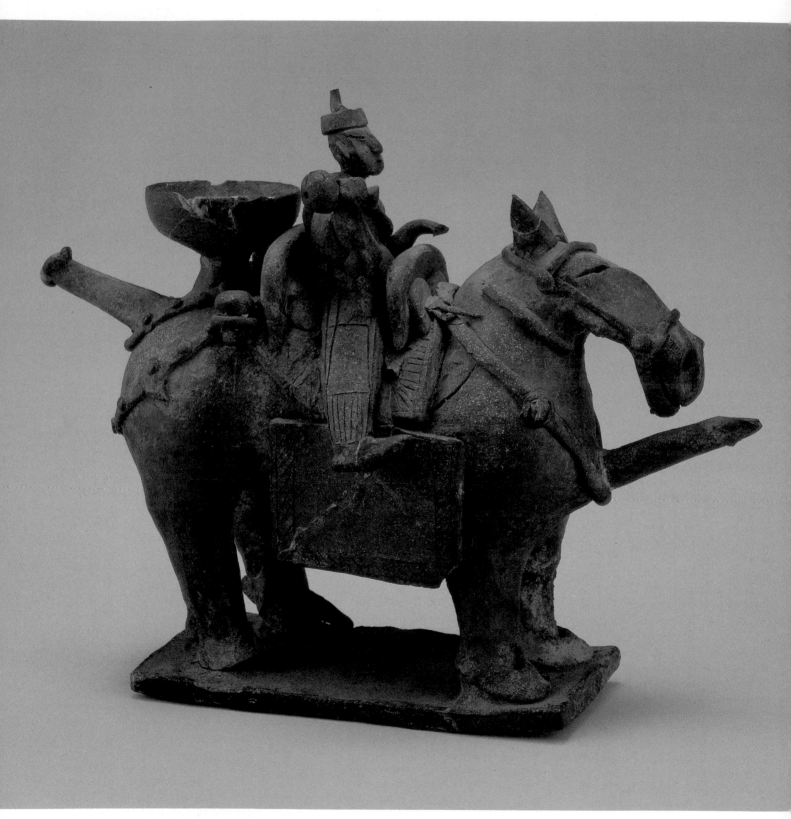

69

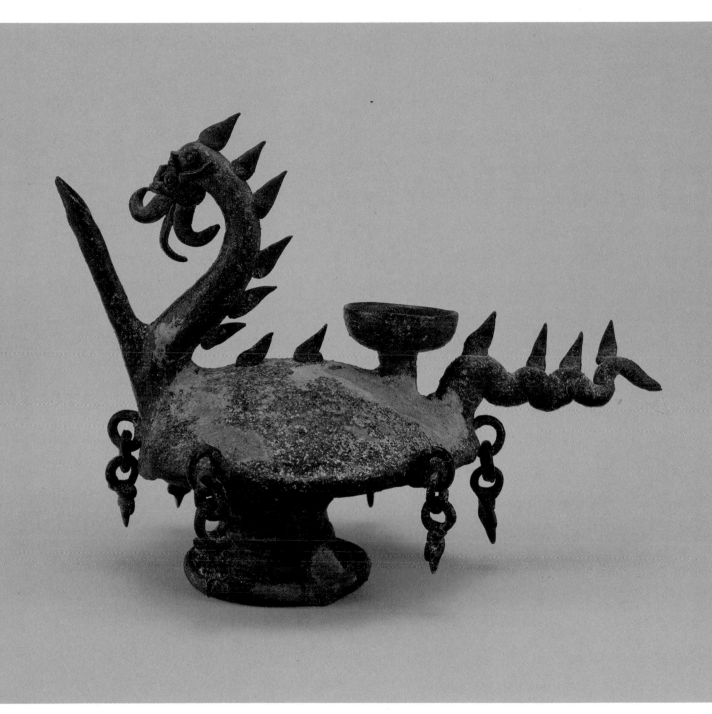

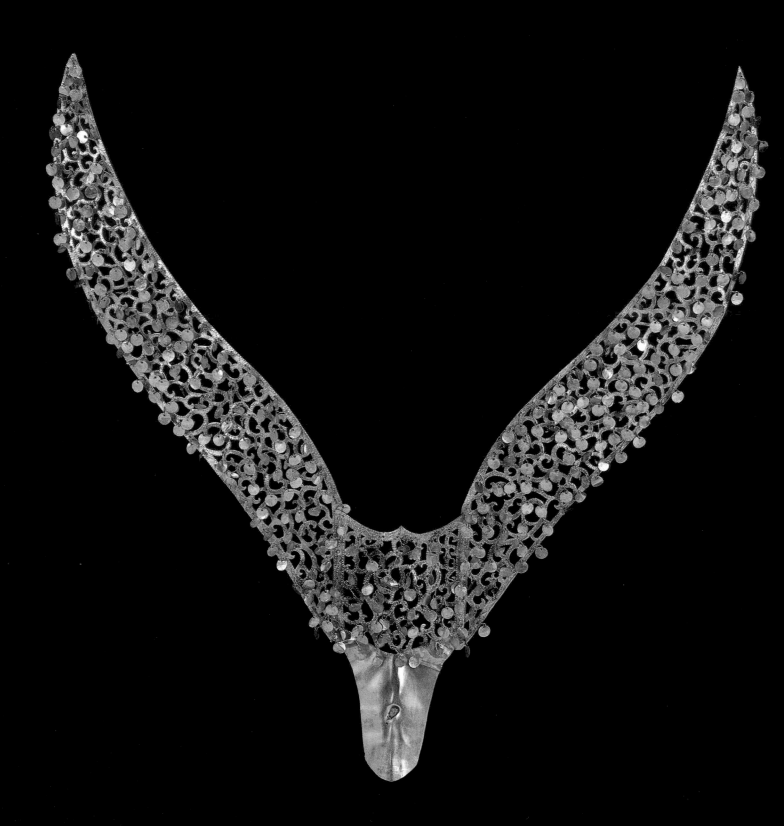

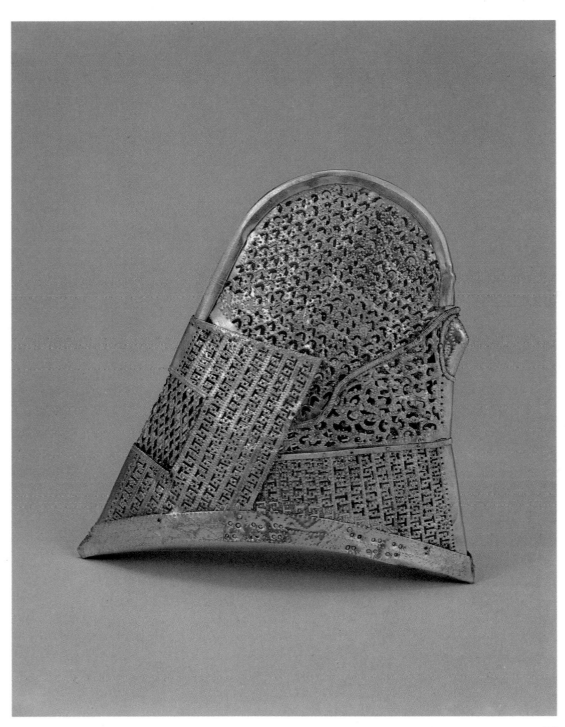

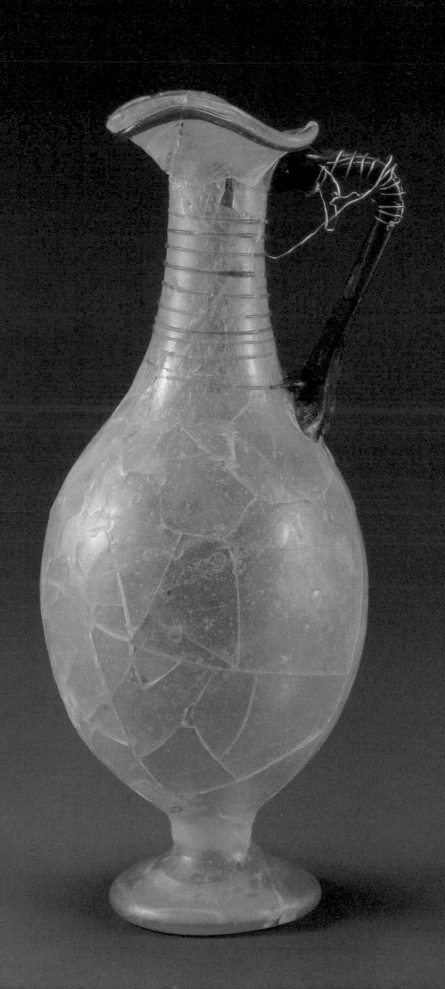

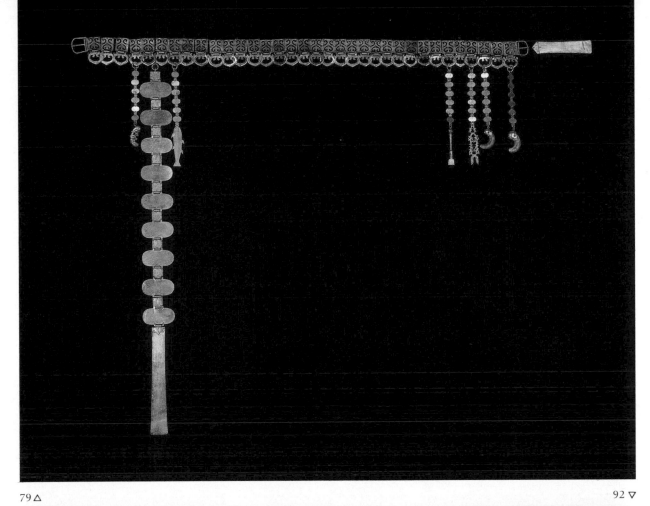

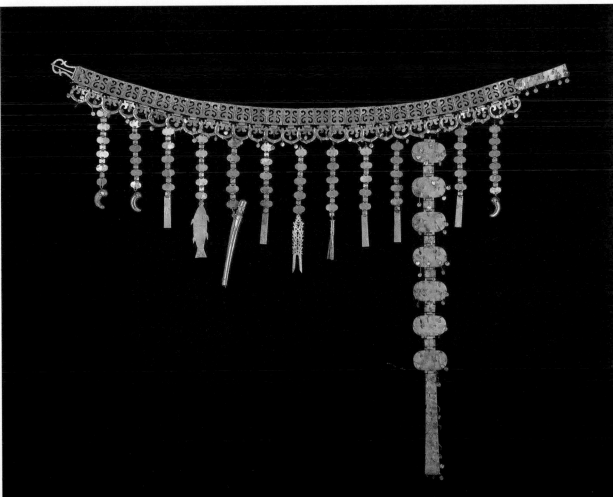

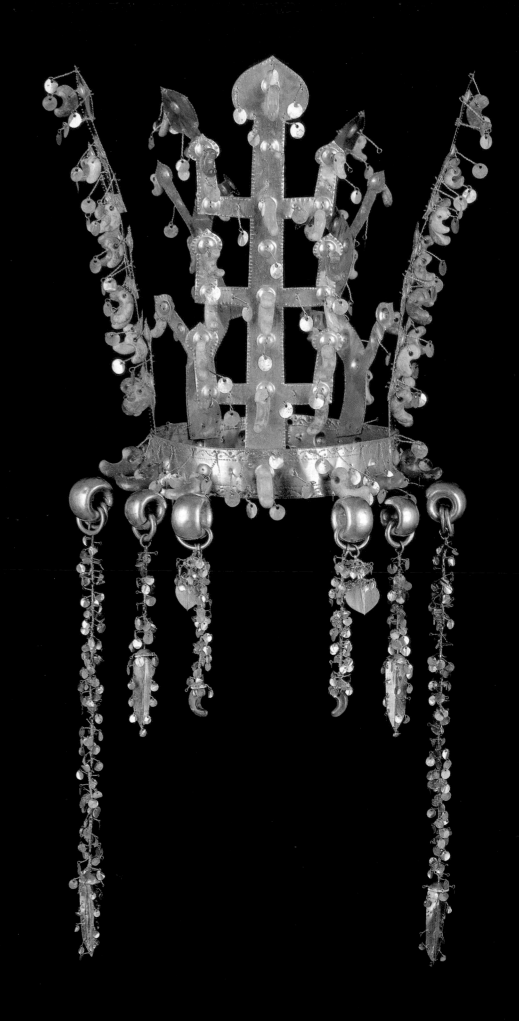

93

Kaya (AD 42–562)

Kaya or *Yuk Kaya* ('the Six Kayas'), also known as Karak, was situated to the west of the Nakdong River. Kaya had close contacts by the sea route with the Han dynasty colony of Lelang to the north, and with Japan. However, enclosed by the larger and more powerful states of neighbouring Silla and Paekche, Kaya encountered political difficulties, and was finally absorbed by Silla in AD 562.

The numerous finds of pottery from Kaya tombs display some regional characteristics, but are basically similar to those of Silla. Kaya developed the 'eggshell-coloured' ceramics of Paekche, invented new forms and, above all, developed an improved method of firing. It was in Kaya that the first tunnel kilns were built on hill-sides, making it possible to fire pottery at temperatures of 1000°C or more. From Kaya too came the strange vessel shapes typical of Silla ceramics – sculptured vessels on tall feet, and drinking horns. These in particular suggest that there must have been direct contacts with Western Asia which did not pass through Paekche or Koguryŏ, for such forms are found in neither of these kingdoms.

Kaya also was the source of the most typical of Korean musical instruments, the *kayagŭm*. This is a twelve-stringed zither with movable bridges (known as *kirŏgibal* because of their shape, which is like the feet of wild geese), invented by the music master Urŭk and transmitted by him to Silla. JHW/RW

37 Tall stand for jar

Kaya, 5th–6th century AD
Grey stoneware with traces of ash glaze.
H 52.8 cm
Provenance unknown
Hoam Art Museum, Yongin

In Kaya, and later in Silla, tall openwork ped-
estals and stands became the characteristic and
dominant forms in ceramics. In Kaya their ap-
pearance is somewhat austere. This tall stand,
with its rather forbidding functionality, looks
not unlike a defensive tower with battlements
and loopholes. Its shape is almost exactly mirrored
in the Ch'ŏmsŏngdae observatory tower of mass-
ive granite blocks, still standing in Kyŏngju, and
in fact Kim Won-yong has called this kind of
stand the Ch'ŏmsŏngdae type (Han Byong-sam,
pl. 55, note by Kim Won-yong). Its ritual charac-
ter is evident. JHW/RW

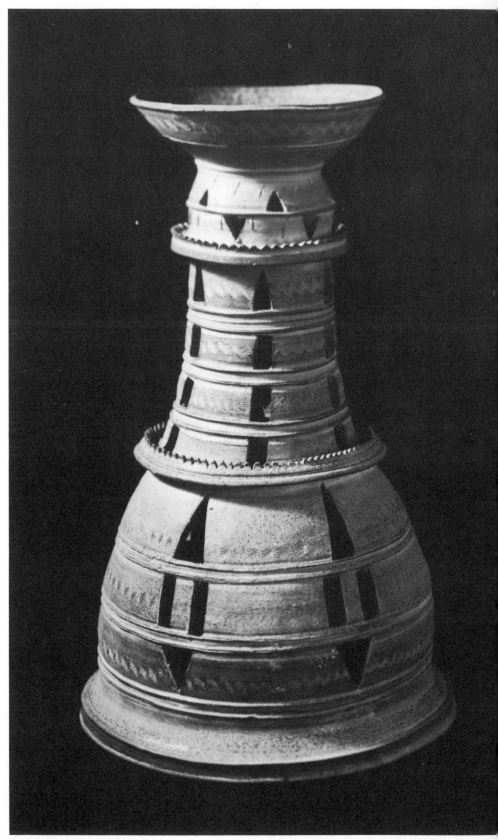

37

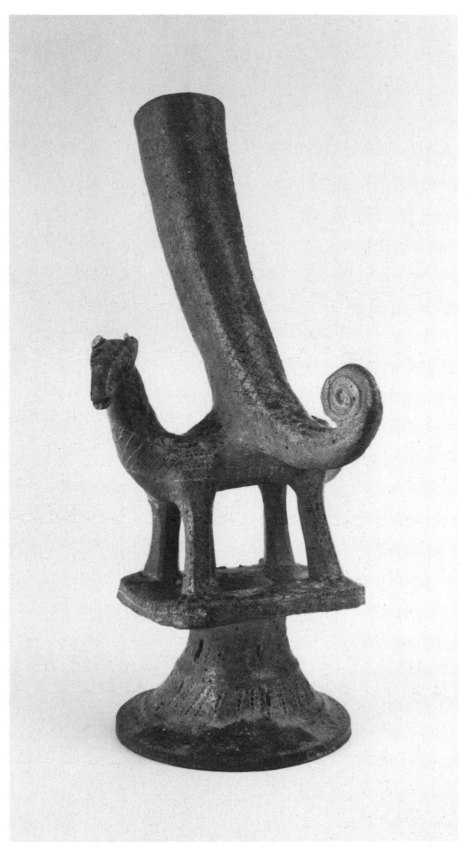

38 Horn-shaped cup with deer

Kaya, 5th–6th century AD
Stoneware with traces of ash glaze. H 24.4 cm
Provenance unknown
National Museum of Korea, Seoul

This funerary drinking horn mounted on the back of an animal, here a stag, is a vessel type found only in Kaya. Two others from the same workshop, with the horn mounted on a horse and a boar respectively, are known (San Francisco 1979, nos 50–1). In all three the animal stands on a conical base surmounted by a flat platform, and the horn is mounted across its back. The only surface decoration is of incised and impressed lines and dots. JHW

38

39 Pair of double cups with wheel stands

Kaya, 5th–6th century AD
Grey stoneware with traces of ash glaze.
 H 16.2 cm; D (wheels) 11.2 cm
Said to be from a grave in Ch'angnyŏng,
 South Kyŏngsang province
National Museum of Korea, Seoul

A number of vessels of this type have been found in pairs in Kaya and Silla graves. The wheels are sometimes fixed, as in this example, and sometimes placed on an axle so that they can turn; the vessels, however, always rest on tall stands with openings. The two horns or cups are joined together by a tube, so that a liquid would reach the same level in both.

 According to Kim Jeong-hak, such vessels, and others in the form of birds, were intended as vehicles for the soul in the next world (Han Byong-sam 1981, p.196). JHW

Published San Francisco 1979, no. 54;
Han Byong-sam 1981, pl. 89

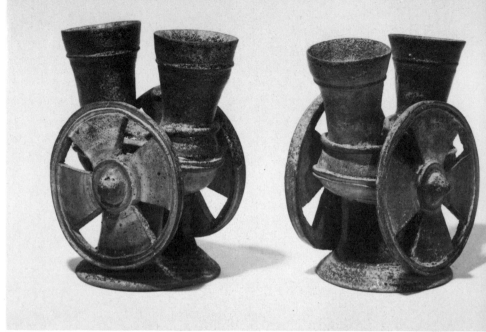

39

40 Pair of duck-shaped vessels

Kaya, 5th–6th century AD
Grey stoneware with traces of ash glaze.
 H 16.0 cm; L 17.5 cm
Said to be from a grave in Ch'angnyŏng,
 South Kyŏngsang province
National Museum of Korea, Seoul

Funerary cups in the form of ducks are peculiar to Kaya, unlike the type with wheels which are also found in Silla. This pair is naturalistically rendered, especially in the details of the head and beak. The toothed decoration around the rims of the cups is typical of Kaya, and found also in the galleries around the tall pierced stand (no. 37). JHW

Published San Francisco 1979, no. 53

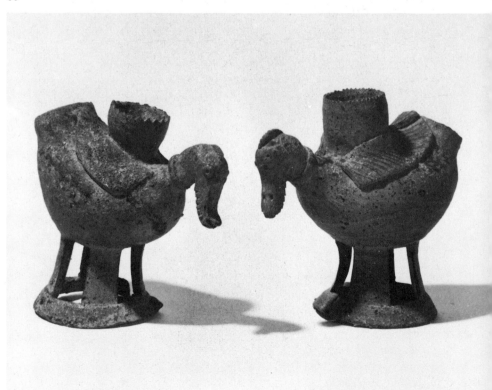

40

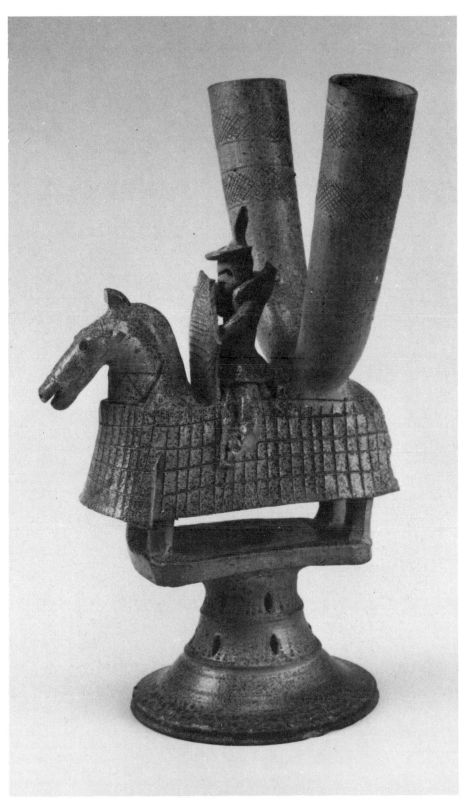

41

41 Mounted warrior with twin horn cups

Kaya, 5th–6th century AD
Grey stoneware with traces of ash glaze.
 H 23.0 cm
Provenance unknown
Lee Sang-yun Collection

Pottery figures of horses and riders wearing scale armour are known from the Northern Wei (AD 386–523) in China, but the familiar Kaya pierced stand and the smooth surface of the grey stoneware with its incised decoration give this warrior an added elegance. A second piece (Tokyo 1983, no. 74) preserves the crest of the mane intact: it curves down in front of the forehead of the horse. RW

Published Tokyo 1983, no. 74

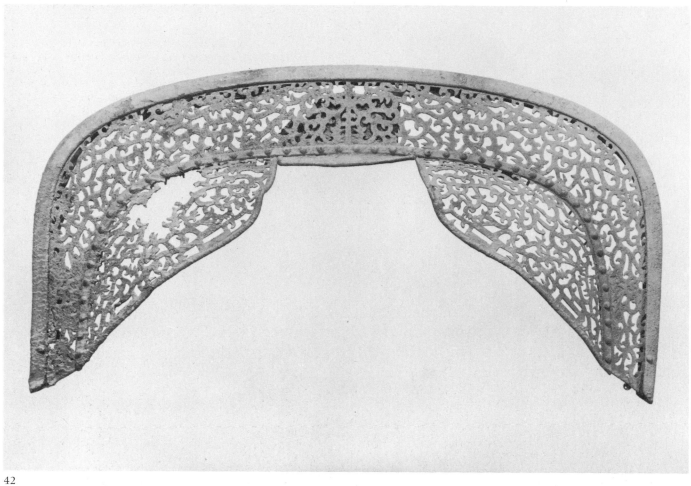

42

42 Saddle ornament

Kaya, 5th–6th century AD
Gilt bronze. H 30.0 cm; W 56.5 cm
From Koryŏng, North Kyŏngsang province
National Museum of Korea, Seoul

The noblemen of Kaya and Silla were not only
the proud possessors of horses, which they decked
out with great splendour, they also took them
with them into the next world. The lacquered
wood saddle was decorated with a high saddle-
bow; the back of the saddle had one too, but
lower and broader, as in this example (cf. Kim
and Kim 1966, p.186). The openwork dec-
oration is of stylised dragons in a floral scroll,
their heads and claws alone still distinguish-
able. In order to make the gilt bronze openwork
still more opulent, it was underlaid with silk. In
Silla saddle-bows and other items of harness
have been found decorated with the wings of
the metallic beetle. JHW

Published Han Byong-sam 1978, pl. 73.
Cf. San Francisco 1979, no. 52 (front ornament)

43 Crown *(see front cover)*

Kaya, 5th–6th century AD
Gold and jade. H 11.5 cm; D 20.7 cm
Said to be from Koryŏng,
 North Kyŏngsang province
Hoam Art Museum, Yongin;
 National Treasure no. 138

The exact circumstances of the discovery, and therefore of the original appearance, of this important crown are unfortunately not known. The eight green and white curved jades are of a quality commensurate with that of the crown itself, and they have probably been replaced in their correct positions, but there may have been an interior element and further pendants.

A number of other ornaments belong with the crown, and are most unusual in form. Made of gold foil, each is shield shaped with two curved ears and two jades with slightly curved tips, of the same colour as those on the crown, serving as 'horns'. There are three of these ornaments, each 6.8 cm high, and a fourth, which is 10.2 cm high and has three jade 'horns' instead of two. Their exact relation with the crown cannot now be known, but all four have pairs of small holes, probably for sewing onto an inner cap (Hoam 1982, pl. 149).

The varieties of Korean crowns are too numerous to discuss here, but are thought to have their origins in Scythian crown types. In their most developed form in Silla the uprights are trident shaped (no. 93)　　　　RW/YSP

Published Kim Won-yong 1971;
Han Byong-sam 1978, pl. 7; Hoam 1982, pl. 149

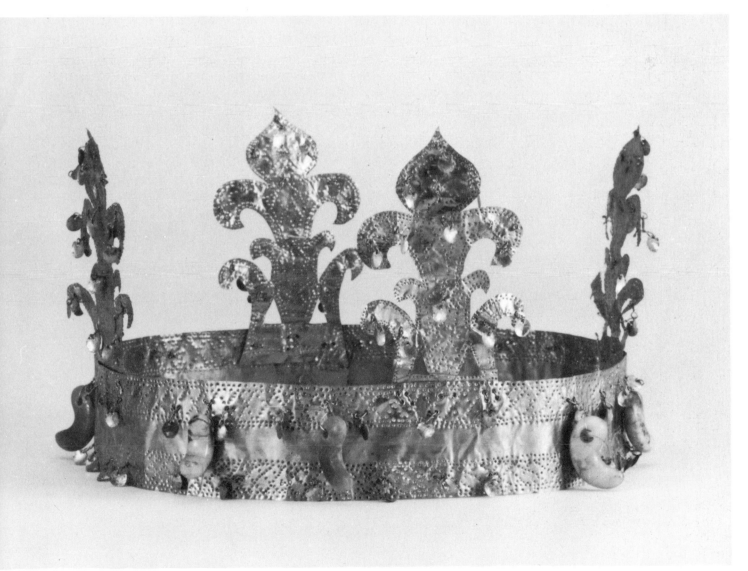

43

Silla (57 BC–AD 668)

Silla, lying in the south-east of Korea, was the last of the Three Kingdoms to receive Buddhism (AD 535), and the native shamanistic religion probably survived longest there. Its capital, for almost a thousand years (until the end of Unified Silla), was in Kyŏngju.

The rulers who maintained Silla's identity over such a long period came from a few leading families, in a hierarchy known as *kolp'um* the 'bone system'. The Silla kings at first came only from the highest in lineage, the *sŏnggol*, 'sage bone', and then when this line died out, from the next in rank, the *chingol*, 'true bone'. The remainder of the people were divided into six ranks, *yukdup'um.* The aristocracy constituted the first three ranks, and the rest were commoners.

The sixth century saw a great expansion of Silla, and the establishment of a bureaucracy on the Chinese model, under the reigns of King Pŏphŭng (AD 514–40) and King Chinhŭng (AD 540–76). The same period saw the rise of the *hwarang*, the aristocratic and military youth organisation that was behind Silla's military successes. These events led to the absorption of Kaya and the eventual unification of the peninsula in AD 668.

Silla first came to the attention of archaeologists in 1921 with the discovery of the Gold Crown Tomb, with grave treasure in quantity and quality never before thought possible in Korea. Even today the quantity of gold objects in Silla tombs is a source of amazement. An essential characteristic of Korean goldworking is the almost exclusive use of thinly rolled gold foil and gold wire; there are few objects of solid gold. The origins of this goldworking skill are still unclear, but there is a connection between the fall of the Chinese colony of Lelang (Naknang) in AD 313 and the subsequent flowering of goldworking in all the Korean states. Some of the Chinese craftsmen may have remained, bequeathing their skill in goldworking to Korea, where it took on a typically Korean character.

Silla tombs include cist graves and underground stone chambers, but the principal form in the capital seems to have been a wooden chamber at ground level, surrounded and covered by a protective layer of large river stones, and covered again by a tall mound of earth. This simple formula protected the contents effectively against robbery, since the chamber could be opened only after the mound and the layers of stones had been cleared away. The objects deposited range from storage jars, to eating utensils and sacrificial vessels, and from unworked iron bars, to pieces of armour, agricultural implements, personal ornaments and ceremonial jewellery. Ceramics were deposited in particularly large numbers.

RW/JHW

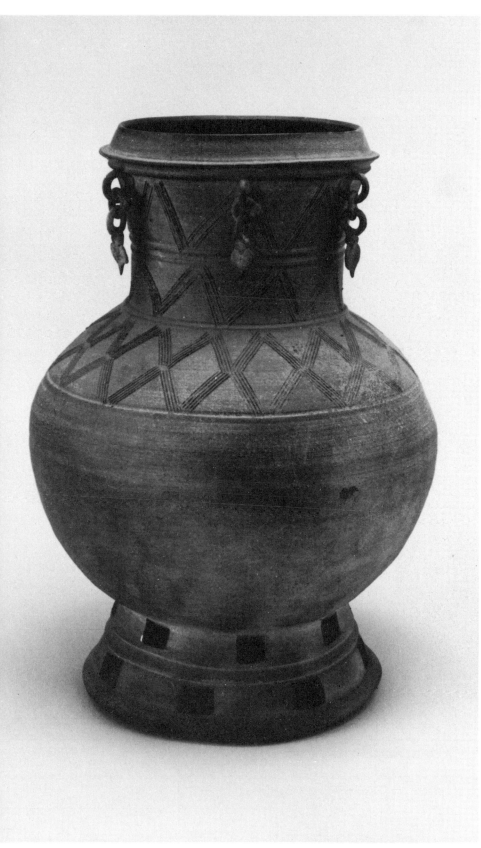

44 Large jar with pendants

Silla, 5th–6th century AD
Grey stoneware. H 39.8 cm;
 D (mouth) 17.7 cm, (foot) 21.1 cm
From Kyŏngsang province
Kyŏngju National Museum

This storage jar is one of a numerous group of large, tall-necked jars on fairly high pierced stands. It originally had a cover, now lost: according to the excavation report, this was decorated like the vessel with facing rows of combed zig-zag lines. Reference to a complete vessel (Han Byong-sam 1981, pl. 45) suggests that the cover may have been a shallow dome with straight sides, and a spreading ring as a knob, pierced in the same manner as the foot.

The seven clay pendants, of the same form as the gold pendants common in Silla, mark this jar as a ritual vessel. Such pendants also appear on other pottery vessels (see no. 51). JHW/RW

Published Tokyo 1983, no. 54

44

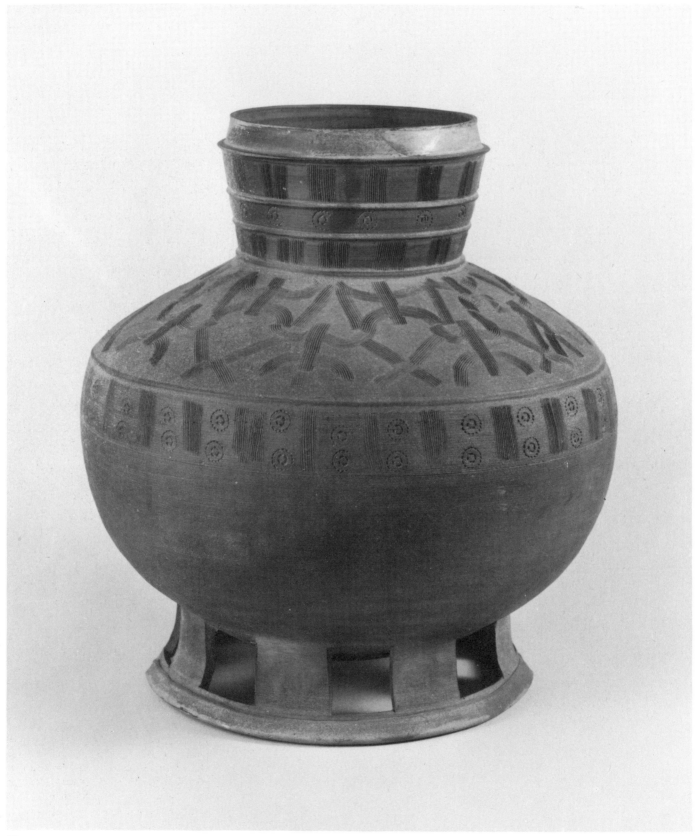

45 Large jar

Silla, 5th–6th century AD
Grey stoneware. H 37.6 cm;
 D (mouth) 16.6 cm, (foot) 25.0 cm
Provenance unknown
National Museum of Korea, Seoul

This vessel is of similar type to the previous one, and would also have had a cover. The main interest is in the decoration, which is of incised combed lines like no. 44, but in the form of a double frieze of dancing human figures in abstract representation, around the shoulder. The rest of the decoration consists of a repeated motif of two impressed concentric circles between combed vertical lines.

According to Kim Won-yong, the vessel belongs to the end of the early period or the beginning of the middle period of Silla ceramics, around the end of the fifth century AD (Han Byong-sam 1981, pl. 48, notes), and may represent a shaman dance. JHW/RW

Published Tokyo 1983, no. 53

46 Large jar with applied figures *(colour ill.)*

Silla, 5th–6th century AD
Grey stoneware. H 34.2 cm;
 D (mouth) 22.4 cm
From a tomb in the area of the grave of
 King Mich'u in Kyŏngju
Kyŏngju National Museum

The shape of this vessel, which has no stand, is reminiscent of the earlier ceramics (cf. no. 22), but the incised decoration and wide mouth date it to the late fifth or early sixth century AD. The surface is divided into bands of panels with combed lines and impressed circles and dots. Over these numerous small figures have been modelled in relief and applied. They include animals, such as a tortoise, ducks, a recurring motif of a frog or toad pursued by a snake, a copulating couple, and a figure playing the *kayagŭm*, its strings and characteristic headpiece shown well despite the crudity of the modelling. These figures concern life and reproduction and are clearly connected with rites designed to ensure fertility and good harvests.
 JHW/RW

Published Han Byong-sam 1981, pl. 46

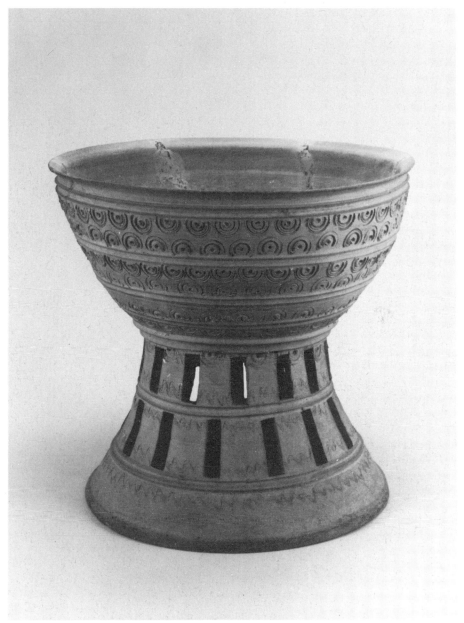

47

47 Large pedestal bowl

Silla, 5th–6th century AD
Yellowish brown stoneware. H 36.7 cm
Provenance unknown
Dong-a University Museum, Pusan

This large bowl on a high pedestal may itself have been used as a container, or have served to support a round-bottomed vessel such as no. 46. The dot and concentric circle motif is used in a different way, with half-circles alternating along the edges of each band of decoration. RW

Published San Francisco 1979, no. 41; Chin Hong-sop 1978a, pl. 58

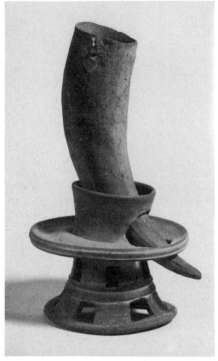

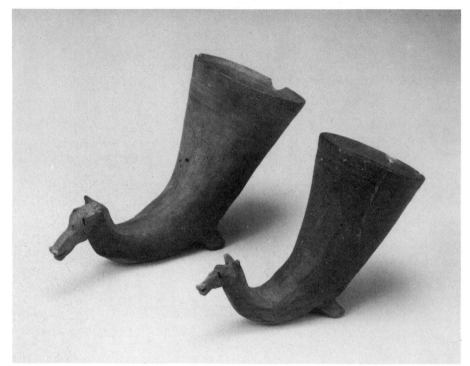

48

49

48 Drinking horn with stand

Silla, 5th–6th century AD
Grey stoneware. H 24.0 cm
From the site of Inyong-sa temple, Kyŏngju
Kyŏngju National Museum

This drinking horn is much more realistic than those from Kaya. It is not elongated for decorative purposes, but is just like a natural horn. An ingenious solution has been found to the difficult problem of how to make it stand firm in an upright position: the stand itself is a vessel, with a round hole cut through the wall of the beaker and another in the side of the supporting stand. The horn was constructed by hand and then smoothed with a bamboo knife, the traces of which can be clearly seen on the surface. JHW

Published Han Byong-sam 1981, p.180

49 Pair of horse-head rhyta

Silla, 5th–6th century AD
Grey stoneware. H 14.5 cm
From Bokch'ŏn-dong, Pusan
Dong-a University Museum, Pusan;
 Treasure no. 598

The model of these two drinking horns was unmistakably a rhyton with a horse's head from Western Asia. The Korean potter has made them with two short legs so that they could stand on their own. Probably they were for funerary use only, but they were evidently popular, for fairly large numbers of such horse-headed horns have been found in Kaya tombs. JHW

Published Chin Hong-sop 1978a, pl.61; San Francisco 1979, no.49a,b

50 Model of a cart

Silla, 5th–6th century AD
Grey stoneware with ash glaze. H 12.8 cm
From grave No.25 on the Kyerim-ro,
 Kyŏngju, 1973
Kyŏngju National Museum

Unlike the symbolic vehicles from Kaya (no.39), this Silla cart, which was found inside an urn, is an accurate model of a contemporary cart for the transport of goods; even the axle is made to turn. It seems likely that it simply represented an item of property for use in the next world. JHW

Published San Francisco 1979, no.48; Han Byong-sam 1981, pl.63

50

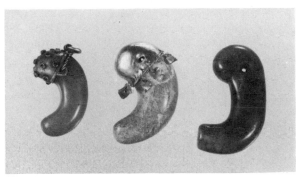

52

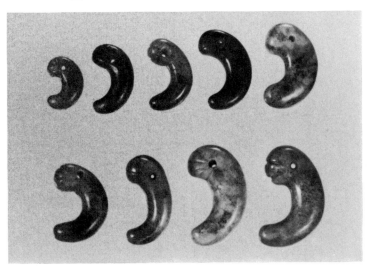

52

51 Fabulous bird *(colour ill.)*

Silla, 5th–6th century AD
Grey stoneware with ash glaze. H 14.0 cm;
 L 13.5 cm
From a grave near the tomb of King Mich'u,
 Kyŏngju, North Kyŏngsang province
Kyŏngju National Museum; Treasure no.636

Although small in scale, this vessel is one of the most elaborate and sculptural of those found in Silla tombs. It is generally described as a dragon, but the shape is more like a bird, with a long, gracefully curved neck and smooth body. The flame-like projections along the neck and back, continuing in the strangely contorted tail, recall the flaming mane and tail in the depiction of the flying horse painted on birch-bark in the Tomb of the Heavenly Horse. Like the rider from the Gold Bell Tomb (no.69), this piece has a funnel and spout which, with the spangles hanging from the edges, denote its ritual character. RW

Published San Francisco 1979, no.44;
Han Byong-sam 1981, pl.62

52 Twelve curved jade pendants

Silla, 5th–7th century AD
Jade, gold and glass. L 2.4–6.7 cm
From Kyŏngju
National Museum of Korea, Seoul

The *kogok* or curved jades from Silla have a more open form than those from Paekche (cf. no.34). They were made in a variety of different stones, especially jadeite, and in glass, and are also varied in shape. The head is always bored with a hole, for attachment with gold wire as a pendant, and the head usually has two or more radial grooves. The caps are distinct from those of Paekche, being made of smooth gold foil, with serrated edges and small leaf-shaped pendants attached. Some have tiny settings for glass or semi-precious stones. Particularly beautiful is the opaque honey-coloured *kogok* which was found in the Gold Bell Tomb (see nos 68–70). JHW

Published San Francisco 1979, nos 34–5, pl.VI

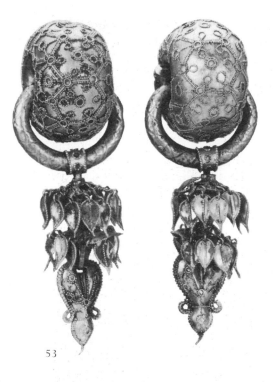

53

53 Pair of ear-rings

Silla, 5th–7th century AD
Gold. L 9.0 cm
From Kyŏngju
Hoam Art Museum, Yongin; Treasure no. 557

The most splendid gold pendants of Silla are those with a thick hollow main ring, often decorated with granulation (see no. 33). The earliest such pendant or ear-ring with a thick ring was found in a tomb in P'yŏngyang, dated AD 353 (Kim and Kim 1966, p. 183).

In this pair the granulation on the main rings is in a pattern of hexagons enclosing tiny circles, all done by attaching tiny grains of gold to the surface. From the main ring there hangs another oval ring to which the pendant proper is attached. In this case the pendant consists of two spherical elements hanging one below the other and formed of small gold rings. All around hang small leaf-shaped spangles which are serrated at the edges and mid-rib to imitate granulation. The lowest ornament is a seed-shaped drop, itself elaborately shaped and decorated with granulation. JHW/RW

Published Hoam 1982, pl. 144

54, 55 Two pairs of ear-rings

Silla, 5th–7th century AD
Gold. L 6.1 cm, 7.2 cm
From Kyŏngju
Hoam Art Museum, Yongin

Similar leaf- or pen-nib-shaped pendants hung

by a thread from a glass tube passing through the ear-lobe in the ear-rings worn by the Lelang Chinese (Kim and Kim 1966, p. 183). RW

54 *Published* Hoam 1982, pl. 151

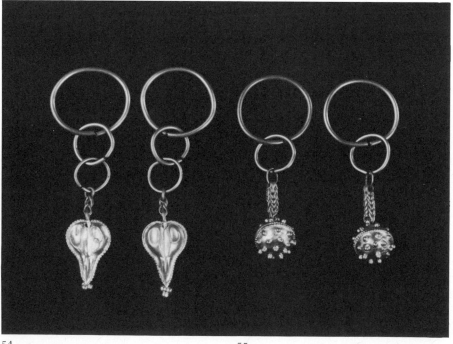

54 55

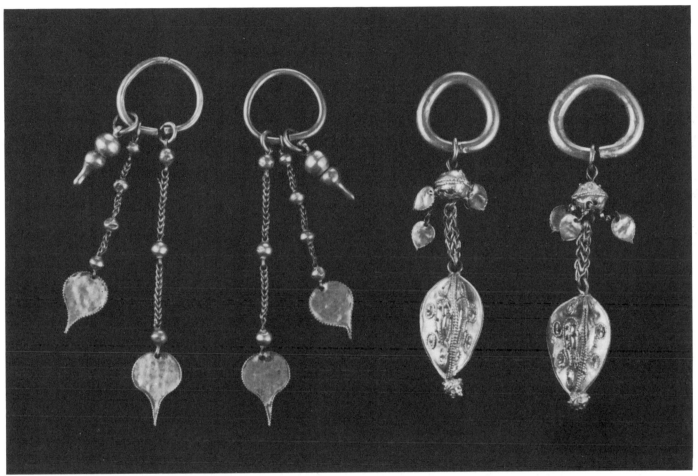

56

57

56,57 Two pairs of ear-rings

Silla, 5th–7th century AD
Gold. L 9.6 cm, 9.1 cm
56 From Ch'angwon, South Kyŏngsang
 province
57 Provenance unknown
National Museum of Korea, Seoul

Published San Francisco 1979, no. 32b

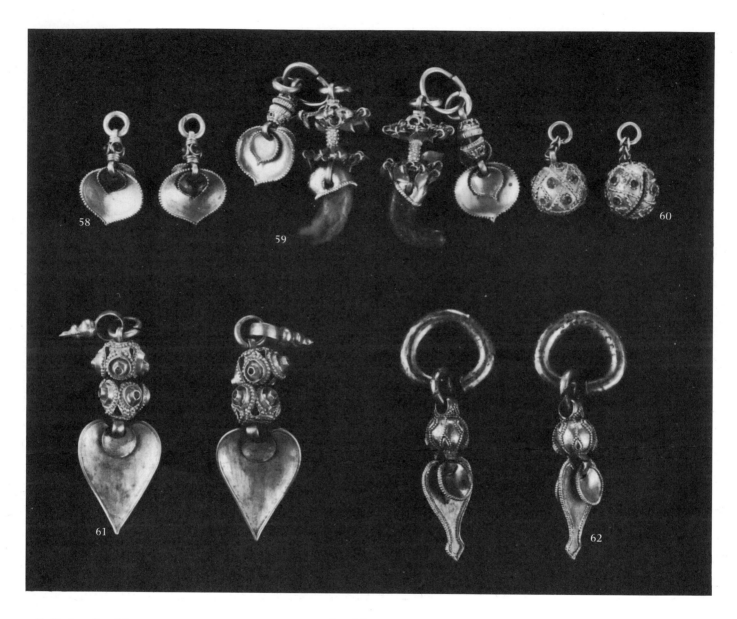

58 Pair of gold ear-rings

Silla, 5th–7th century AD
Gold and glass. L 2.8 cm
From the Gold Bell Tomb, Kyŏngju
National Museum of Korea, Seoul

Published San Francisco 1979, no. 31e

59 Pair of gold ear-rings

Silla, 5th–7th century AD
Gold and glass. L 5.0 cm
From the Gold Bell Tomb, Kyŏngju
National Museum of Korea, Seoul

Published San Francisco 1979, no. 31c

60 Pair of gold ear-rings

Silla, 5th–7th century AD
Gold and glass. L 2.5 cm
From the Gold Bell Tomb, Kyŏngju
National Museum of Korea, Seoul

These ear-rings are set with blue glass beads,
each within one of the fifteen diamond panels
formed by granulation. There is a rattle inside.
Because of their great beauty, the tomb in which
they were found was given the name of Gold
Bell Tomb. YSP

Published San Francisco 1979, no. 31f;
Han Byong-sam 1978, pl. 32B

61 Pair of gold ear-rings

Silla, 5th–7th century AD
Gold. L 5.5 cm
From Kyŏngju
National Museum of Korea, Seoul

Published San Francisco 1979, no. 31d

62 Pair of gold ear-rings

Silla, 5th–7th century AD
Gold. L 6.2 cm
From Hwang'o-dong, Kyŏngju
National Museum of Korea, Seoul

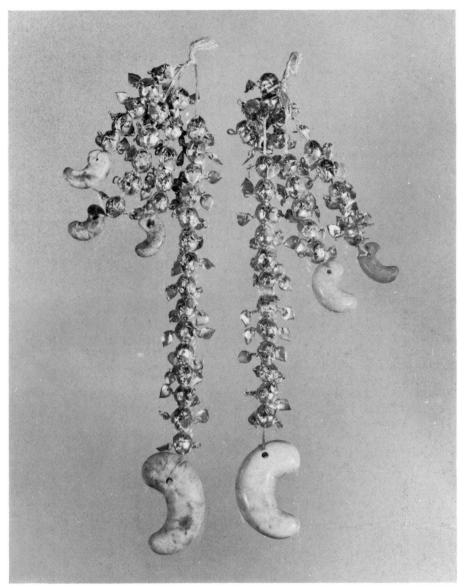

64

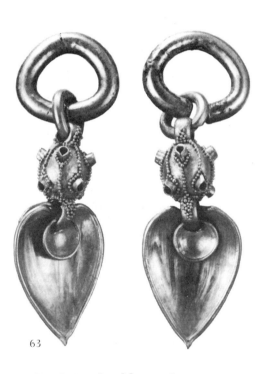

63

63 Pair of gold ear-rings

Silla, 5th–7th century AD
Gold. L 7.0 cm
From a tomb in the Hwangnam area,
 Kyŏngju
Kyŏngju National Museum

Ear-rings or pendants are always found in pairs,
in the tombs of both men and women. This pair
illustrates the type with a solid main ring,
thought to be earlier than the hollow thick ring
type. The middle bead in these ear-rings with a
solid main ring is also solid gold, and they are
accordingly quite heavy. RW

64 Pendants for a crown

Silla, 5th–7th century AD
Gold, jade and glass. L 15.5 cm
From a tomb in the Hwangnam area, Kyŏngju
Kyŏngju National Museum; Treasure no.633

Several smaller tombs have been excavated in
the vicinity of the large tumulus of King Mich'u,
the first king of the Kim clan, who is said to have
reigned from AD 262 to AD 284. King Mich'u's
own tumulus has not yet been excavated, and
nothing is known of the relationship of the
smaller tombs in the large one.

 This pair of pendants have been rethreaded,
as the original thread, as well as the cap or
head-dress to which they were attached, was
made of a perishable material. The small gold
balls are each made in two halves, with small
leaf-shaped spangles attached at the mid-point.

 JHW

Published San Francisco 1979, no.27

65 Gold necklace *(colour ill.)*

Silla, 5th–7th century AD
Gold and jade. L 30.3 cm
From a tomb at Nosŏ-dong, Kyŏngju
National Museum of Korea, Seoul;
 Treasure no. 456

This necklace consists of seventy-seven beads
each made up of small rings, with leaf-shaped
spangles attached. Both the beads and the edges
of the spangles are decorated with granulation.
Part of the necklace was formerly in Japan and
many publications show it in a shortened form
with only forty-four beads, but following a cul-
tural agreement between Korea and Japan the
remaining thirty-three beads were returned and
the necklace is now shown complete. The ter-
minal pendant of curved jade is a fine trans-
parent green, combining well with the gold.
 JHW

Published San Francisco 1979, no. 38

66 Pair of bracelets

Pair of bracelets
Silla, 5th–7th century AD
Gold. D 8.0 cm
From a tomb at Nosŏ-dong, Kyŏngju
National Museum of Korea, Seoul;
 Treasure no. 454

This pair of bracelets is the most complicated
and decorative example from Silla, comparable
to the outstanding silver pair from the tomb of
King Munyŏng (no. 31). Each is decorated with
indentations and has four sinuous dragons on
each side, their bodies incised to indicate scales.
 JHW

Published San Francisco 1979, no. 37;
Han Byong-sam 1978, pl. 38

67 Nine finger-rings

Silla, 5th–7th century AD
Gold, silver and glass. D 1.5–2.0 cm
From various tombs in Kyŏngju
National Museum of Korea, Seoul

Finger-rings were an essential part of tomb
jewellery. They were worn by men and women,
often with a ring on each finger. The gold rings
were generally made from gold foil, not from
solid gold, so that they are light and delicate.
They are often undecorated, with only a slight
widening to indicate the upper side. The two
examples at the top left, with their richer dec-
oration, come from the same tomb as the brace-
lets (no. 66) and the necklace (no. 65), which
are notable for their intricacy. JHW

Published Cf. Han Byong-sam 1978, pls 35–6

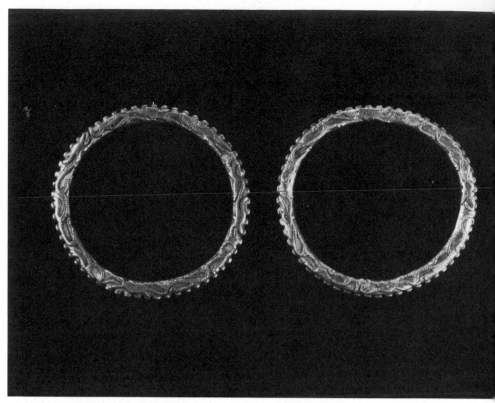

66

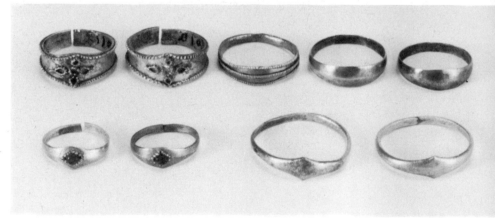

67

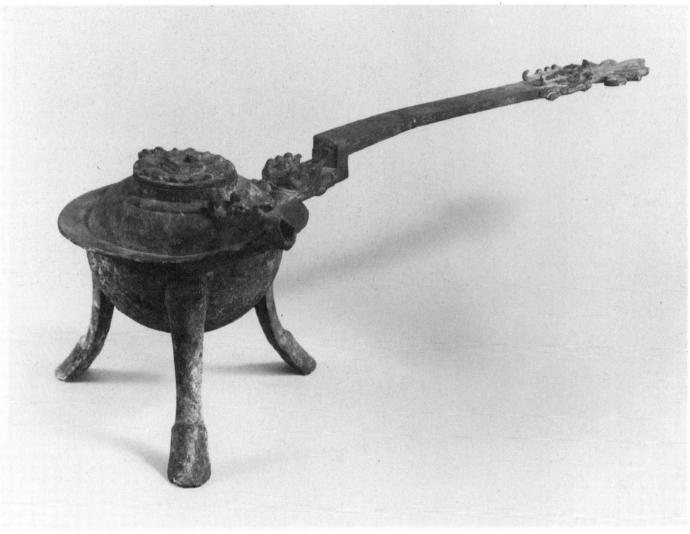

68

68 Tripod censer with long handle

Silla, 5th–7th century AD
Bronze. H 15.9 cm; L (handle) 33.7 cm,
(whole) 44.0 cm
Excavated in 1921 from the Gold Crown Tomb
(Kŭmkwan-ch'ong), Kyŏngju
National Museum of Korea, Seoul

The Gold Crown Tomb was the first Silla grave
to be systematically excavated, and the quality
of its contents has hardly been equalled by sub-
sequent discoveries. This long-handled tripod,
closely modelled on a Chinese *jiaodou* of the Six
Dynasties, was a vessel for heating medicine or
wine. The hinged cover is crowned by a lotus
flower in relief, with a square opening in the
centre, perhaps for a stopper or knob that has

been lost. The long horizontal handle, bent
through two right angles, has the form seen in
hand-held incense burners in Tang China. It is
splendidly decorated on the top and edges with
incised patterns and features a dragon's head at
each end, one grasping the rim of the vessel,
which is also incised with a palmette scroll,
while the other spits forth a whole palmette. A
third dragon's head forms the pouring spout.

JHW/RW

Published San Francisco 1979, no. 26;
Han Byong-sam 1978, pl. 47

69 Ritual vessel in the form of a rider *(colour ill.)*

Silla, 5th–7th century AD
Grey stoneware with traces of ash glaze.
 H 21.3 cm; L 26.8 cm
Excavated from the Gold Bell Tomb
 (Kŭmnyŏng-ch'ong), Kyŏngju, in 1924
National Museum of Korea, Seoul;
 National Treasure no. 91

The Gold Bell Tomb, named for the tiny pair of ear-rings already described (no. 60), was investigated and preserved in 1924. Local residents had built their houses and yards up to the tumuli, and had used some of the stones from the mounds to build walls. The person buried in this tomb must have been a king or prince, for he was buried with a large quantity of weapons and harness. On his right lay a sword in its scabbard, accompanied by a small combat knife. He wore a ceremonial girdle with a very long main pendant lying on the left leg, and his other ornaments (see also no. 52) included a gold crown with three uprights with branches and two in antler form (cf. no. 93).

Two of these ceremonial pouring vessels in the shape of riders were found by the dead man's head. The two riders are clearly of different ranks: the one shown here appears to be a servant, carrying a bag slung across his shoulder, and wearing a jacket and trousers. The other figure wears pointed shoes resting in stirrups, and wears a high narrow cap with broad ornamented rim, held on top of the head by a double strap passing either side of the ears. The two figures are perhaps the most striking of all the strange vessels found in Kaya and Silla tombs. The harness on both of them give clues for the interpretation of fittings found in this and other Silla tombs. JHW/RW

Published Tokyo 1983, no. 45;
Chin Hong-sop 1978a, pl. 31

70 Necklace

Silla, 5th–7th century AD
Gold, jade and glass. L 44.0 cm
Excavated from the Gold Bell Tomb
 (Kŭmnyŏng-ch'ong), Kyŏngju, in 1924
National Museum of Korea, Seoul

On the dead man's chest lay two single chains and this necklace, and between them the ear-

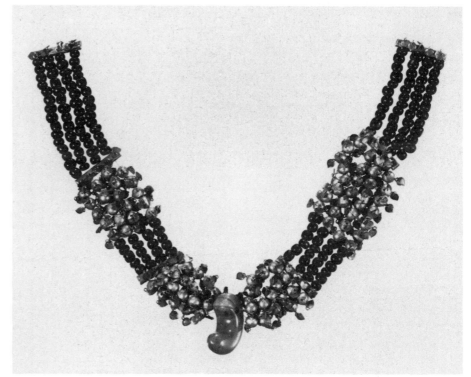

70

rings. The necklace ended at shoulder level and was probably attached to the wearer's clothing. The original threads had disintegrated, as had some forty-eight silver beads which, in six groups of eight, alternated with the gold and blue glass beads. Each of the gold beads is decorated with three tiny spangles. Gold bridges served to hold the four rows of the necklace in place. The blue glass beads were locally made and are often found under the heads of the dead, suggesting that they were sewn onto their caps. JHW

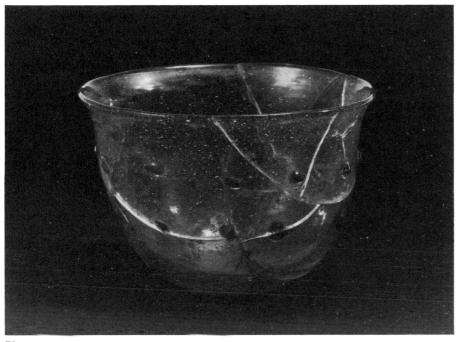

71

71 Glass cup

Probably from Iran, 5th century AD
Glass. H 6.9 cm; D 10.5 cm
Excavated from the
 Gold Bell Tomb (Kŭmnyŏng-
 ch'ong), Kyŏngju, in 1924
National Museum of Korea, Seoul

Fine glass was apparently highly esteemed in
Silla and glass objects have been found in all the
larger tombs. The thousands of blue beads were
made locally, but glass vessels from the Roman
world were obtained, thanks to the flourishing
trade between western and eastern Asia.

Two cups of almost identical form were found
in the Gold Bell Tomb. They are made of a
transparent pale-green glass, which has been
shown to be a lead-free alkaline glass. Two rows
of small pieces of cobalt-blue glass are fused to
the surface of each cup. The cup was free-blown
and the bottom is flat. JHW/RW

Published Koseki chōsa hōko 1924, p.131;
Han Byong-sam 1978, pl.57

72 Glass bowl

Possibly from East Asia, 5th–6th century AD
Glass. H 5.2 cm; D 10.4 cm
Excavated from the Lucky Phoenix
 Tomb (Sŏbong-ch'ong), Kyŏngju
National Museum of Korea, Seoul

This small bowl of cobalt-blue glass with a well-
formed foot-ring and a raised band around the
sides, is not a type known in Western Asia. It is
therefore possible that it was made in China,
where there seems to have been a limited pro-
duction of glass vessels, although nothing like
the quantity seen in the Roman world and in
Western Asia. For the shape of the bowl and the
proportions of the raised band, see the small
gold cup from the tomb of Li Jingxun, dated
c. AD 600 (Brinker and Goepper 1981, no. 50).
 YSP

Published Tokyo 1983, no. 41

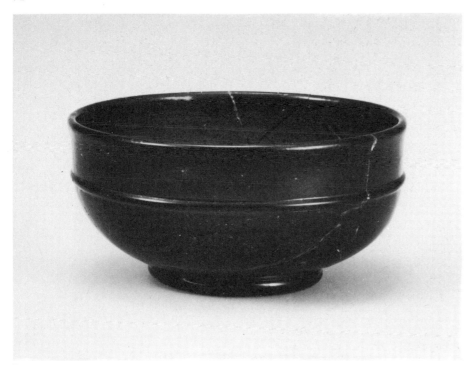

72

Ch'ŏnma-ch'ong, The Tomb of the Heavenly Horse

Tomb No.155, a 12m high tumulus in the vicinity of the Tomb of King Mich'u in Kyŏngju was excavated in 1973, in preparation for the excavation of the large twin tumulus Tomb No.98, Hwangnam daech'ong. It proved to be itself the burial of a king and one of the most important Silla tombs, with 140 funerary objects totalling over 11,000 component parts.

Many of the Silla royal tombs, unlike those of Koguryŏ and Paekche (with the single exception of the Tomb of King Munyŏng), survived intact, as they were constructed so as to be virtually impregnable. This type of tomb construction is called *chŏksŏk moggwak bun*, 'tomb with wooden chamber and piled stones'. First, the wooden burial chamber was built at ground level, then it was protected by layers of large pebbles sealed with clay to keep out water. The coffin was placed on a stone platform and contained a sword and the ornaments worn by the dead king, all of gold: a crown and pendants, ear-rings, rings and bracelets, and an elaborate girdle. The king had a pair of shoes in gilt bronze openwork, which were probably lined with silk to give a still richer effect. On the platform were other objects, including caps of gold and of birch-bark.

A separate chest contained pottery, metal vessels, lacquerware, and items of riding gear. The latter included four saddles and two pairs of saddle-flaps of birch-bark, each painted in white with a winged horse. The closest comparison for the winged horse is to be found in the Koguryŏ tomb Kangsŏ taemyo near P'yŏngyang, which has been dated to the early seventh century (Kim Won-yong 1968, p.62; Kim Kiung 1980, pls 51, 54), and which has the same type of floral scroll seen on the borders of the saddle-flaps. With the exception of the wall-paintings in Koguryŏ tombs, these are among the earliest examples of Korean painting. Unlike the Paekche tomb of King Munyŏng, there was no Chinese-style epitaph tablet to identify the buried king, and his tomb is accordingly named after these unique paintings on birch-bark, as Ch'ŏnma-ch'ong, the Tomb of the Heavenly Horse.

RW/YSP

Published Ch'ŏnmach'ong 1975.

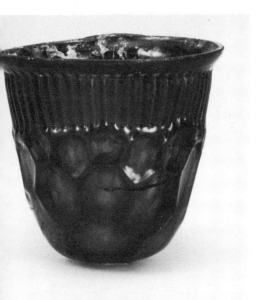

73

73 Glass cup

Syria, 4th–5th century AD
Blue glass. H 6.8 cm
From Ch'ŏnmach'ong, Tomb of the
 Heavenly Horse, Kyŏngju
Kyŏngju National Museum

This cup of cobalt-blue glass was blown in a
mould and there are very close parallels in Syrian
glass of the fourth and fifth centuries AD, show-
ing the same serrated pattern of vertical lines
under the rim and hexagons of varying size in
the lower part (cf. Mathesan 1980, no. 284).

<div align="right">YSP</div>

Published Ch'ŏnmach'ong 1975, pls 1–2;
Han Byong-sam 1978, pl. 58

74 Girdle pendant

Silla, 5th–7th century AD
Silver. L 48.0 cm
Excavated in 1975 from Ch'ŏnmach'ong,
 Tomb of the Heavenly Horse, Kyŏngju
Kyŏngju National Museum

This fine pendant, evidently the principal pen-
dant of a ceremonial girdle, was found in the
treasure chest in the Tomb of the Heavenly
Horse, and is distinct from the complete girdle of
gold worn by the deceased king and also found
in the tomb. The workmanship is extremely fine,
with large oblong plaques alternating with
smaller elements, all hinged to each other and
terminating in a single longer vertical piece,

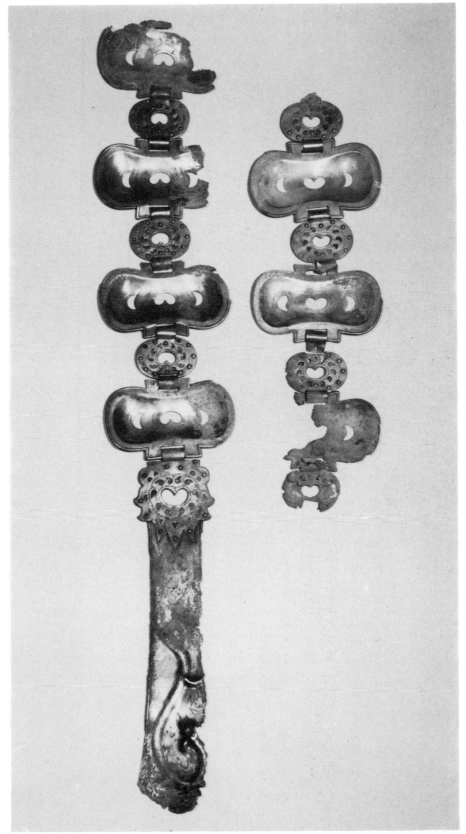

74

which is decorated in repoussé with a dragon.

The larger plaques have a swelling upper surface with three openings, and additional finely engraved decoration around them. In the smaller elements, which are of double thickness, the central opening is surrounded by a row of punched dots, and then by further pierced ornament in the top layer only, each opening having the shape of the familiar curved jades. These are arranged around the centre in the manner of a flower. It seems probable that the wings of the metallic beetle (*Chrysochroa fulgidissima*) or another material with a rich effect, were enclosed between the two layers so as to be visible through the openings, as may also have been the case with saddle ornaments (cf. no. 42). Finally, after another row of punched dots, the two layers were held together by rivets which stand out like pearls or drops on the surface. RW

Published Han Byong-sam 1978, pls 16–17; Tokyo 1983, no. 29

75 Cap ornament

Silla, 5th–7th century AD
Gold. H 23.0 cm; W 23.0 cm
From Ch'ŏnmach'ong, Tomb of the
 Heavenly Horse, Kyŏngju
Kyŏngju National Museum; Treasure no. 617

This and the following ornament were both made to fit in the cap which was also found in the Tomb of the Heavenly Horse. Although they are now spread out and appear like a pair of horns, when actually worn they were seen to best advantage from the side and not from the front. Each of them was bent down the centre, so that they rose upwards and back, just as the feathers worn by Korean officials did (see the wall-painting of a Korean envoy in the tomb of Prince Zhang Huai, who died in AD 684). Not only gold but also silver wing ornaments of this type have been found, for example in the south mound of Hwangnam daech'ong (Tokyo 1983, nos 16–17). In each case the undecorated part of the ornament was that inserted into the slot at the front of the cap (see no. 77). RW/YSP

Published San Francisco 1979, no. 22; Han Byong-sam 1978, pl. 11

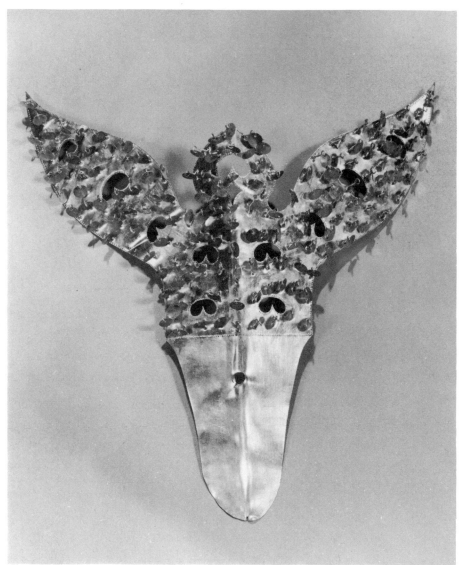

75

76 Cap ornament (colour ill.)

Silla, 5th–7th century AD
Gold. H 45.0 cm
From Ch'ŏnmach'ong, Tomb of the
 Heavenly Horse, Kyŏngju
Kyŏngju National Museum; Treasure no. 618

The whole surface of the two wings of this large ornament is decorated with complicated abstract scrolls in openwork, with additional rows of punched dots along the outlines. Above this openwork design, tiny round foils are fastened with gold wire, and almost completely cover it. Both shape and decoration serve to enhance its fantastic and ritual content. YSP

Published San Francisco 1979, no. 21;
Han Byong-sam 1978, pl. 11A

77 Cap (colour ill.)

Silla, 5th–7th century AD
Gold. H 16.0 cm
From Ch'ŏnmach'ong, Tomb of the
 Heavenly Horse, Kyŏngju
Kyŏngju National Museum;
 National Treasure no. 189

Silla graves have yielded a large number of different kinds of head-dress, made of various materials. Those worn by men in particular varied from silk embroidered with beads, to caps made of birch-bark, silver or gold. It was on caps of these precious materials that the wing ornaments like those just described were attached.

The long slanting edge of the cap was at the front, and the shorter, more vertical edge at the back (not the other way around as has sometimes been thought). Since the cap was very narrow from side to side, presumably fitting over a bun on the top of the head, it had to be held on by straps. The holes for attaching these can be seen in two places along the lower edge

of the cap. Surviving depictions of Koreans wearing similar caps, for instance the envoy represented in the wall-paintings of the tomb of Prince Zhang Huai, show a double strap passing either side of the ear (cf. Zhang Huai 1974, pl. 25).

The cap is made up of panels, each with a different openwork design. The panel at the front is set slightly forward of the main spine, to allow for the insertion of the wing-shaped ornament, whose gently rising curves would be echoed in the boundary between panels rising to a knob at the back of the cap. The silver cap of similar size from the south mound of Hwangnam daech'ong is plain except for the front panel, which is again set forward of the main spine, and decorated with openwork designs (cf. Ōsaka 1980, pl. 1). RW/YSP

Published Han Byong-sam 1978, pls 9–10;
San Francisco 1979, no. 20, pl. VII

78 Pair of gold ear-rings

Silla, 5th–7th century AD
Gold and gilt bronze. L 5.0 cm
From Ch'ŏnmach'ong, Tomb of the Heavenly
 Horse, Kyŏngju
Kyŏngju National Museum

This pair of ear-rings was apparently placed on top of the coffin. The main ring is of gilt bronze. With the surface studded with small stones, the fashion is similar to ear-rings from Kaya. RW

Published Ch'ŏnmach'ong 1974, p. 97;
San Francisco 1979, no. 28

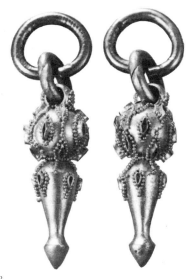

78

Hwangnam daech'ong,
The Great Tomb of Hwangnam-ni, Kyŏngju

The excavation of Tomb No. 98, the twin-tumulus tomb known as Hwangnam daech'ong, the Great Tomb of the Hwangnam area in Kyŏngju, was undertaken between 1973 and 1975. The whole site is very extensive, about 80 m from east to west and 120 m from north to south. The two graves are aligned from east to west; the south mound is about 22 m high, and the north mound 23 m.

According to the excavation report, the south mound was built first and on the same plan as the Tomb of the Heavenly Horse with two wooden chambers at ground level, one containing an unprecedented quantity of harness, weapons, pottery and even iron bars, the other containing the coffin and a treasure chest. The coffin was placed on a floor of gravel and gravel was packed all around it in the chamber, before this was closed. The chamber in its turn was covered by large pebbles and sealed with the earthen mound. The slightly larger northern mound had a single chamber which apparently had an overhanging wooden roof.

Although no identifiable remains were found in the larger north mound, several circumstances point to the burial being that of a queen. She was buried with a gold crown with pendants (no. 93), a girdle also with numerous pendants (no. 92), and a large quantity of costly ornaments. In the treasure chest was a second girdle, of silver, inscribed 'Girdle for the Lady'. There was no sword accompanying the burial, as there was in the case of the man, aged between fifty and sixty, who was buried in the south mound. His girdle was also of gold, but with fewer pendants (no. 79), and his crown was of gilt bronze, and not of gold, so it is possible that, although of royal birth, he was not in fact a king.

Korean archaeologists believe that the south mound may be the tomb of King Soji, who reigned from AD 478 to 500, and the north mound that of his queen. In most publications the tomb and its wealth of contents are assigned to the late fifth or early sixth centuries. However, there seem to have been few opportunities at this time for Silla to acquire objects, such as the glass vessels, which are clearly of Chinese or Western origin. It was not until the reign of King Chinhŭng (AD 540–76) that direct contact with China became possible for Silla (Yi Kibaek 1976, p. 59). Again, as Kim Won-yong has pointed out ('The Unicorn, the Phoenix and the Flying Horse', leaflet accompanying the San Francisco exhibition, 1979), there were no Queens of Silla during the fifth and sixth centuries. It was not until the death of King Chinp'yŏng (reigned AD 579–632) that, as there were no male descendants in the *sŏnggol* or 'sacred bone' lineage from which alone the kings of Silla could descend, first his daughter Queen Sŏndŏk (reigned AD 632–47) and then Queen Chindŏk (reigned AD 647–54) ascended the throne. It was the time of Silla's greatest activity. Under Queen Sŏndŏk, the Ch'ŏmsŏngdae observatory and the great nine-storey pagoda of the Hwangryong-sa were built. Both queens sent envoys to China, and Queen Chindŏk allied with Tang to invade Koguryŏ. She received envoys and a title from Emperor Taizong, adopted a Chinese reign title, and from AD 649 the court wore Chinese dress. The History of the Three Kingdoms, *Samguk sagi*, records that Queen Sŏndŏk was buried at Nangsan, and her tomb there is still known today. Queen Chindŏk, who died in AD 654, the last of the *sŏnggol* lineage, was buried in Saryangbu, now Kyŏngju, and the Tang emperor Gaozong sent envoys with three hundred bolts of silk to her funeral (*Samguk sagi*, vol. 5, *Silla bongi* 5).

It is tempting to suggest that the sumptuous burial of a great queen in the north mound of Hwangnam daech'ong might be that of Queen Chindŏk, who had

regular communications with China, and whose reign was prosperous enough to support the construction of such a tomb. As her father was an uncle of King Chinp'yŏng, but was not himself a king, it is also possible that it might be he who was buried, some years before the death of his daughter, in the smaller south mound (Pak Young-sook 1984).

The identification of the occupants of the Hwangnam daech'ong must remain open for the present, however, although none of the Silla tombs before unification can be dated exactly, it does seem likely that the custom of grave furnishings with elaborate goldwork may have continued in the first half of the seventh century. The *sarira* finial (no. 115), which is generally accepted as being from Unified Silla, shows decoration and a metalworking technique close to the gold crowns and ornaments of Silla as late as the eighth century.

In this catalogue we have accordingly dated goldwork from Silla in the period from the fifth to the seventh century, to take account both of this possibility and of the orthodox dating of Korean archaeologists, who prefer a date from the fifth to the sixth century only. Further studies of the archaeological material and the historical record will, it is hoped, help to resolve the important questions of identification and dating posed by the Silla royal tombs in Kyŏngju. RW/YSP

Published Hwangnam dae-ch'ong 1975–6

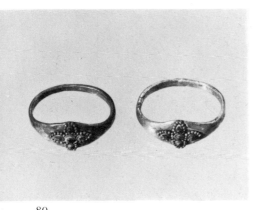

80

79 Girdle with pendants *(colour ill.)*

Silla, 5th–7th century AD
Gold and jade. L 115.2 cm
Hwangnam daech'ong, South Mound, 1974
Kyŏngju National Museum: Treasure no. 629

The girdles recovered from the two burial chambers of Hwangnam daech'ong are of particular archaeological importance since they were undisturbed. This girdle, worn with the main pendant hanging in front of the left leg, consists of thirty-four rectangular gold plaques, which must originally have been fastened to a backing of leather or cloth. It would seem possible that the smaller number of pendants (compared to no. 92) reflects a difference in rank between the occupants of the south mound and the larger and later north mound. JHW/RW

Published Tokyo 1983, no. 18

80 Two finger-rings

Silla, 5th–7th century AD (?)
Gold and glass. D 2.1–2.3 cm
Hwangnam daech'ong, South Mound, 1974
Kyŏngju National Museum

Finger-rings were usually plain bands of gold or silver (see also no. 67), and only occasionally were decorated like these, with granulation as a setting for small pieces of blue glass. The discovery of thousands of blue glass beads in some Kyŏngju tombs suggests that these were locally made. JHW

81 Necklace

Silla, 5th–7th century AD
Gold. L 33.2 cm
Hwangnam daech'ong, South Mound, 1974
Kyŏngju National Museum;
 National Treasure no. 194

This necklace, worn by the man buried in the south mound, is the simplest and most elegant to have been discovered so far. The curved pendant is unique in being made of gold, rather than jade. JHW

82 Glass ewer (colour ill.)

Syria, 4th–5th century AD
Glass, with gold wire repair. H 25.0 cm
Hwangnam daech'ong, South Mound, 1974
Kyŏngju National Museum;
 National Treasure no. 193

This glass ewer, when found, was in tiny fragments. It had in fact been broken and repaired even before it was placed in the tomb, as shown by the gold wire repair to the handle, which shows the value set on it by its owner.

In both form and the weathering of the glass, this ewer matches examples from Syria of the fourth to fifth centuries AD (*Glass at the Fitzwilliam Museum* 1978, pl. 108c). The trailed decoration in cobalt-blue around the neck and just under the lip is a common feature of such glass vessels. In East Asia the shape of the curved mouth came to resemble a phoenix head, and the form was imitated in Tang dynasty pottery and metal-work (Medley 1972, pls 1–4). YSP

Published Tokyo 1983, no. 28

83 Stem-cup

Probably from China, 6th century AD
Brown and white glass. H 7.0 cm; D 10.5 cm
Hwangnam daech'ong, North Mound, 1974
Kyŏngju National Museum; Treasure no. 624

In both form and technique this stem-cup seems likely to have been made in China, rather than in Western Asia where no such pieces are known. There are parallels for the shape in Tang silverware (cf. Gyllensvärd 1971, no. 52), and marbling of this kind was also common in the Tang dynasty. YSP

Published Kyōto 1976, no. 30

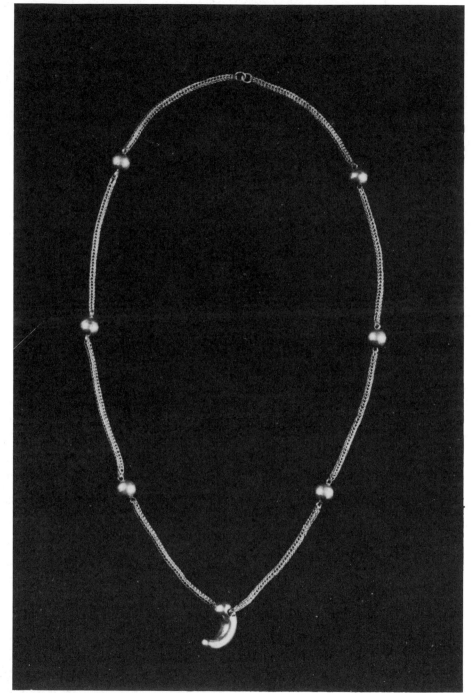

81

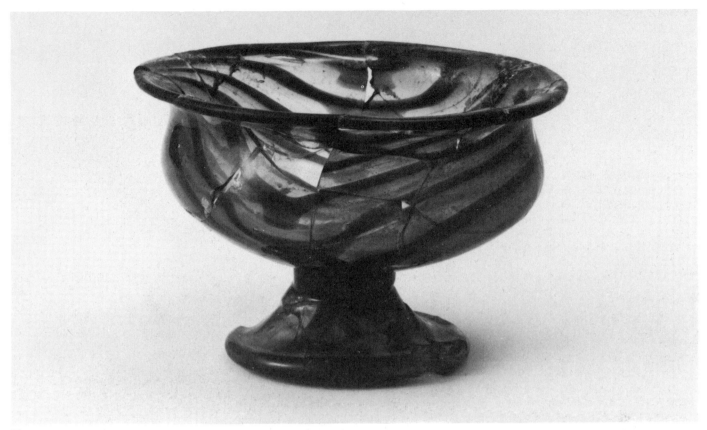

83

84 Faceted cup

Possibly from Iran, 4th–6th century AD
Glass. H 7.0 cm; D 10.5 cm
Hwangnam daech'ong, North Mound, 1974
Kyŏngju National Museum

This cup with the outer surface cut in shallow
concave circular facets is of a type well known
from Iran in the fourth to sixth centuries AD.
Two similar bowls are in Japanese collections:
one is in the famous imperial repository, the
Shōsōin, and the other was excavated from the
tomb of the emperor Ankan (reigned AD 531–5;
cf. Harada 1951). Both are of the classic Sasanian
type with incurved rim and perfectly circular
facets. The cup shown here is alone in having
an everted rim, while the facets are placed with
less regularity and hence tend to overlap and
assume a hexagonal shape. YSP

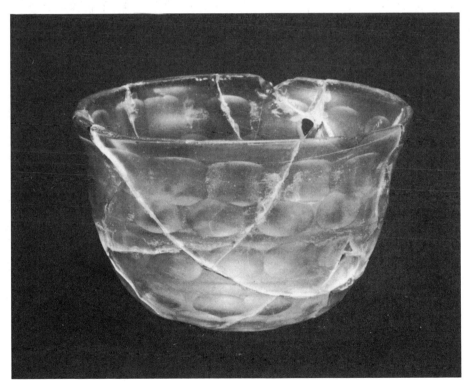

84

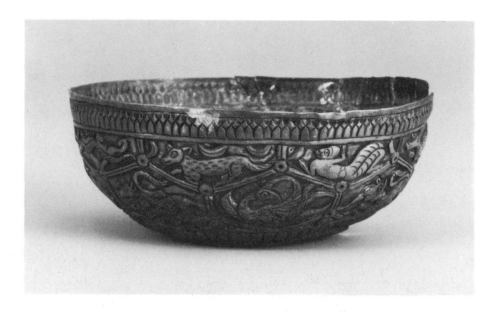

85 Cup with animal designs

Silla, 5th–6th century AD
Silver with repoussé designs. H 3.5 cm;
 D 7.0 cm
Hwangnam daech'ong, North Mound, 1974
Kyŏngju National Museum; Treasure no. 627

This small cup without a foot-ring or pedestal is decorated all over with a powerful design. The sides are divided by double lines into hexagons, with a small circle at each corner, and each filled with an animal or bird. Both the hexagon motif and the animal or bird it encloses can be found as an ornament on the hilt of the sword of King Munyŏng (Han Byong-sam 1978, pl. 108). The style of the birds with their somewhat startled look is derived from China in the Northern Wei period, eg. at Yun'gang. RW

Published San Francisco 1979, no. 18

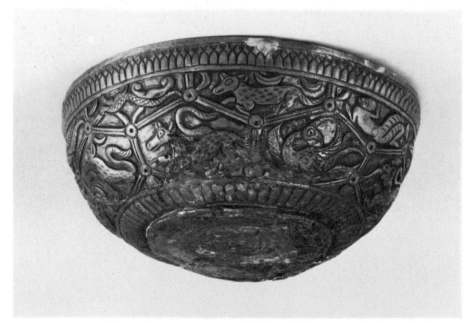

86 Pair of cups on openwork stems

Silla, 5th–7th century AD
Gold. H 9.0 cm, 10.0 cm; D 9.5 cm, 10.0 cm
Hwangnam daech'ong, North Mound, 1974
Kyŏngju National Museum; Treasure no. 626

These cups have the typical Silla form, with a pierced pedestal, also found in pottery. The spangles attached around the rim emphasise their ritual purpose. JHW

Published San Francisco 1979, no. 16

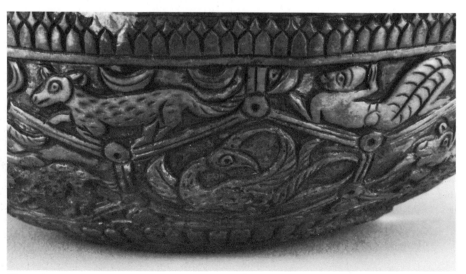

85

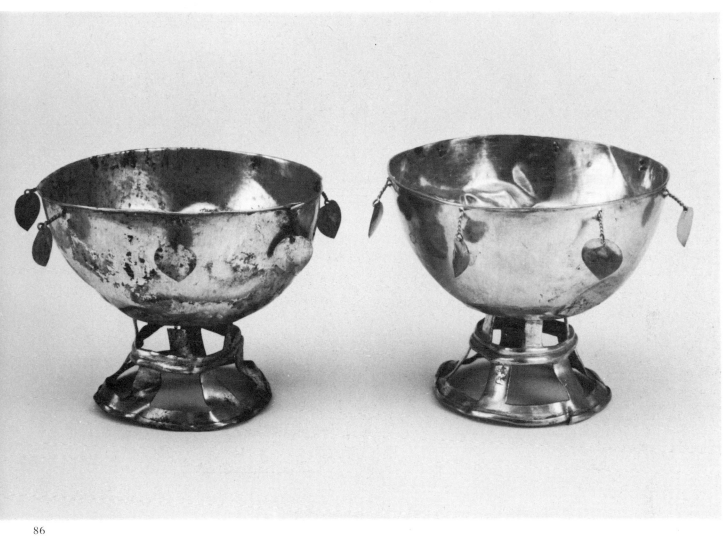

86

87 Bracelet

Silla, 5th–7th century AD
Gold, mounted with blue and turquoise stones.
 D 7.2 cm; W 2.1 cm
Hwangnam daech'ong, North Mound, 1974
Kyŏngju National Museum; Treasure no. 623

When found, this bracelet, the only one of its
kind to have been found in Korea, was on the
left arm of the lady in the north mound. She also
wore five gold bracelets of the more usual solid
ring type (cf. no. 66). JHW

Published San Francisco 1979, no. 15;
Han Byong-sam 1978, pl. 37;
Tokyo 1983, no. 11

87

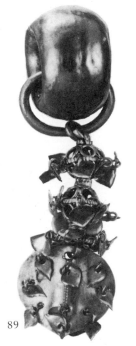
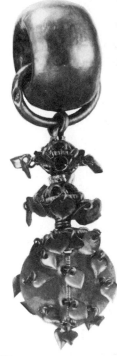

88

89

88 Pair of ear-rings

Silla, 5th–7th century AD
Gold. L 4.6 cm
Hwangnam daech'ong, North Mound, 1974
Kyŏngju National Museum

Published San Francisco 1979, no. 14

89 Pair of ear-rings

Silla, 5th–7th century AD
Gold. L 9.6 cm
Hwangnam daech'ong, North Mound, 1974
Kyŏngju National Museum

Pendants such as these, of which numbers were
found in pairs inside the coffin, may simply
represent the personal jewellery of the deceased.
RW

90 Pair of pendants

Silla, 5th–7th century AD
Gold. L 19.5 cm
Hwangnam daech'ong, North Mound, 1974
Kyŏngju National Museum

Published Choi Sunu 1979, pl. 21

91 Pair of pendants

Silla, 5th–7th century AD
Gold. L 24.6 cm
Hwangnam daech'ong, North Mound, 1974
Kyŏngju National Museum

These are among the most beautiful and delicate
of Korean gold pendants, showing the elegance
of Silla style. Both the long pointed leaf shapes,
and the fine chains in combination with tiny
spangles, appear quite unusual. RW

Published Choi Sunu 1979, pl. 20

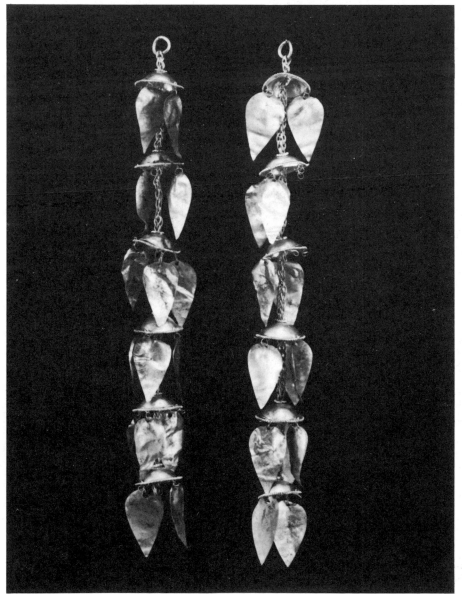

90

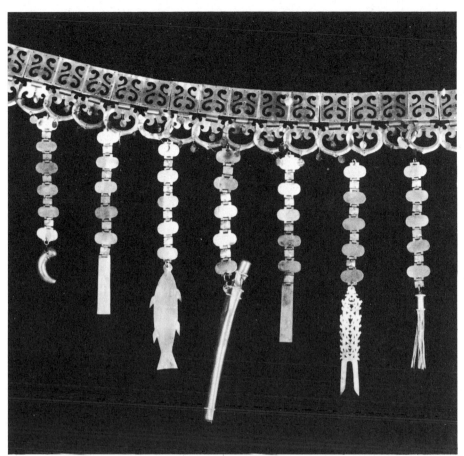

92

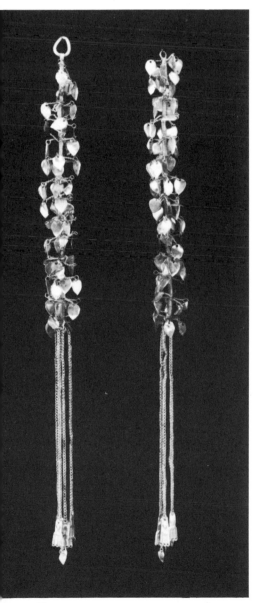

92 Girdle with pendants *(colour ill.)*

Silla, 5th–7th century AD
Gold and jade. L 120.0 cm;
 (longest pendant) 77.5 cm
Hwangnam daech'ong, North Mound,
 Kyŏngju, 1974
National Museum of Korea, Seoul;
 National Treasure no.192

This girdle is arranged according to the same fashion as those from other sites, such as the Gold Crown Tomb, Gold Bell Tomb, Lucky Phoenix Tomb and the Tomb of the Heavenly Horse (Han Byong-sam 1978, pls 12–15). The main features of these Korean girdles, which according to Kim Won-yong came to Silla from China by way of Paekche, are the plaques forming the belt itself, and the pendants hanging from them, of which one is much larger and longer than the others. The belt plaques, which were probably originally sewn to a backing of leather or fabric, are square with pierced designs. Each is hinged to a buckle-shaped loop. Two small gold spangles are fastened to each loop; on some belt girdles these are much more numerous and almost cover the belt plaques. A thong and buckle, or sometimes two buckles, are attached to the ends of the belt.

A series of pendants hang at regular intervals along the belt, thirteen in all on this girdle. Each of them consists of a series of ovoid plaques joined together with small square ones. One pendant on every girdle is much larger and

longer than the rest. In this case it is abundantly spangled, and lay in the tomb in front of the right leg. Each of the smaller pendants ends in a finial, which may be flat or in the round. Those seen here include curved jade and gold pieces, a fish, a small knife in a curved sheath, another highly stylised fish in openwork, and a tassel of gold wire. Several if not all of these, as well as others, can be found in almost identical form on other girdles, for example, the one from the Gold Crown Tomb (Kim and Kim 1966, pl.92).

The custom of wearing belts with small implements attached seems to have its origins in the northern nomadic tradition. Tomb engravings of the Tang dynasty show attendants wearing narrow leather belts from which hang pendants of varying length, some of them with purses or other utensils attached (cf. Seian Hirin 1966, pls 203, 205). Kim Chewon and Kim Won-yong have explained how the objects to be worn as girdle pendants were regulated in the chapter on Chariots and Uniforms in the Tang History; according to the Song History, the fish tally or *yufu* was 'a Tang dynasty invention which displaced the earlier tiger tally [as] a kind of credential or warrant for military personnel' (Kim and Kim, p.188). However, it is clear from the elegant refinement of the Korean girdles that they are from a long tradition with its origins in the Han dynasty or earlier. RW/YSP

Published San Francisco 1979, no.13, pl.IV;
Han Byong-sam 1978, pl.15

91

93 Crown and pendants *(colour ill.)*

Silla, 5th–7th century AD
Gold and jade. H 27.5 cm;
 (longest pendants) 30.3 cm
Hwangnam daech'ong, North Mound,
 Kyŏngju, 1974
Kyŏngju National Museum;
 National Treasure no. 191

The first of the impressive gold crowns to be discovered was that from the Gold Crown Tomb, found in 1921. The discovery was all the more surprising since such crowns were never mentioned in historical records. It is possible that they were only for ritual or funerary use, as suggested by the small spangles attached to them in large numbers (such spangles have even been found attached to the soles of gilt bronze shoes, making it clear that they were for spirit use only).

This crown is made of cut sheet gold in the same way as the one from the Gold Crown Tomb and others that have been found. The circlet supports three upright standards each with three pairs of right-angled branches, and two gently curving uprights of antler form with alternate branches, placed to the rear. Six pendants hang in front from thick, hollow gold rings, and numerous curved jades are attached to the ends of the pendants, around the circlet, and on the branches. The edges of all the elements are bordered with rows of punched dots.

Similar crowns have been found in the Lucky Phoenix Tomb, Gold Bell Tomb, and the Tomb of the Heavenly Horse. Some have four pairs of branches on the standards, and the number of pendants also varies. Essentially, however, they differ only in elaboration from simpler crowns such as the one from Kaya (no. 43), and they must also be descended from more realistic crown types in the northern tradition. RW

Published San Francisco 1979, no. 12;
Han Byong-sam 1978, pl. 5

94 Seated figure of Maitreya

Silla, 6th century AD
Gilt bronze. H 15.4 cm
Found in 1937 at Andong, North Kyŏngsang province
National Museum of Korea, Seoul

An indication of the popularity of the belief in the Bodhisattva Maitreya (Korean Mirŭk-bosal) in sixth-century Korea is the relatively large number of sculptures representing this future Buddha, the last of our age. The posture is characteristic, and means that Maitreya is sitting in his paradise, Tushita (Korean Tosolch'ŏn), in preparation for future birth in our world for the salvation of living things. The correct term for the posture is therefore 'sitting pensively with legs half-crossed' (Korean *banga sayusang*).

The Bodhisattva sits on a pedestal which is hidden by the folds of his robe, the left leg hanging down and resting on a small pedestal. The right foot is placed on the left thigh near the knee and held by the left hand. The right elbow is supported by the right knee, and the fingers lightly touch the right cheek, as if gently supporting the head, which is inclined slightly forwards.

The figure is heavily patinated and encrusted. The upper part of the body is naked. The neck is encircled only by a broad band. On the head is a low crown, from which, at each side, the hair hangs down over the shoulders. The folds of the dhoti are still modelled in the round to a modest extent; they run horizontally under the right knee, and fall vertically over the block-like pedestal to form a rising wavy edge. On the back of the head is a peg on which a nimbus was probably attached.

This figure was found at Andong, which lies on an old route between Silla and Koguryŏ, though still in Silla territory, and which served as an important stage in the introduction of Buddhism into Silla from the north. We may, therefore, classify this small sculpture among the early Silla works. RG

Published San Francisco 1979, no. 74;
Choi Sunu 1979, pl. 217;
Hwang Su-yong 1983, pl. 34

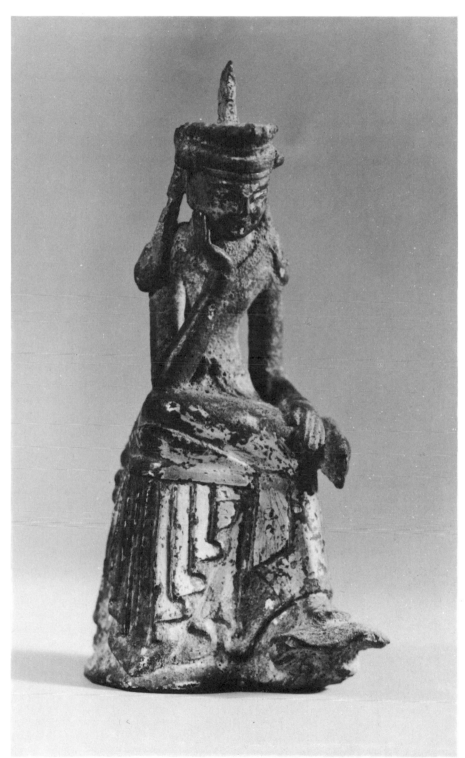

94

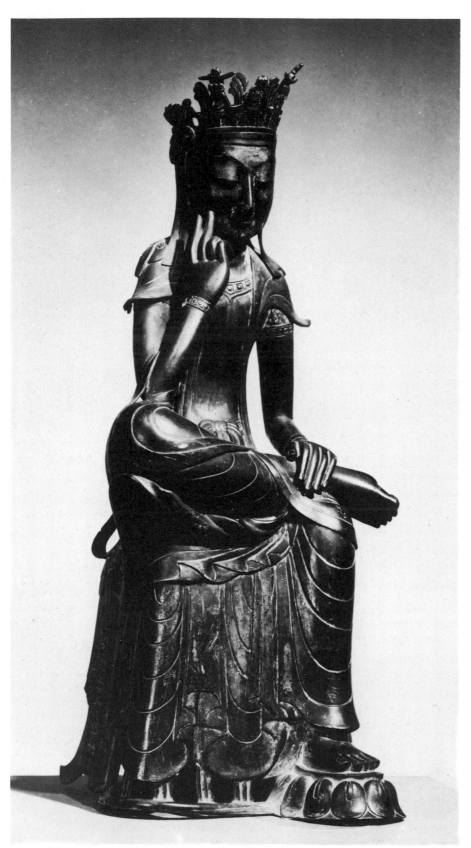

96

95 Seated figure of Maitreya
(colour ill.)

Silla, 6th–7th century AD
Bronze, formerly gilt. H 27.5 cm
Excavated from Yusan-ri, Yangsan,
 South Kyŏngsang province
National Museum of Korea, Seoul

The Bodhisattva sits in the posture typical of
Maitreya. He wears a crown with three large
flower medallions (*sammyŏn-hwagwan*) in front
and at the sides. The hair falling down to the
shoulders has been broken off, but remnants are
discernible on the shoulders. The upper part of
the body and the arms are comparatively long
and, like the face, softly modelled. The upper
part of the body is unclothed, and there are
plain bracelets on the wrists and upper arms.
Around the pedestal, which is of round cross-
section, the dhoti falls in folds which are modelled
in the round. This is especially true of the hori-
zontal folds directly under the right lower leg.
This figure, which has acquired a strong green
patination from being buried for so long, shows
an affinity, especially in the lower folds, to a
large stone fragment discovered at Bŏnghwa in
North Kyŏngsang. RG

Published Hwang Su-yong 1983,
pl. 38 (reversed); Tokyo 1983, no.155

96 Seated figure of Maitreya

Three Kingdoms, early 7th century AD
Gilt bronze. H 83.2 cm
National Museum of Korea, Seoul;
 National Treasure no. 78

This large bronze figure is one of the master-
pieces of Korean sculpture, indeed of Far Eastern
sculpture as a whole. As such it belongs, together
with the similarly large but stylistically quite
different Maitreya, also in the National Museum,
which was seen in Europe in the great exhibition
of Korean art in 1961. It has been known since
1912, and according to an unconfirmed report it
was discovered at Andong, in Old Silla territory.
In general structure this Maitreya corresponds
to the type common in Korea from the sixth
century AD, but it has stylistic and iconographic
peculiarities. The Maitreya sits on a round stool
which is made of a lattice-like structure of small
bars and is largely covered by his robe. The left
foot rests on a well-modelled lotus with down-
turned petals. The modelling of the body is soft,
with gentle contours, and the face has 'Korean'
features: the nose is long and high, the eyes
slanted, with high upper lids under curved brows.
The mouth is small but distinctly shaped, and
there is an obvious dimple in the chin. The
crown (*pokwan*) is richly decorated with orna-
ments that have been interpreted as pagodas
symbolising the Maitreya, as well as the sun and

the moon. Recently this type of crown has come to be called the 'three mountain peak crown adorned with sun and moon' (*ilwolshik-samsan-kwan*). It can be traced back via China to Persian prototypes.

The upper part of the body is bare and adorned with neck- and armbands. The gently bent fingers seem to have no joints, and the feet are well modelled. Ribbons and curls fall onto the shoulders, which are covered by a shawl (*ch'ŏnŭi*). This projects slightly like wings, but then hangs down, clinging to the body, curves over the knees and finally sweeps backwards in small folds. The folds of the skirt are not sculptured, but are simply represented by incised lines. This feature links this Maitreya stylistically with the famous wooden Kannon, the Kudara (= Paekche) Kannon, whose name suggests its association with the Korean kingdom. However, there are also affinities to the stone sculptures of Silla at Songhwa-san near Kyŏngju. Viewed as a whole, the style of this Maitreya derives from the Chinese Northern and Eastern Wei period, although the Koreanisation is here fairly well advanced.

The figure is a technical masterpiece, cast by the lost-wax technique. X-ray investigations have shown that the casting core, consisting of baked sand, still extends from the head to the chest, and that the head and body are joined by metal pins in the core, and that there are metal reinforcing pins also in the head and along both arms. RG

Published Han and Koh 1963; Kim and Lee 1974, pls 6–7; Nara 1978, no. 49; Kang Woo-bang 1982; Tokyo 1983, no. 145

97 Standing figure of Avalokiteśvara *(colour ill.)*

Silla, early 7th century AD
Gilt bronze. H 20.7 cm
Excavated at Samyang-dong, Seoul, in 1967
National Museum of Korea, Seoul;
 National Treasure no. 127

Near where this figure was found, in the northern part of Seoul, traces of an old temple have also been discovered; these consisted of tile fragments and stone bases for wooden pillars. The site lies in the border area where the former kingdoms of Koguryŏ, Paekche and Silla met and has consequently changed hands several times during the course of history. For this reason the figure has been attributed by some Korean specialists to Silla (Hwang Su-yong), but by others to the kingdom of Paekche (Kim Won-yong).

The figure stands on a simple lotus pedestal with down-turned petals. It displays several archaic features: the feet are crudely modelled and the head, with downcast eyes, is dispro-

portionately large. The body, with the arms close to the sides, is almost cylindrical. Seen from the side, it still seems surprisingly flat, only the head and the hands being fully rounded. On the front element of the three-pointed crown (*samsan-pokwan*) one may discern the figure of a seated Buddha (*hwabul*), which, together with the flask held in the right hand, identifies the Bodhisattva as Avalokiteśvara (Kwanseŭm-bosal). The left hand is slightly raised, palm outwards, the thumb and the index finger spread as if holding something, probably a lotus which is now lost. The shawl forms two separate U-shaped curves, one above the other, in front of the body. A notable feature is the simple neck-band with pendants.

As a whole, the figure is stylistically related to other examples from the Silla area and is strongly reminiscent of the Chinese style of the Sui period (AD 581–618). RG

Published Hwang Su-yong 1968; Matsubara 1972; Kim and Lee 1974, pls 8–9; Choi Sunu 1979, pl. 226; San Francisco 1979, no. 77

98 Standing figure of Avalokiteśvara *(colour ill.)*

Silla, mid-7th century AD
Gilt bronze. H 34.0 cm
Excavated at Sonsan,
 North Kyŏngsang province, in 1967
National Museum of Korea, Seoul;
 National Treasure no. 183

This slim but fully sculptured figure stands with slightly bent knees on a lotus pedestal with petals arching downwards over an octagonal base. Parts of the shawl and the left thumb are missing.

In his raised right hand the Bodhisattva holds a drop-like jewel. The left hand hangs down and perhaps once held a flask. The face has a rounded outline. At the front of the richly ornamented diadem is a *hwabul*, a small seated figure of Amitābha, the iconographic sign of Avalokiteśvara. Ornamental pendants with round plaquettes at the intersections lie on the breast and in front of the body, crossing at waist level. The folds of the dhoti are represented simply but naturalistically. The shawl is laid across the arms, but the free-hanging portions are lost. Locks of hair fall onto the shoulders. Altogether the figure is reminiscent of the Chinese style of the Sui or the early Tang dynasty. A comparable figure of a Bodhisattva from the Paekche area was discovered at Ŭidang-myŏn, Kongju. RG

Published San Francisco 1979, no. 79, pl. XII; Choi Sunu 1979, pl. 228; Hwang Su-yong 1983, pl. 29; Tokyo 1983, no. 148

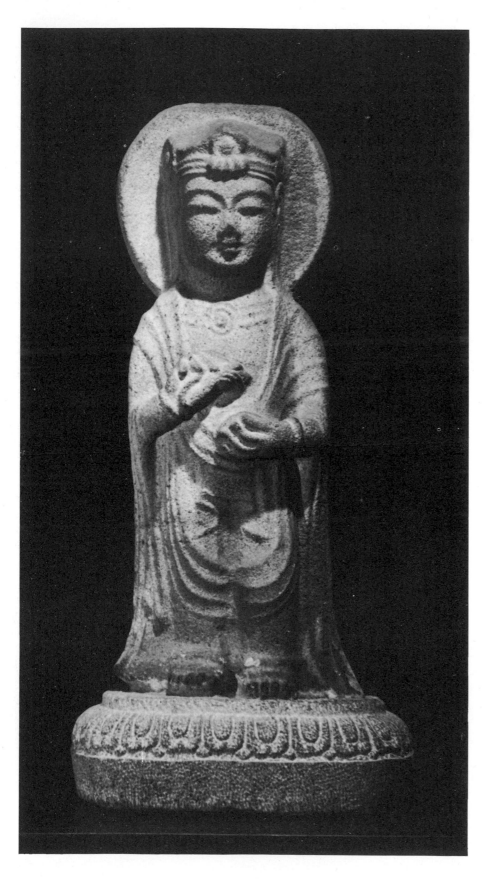

99 Standing Bodhisattva

Silla, mid-7th century AD
Granite. H 90.8 cm
From Samhwa-ryŏng, Kyŏngju,
 North Kyŏngsang province
Kyŏngju National Museum

This Bodhisattva is the left-hand figure of a triad which originally stood in a chamber hewn out of the natural rock on Samhwa-ryŏng, the northern peak of the Namsan massif to the south of Kyŏngju. The central Buddha is represented seated with legs pendant and has therefore been indentified both as Amitābha and as Maitreya. Because of this uncertainty it is not possible to identify the accompanying Bodhisattvas iconographically with any confidence. Possibly the triad is identical with a group which, according to an ancient source, was carved in the rock chapel in AD 644.

Like the two others in the triad, this figure seems strangely lacking in proportion, the lower part of the body being excessively short. The block-like impression made by the whole figure with its lack of detail is due to the hardness and brittleness of the granite, which does not allow fine modelling. A very similar effect was produced by the use of granite in south Indian sculpture during the late Middle Ages.

The figure stands erect, both hands raised in front of the breast. The large head is backed by a plain circular nimbus. The folds of the shawl and the dhoti are only slightly raised. Round the neck is a band with a rosette in the middle.

The sculpture is an early example of the extensive activity of Buddhist sculptors, who were soon to be carving Buddhist images in relief and in the round from the natural rock found throughout the Namsan massif. Stylistically the Samhwa-ryŏng triad may be linked with Chinese stone sculpture of the Sui dynasty, but it already evinces unmistakable Korean features in its tendency to simplify and stylise folds in the robe, for example in the spiral fold on the right knee of the central Buddha figure (Hwang Su-yong 1983, pl. 103). This tendency was to establish itself clearly in the sculpture of Unified Silla. RG

Published Hwang Su-yong 1974, pl. 38;
Kim and Lee 1974, pl. 49; San Francisco 1979,
no. 80; Choi Sunu 1979, pl. 231;
Hwang Su-yong 1983, pl. 104

3 Unified Silla
(AD 668–935)

Silla, by alliance with Tang China, expanded to unify the whole peninsula by AD 668, though it became necessary for her to compete with Tang for the possession of Paekche, and much of the former territory of Koguryŏ beyond the Taedong river was lost. In this area the descendants of Koguryŏ established the state of Palhae which continued to exist alongside Unified Silla until AD 926. Nevertheless, Silla's unification of the rest of the peninsula was extremely important, as it laid the foundations of the homogeneous culture and society of Korea that were to endure until the present day (Yi Ki-baek 1976, pp. 86ff). Buddhism was the source of ideological support for the state, while Confucianism concerned itself with the practical aspects of government, and with education through the establishment of Confucian schools and universities. The process of adoption of Chinese institutions and administrative systems, already begun in the seventh century, continued, and the culture of Unified Silla shared in the international character of the Tang dynasty.

The capital city Kyŏngju rivalled in splendour the Tang capital of Chang'an on which it was modelled. Impressive remains such as the site of the Hwangryong-sa temple, the Ch'ŏmsŏngdae observatory tower, the pagoda of the former Punhwang-sa temple, and the site of the detached palace recently excavated at Anap-chi (Anap Pond), testify to the magnificence of the ancient capital. Some of these monuments were built under Silla before the unification, but some like Anap-chi were entirely new and others were rebuilt or enlarged on a magnificent scale. The *Samguk yusa* (chapter 5, section 7) records that the minister Kim Taesŏng (AD 700–74) built two of the great monuments of the capital; both were completed by the state after his death. In AD 751 he began the rebuilding of Pulguk-sa, the Temple of the Buddha Land, which had been founded in AD 553. It was actually built rising out of a lotus lake, on the plan of the palaces seen in contemporary paintings of the Buddhist Pure Land or Western Paradise of Amitābha Buddha.

The second of Kim Taesŏng's great monuments was the granite temple of Sŏkkuram, on the heights of Mt T'oham, near Kyŏngju, begun in AD 751 and completed in AD 774 after his death. As a complement to Pulguk-sa, which was dedicated to the present generation, the Sŏkkuram shrine was intended to honour those who had been his parents in previous lives. The plan of the temple recalls ancient Indian cave-temples, with a rectangular ante-chamber leading to a circular domed main chamber. The main figure is a huge seated Buddha, an image of serenity and power, which is one of the masterpieces of all Buddhist art. All the other divinities, Bodhisattvas, disciples, guardian kings and devas are in high relief on the granite panels of the walls or in deep niches, forty-one figures in all.

The influence of Buddhism was felt not only in such great monuments, but in all the arts, under the patronage of the aristocracy. The elegant taste and international style of the time can be seen in the earliest and sole surviving fragment of Silla Buddhist painting, an illuminated fragment in gold and silver on purple paper of the Hwaŏm-gyŏng (Avataṁsaka sutra), dated AD 754–5, now in the Hoam Art Museum. In the Śākyamuni pagoda of the Pulguk-sa a woodblock-printed sutra in twelve sheets, dating from the early eighth century, has recently been found, predating by more than a century the famous Diamond Sutra of AD 868 from Dunhuang, now in the British Library.

Learned Buddhist monks from Silla travelled extensively to China and as far as India. Among them Wŏn'gwang, Chajang, and Ŭisang all brought new doctrines

from China, and left other writings (Lee 1968). The most famous account, *Wang-o ch'ŏnch'uk kukjŏn*, 'Travels to Five Indian Countries' written by the monk Hyech'o (AD 704–87), was discovered early this century in the Dunhuang cave-temples in China, and is now in the Pelliot collection in the Bibliothèque Nationale in Paris. The most eminent of all Silla monks, Wonhyo (AD 617–86), succeeded in combining the doctrines of different Buddhist schools to establish a uniquely Korean form of Buddhism and, although he never travelled, was greatly respected in both China and Japan.

Contemporary evidence such as the diary of the Japanese priest Ennin, who spent several years in China in the mid-ninth century, shows that in addition to the Korean monks who came in considerable numbers to China at the time, control of the sea routes between Korea and China was in Korean hands. Foreign merchants also came to Korea (Yi Yong-bom 1969, 1973). However, the concentration of luxury in the capital and the entertainment of large foreign embassies inevitably drained state finances and weakened its control of the provinces. In the end powerful forces emerged in other parts of Korea, and in AD 935 Wang Kŏn, the leader of one of these, received the submission of the last king of Silla and confirmed the rule of Koryŏ, which he had already established in AD 918.

RW/YSP

Anap-chi

The excavations undertaken at Anap-chi in Kyŏngju are among the most important in Korea, both in the number of finds and for the evidence that these have brought of the achievements of Korean craftsmanship and art in the Unified Silla period. According to the History of the Three Kingdoms, King Munmu, in the second month of the fourteenth year of his reign (AD 674), soon after his unification of Korea (AD 668), 'dug a pond and built a mountain in the palace grounds. Flowers and plants were planted and rare birds and strange animals were raised.' (*Samguk sagi, Silla bongi, 7.*)

King Munmu may have had in mind Chinese palace parks, known since the Han dynasty and much in vogue in Tang China. The name of the detached palace referred to was Imhae-jŏn. It seems likely that the pond acquired its present name, Anap-chi, 'Pond of Wild Geese and Ducks', after the Unified Silla period, when the place had become deserted.

Anap-chi, and four buildings of the Imhae-jŏn on its western side, was excavated in 1975–6. The finds, over 15,000 in all, include Buddhist images and ornaments, and architectural tiles with varied decorative patterns. Other finds were for daily use, such as pottery and metal vessels, and fragments of lacquer. Many of the finds are especially valuable since they cast new light on objects of hitherto unknown origin preserved in the Shōsōin, the famous mid-eighth century imperial storehouse in Nara, Japan.

RW/YSP

100a

100b

100c

101

100a-c Three tile-ends with *kalaviṅka*, confronting ducks, and lion

Unified Silla, 7th–8th century AD
Earthenware. D 14.6cm, 13.7cm, 15.8cm
Excavated from Anap-chi, Kyŏngju,
 North Kyŏngsang province
National Museum of Korea, Seoul

The excavation of Anap-chi produced 5,798 tiles of seventeen kinds, with over five hundred different designs, the largest quantity ever found in Korea. The motifs on them are thus much more elaborate and varied than the tiles from Koguryŏ and Paekche (nos 18, 21). Some of them reflect the influence of Pure Land Buddhism in their choice of motifs: the *kalaviṅka* (no. 100a) is a human-headed bird which appears among other birds in Kumarajiva's translation of the Sanskrit *Sukhāvati-vyūha*, in the description of the Western Paradise (Whitfield 1982, p. 306). The motif of confronting birds (no. 100b) is a frequent one in Tang textiles, and can be seen in one of the silk banners of the eighth century AD from Dunhuang (Whitfield 1983, pls 30–3). The seated lion (no. 100c) is a new motif, less easily adapted to the constraints of the circular tile-end. RW

101 Diagonal ridge-end tile with demon-mask *(kwimyŏn)*

Unified Silla, 7th–8th century AD
Earthenware with green glaze. H 39.0cm;
 W 29.2cm
Excavated from Anap-chi, Kyŏngju, 1975–6
Kyŏngju National Museum

A variety of special tiles were needed at the corners of the roof, where a heavy diagonal descends from the main ridge: this tile covered the end of the diagonal and served to articulate the transition to a final smaller section reaching to the outermost corner of the roof. A demon-mask thus would look out from each corner of the building to protect it. The whole tile gives the dimension of the diagonal ridge, and the smaller semicircular cut-out that of its final continuation (cf. no. 102c). Still larger tiles called *ch'imi* faced each other at each end of the main ridge of the building: one found at Hwangryŏng-sa is 180cm (almost six feet) high.

The demon-mask, clearly related to earlier types (cf. no. 18b), but of much greater sophistication, is moulded in high relief in the recessed face of the tile. The edges of the raised border are also moulded, with a strong 'honeysuckle' scroll.
 RW

Published San Francisco 1979, no. 100;
Nara 1978, no. 46, p. 125

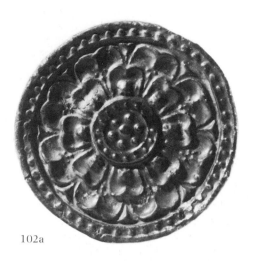

102a

102a Tile-end (*sud-maksae*) with lotus

Unified Silla, 7th–8th century AD
Earthenware with green glaze. D 12.7cm
Excavated from Anap-chi, Kyŏngju, 1975–6
Kyŏngju National Museum

102b End-tile (*sud-maksae*) with lotus

Unified Silla, 7th–8th century AD
Earthenware. L 38.5cm; W 15.0cm
Excavated from Anap-chi, Kyŏngju, 1975–6
Kyŏngju National Museum

102c Ridge-end tile (*kopsae kiwa*)

Unified Silla, 7th–8th century AD
Earthenware. L 56.0cm; W 14.3cm
Excavated from Anap-chi, Kyŏngju, 1975–6
Kyŏngju National Museum

The vast majority of roof-tiles were of course undecorated, but great care was lavished on the decoration of those at the edges. In these examples (nos 102a–c) the greater elaboration of the lotus, with two rows of petals where the Koguryŏ and Paekche tile-ends had only one, can be seen (cf. nos 18, 21). The outer circumference, at right angles to the tile-end, might also be decorated (cf. Hamada and Umehara 1934, pl. xxx).

No. 102b shows the full length of the convex end-tiles (*sud-maksae*); its oval end is a variant on the more common circular end. No. 102c, with its rising end, would have been fitted at the lower end of one of the diagonal ridges at the corners of the building; there was one on top of the demon tile (no. 101) and another just below it, both projecting outwards and up. RW

Published Seoul 1980, no. 162

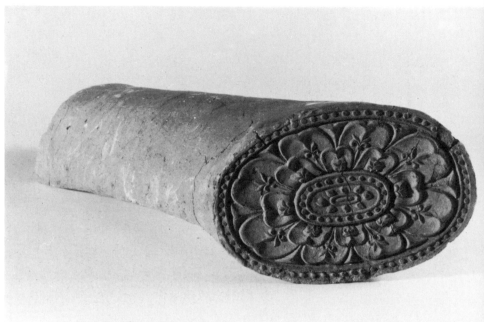

102b

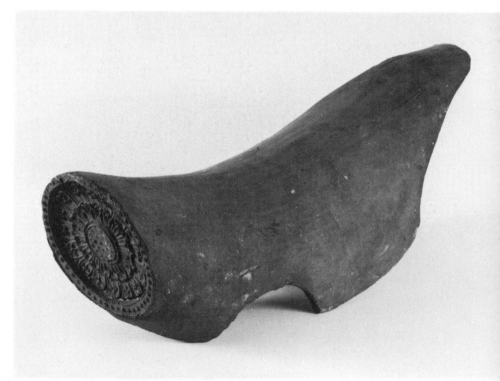

102c

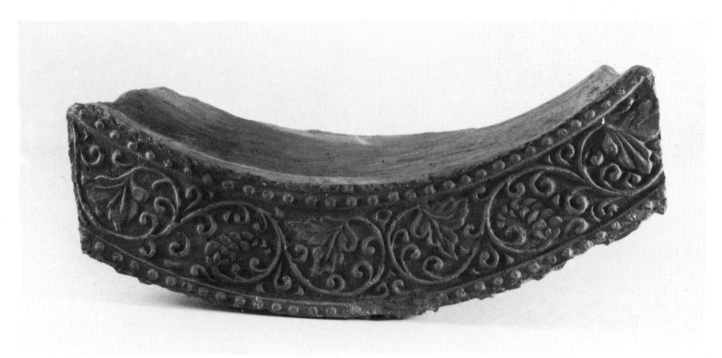

103

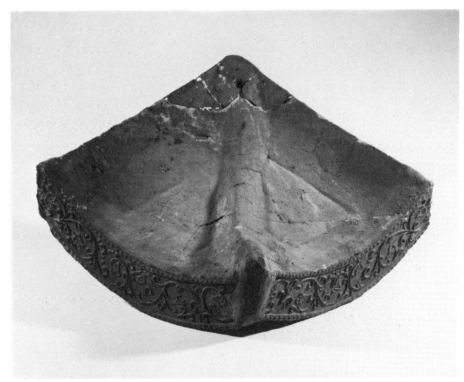

104

103 Tile (*am-maksae*) with grapevine scroll

Unified Silla, 7th–8th century AD
Earthenware. L 36.0 cm; W 30.0 cm
Excavated from Anap-chi, Kyǒngju, 1975–6
Kyǒngju National Museum

The shallow concave tiles were left undecorated in Koguryǒ and Paekche, but in Unified Silla the face and even the underside were decorated with floral scrolls, flying celestial figures, and pairs of animals or birds (cf. Hamada and Umehara 1934, pls XXIX ff). In this particularly fine example the scroll consists of a vine with bunches of grapes, set between pearl borders.

RW

Published Seoul 1980, no. 176

104 Corner tile (*mo-sǒri am-maksae*)

Unified Silla, c. AD 680
Earthenware. L 44.4 cm; W 44.4 cm
Excavated from Anap-chi, Kyǒngju, 1975–6
Kyǒngju National Museum

At each of the four corners of the roof two edges meet, and a single shallow concave tile with two decorated edges joins them. A ridge-end tile *kopsae kiwa* (see no. 102c) was placed on top of it on the diagonal.

RW

Published Seoul 1980, no. 199

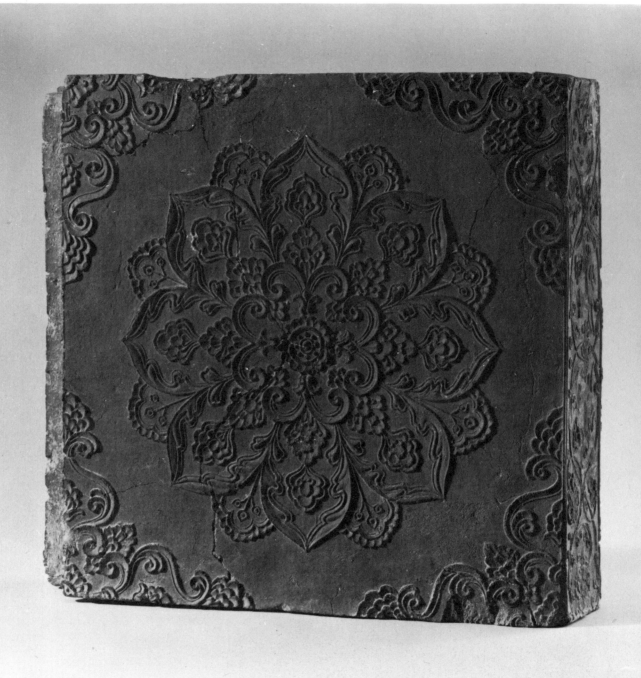

105

105 Altar floor-tile

Unified Silla, 7th–8th century AD
Earthenware. L 35.4 cm; W 31.8 cm
Excavated near Anap-chi, Kyŏngju, 1975–6
Kyŏngju National Museum

The most splendidly decorated tiles of all are those which formed the floors, perhaps used as an image base in a temple or on a low dais in the palace, since on some of them one edge, as well as the top surface, is decorated. The floral motifs found on them are known in Korea as *posang* (Chinese *baoxiang*, 'precious visage'). One *posang* is in the centre of each tile, and four more are formed at the corners in combination with the adjacent tiles. The designs on the Anap-chi tiles are close to those which are seen on the painted ceilings of the Dunhuang caves, and no doubt also in the temples of Chang'an, in the early Tang dynasty (seventh–eighth centuries AD).

The design on the front edge of the tile shows two deer, a stag and a doe, lying in graceful posture and enclosed by delicate interlacing *posang* scrolls, in allusion to the Buddha's first sermon in the Deer Park at Benares (cf. Nara 1978, no.62; Hamada and Umehara 1934, pl.LX). A fragment of the same design has been found at Anap-chi with a stamped date corresponding to AD 680 (Seoul 1980, no.219). RW

Published San Francisco 1979, no.101

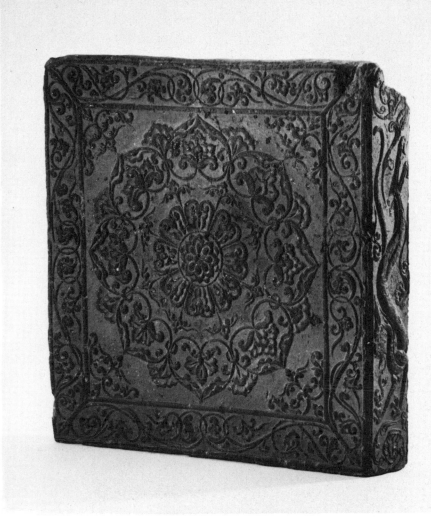

106

106 Altar floor-tile

Unified Silla, 7th–8th century AD
Earthenware. L 37.3 cm; W 36.0 cm; TH 6.0 cm
Excavated from the site of Hwangryong-sa,
 1976
Kyŏngju National Museum

Hwangryong-sa, Temple of the Imperial Dragon,
was begun in AD 553 and completed in AD 643;
it was finally destroyed in AD 1238 during the
Mongol invasions after 685 years as the greatest
monastery in the land. It was near Anap-chi,
and this tile shows that it must have appeared as
splendid as the palace buildings, since the mould-
ing of the *posang* motifs is equally crisp and
delicate. Although this was of course a Buddhist
temple, it is interesting to note that the motif on
the front edge of the tile is a sinuous animal
racing among clouds, probably the White Tiger
of the West, one of the fabulous animals of the
Four Directions, frequently seen in the wall paint-
ings of Koguryŏ, and here still retaining the
style of the fifth and sixth centuries, though in
combination with the fully-developed *posang* of
the Tang. RW

Published Nara 1978, no. 63, p. 136

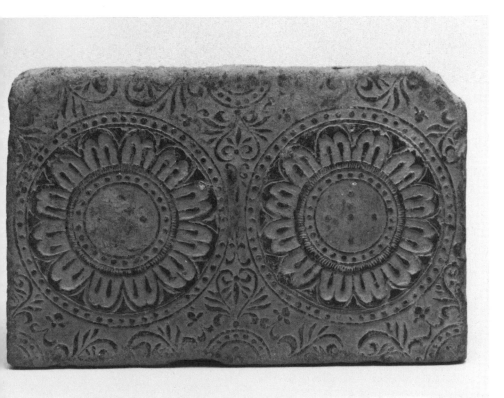

107

107 Altar floor-tile

Unified Silla, 7th–8th century AD
Earthenware. L 22.0 cm; W 35.0 cm; TH 5.0 cm
Provenance unknown
Dong-a University Museum, Pusan

The lotus and *posang* offered endless possibilities
for combination. On this tile two lotuses, each
with twelve petals, are set side by side. Other
variations include square corner tiles (with two
decorated edges) of which four were needed to
make one large pattern with a border of smaller
lotuses, and triangular corner tiles which show
that the squares were sometimes set on the
diagonal (cf. Kyŏngju n.d., no. 92; Seoul 1980,
nos 222–6). RW

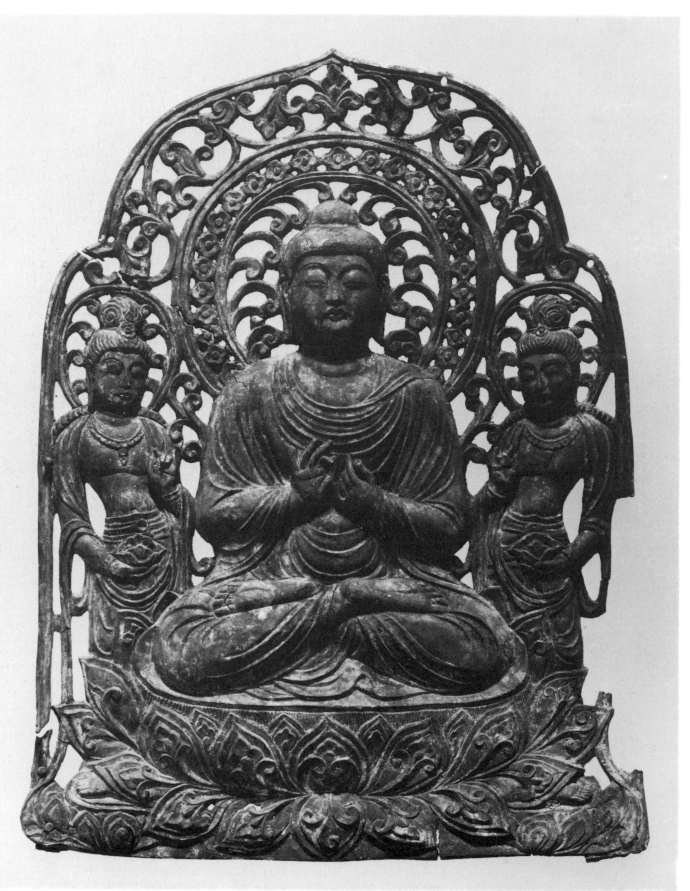

108 Buddha triad

Unified Silla, late 7th–early 8th century AD
Bronze, formerly gilt. H 27.0 cm; W 20.5 cm
Excavated from Anap-chi, Kyŏngju, in 1975
Kyŏngju National Museum

The palace complex of Imhae-jŏn ('Hall by the
Sea') was laid out with its artificial lake Anap-
chi between 674 and 679, as an extension of
the Old Silla palace of Panwŏl-song ('Half-moon
Palace'). Numerous small Buddhist sculptures,
probably votive gifts, have been found there,
including two bronze plaquettes with Buddhist
triads in low relief from the eastern part of the
lake. Having lain in the mud for so long, these
pieces have all lost their gilding and the surface
of the bronze has become dull, so that their
original splendid appearance has been impaired.

The central figure of the triad is a Buddha
seated on a richly carved double lotus. The
hands are placed together in front of the chest
in the gesture of turning the wheel of the law
(*chŏnpŏpyun-in*) or in the gesture of teaching
(*sŏlpŏp-in*). The body is powerful, the hands
soft, and the face full, with heavy eyelids and
a small mouth. The hair and the *uṣṇīṣa* are
smooth. The robe covers both shoulders; its
folds curve naturally and are modelled distinctly.

The Buddha is considerably larger than the
two Bodhisattvas who attend him. They stand
on smaller lotus pedestals, just visible below the
main lotus throne. Their *tribhanga* pose, with
the weight on the outer foot, enables them to
stand slightly behind and to the side of the cen-
tral figure. Their scarves fall paralleling the out-
line of the mandorla which surrounds the whole
triad. Each of the three figures also has a separate
nimbus; that of the Buddha contains a band of
florets, and can be compared with the Amitābha
on the south wall of cave 220 at Dunhuang in
China, dated AD 642 (Tonkō 1982, vol. 3, pl. 26).
The care observed in the proportions of the
figures and in their relation to one another is
also typical of Buddhist painting in the early
Tang dynasty. Dietrich Seckel has compared the
group with a similar Japanese one from Hōryū-ji
(now in the Tokyo National Museum) made
about AD 700 (Seckel 1977). There is also a
certain affinity to the representation of the
Amitābha in his paradise in the wall-paintings
of the Hōryū-ji, which were done about the
same time, around AD 690. All these works are
examples of what Soper has called the inter-
national style of Buddhist art, which spread to
other countries from China during the Tang
period.

The piece was cast from a mould. On the back
one can see a lattice of wire-like rods which was
included in the casting to strengthen it. RG/RW

Published Anap-chi 1978, pl. 135; Seckel 1977;
Nara 1978, no. 100; Hwang Su-yong 1983,
pl. 44; Choi Sunu 1979, pl. 235;

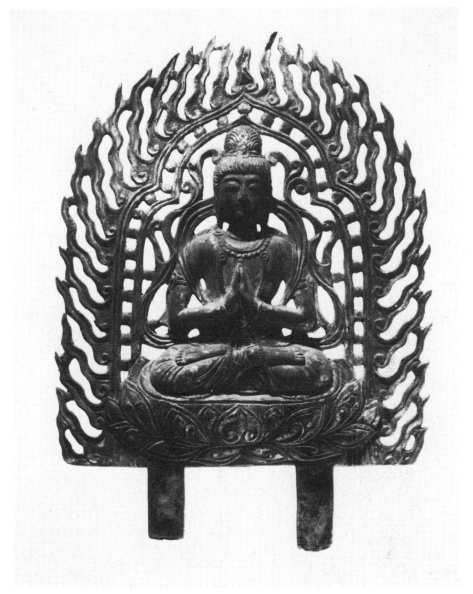

109

San Francisco 1979, no. 85;, pl. XV
Tokyo 1983, no. 118

109 Bodhisattva

Unified Silla, late 7th–early 8th century AD
Bronze, formerly gilt. H 27.0 cm
Excavated from Anap-chi, Kyŏngju, in 1975
Kyŏngju National Museum

Together with the two Buddha triads, eight
identical plaques with adoring Bodhisattvas
were discovered in the eastern part of the lake at
the foot of the walled bank. Like the triads, they
have two pegs projecting from the lower edge,
which suggest that they were inserted into a
wooden support.

The Bodhisattva sits with fully crossed legs on
a double lotus. The hands are placed together
in adoration (*hapjang-in*). The Bodhisattva, who
cannot be identified precisely, owing to the ab-
sence of any emblems, wears the customary
dhoti, pendants reaching down to the lotus
pedestal, and a shawl which floats upwards
round the figure, forming the openwork orna-
ment within the mandorla (*kwangbae*), which is
ogee-shaped, with a border of pearls surrounded
by a wide band of flame. The Bodhisattva is alert
and expressive, with clearly modelled features
and finely proportioned limbs.

Here too, as in the Buddha triad (no. 108), a
framework of thin metal rods is included in the
casting at the back. Both plaques reflect the
high standard of casting technique in Korea,
and are closely linked in style to the Buddhist art
of the Tang dynasty at its height. RG/RW

Published Anap-chi 1978, pls 137–9;
Hwang Su-yong 1983, no. 60;
San Francisco 1979, no. 86;
Tokyo 1983, no. 119

110 Standing Buddha

Unified Silla, 9th century AD
Bronze, formerly gilt. H 35.0 cm
Excavated from Anap-chi, Kyŏngju, in 1975
Kyŏngju National Museum

As well as the relief plaques, the site of the Anap-chi palace yielded the figures of six standing and one seated Buddha modelled more or less in the round. They were also probably votive images.

This Buddha stands on a lotus which rises over a complex pedestal on an octagonal base with openings and rising palmettes. The right hand is stretched forwards, and the left hand is lowered; in both the two middle fingers are slightly bent. The body is substantial, the face broad and full. The head and the not very prominent *uṣṇīṣa* are covered with curls. The robe covers both shoulders, leaving the upper part of the breast bare, and the sleeves fall in slightly wavy lines. The material fits more tightly round the legs, so that their shape can be clearly seen. The intermediate folds of the robe are represented by incised lines and the parallel pairs of U-shaped lines in front of the legs. The simplification of such details conforms with the general line of

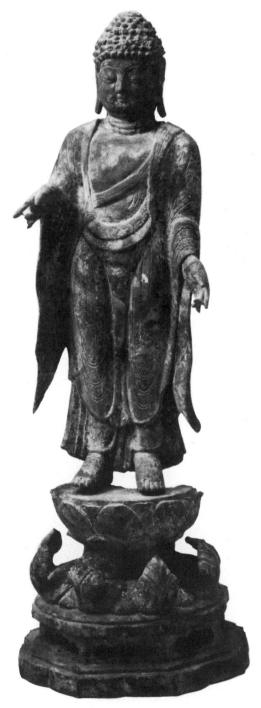

stylistic development from the Unified Silla period to the Koryŏ period. In a generally comparable piece belonging to the Nelson Gallery, Kansas City, dating to the eighth century AD, these details are still given full sculptural treatment.

The figure of the Buddha was cast separately from the pedestal and is fitted to it by means of pegs on the feet. On the back of the figure there is a large aperture extending almost the full

at Anap-chi on the site of the Imhae-jŏn palace (Lee Nan-young 1983). They are the more valuable since such objects are rarely found in the tombs of Unified Silla. This large pair of candle- or wick-snuffers are particularly interesting as they suggest an origin for another pair, long kept in the Shōsōin in Nara (Shōsōin 1976, pl. 68). Both pairs have a similar profile and raised edges to the wick-cutting blades but,

Kwon Sang-ha Collection, Seoul;
 National Treasure no. 174

This is the only pair of candlesticks to have been preserved from the Unified Silla period. They are said to have been unearthed from a tomb, but the exact circumstances of the find are unknown. Nevertheless, they are generally considered to be of a quality commensurate with the finds from Anap-chi. The feet are of palmette type,

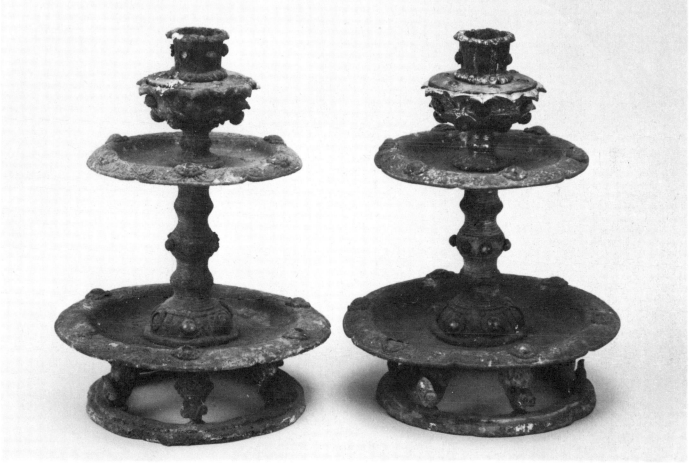

112

length of the body, and a similar one in the head. The casting core has been removed. RG

Published Anap-chi 1978, pl. 142;
Tokyo 1983, no. 117

111 Candle-snuffers

Unified Silla, 7th–8th century AD
Gilt bronze. L 25.5 cm
Excavated at Anap-chi, Kyŏngju, in 1975–6
Kyŏngju National Museum

A large number of objects of everyday use, including spoons, bowls and dishes, were discovered

whereas the Shōsōin pair have no engraved decoration, the handles of this pair are covered with floral scrolls with engraved outlines, reserved on a ground of closely-set small dots.
 JHW/RW

Published Seoul 1980, no. 269;
Tokyo 1983, no. 110

112 Pair of candlesticks

Unified Silla, 8th–9th century AD
Gilt bronze and crystal. H 36.8 cm;
 D (foot) 21.5 cm
Provenance unknown

with a pronounced outward curve, like the palmettes surrounding the pedestal of the standing figure of Buddha from Anap-chi (no. 110). The two candlesticks were once gilt, and each is set with forty-eight crystals on the dishes, stem and lotus petals, with a further twelve, it would appear, on the feet. Their original appearance must have been splendid. JHW/RW

Published Chin Hong-sop 1978b, pl. 106;
Choi Sunu 1978, pl. 204;
Tokyo 1983, no. 162

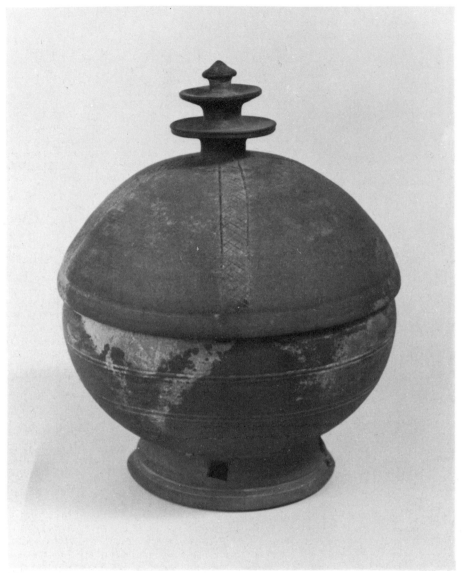

113

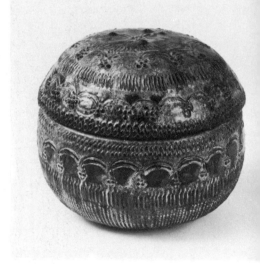

114

113 Reliquary

Unified Silla, 7th–8th century AD
Grey stoneware. H 28.1 cm
National Museum of Korea, Seoul

This reliquary is of an impressive monumental shape, and might have been used to contain the ashes of a Buddhist monk. It is close in shape to a bronze reliquary from Unified Silla, of the eighth century (Nara 1978, no. 10).

The old ceramic tradition of Silla is still visible in the stand with its square perforations. The remainder of the vessel is almost globular, with a high domed lid, crowned by a knob with two *chatras*, recalling Indian Buddhist reliquaries and the tops of the stone pagodas. The only decoration consists of incised parallel horizontal lines on the base and four bands of incised criss-cross lines on the cover, meeting at right angles at the top, like the steps approaching a pagoda.

RW/YSP

Published Nara 1978, no. 12, p. 164;
Han Byong-sam 1981, pl. 112

114 Funerary urn

Unified Silla, 8th–9th century AD
Stoneware with green glaze. H 16.0 cm
National Museum of Korea, Seoul;
 National Treasure no. 125

One of the most important changes brought by Buddhism was the decline of the lavish grave-cult. Since the Buddhist faithful might hope to be reborn in the Buddhist paradise or Pure Land, they no longer needed to be buried with their possessions. A single urn for the ashes, instead of hundreds of pottery vessels, was all that was needed.

The decoration of this urn is of stamped motifs under a green and yellowish lead glaze. On the cover the central band, between two rows of garlands with flowers, is composed of flame-like motifs. The top of the cover has a number of small protuberances around a central four-petalled rosette. This urn was found enclosed in a square granite box. Like the last item, it may have been intended for the ashes of an eminent monk.

JHW/RW

Published Kim and Lee 1974, pl. 132;
San Francisco 1979, no. 103;
Han Byong-sam 1981, pl. 144

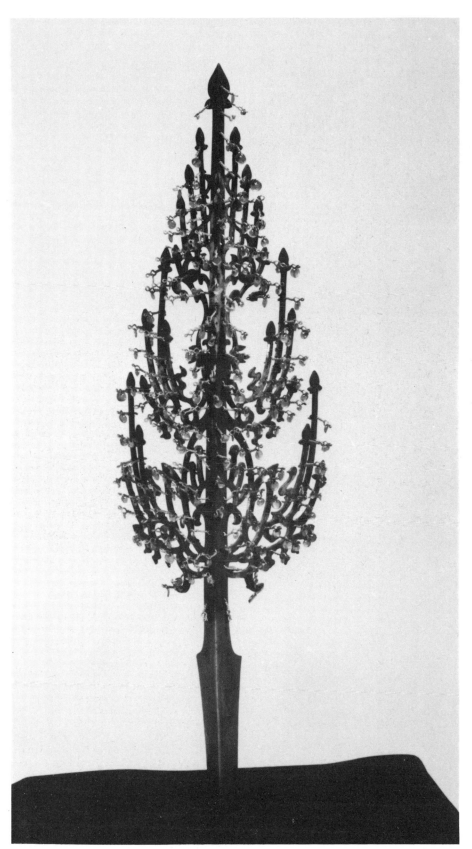

115 *Sarira* finial

Silla or Unified Silla, 7th–8th century AD
Gilt bronze with gold spangles. H 22.3 cm
From the pagoda of the Songnim-sa temple.
 Ch'ilgok, North Kyŏngsang province
National Museum of Korea, Seoul;
 Treasure no. 325

This finial was discovered in 1959 together with an elaborate *sarira* or Buddhist reliquary in the shape of a small pavilion, housing a cup of green glass within which was a miniature glass vase like that of no. 116. Both the *sarira* and the finial were contained in a tortoise-shaped granite casket lodged in the second storey of the five-storey tiled pagoda of the Songnim-sa.

 The form and decoration of the finial recall those of the head-dress ornaments of Paekche and Silla, particularly those of King Munyŏng and his queen (nos 35–6). The tree-like form is cut out of a sheet of thin gilt bronze, folded longitudinally in the same manner as the wing ornaments from Kyŏngju tombs (nos 75–6).

 The two halves are cut symmetrically into branches, the lowest of which are in the form of an opened lotus blossom. Other bud and flower shapes are suggested by the stem as it rises, and all the branches end in pointed buds. Over two hundred small gold spangles adorn them, again like the Silla crowns and pendants. The whole finial may symbolise a *bodhi* tree, the tree under which Buddha Śākyamuni attained enlightenment.

 The *sarira*, not included in this catalogue, employed the same skill in cutting and bending gilt bronze sheet as the finial which may have crowned it. The glass cup, probably made in East Asia rather than in the West, sits on a lotus blossom on a dais, with a low railing around it. Four slender columns support the double roof. The piece is thought (Kim Won-yong 1982, p. 102) to have been inspired by another gilt bronze *sarira* found in the western pagoda of Kamŭn-sa, dated AD 682 or slightly earlier, which originally had columns and a roof (see nos 118–19).

 Both the *sarira* itself and this finial are creations from a transitional period, in which the materials and motifs of the pre-Buddhist period were put to new use through the inspiration of Buddhism.

RW/YSP

Published Chin Hong-sop 1978b, pl. 65;
Choi Sunu 1979, pl. 188

116 *Sarira* bottle and casket

(colour ill.)

Unified Silla, 8th century AD
Green glass and gold. H (bottle) 6.1 cm;
 (casket) 10.3 cm
Found in 1965 in the five-storey stone pagoda
 of Wanggung-ni, Iksan, North Chŏlla province
National Museum of Korea, Seoul;
 National Treasure no. 123

The tiny green bottle is the innermost container
of a *sari* or relic of the Buddha. It would have
been kept hidden inside the gold casket, which
in turn, together with the casket containing the
Diamond Sutra written on gold sheets (no. 117),
was enclosed in the five-storey stone pagoda at
Wanggung-ni, on the site of a vanished temple.
The pagoda itself was built in the Unified Silla
dynasty, and contained a total of five compart-

ments for reliquaries, three above the foundation
stone and two in the first storey. A tiny bronze
figure of a standing Buddha, 9.0 cm high on its
pedestal, was also found (Kim and Lee 1974,
pl. 114). Such precious deposits were at the heart
of Buddhist worship in every Korean temple.

The glass bottle has a gold lotus support and
gold lotus bud stopper. One almost exactly
similar, kept inside a green glass cup, is the
innermost container of the reliquary from
Songnim-sa (see no. 115). The casket is dec-
orated on each face and on the lid with panels
of floral decoration on a background of small
punched rings, with borders of larger circles on
the same ground. The edges of the lotus flowers
and buds have additional engraved hatching.
The ring-punched ground and hatched orna-
ment echoes the technique of Tang gold- and

silversmiths' work. The same features can be
found again on the silver mount of a blue glass
cup (matching the green one in the Songnim-sa
reliquary) in the Shōsōin (Shōsōin 1965, pls 3,
31–8). The delicacy of the whole casket, especi-
ally the making of the separate lotus petals, is
entirely Korean, and very similar to that seen on
a reliquary from Namwon, of a different type
but again with a glass container inside, now in
the National Museum, Seoul, and thought to be
eighth century (Seoul 1972, pl. 41). RW/YSP

Published Kim and Lee 1974, pls 28–9;
San Francisco 1979, no. 95, pl. XVI;
Chin Hong-sop 1978b, pls 66–7

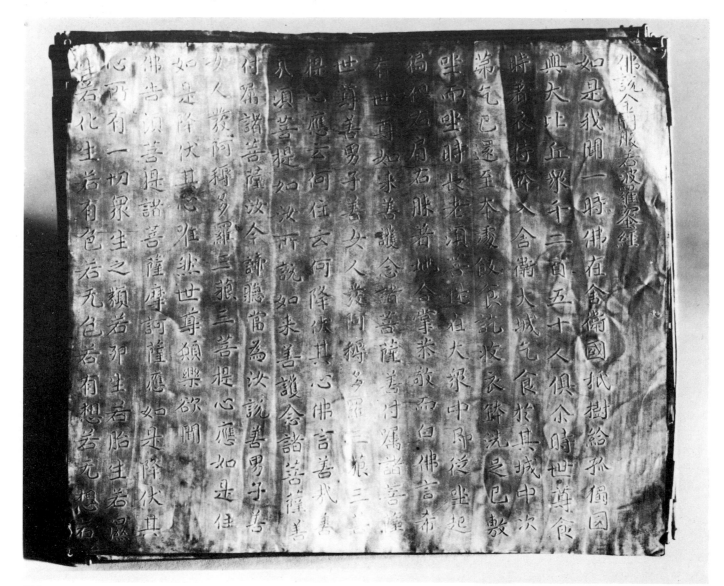

117 Sutra casket with the text of the Diamond Sutra *(colour ill.)*

Unified Silla, 7th–8th century AD
Gold. H (casket) 6.3cm, (each leaf) 14.8cm;
 W 13.7cm
Found in 1965 in the five-storey pagoda of
 Wanggung-ni, Iksan, North Chŏlla province
National Museum of Korea, Seoul;
 National Treasure no.123

This reliquary casket was found together with no.116. There was an outer as well as an inner casket for the codex of nineteen gold sheets hinged together. Each sheet has seventeen columns, each of seventeen characters (the standard number found in sutra manuscripts of the seventh and eighth centuries in Tang dynasty China). The characters were not engraved but are in repoussé. The text is that of the *Vajra-prajñāpāramitā sūtra*, the sutra of the Diamond Perfection of Transcendental Wisdom, first translated by Kumārajīva in the fourth century AD, and one of the most precious of Mahāyāna scriptures, preaching the doctrine of *sunyata* or the void. In Korea this text is particularly associated with the Sŏn sect (Chinese Chan, Japanese Zen) which came to Korea in the mid-eighth century. RW/YSP

Published Chin Hong-sop 1978b, pl.68;
San Francisco 1979, no.95

118 *Sarira* case

Unified Silla, *c.* AD 682
Gilt bronze, with crystal bottle. H 15.0cm;
 base 14.0cm square
From the western stone pagoda of Kamŭn-sa,
 Wŏlsŏng, North Kyŏngsang province
National Museum of Korea, Seoul;
 Treasure no.366

This *sarira* originally had a double roof supported on four columns. It was enclosed in a gilt-bronze outer box on the sides of which were relief figures of the Four Guardian Kings (see no.119). The relic was kept inside a small crystal bottle which is inside the stupa-shaped vase on the platform, worshipped by four musicians playing flute, phoenix-headed lute, cymbals and drum. Eight other musicians are seen in the openings of the lower storey, and the whole rests on a square lotus pedestal base.

The reliquary was found in the western stone pagoda of Kamŭn-sa; the building of the temple was begun by King Munmu (reigned AD 661–81), to provide protection against Japanese pirates, who were harrassing the coast during the Silla period. The work was completed in AD 682, after his death, by his son King Sinmun (reigned AD 681–92), who dedicated it to his father's memory. Munmu's ashes were interred nearby at Taewang-am (Stone of the Great King), under

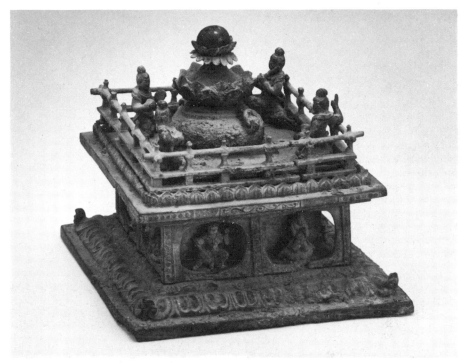

118

the sea, and it is recorded in *Samguk yusa* that after his death he became the king of the sea-dragons and continued to guard the Eastern sea, that is the east coast of Silla, against intruders. Excavations have revealed that the construction of the Golden Hall was most unusual, with a stone instead of a wooden floor, and a hollow beneath it; this confirmed the record in *Samguk yusa* which says that a hole was dug under the Golden Hall towards the Eastern sea so that the dragon might come and go as he pleased (*Samguk yusa*, chapter 2, section 2). JHW/RW

Published Kamŭn-sa 1961;
Kim and Kim 1966, p.244 (reconstruction);
Kim and Lee 1974, pls 59–60;
Chin Hong-sop 1978b, pls 54–6

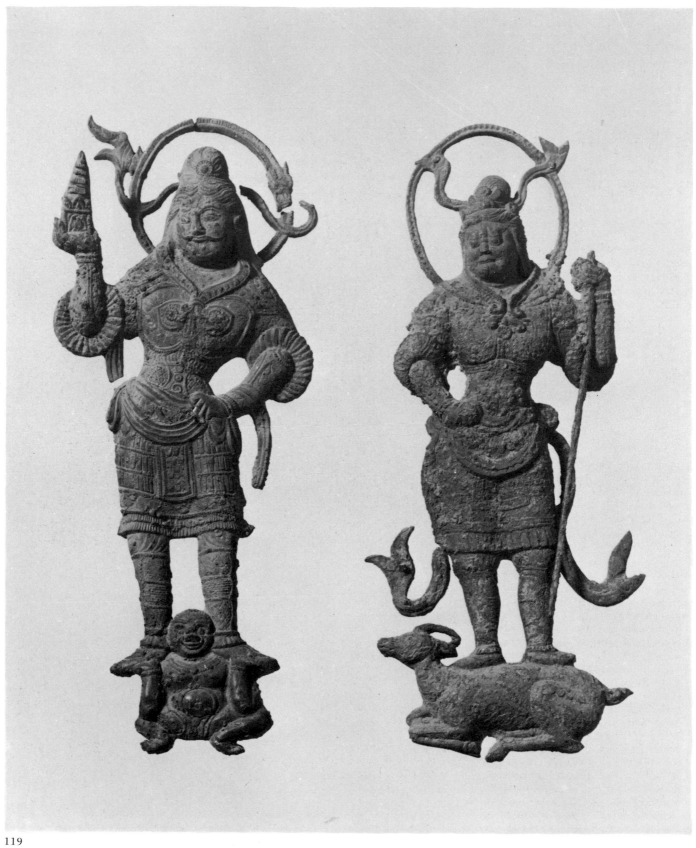

119 Heavenly Kings
Vaiśravaṇa and Dhṛtarāṣṭra

Unified Silla, about AD 682
Bronze. H 21.6 cm
From the western stone pagoda of Kamŭn-sa,
 Wŏlsŏng, North Kyŏngsang province
National Museum of Korea, Seoul;
 Treasure no. 366

In 1960, during restoration work on the western
stone pagoda of Kamŭn-sa, Korean archae-
ologists discovered a reliquary (no. 118) which
was protected by a gilt-bronze casket. The outer
sides of the casket had appliqué figures of the
Four World Guardians (Sanskrit *lokapāla*) or
Heavenly Kings (Korean *sach'ŏnwang*); two of
these are exhibited here. They carry Central
Asian or Chinese weapons of the early Tang
period, stand on symbolic animals or demons,
hold weapons or attributes in their hands and
have a ring-shaped nimbus round their heads.

Vaiśravaṇa (Korean Bisamun-ch'on), who
resides in the north, stands on the hands of a
small demon usually interpreted as an earth
divinity (*jich'ŏn*) and holds his attribute, a
pagoda, in his right hand. The left hand grasps
the ribbons at his hip. The god's eyebrows are
knitted angrily, he wears a moustache and his
hair, which is gathered up in a bun on the top of
the head, falls down to the shoulders. Dhṛtarāṣṭra
(Korean Chiguk-ch'ŏn), the Heavenly King of
the East, stands on a gazelle-like animal and
holds a spear in his left hand. Shawls flap round
his head and legs.

These figures cast in low relief are best com-
pared with the two colossal guardians in front of
the Fengxian-si temple at Longmen, carved about
AD 680, and with those on the seven-storey
pagoda of Yunju-si on the Tangshan in the
northern Chinese province of Henan. The reliefs
of the Heavenly Kings are therefore relatively
datable. RG

Published Kamŭn-sa 1961; Propyläen 1968,
pls 326–7; Hwang Su-yong 1974a, pl. 51;
Kim and Lee 1974, pls 14, 56–8;
Hwang Su-yong 1983, pl. 67; Choi Sunu 1979,
pl. 191; San Francisco 1979, no. 81, pl. XIV;
Kim Kyong-hi 1980, pl. 22 (all four figures)

120 Standing Buddha

Unified Silla, 8th century AD
Gilt bronze. H 24.5 cm
Excavated in Kŭmsan,
 South Ch'ungch'ŏng province
National Museum of Korea, Seoul

This Buddha stands on a complex base, similar
to the previous one, with up-turned petals and a
drum-shaped shaft topped by the lotus pedestal
proper. He is relatively slim; his right hand
stretches slightly forwards, while his left hand

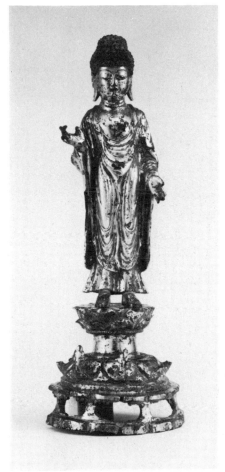

120

is lowered. He wears a monk's robe covering
both shoulders. Its folds hang down naturally,
falling in large U- and V-shapes in front of the
body, and in large oval shapes in front of the
thighs; the modelling has not yet become stylised
in the ninth-century manner (no. 110). Despite
its small size the oval head is finely sculpted; the
part of the head which is covered with dark-
coloured curls, together with the *uṣṇīṣa*, is
comparatively high and large. The position of
the hands and the manner in which the robe is
rendered suggest that the figure represents the
Buddha Śākyamuni. RG

Published Tokyo 1983, no. 152

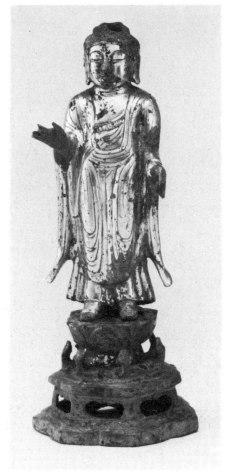

121

121 Standing Buddha

Unified Silla, 8th century AD
Gilt bronze. H 22.6 cm
Excavated at Hongch'ŏn, Kangwŏn province
National Museum of Korea, Seoul

This Buddha stands on a pedestal close to that of
no. 120 and has similar iconographic character-
istics, though the style is quite different. The
folds in the robe are entirely two-dimensional,
being rendered simply by incised lines. The almost
square face also gives a largely two-dimensional
impression. Since the piece was discovered in
the north of the Unified Silla Kingdom quite a
long way from Kyŏngju it may be assumed that
this is a piece of provincial sculpture. RG

Published Tokyo 1983, no. 150

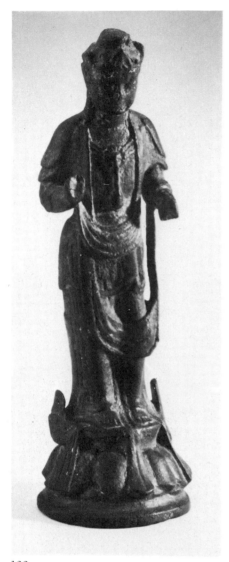

122

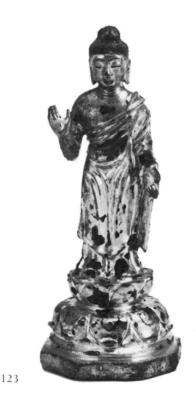

123

bestowing favour. The whole gesture indicates a momentary movement, and is different from the frontal representation of most Bodhisattvas.

RG/YSP

Published Tokyo 1983, no. 153

122 Standing Bodhisattva

Unified Silla, 7th–8th century AD
Gilt bronze. H 20.0 cm
Excavated at Yŏngwŏl, Kangwŏn province
National Museum of Korea, Seoul

Like no. 121, this figure was discovered in central Korea, some distance from the Silla capital of Kyŏngju. It represents a provincial style in which earlier features tend to be retained. The lotus pedestal still has a plain circle of down-turned petals. The shawl, which broadens to cover the shoulders, hang down in two large U-shaped loops in front of the body, and is still reminiscent of the style of the Three Kingdoms. Because of the heavy patination some details appear unclear, but the figure as a whole is very graceful. The Bodhisattva inclines slightly forwards, with a compassionate appearance as if welcoming or

123 Standing Buddha

Unified Silla, 8th century AD
Gilt bronze. H 9.1 cm
Excavated from the site of Hwangryong-sa, North Kyŏngsang province
Kyŏngju National Museum

For many years Korean archaeologists have been investigating the site of the great temple of Hwangryong-sa in Kyŏngju and reconstructing its ground-plan. As well as numerous fragments of architecture (cf. no. 106) this small standing Buddha was discovered. The gilding is still well preserved, and there are the remnants of the original paintwork on the face. The Buddha stands upright on a double lotus over an octagonal base. The right hand is raised in the gesture which grants the absence of fear (*abhaya-mudrā*), the left hand lowered in the gesture of blessing

(*varada-mudrā*). The left shoulder is bare. This tiny figure bears witness to the skill of the artists of the Unified Silla Kingdom in maintaining the quality of their sculpture even when working on a miniature scale.

RG

Published Tokyo 1983, no. 136

124 Seated figure of a Heavenly King *(colour ill.)*

Unified Silla, *c.* AD 679
Earthenware with traces of green glaze.
H 53.0 cm
From the site of Sach'ŏnwang-sa, Temple of the Four Heavenly Kings, Kyŏngju, North Kyŏngsang province
National Museum of Korea, Seoul

The temple dedicated to the Four Heavenly Kings (*sach'ŏnwang*) or World Guardians (Sanskrit *lokapāla*) was founded during the reign of King Munmu (AD 661–81) in 679 by the monk Myŏngnang as a defence against the threatened invasion of Silla by the Tang armies of China. The large tiles of fired clay with the remains of green glaze were most probably set in the walls of the two great wooden pagodas which are no longer extant. Fragments of all of the four kings have been found. Some pieces are so similar that they must have been made from the same mould. In all, therefore, there may have been two sets of four tiles divided between the two pagodas; the Kyŏngju National Museum has a tile matching the tile shown here. On the basis of further fragments it has only recently been possible to make a reconstruction drawing (Kang Woo-bang 1979; see opposite).

Despite being so close in date to the Kamŭn-sa figures (no. 119), these tiles represent a considerably more developed relief style. They make a much more realistic impression, almost producing an optical illusion in the foreshortening of the thigh zones. The tile illustrated here shows a seated figure of a World Guardian with the upper part of the body missing. He wears the rich armour of a general of the Chinese Tang dynasty, with shoes, coat, corslet and puffed sleeves. In his left hand he holds a sword, while his right hand rests on his thigh. He sits with legs pendant on two demons which are looking out on both sides and which have muscular bodies and grotesque faces with bristling curly hair. They are strongly reminiscent of the demons in the pedestal zone of the great bronze triad of Yakushi-ji at Nara and of recently restored reliefs from the pagoda of Xiuding-si of the Tang period at Anyang in China.

RG

Published Hamada and Umehara 1934, frontispiece; Propyläen 1968, pl. 235; Kim and Lee 1974, pl. 55; Kang Woo-bang 1979; Tokyo 1983, no. 157

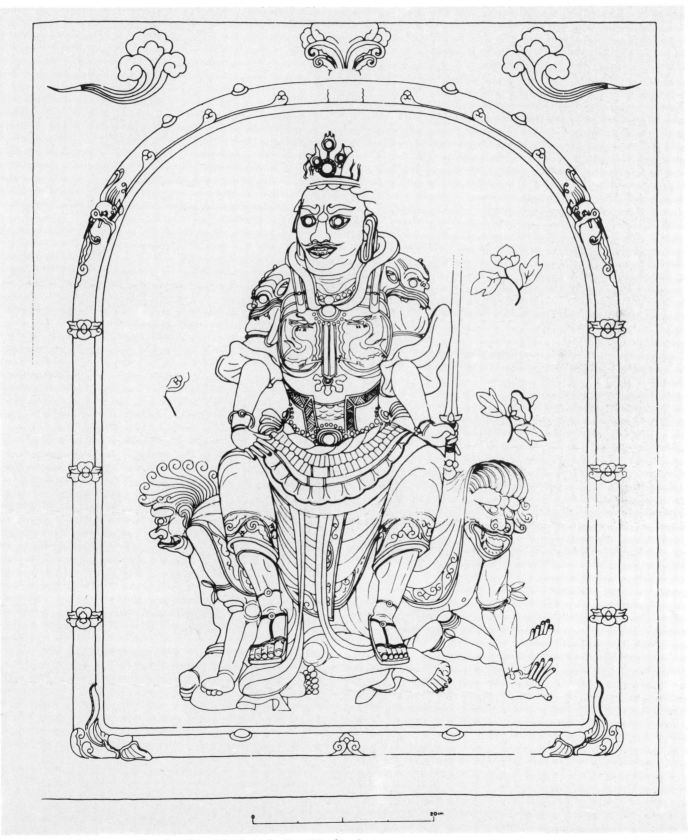

Reconstruction of Dhṛtarāṣṭra, Guardian King of the East (after Kang Woo-bang).

125 Dragon's head flagstaff finial *(colour ill.)*

Unified Silla, 8th–9th century AD
Gilt bronze. H 65.0 cm
Found in 1976 at Yŏngju,
 North Kyŏngsang province
Kyŏngju National Museum

This dragon's head once crowned the flagstaff of a Buddhist temple. In the Korean countryside one often finds, as the only visible remains of once proud temples, stone pagodas or twin stone supports for the tall masts from which were hung long narrow temple banners. The proportions and appearance of such flagstaffs can be seen from the miniature model (no. 133).

This head is boldly modelled with hair and scales rendered in fine incised lines. In keeping with its practical purpose, a large pulley is contained in the open mouth, turning on an axle held between the teeth; the lower jaw has an opening to let the rope pass through. JHW

Published San Francisco 1979, no. 96 pl. XVIII;
Choi Suna 1979, pl. 187;
Tokyo 1983, no. 161

126 Head of *vajrapaṇi*

Unified Silla, mid-18th century AD
Granite. H 56.0 cm
From Sŏkkuram, Kyŏngju,
 North Kyŏngsang province
Kyŏngju National Museum

This stone head was discovered during the first restoration works at the famous cave-temple of Sŏkkuram on Mt T'oham to the south-east of Kyŏngju. It probably belonged to one of the two door-keeper figures (*vajrapaṇi*) which flanked the entrance to the cave site but which were soon replaced by other sculptures that remain there to this day. The temple was not cut out of the natural rock, but constructed of slabs of stone which were then covered with earth. It was begun by Kim Taesŏng in AD 751 in memory of his parents in his previous existences, and its large group of carved figures constitutes the undisputed high-point of Buddhist sculpture in Korea. It contains a whole pantheon of Buddhist divinities, culminating in the great central figure of the seated Buddha.

The head of the door-keeper, though corroded on the surface so that the detail appears blurred, shows the mature style of Unified Silla sculpture in the round. The muscular face with the corners of the mouth drawn down, with its broad nose and eyes staring angrily under the highly arched

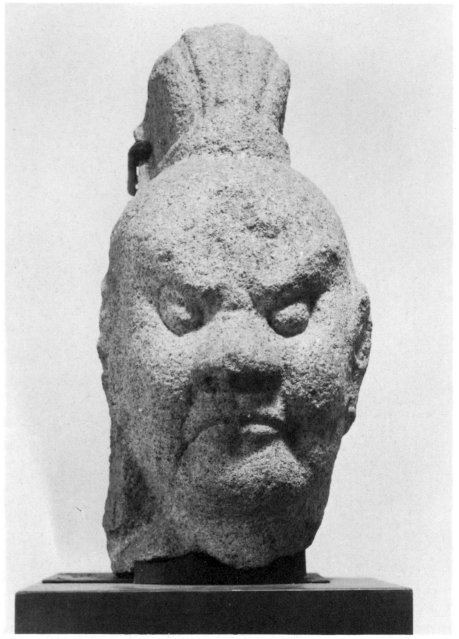

126

forehead displays a realism hitherto unknown in Korean sculpture. The hair is gathered in a high knot. In style and detail this head goes back to the mature phase of Buddhist art in Tang China, although direct parallels cannot be adduced. It has been suggested that linear iconographical pattern drawings, rather than actual Chinese sculptures, provided the inspiration and the model for this style. RG

Published Choi Sunu 1979, pl. 240;
San Francisco 1979, no. 89

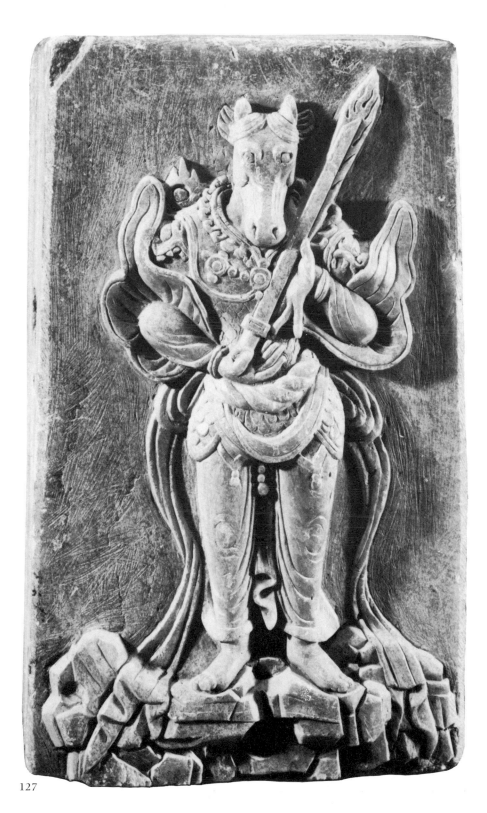

127

127 Zodiac figure of the Horse

Unified Silla, early 8th century AD
Steatite. H 39.3 cm; W 24.0 cm
Excavated in 1973 in Chunghyodong, Kyŏngju,
　North Kyŏngsang province
Kyŏngju National Museum

In East Asia, and especially in the Unified Silla Kingdom, the twelve figures of the zodiac (*sibiji*) but with the appropriate animal heads. During the Unified Silla period it was common to adorn the graves of members of the royal family or high dignitaries with reliefs of the twelve zodiac animals, arranged around the outside of the drum-shaped retaining wall of the tumulus, facing the appropriate directions. In the area surrounding the huge tumulus of the Silla general Kim Yusin (AD 595–673) on Mt Songhwa to the north-west of Kyŏngju, the most famous set of such reliefs can be seen. Besides the reliefs around the mound, three steatite panels with zodiac figures have been found. They had been placed in the ground at some distance from the tumulus, as a kind of additional protection for the whole site. Since the reliefs were thus protected from the weather, they have been exceedingly well preserved in spite of the soft material of which they were made.　　　　　　RG

Published Kang Woo-bang 1973;
Tokyo 1983, no.159

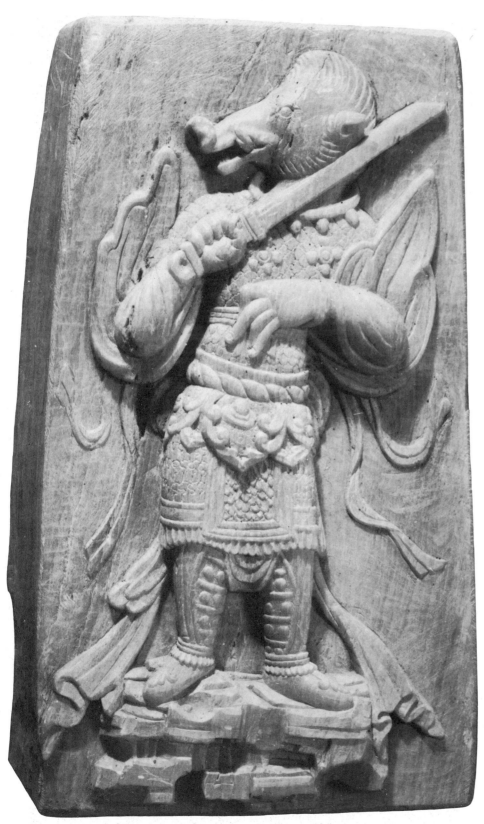

128

128 Zodiac figure of the Boar

Unified Silla, early 8th century AD
Steatite. H 39.3 cm
Excavated in 1973 in Chunghyodong, Kyŏngju,
North Kyŏngsang province
Kyŏngju National Museum

This relief belongs to the same set as no. 127. A
third plaque with the sign of the Rat was also
discovered. The Boar, the last of the twelve
signs, corresponding to the north-north-west
and the Western sign of Pisces, stands, like the
Horse, on a layered rock. The figure wears shoes,
leg-guards and armour, reminiscent of that worn
by the Heavenly Kings (no. 119). The wide ends
of his sleeves billow upwards, and the ends of his
scarves flutter around him. With his right hand
he holds a sword across his left shoulder, and his
plump left hand is held in front of the chest, the
fingers slightly bent. The softness of the model-
ling is noteworthy. The boar's head with tusks
and bristling mane is seen in profile, as is the
case with most of the zodiac animal reliefs. RG

Published Kang Woo-bang 1973;
Tokyo 1983, no. 160

129 Zodiac figure of the Monkey

Unified Silla, 8th century AD
Granite. H 116.0 cm
From the grave traditionally known as that of
 King Sŏngdŏk, Kyŏngju,
 North Kyŏngsang province
Kyŏngju National Museum

This sculpture is from the grave site reputed to be the burial of Sŏngdŏk, King of Silla from AD 702 to 736. Whereas other zodiac figures were carved in relief and placed against the lower half of the tumulus, this work, like the others from the tomb, is fully in the round. Two other figures survive complete, but the remainder, making up the total of twelve, are badly weathered.

The monkey is the ninth animal of the group, corresponding to the Western sign of Sagittarius, and represents the direction south-south-west. The figure is thick-set and stands erect, leaning on a large sword. He wears boots, armour of the kind commonly worn by the Guardian Kings, and over this a cloak-like garment. The face, though damaged, is still raised defiantly. Because of the hardness and brittleness of the material the detail is summarily rendered, especially compared to the two preceding items. In appearance the figure resembles the large stone figures of officials which line the so called spirit ways leading to the more important tombs.

There is evidence that the tomb was not completed at once. The foundation stones were made in the reign of King Hyosŏng (reigned AD 737–42), and the columns and bases around the tumulus in the reign of King Kyŏngdŏk (AD 742–65). The stele was completed in AD 754, and it is presumed that the figures also were made around this time. RG/RW

Published Kang Woo-bang 1973;
San Francisco 1979, no. 90

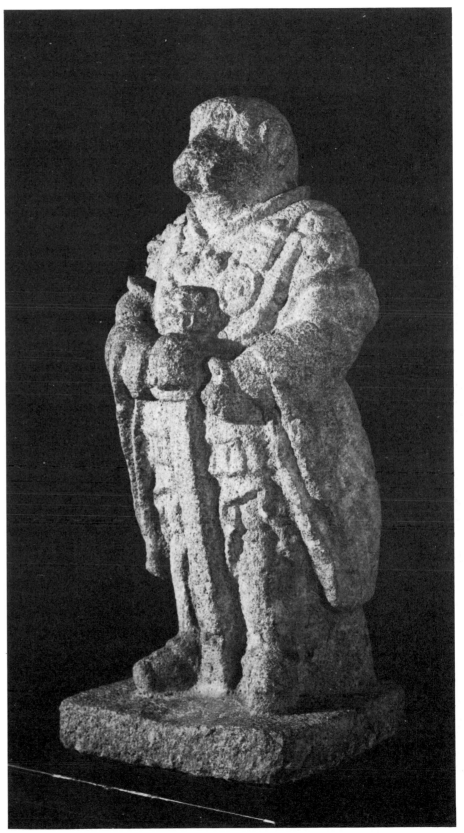

129

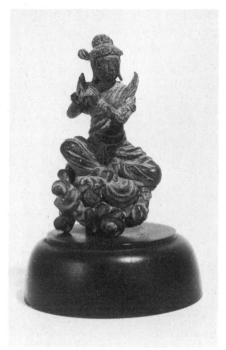

130

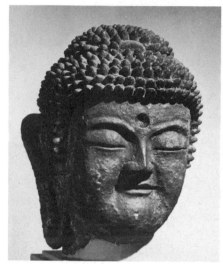

131

no doubt also belonged to the mandorla of a larger figure. RG

Published Hwang Su-yong 1983, pl. 68;
Choi Sunu 1979, pl. 242

130 Apsaras playing a flute

Unified Silla, 9th century AD
Gilt bronze. H 11.8 cm
From Yugŭm-sa, Yŏngdŏk,
 North Kyŏngsang province
National Museum of Korea, Seoul

The figure of an apsaras (*ch'ŏnin* or *bich'ŏn*) sitting on a cloud and making music possibly adorned the mandorla of a fairly large Buddha figure or was placed, together with others, on the walls of a temple hall as part of the symbolic representation of paradise, such as is found in Hōō-dō ('Phoenix Hall') in the Byōdō-in temple at Uji, near Kyōto. This charming figure sits in a relaxed posture – not in the strict attitude of meditation with legs crossed – on spiralling sculptured clouds. The position of the hands and the shape of the mouth indicate that she was originally playing a transverse flute (*hoengjŏk*). Her dress corresponds to that of a Bodhisattva: the legs are covered by a skirt-like dhoti held by a cloth belt. Across the breast and over the shoulders is a shawl which originally arched up over the head. One can still see the ends of this missing portion at the shoulders. The head, with its plump face, is slightly inclined, and altogether the whole figure is full of movement. Around the hair with its high knot is placed a diadem with ornamental medallions. All the details are relatively naturalistic and modelled in the round, thus proclaiming a transition to a new style.

So far only one earlier similar piece has been found at Anap-chi, a relief of an apsaras which

131 Head of the Buddha

Unified Silla or early Koryŏ period,
 10th century AD
Cast iron. H 27.4 cm
National Museum of Korea, Seoul

After the ninth century, mainly for economic reasons, most of the larger pieces of Buddhist sculpture in metal were cast in iron and no longer in bronze. The same thing happened in China and Japan. This head of the Buddha, once part of a large figure, has a full fleshy face with a heavy chin, a small low-set mouth, eyes almost closed in a straight slit, and bulging eyebrows. Rows of tight curls cover the top of the head and the large, relatively flat *usṇīṣa*. In the front part of the *usṇīṣa* one can see a low swelling, free of curls. This occurs also in Chinese and Japanese Buddha heads at least as early as the Song (AD 960–1279) or Fujiwara (AD 898–1185) periods. In the middle of the forehead is the hole for the *ūrṇā*, which was probably of rock-crystal and is now missing. The ears are very long, large and fleshy. This piece shows complete mastery of the difficult technique of iron-casting. The fullness of the sculptural style has not yet become mannered and formalised, as it was to do in the later iron sculpture of the Koryŏ period.
 RG

Published San Francisco 1979, no. 104;
Choi Sunu 1979, pl. 241;
Hwang Su-yong 1983, pl. 77

132 Seated Buddha

Unified Silla, late 9th–early 10th century AD
Cast iron. H 150.0 cm
From Powon-sa Temple, Sosan,
 South Ch'ungch'ŏng province
National Museum of Korea, Seoul

The Buddha sits with legs crossed in the so-called lotus posture. Although both hands are missing, one may conclude from the position of the forearms that the right hand was lowered in the gesture of the 'subjection of the demon king Mara and the touching of the earth' (*hangma-ch'okji-in*) while the left hand lay in his lap. This Buddha may therefore be identified as Śākyamuni. The full, broad-shouldered body makes a powerful impression, and the head is relatively small by comparison with other Buddha figures. The three characteristic folds in the neck (*samdo*) are distinct, and the oval face has well-formed features, a finely curved mouth, straight nose, long and elegantly slanting eyes and arched eyebrows. In the middle of the forehead is an inordinately large hole which once held the *ūrṇā*, no doubt of rock-crystal, and there is another cavity at the bottom of the *usṇīṣa*. The closely fitting monk's robe leaves the right shoulder uncovered and has naturalistic folds. With its clear and monumental forms, in which all superfluous detail is suppressed and which are full of formal tension, this figure of the Buddha is clearly reminiscent of the one from Sŏkkuram from the mid-eighth century. It is a masterpiece of early cast-iron technique in Korea. The joints between the separately moulded parts are easily discernible. Perhaps they were once hidden under a polychrome covering. The artistic quality of the work surpasses that of the two great bronze Buddhas at Pulguk-sa and the one at Paegyul-sa. RG

Published San Francisco 1979, no. 92;
Choi Sunu 1979, pl. 244;
Hwang Su-yong 1983, pl. 70 (detail)

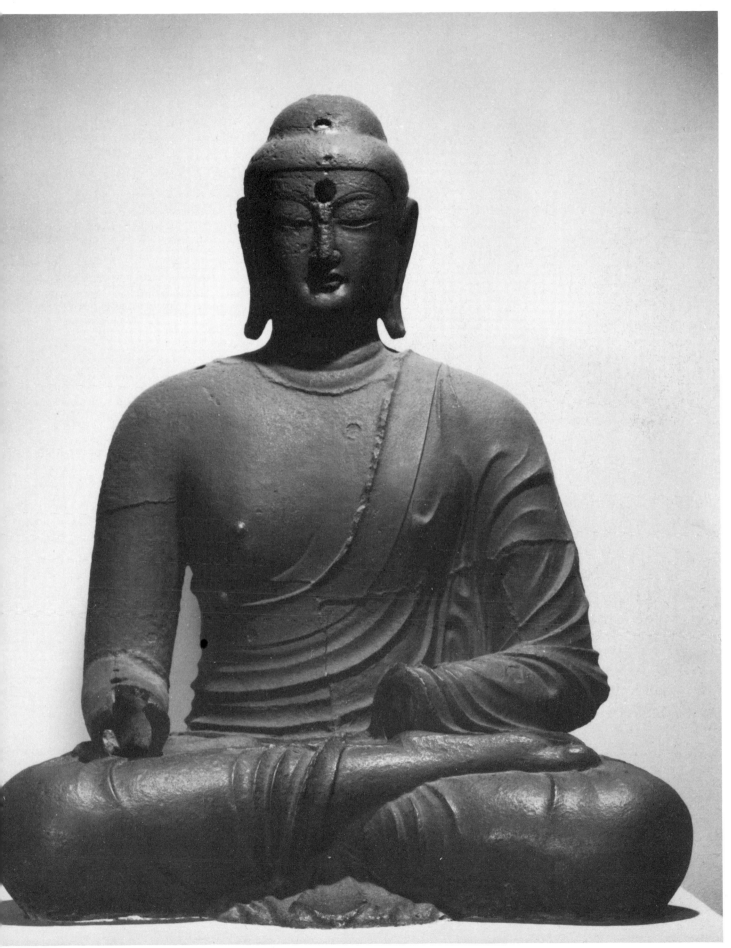

132

4 *Koryŏ Dynasty*
(AD 918–1392)

The Koryŏ period produced some of Korea's outstanding achievements in culture and the arts, despite foreign invasions and internal strife. In its last few decades Unified Silla or 'Great Silla' was no longer a reality. The country had been split into various warring provinces or part-kingdoms, all anxious to gain supremacy. In AD 902 Chin Hwŏn (AD 892–936) proclaimed the kingdom of Later Paekche, but was defeated in AD 936 by his former ally, Wang Kŏn, who had in AD 918, founded the Koryŏ Empire at Ch'olwŏn in Kangwŏn province. Koryŏ claimed legitimacy from the former Koguryŏ kingdom, and in AD 919 Wang Kŏn moved his capital to Kaesŏng in the centre of the Korean peninsula. In October 935 King Kyŏngsun of Silla signed a document of surrender at the Imhae-jŏn palace in Kyŏngju, and left with his family and possessions for Kaesŏng. Friendly relations between the two houses were strengthened by intermarriage, and the subsequent kings of Koryŏ were equally descended from Silla and Koryŏ.

Wang Kŏn began his reign with the proclamation of a series of Ten Admonitions, *sip-hunyo*. Three of them concerned Buddhism, which was established at the core of the new rule, and one reads as follows:

The greak task of our country surely depends on the protecting power of the Buddha. Therefore, build monasteries for [the two leading Buddhist schools] Sŏn and Kyo, dispatch abbots and cultivators of purity, and let them carry out their work.

At first Wang Kŏn and his followers effectively pursued the policies of land reform, centralisation of government, and the furtherance of science and trade. The fourth king, Kwangjong (reigned 949–975), established a bureaucracy and state examination system, and proclaimed his own reign-title, calling Kaesŏng the Imperial City.

Since it was the aim of the Koryŏ kings, implicit in the name chosen for the dynasty, to regain the former Koguryŏ territory, confrontations were inevitable on the northern borders. From the eleventh century onwards, there were repeated invasions from the north by the Khitan Liao and subsequently the Jurchen, whose Jin empire replaced Liao and conquered the north of China. Culturally, this threat from the north led to a greater respect for Song China in Korea of the Koryŏ period. As the land route was blocked, Koryŏ official contacts and trade with the Song court were maintained by sea.

For Koryŏ itself the twelfth century was a time of relative peace and of prosperity, during which some of its finest art objects and celadon wares were produced. To Song China Koryŏ sent gold, silver, bronze, paper, brushes, inkstones and fans, together with ginseng and pine-kernels, while importing in return silk, books, ceramic wares, materia medica, perfumes and musical instruments. The extent of this trade can be gauged from the memorial submitted to the Chinese emperor by the famous scholar and poet Su Shi (Su Dongpo, 1036–1101), who petitioned for a ban on the purchase of books and manuscripts by visiting Koreans. Literary forms and poems from China also became an important influence for the literary class in Korea. Little remains of secular painting, but during the reign of King Injong (1122–46) it is recorded that Yi Nyŏng was a famous painter and his painting *Yesŏngkang-do* was praised by Emperor Huizong of Song.

Against this background of peaceful economic and cultural exchange with Song China, there was growing political unrest within Koryŏ. In AD 1170 a military coup effectively removed power into the hands of the military Choi clan, who retained it for nearly a century, until their inability to resist the Mongol invasions

of the twelfth century led to their execution and the end of military rule. In AD 1259 the Crown Prince, later King Wŏnjong, signed a peace treaty with the Mongols and the last two centuries of the Koryŏ dynasty were marked by constant economic and cultural contacts with China under their rule. Koryŏ kings were forced to marry Mongol princesses, and their heirs to live in Peking.

From the beginning of the Koryŏ period Buddhism occupied a prominent position. The support of the royal family and the aristocracy, seeking by meritorious deeds to be reborn in the Western Paradise after death, and to ensure their happiness and prosperity in their present life, meant that monasteries grew rich in wealth, land and political power. Numerous rites and *pŏphoe* (meetings when eminent monks discoursed on the Buddhist scriptures and prayed for the national welfare) were held on the king's birthday and other special occasions. In the first years of the reign of King Hyŏnjong (1009–31) the carving of the Korean Tripitaka was begun and in AD 1087 under King Sŏnjong it was completed. This enormous undertaking had a dual purpose, both the ordering of the entire corpus of Buddhist scriptures, and in order to pray for the Buddha's protection against the Khitan invasions. Later the eminent priest and National Preceptor Ŭich'ŏn (1055–1101), fourth son of King Munjong, collected Buddhist scriptures and commentaries from Song and Liao, and established the Changgyŏng Togam (Royal Buddhist Scriptures Bureau) to work on the *Sokchanggyŏng*, the second collection of the Buddhist canon.

When the first edition of the Korean Tripitaka, stored in the Puin-sa, Taegu, was destroyed in the Mongol invasion, another edition was begun in the reign of King Kojong (AD 1213–59) when the court took refuge on Kanghwa Island, and was completed during the war. Entitled *Koryŏ taejang-gyŏng*, its 81,137 carved wooden printing blocks are still preserved in the Hae'in-sa temple, and it is regarded as one of the best among a total of twenty editions of the Tripitaka carved in East Asia because of its correct content, beautiful calligraphy and excellence of carving.

An important aspect of the Koryŏ dynasty is the efforts that went into literature and the compilation of historical records. By an imperial edict of 1145, Kim Pusik compiled *Samguk sagi* (Historical Records of the Three Kingdoms), using the *Ko Samguksa* (Old History of the Three Kingdoms) and Chinese historical materials. His work was written on the model of Chinese official histories and from a Confucian viewpoint. Another important historical work, of a completely different character, was written during the reign of King Ch'ungyŏl (1274–1308) by Iryŏn (1206–89), a prominent Buddhist monk. Entitled *Samguk yusa* (Reminiscences of the Three Kingdoms), it included myths and stories, beginning with the legendary founder of Korea, Tan'gun. These had been omitted by Kim Pusik in *Samguk sagi*. Iryŏn's purpose was in part to foster Korean national consciousness and independence at a time when these were threatened by the Mongol invasions. In this way Buddhist priests played an important role in the political and cultural life of Koryŏ.

RW/YSP

133 Model of a temple banner staff

Koryŏ dynasty, 12th–13th century AD
Bronze with traces of lacquer and gilding.
 H 73.8 cm; base 20.9 x 16.0 cm
Provenance unknown
Hoam Art Museum, Yongin; National
 Treasure no. 136

This model is an accurate reproduction in minia-ture of the flagstaffs which stood outside Buddhist temples in Korea from the time of the Three Kingdoms, one on each side of the main entrance. At the Mirŭk-sa or Maitreya temple, erected in the seventh century AD under Paekche and probably destroyed during the Koryŏ dynasty, there are impressive remains of a giant stone pagoda, with the stone foundations for twin flagstaffs at the entrance, one hundred metres apart. The stone bases with their supports stand about three metres high. If we relate their pro-portions to those of this model, the Mirŭk-sa flagstaffs must have stood about twelve or thirteen metres high.

 In this model the base with its supports, and the two lower sections of the flagstaff, were cast separately from the rest of the pole and the head, and then assembled. JHW

Published Chin Hong-sop 1978b, pls 98–9;
Choi Sunu 1979, pls 185–6

134 Cylindrical box

Koryŏ dynasty, 11th–12th century AD
Bronze, inlaid with silver. H 9.9 cm; D 18.3 cm
Hoam Art Museum, Yongin; National
 Treasure no. 171

Bronze continued to be the most popular material for objects of daily use, such as this box, which probably served to store incense. It is a notable feature of the Koryŏ period that re-ligious objects often lacked identifiable iconog-raphic motifs. Here the lively and agreeable decoration consists of wide bands of foliage, with a central medallion with a phoenix flying among stylised clouds.

 The technique of gold and silver inlay had already been brought to a fine art in China towards the end of the Zhou period (fifth–fourth century BC). The oldest example of inlay so far discovered in Korea is a bronze sword-hilt with gold and silver inlay, found in a Kaya grave of the fifth–sixth century AD. Korean inlay in metal differs from Chinese work in that it is always linear. Where broader surfaces were to be sug-gested, they were defined by contour lines only.
 JHW

Published Chin Hong-sop 1978b, pl. 100;
Choi Sunu 1979, pls 202–3; Hoam 1982, pl. 141

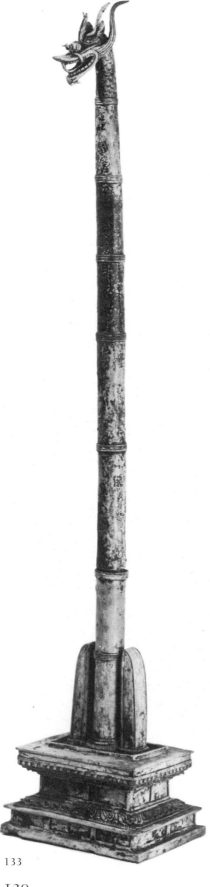

133

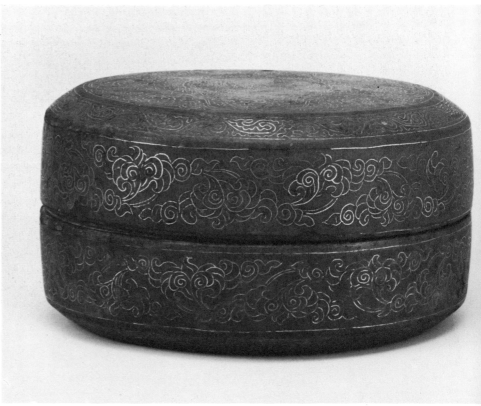

134

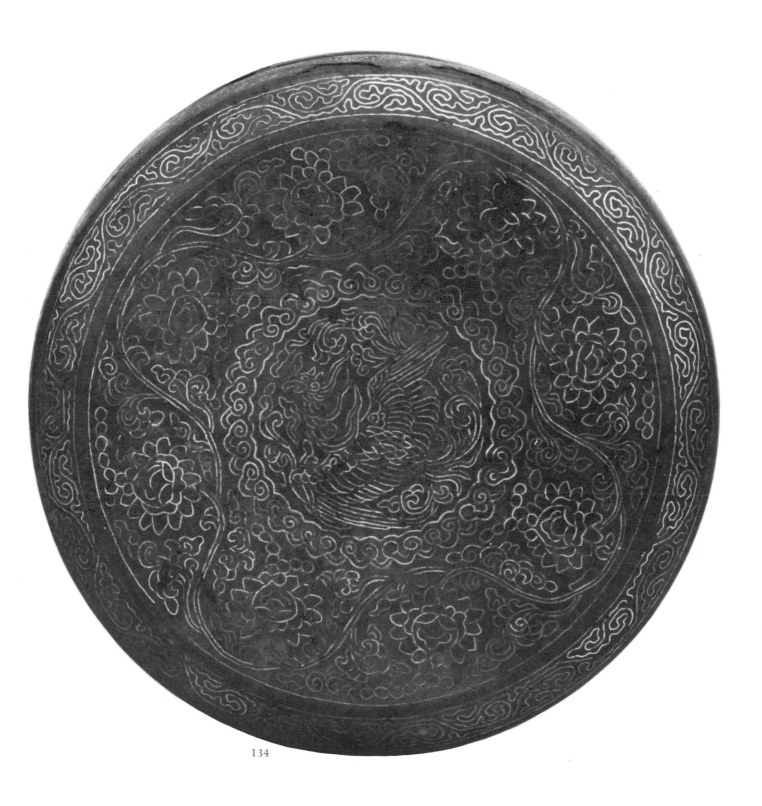

134

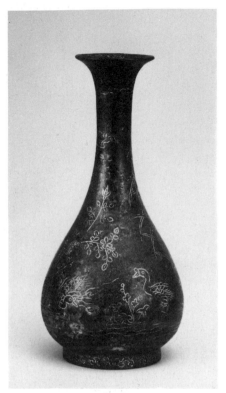

135

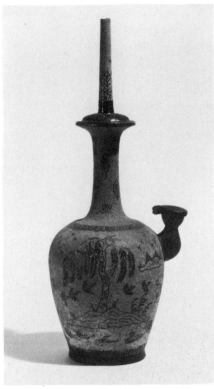

136

135 Bottle

Koryŏ dynasty, 11th –12th century AD
Bronze, inlaid with silver. H 21.0 cm;
D (mouth) 5.6 cm, (foot) 7.0 cm
Provenance unknown
National Museum of Korea, Seoul

The shape of this elegant bottle, with its slender neck and body widest near the base, is evidently closely related to contemporary ceramics, including Koryŏ celadons of the twelfth century. In China it is found in the Northern Song dynasty and the form remained popular throughout the Jin and Yuan periods, that is from the tenth to the fourteenth centuries. Tang dynasty bottles, and those held by images of Avalokiteśvara in the Unified Silla period, had an ovoid body.

The decoration, with ducks, reeds, and flowering plants, was to become a leitmotif in Koryŏ inlaid celadons as well as metalwork. In the famous Liao mausoleum of the early eleventh century at Qingling, with wall-paintings of the Four Seasons, ducks swimming in a similar scene are the main subject of the Spring landscape. The scene on the bottle is not just a vignette but covers the whole surface, with ducks swimming around the neck near the top as well as those seen in varied attitudes near the base. As there were political and cultural exchanges with Liao, especially in the first half of the

eleventh century, and as Koryŏ celadons have been found in Liao tombs, such resemblances cannot be purely fortuitous. RW/YSP

Published Lee Nan-young 1978

136 *Kuṇḍika*, Buddhist ritual sprinkler

Koryŏ Dynasty, 11th–12th century AD
Bronze, inlaid with silver. H 37.5 cm; D (foot) 9.8 cm
National Museum of Korea, Seoul;
 National Treasure no. 92

The *kuṇḍika* or water-sprinkler came to East Asia from India, where since ancient times it had been part of the standard equipment of a Buddhist monk. Such vessels have a very narrow mouth to sprinkle water for purifying, and a shorter opening with a fitted lid, mounted on the shoulder, for filling with water. The piece shown here is one of the masterpieces of Koryŏ metalwork. The subject is a landscape, which surrounds the whole of the main body of the vessel, with not only flying and swimming ducks, but men fishing or boating. In the centre of one side a large willow tree seems to be a specifically Korean addition to the landscape theme. The

overlapping device used to represent triangular banks and hills or islands is an ancient one, and archaic elements are also seen in the difference of scale between these and the reeds growing from them.

The whole vessel, though originally dark (relieved by the playful motifs of the inlaid landscape), is now covered with a fine green patina which has greatly changed its appearance. The delicate openwork mounts for the division of the neck and the cover of the filling spout, as well as the base, are in silver. RW/YSP

Published San Francisco 1979, no. 109, pl. XX;
Chin Hong-sop 1978b, pls 82–4

137 Buddhist incense-burner

Koryŏ Dynasty, probably 13th century AD
Bronze, inlaid with silver. H 30.4 cm;
 D (mouth) 27.5 cm, (foot) 22.3 cm
Hoam Art Museum, Yongin

Numerous incense-burners with a deep basin and broad projecting rim were made during the Koryŏ dynasty. A prototype of the form is known in Cizhou stonewares of the eleventh century in north China (Mino 1980, pls 24–5), and the earliest Korean examples, which are less angular and more rounded in shape, date from the twelfth century. The censer from the Hoam Museum, shown here, is the only one to have a design of ducks and willows, like the *kuṇḍika* (no. 136). Other Koryŏ metal censers with silver or gold inlay display Sanskrit *siddham* or 'seed' characters in large medallions, with a ground of lotus scrolls. Some are decorated with dragons on the base. Such censers are quite heavy and were usually made in two pieces, with a projecting flange on the stand fitting into a recess under the bowl.

The inscription in five columns enclosed in a lotus cartouche is undated. After the names of the donors, it expresses their sincere wish that, together with all other sentient beings, they be released from suffering, obtain joy and attain perfect wisdom without delay. Other examples, some of them dated, specify the precise building of the temple for which the censer was intended: these include the golden or main hall, lecture hall, refectory, hall for storage of sutras, etc.
 RW/YSP

Published Hoam 1982, pl. 148;
Hwang Su-yong 1978b, p. 484 (inscription)

138 Miniature eleven-storey pagoda

Koryŏ Dynasty, 12th–13th century AD
Bronze. H 74.5 cm;
National Museum of Korea, Seoul

The shape of East Asian pagodas differs considerably from the rounded form of the Indian *stūpa*, the function of which they continue. Instead, they took the form of Chinese wooden architecture, rising in many storeys. They are crowned with a mast bearing a series of rings, corresponding to the Indian *chatras* or honorific parasols. This mast always rises out of a hemisphere on a square, the basic form of the Indian *stūpa*.

This model, one of several known from the Koryŏ period, shows how the vanished wooden pagodas of Korea must have looked, even to the appearance of the steps leading to the first floor. The construction shows clearly how the mast at the top rises all the way from the base of the structure. At the first storey small figures of the Four Heavenly Kings stand on guard. Although tiny, they can be seen to be wearing armour like the larger figures on which they were modelled (cf. no. 119). It is likely that the panels from Sach'ŏnwang-sa (no. 124) may originally have been set around the central mast at this level. Above, dragons look out from the four corners of each roof, though only the lowest ones are described in detail. At each storey the details of the wooden architecture, railings, columns and bracket system, are faithfully rendered in bronze. The *chatras* are surmounted by a *cintāmaṇi* or precious jewel and a finial at the very top.

RW/YSP

Published Chin Hong-sop 1978b, pls 90–1

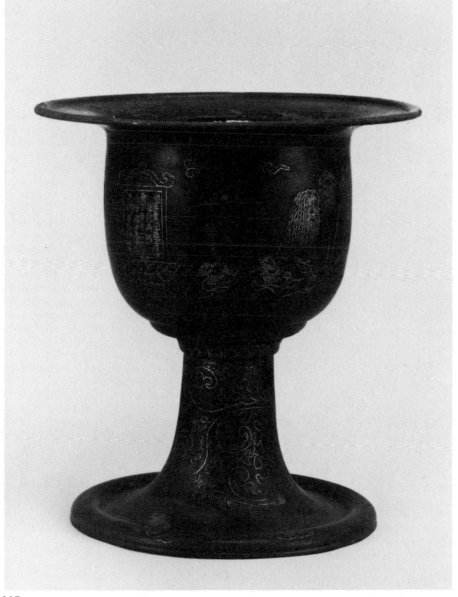

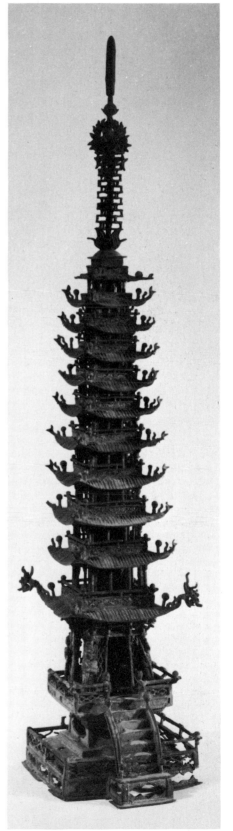

137

138

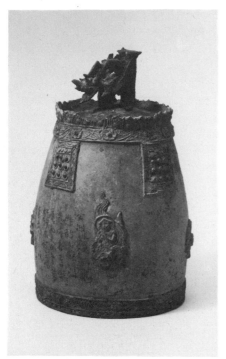

139

139 Buddhist bell

Koryŏ dynasty, probably AD 1338
Bronze. H 25.0 cm; D (mouth) 15.0 cm
Horim Art Museum, Seoul

Like incense-burners, bronze bells were essential for the daily routine in Buddhist monasteries. They served practical as well as ritual purposes: the smaller bells were used to mark times of day and call monks to services or meals, while the largest bells were struck for the services at the beginning and end of the day and were heard far beyond the monastery itself. Korean bells include the largest and finest of the Far East. The oldest, dated AD 725 is in Sangwŏn-sa on Mt Odae; the most famous and largest, now in Kyŏngju National Museum, is from Pongdŏk-sa and is 3.33 m high. Numerous inscribed and dated Silla and early Koryŏ bells are to be found in collections in Japan (Tsudoi 1974, *passim*; Hwang Su-yong 1978b, *passim*).

Several features distinguish Korean bells from those made in China and Japan. The suspension loop is always a single dragon head, behind which is a short hollow post whose function is not clear. Bands of floral ornament mark the top and bottom of the bell, and four panels each with nine knobs are placed next to the top border. These have a distant origin in Chinese bronze bells, but other decorations in low relief, of Buddhist figures on clouds, are only found in Korea. Each of the nine knobs is the centre of a small lotus, and larger lotus medallions in the lower zone mark the striking points. Although

the size of Korean bells diminished with time from Unified Silla to Koryŏ, this idiom was not abandoned.

This bell is said to have been excavated in 1966 in Kongju. The inscription incised in seven columns says that the donor made this small bell for a temple in Kongju. The name of the maker and the weight of the bell (six *gŭn*) are also inscribed, with the date *muin*, probably corresponding to AD 1338. RW/YSP

Published Hwang Su-yong 1978b, pp. 320–1 (inscription); Tsudoi 1974, pp. 171–2

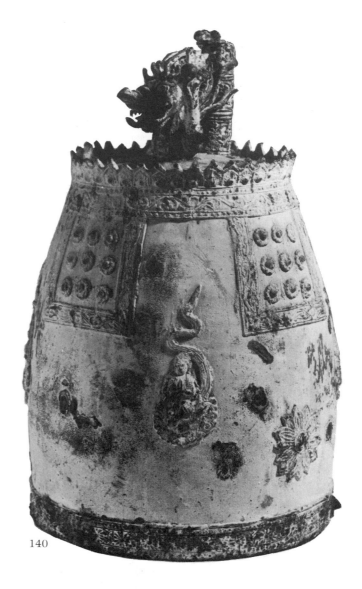

140

140 Buddhist bell

Koryŏ dynasty, 13th–14th century AD
Bronze. H 40.5 cm; D (mouth) 25.0 cm
National Museum of Korea, Seoul

This bell is probably of similar date to no. 139. As with many Korean bells, the dragon emerges bodily from the top of the bell, its neck braced by the hollow cylinder behind it, and curves sharply forwards. One forefoot is raised aloft with a pearl. The modelling still displays some of the strength seen in the dragon finial for a Buddhist banner staff (no. 125). On the sides of the bell the four adoring apsarasas on individual clouds are gently modelled. There are three lotus rosettes at the striking points. The space for the fourth is left blank for an inscription that was never added. RW

Published San Francisco 1979, no. 156; Tsudoi 1974, pp. 191–2

Koryŏ Ceramics

In many respects ceramics reached their zenith during the four centuries of the Koryŏ dynasty. They became used for a wider variety of purposes: Silla shapes, mostly designed for use in ritual, gave way to softer, more gentle lines. The most famous Koryŏ ware was *ch'ŏngja*, porcellanous stoneware with a fine bluish-green glaze, known in the West as celadon. Besides this an unglazed, high-fired dark-grey stoneware was still produced. It was fired like the Silla ware, but the shapes were typical of Koryŏ. This was the pottery in ordinary use, whereas celadon was used in court circles and in Buddhist temples. The clay was noted for its purity, and the Koryŏ celadon ware, much of which has been preserved, bears vivid witness in its variety to the more refined lifestyle and taste of the aristocracy and to Buddhist patronage.

There were about 270 kilns in existence in the Koryŏ period. Of these, about 240 were concentrated in Chŏlla province. The most important centres of production were Sadang-ri in Kangjin district, and Yuch'ŏn-ri in Puan district. They were regarded to some degree as the official factories. Excavations carried out at Koryŏ celadon kiln sites by National Museum personnel since the 1960s have facilitated dating, but the most significant datable pieces come from those tombs of kings or senior officials that have not been plundered.

In the view of Choi Sunu, Chinese techniques were introduced to Korea by two different routes. Northern techniques were used as early as the beginning of the tenth century in central Korea, at Kyŏngsŏ-dong, Inch'ŏn district, and at Sosan in South Ch'ungch'ŏng province. The kiln was a gently sloping tunnel with a single chamber, and the shapes include long-necked bottles and dishes reminiscent of Tang ceramics. Southern techniques following the Yueyao tradition were probably introduced by sea to Kangjin and Puan, and became widespread in the first half of the tenth century. The wares produced at Yongun-ri in Kangjin have shapes and foot-rings closely connected with Yue celadon ware of the late eighth century. A group of kilns for white wares, with a broad foot-ring similar to that of Yue ware, has been discovered at Sŏ-ri, Yong'in, in Kyŏnggi province. As early as the tenth century, the northern Chinese Cizhou production technique was adopted in Korea. In Tŏkpo-ri, Pusan, a kiln has been found which made celadons with floral decoration painted in brown iron oxide under the glaze (*ch'ŏlhoe ch'ŏngja*). The iron-brown underglaze technique is derived from Cizhou ware, but the brushwork of the Korean pieces has a character all its own (no. 141).

Koryŏ ceramics reached their peak in the celadons of the first half of the twelfth century. The shapes vary considerably, the most common being dishes in the form of a flower (no. 143), wine ewers in the form of a melon or gourd, wine-cups with matching stands, *maebyŏng* vases, censers with the cover in the form of an animal (no. 145), and water-droppers in the form of human figures or of fruit. The Chinese envoy Xu Jing, who visited the Koryŏ court in AD 1123, expressed his admiration of Koryŏ celadons in the account that he wrote of his visit, *Xuanhe fengshi Gaoli tujing.*

Among the best-known celadon pieces of the first half of the twelfth century are those from the tomb of King Injong (reigned AD 1123–46). Some celadons of this period have plant, phoenix or dragon motifs, either finely engraved or moulded. They include celadon roof-tiles with moulded arabesque motifs, examples of which have been found at the kilns of Sadang-ri (excavations conducted by Choi Sunu in 1964) and at the site of the Yang'i-jong pavilion, which according to the official

history, *Koryŏ-sa*, was erected in AD 1157 in the reign of King Ŭijong (AD 1147–70). Other items of celadon were decorated with dark iron-brown or with copper-red under the glaze, and there were some rare pieces of marbled ware. Above all the quality of white ware (*paekja*) was brought to a high level, being produced in Puan district on the south-west coast and at Tangjŏn-ri, Kangjin.

Towards the middle of the twelfth century an important innovation took place in decoration, the inlay technique known to Koreans as *sanggam*. Its invention was of very considerable importance for the production of ceramics. The decoration is carved or incised on the unglazed, leather-hard body, and inlaid with white or black slip. The surplus slip is wiped off before the vessel is glazed. The preferred decorations are lotus and peony scrolls, chrysanthemum medallions or panels, borders of wavy lines, double lotus petals, and *ruyi* cloud motifs. Typically Korean are cranes flying among clouds and ducks swimming beneath a willow tree. This last subject was also used in earlier Koryŏ metalwork. Celadon ewers often echo the shape of metal pieces, and the decoration of small cosmetic boxes and oil jars is closely linked with the lacquerwork of the Koryŏ period. Sometimes the background, instead of the design, was cut away and inlaid with white slip, a method known as 'reverse inlay', *yŏksanggam* (no.156). Among the earliest datable examples of this type is a celadon bowl with arabesque decoration from the tomb of one Mun Kong-yu, who died in AD 1159.

The glaze on inlaid pieces has a more transparent appearance than on celadons without inlay, and is generally crackled. It derives its special colour from the 3% iron that it contains. Common shapes with *sanggam* decoration are *maebyŏng* vases, dishes, wine ewers and wine bottles in different shapes, and cosmetic oil bottles. Important kilns using the *sanggam* technique are at Sadang-ri in Kangjin district, and Yuch'ŏn-ri in Puan. Excavations conducted at Sadang-ri since 1964 have shown that the kiln there was on a natural slope, rising at an angle of 5–6 degrees. It has a sandy sloping floor with a number of chambers, each with two or three openings. The Sadang-ri kiln is still 7 m long, but successive repairs had raised the floor and narrowed the interior from its original 143–151 cm to its present 112–130 cm. The sites preferred for kiln construction moved in the course of time from the hills to the coastal area.

In the second half of the thirteenth and during the fourteenth century celadon dishes often bore a cyclical date or the name of an official department, or the designation of a royal tomb. There was a decline in the quality of glaze and body; the decoration became simpler or more stylised, and its execution generally more coarse. This decline in the celadons of this time may be attributed to the unsettled conditions as a consequence of the Mongol invasions which began in AD 1231. For the shape of the vessels of this time a solid, practical style was preferred. Important types had decoration painted in gold (*hwagum ch'ŏngja*) or in underglaze copper-red (an example of which was the gourd-shaped ewer with lotus decoration from the tomb of Choi U, also known as Choi I (d. AD 1249), excavated in 1961 on Kanghwa Island). Celadons with copper-red decoration were produced at Yulpo and Yuch'ŏn-ri in North Chŏlla province. They were made as early as the first half of the twelfth century, although only a few pieces, such as a bowl in the British Museum, now remain. The copper-red technique did not become popular in China until the Yuan period (AD 1280–1368).

Koryŏ celadons represent a major achievement in Korean art, and have been

highly prized in the Far East and in Europe for their unusual charm. With the subtle variations in the colours of the glaze from greyish-blue to olive-green, the gracious elegance of their shapes and their inlaid decoration, unique in both technique and subject-matter, the celadons reflect the refined taste and pleasures of the Koryō aristocracy. As an example, the following verses are inlaid in black slip in two panels reserved among carved lotus scrolls on a double-gourd celadon wine bottle of the mid-twelfth century, in the collection of the National Museum, Seoul (*Sekai tōji zenshu*, vol. 18, *Kōrai*, 1978, pl.60):

The bottle is like green jade, finely engraved with golden flowers
A noble family should use it, filling it joyfully with wine.
One should revere old age and know how to greet an honoured guest
We cherish the Spring, and sit intoxicated by the mirror of the lake.

STB

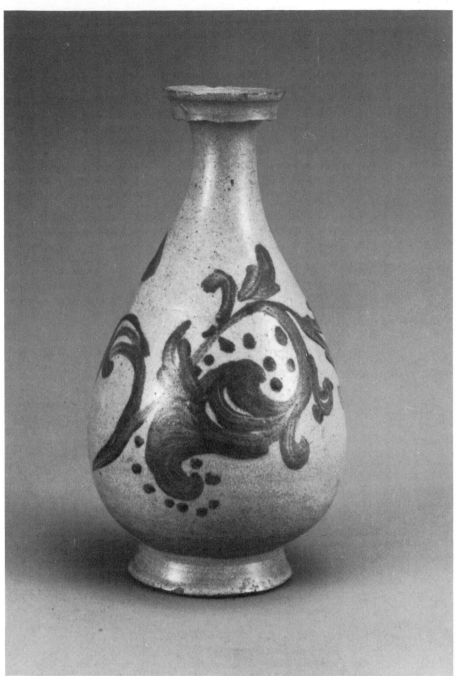

141

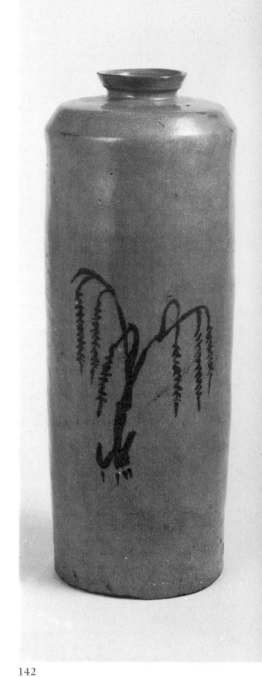

142

141 Bottle

Koryŏ dynasty, late 11th century AD
Stoneware with iron decoration under a
 celadon glaze. H 22.5 cm; D (mouth) 5.4 cm,
 (base) 7.9 cm
National Museum of Korea, Seoul

This pear-shaped bottle with its sturdy, splayed
foot is very reminiscent in shape of Chinese
work of the Tang period. Its solidity, and the
porosity of the clay, date it in the earlier phases
of Koryŏ ceramic production.

The semi-abstract floral design, painted in
iron on the body of the vessel, is executed in
spontaneous and lively brushwork. The tech-
nique is derived from the Song dynasty Cizhou
ware, and was introduced into Korea as early as
the twelfth century AD, although its combination
with a celadon glaze is a Korean feature. STB

142 Cylindrical bottle

Koryŏ dynasty, 12th century AD
Stoneware with underglaze iron decoration.
 H 31.2 cm; D (mouth) 5.5 cm, (foot) 9.6 cm
National Museum of Korea, Seoul;
 National Treasure no. 113

This cylindrical bottle is a rare type in Koryŏ
ceramics.

The weeping willow, painted in brownish
black under a honey-coloured glaze, creates a
spontaneous, almost modern effect, lending life
to the neat cylindrical shape. STB

143 Pair of lobed dishes

Koryŏ dynasty, early 12th century AD
Stoneware with celadon glaze. Each: H 3.8 cm;
 D 17.9 cm
National Museum of Korea, Seoul

These two dishes form part of a five-piece set
discovered in the grave of an unknown man of
the Koryŏ period.

The delicate fluting and twelve-fold division
of the two flat-bottomed dishes represent
chrysanthemum flowers. They are faintly
reminiscent of the Guan ware of the Song period.
The natural shape of the flower, and the very
thin walls, however, give them a distinctive
Korean character.

The delicate greyish-blue glaze prompts a
comparison with the celadon ware of high tech-
nical quality found in the tomb of King Injŏng,
in Changdan-gun in the province of Kyŏnggi.

Fascinating dishes like these with their finely
textured body seldom remain intact. They were
produced in the kiln at Sadang-ri in South Chŏlla
province. Three spur marks remain as slight
indentations on the base. STB

Published Choi Sunu 1975, p.17, fig. 5;
Kodansha 1976, pl. 10; Sekai Tōji 1978, p. 11,
fig. 3; San Francisco 1979, no. 113.

143

144 Bottle

Koryŏ dynasty, 12th century AD
Stoneware with celadon glaze. H 25.2 cm;
 D (mouth) 4.7 cm, (foot) 7.1 cm
National Museum of Korea, Seoul

This elegant, long-necked bottle with a pear-
shaped body and slightly everted lip was prob
ably used for wine. In comparison with the Ru
ware bottles of the Song period, this has a much
lower foot-ring and broader body. The bottle is
coated with a thick smooth, slightly matt light-
grey glaze, delicately shaded and finely crackled.
The base of the vessel is also glazed, and has
three spur marks. STB

Published Choi Sunu 1975, pl. 4

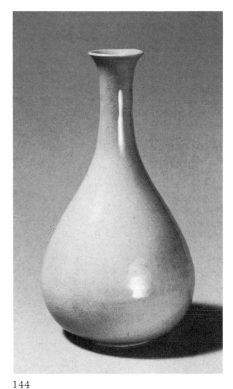

144

145 Censer with cover
in the form of a *kirin*

Koryŏ dynasty, first half of the 12th century AD
Stoneware with celadon glaze. H 17.6 cm
National Museum of Korea, Seoul

This is one of several types of celadon censer
with lids in the form of fabulous animals. The
animals most commonly found were the phoenix,
the lion or, as in this instance, the *kirin* or
'unicorn'. The body of the vessel is cylindrical,
with a finely engraved decoration of clouds, a
flat, boldly projecting rim, and three feet, each
with a moulded lion mask. Many fragments of

such lion masks for the feet of censers like this
have been found in the kilns at Sadang-ri in
South Chŏlla province. The greyish-blue glaze
has collected thickly in the vessel's indenta-
tions, and has a fine network of crackle. The
mouth of the *kirin* is open to allow the
incense smoke to escape. STB

Published Sekai Tōji 1978, pl. 31

145

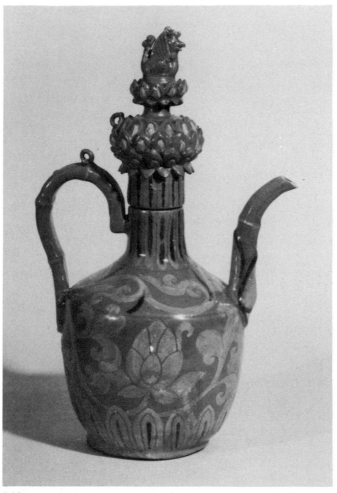

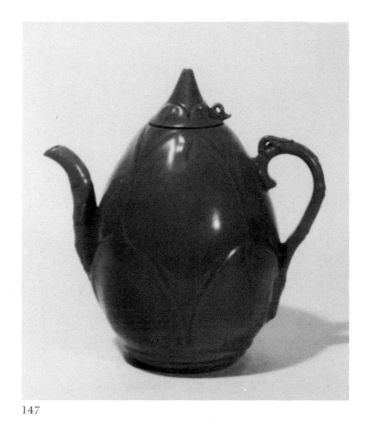

146

147

146 Wine ewer with lid in the form of a lotus and duck

Koryŏ dynasty, early 12th century AD
Stoneware with celadon glaze with decoration
 painted in white slip and underglaze iron.
 H 33.8 cm; D (mouth) 2.2 cm, (base) 9.6 cm
National Museum of Korea, Seoul

This ewer with foot-ring has a handle and spout in the shape of bent bamboo, and a fluted neck. On the cover are two lotus blossoms, placed one above the other, and crowned with a duck about to take flight. The shape of this celadon ewer is derived from the twelfth-century metalwork of the Koryŏ period. Lotus tendrils twine around the body, painted in white slip and with finely engraved contour lines. There is a border of double lotus petals, picked out in white and brown brushwork around the foot-ring. Vertical brown stripes adorn the neck. Trapped bubbles give an opaque appearance to the pale-green glaze, and there are occasional light-brown flecks. STB

Published San Francisco 1979, no. 150;
Seoul 1981, pl. 219

147 Wine ewer in the form of a bamboo shoot

Koryŏ dynasty, first half of the 12th century AD

Stoneware with celadon glaze. H 23.5 cm;
 D (foot) 8.4 cm
National Museum of Korea, Seoul

The egg-shaped body of this beautifully made covered ewer is integrally carved in the shape of a bamboo shoot. The individual leaves in high relief have the veins lightly incised, and the bamboo stem is delicately suggested by the downward curving handle and spout. Both the refined shape and the slightly opaque greyish-blue glaze of the ewer bear witness to the skill of the Koryŏ potters. Fragments of this kind of ewer have been found in the kiln at Sadang-ri, South Chŏlla province. STB

Published Choi Sunu 1975, pl. 24;
Kodansha 1976, pl. 14.

148 Bowl with lobed rim, decorated with a peony flower *(colour ill.)*

Koryŏ dynasty, first half of the 12th century AD
Stoneware with celadon glaze and carved
 and incised decoration. H 6.1 cm; D 19.2 cm,
 (base) 5.2 cm
National Museum of Korea, Seoul

The beautiful shape of this dish, with its rim with six notches and the delicate fluting of its outer surface, is reminiscent of an opened flower.

The foot-ring, angled inwards, gives balance to the vessel. Its charm is enhanced by the fine decoration inside, showing a carved design of a peony in full bloom. In East Asia the peony was a symbol of wealth and reputation. Fragments of dishes with carved peony designs have been unearthed in China at the Yue kilns near Lake Shanglin, at Yuyao xian in Zhejiang province. The dish is covered fairly thickly with a grey-flecked, bluish celadon glaze, known by the Koreans as *pisaek-ch'ŏngja*. The decoration is very skilfully executed, and this, together with the colour of the glaze and the consistency of the clay, is typical of products of the first half of the twelfth century, when the finest Korean celadon ware was produced. Fragments of celadon dishes of this kind have been unearthed in the kiln at Sadang-ri, South Chŏlla province. STB

Published San Francisco 1979, no. 123;
Kodansha 1976, pl. 17.

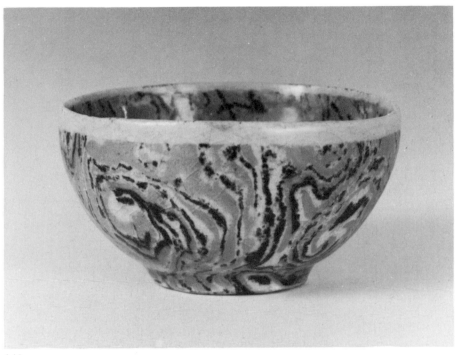

149

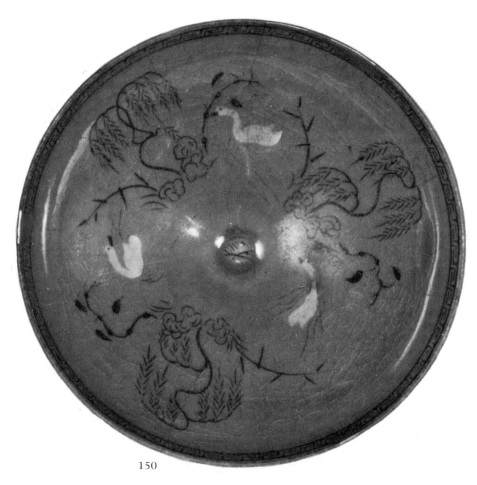

150

149 Bowl

Koryŏ dynasty, first half of the 12th century AD
Marbled stoneware with celadon glaze.
 H 5.0 cm; D (mouth) 9.5 cm, (foot) 4.4 cm
National Museum of Korea, Seoul

This dish is a good example of the rare marbled ceramic ware of the Koryŏ period. Three different clays were kneaded together before throwing, to produce a marbled effect. Pieces like this, mostly small in size, were then coated with celadon glaze. There were marbled ceramics in China during the Tang period, though the Chinese ware differed from the Korean in the colour of the glaze and body. Korean marbled ware was produced at Sadang-ri, South Chŏlla province, and Yuch'ŏn-ri, North Chŏlla province. STB

Published Choi Sunu 1975, pl.135;
San Francisco 1979, no.144.

150 Bowl with weeping willow and ducks

Koryŏ dynasty, first half of the 12th century AD
Stoneware with celadon glaze, inlaid in
 sanggam technique. H 4.5 cm; D 14.1 cm
National Museum of Korea, Seoul

This dish is one of the charming early celadon products, decorated inside with a design of weeping willow and swimming ducks. The white ducks in various swimming attitudes make an effective contrast with the groups of black trees, executed in a well-defined inlay technique under a finely crackled celadon glaze. There is a frieze of wavy lines, also graphically executed in inlay, surrounding the mouth of the vessel. Finely engraved waves are visible in the centre of the dish. The vessel had been repaired with gilt lacquer. Fragments of this kind of celadon ware have been discovered in the kiln at Yuch'ŏn-ri (North Chŏlla province). STB

Published Kodansha 1976, pl.34

151 *Maebyŏng* with crane, plum and bamboo *(colour ill.)*

Koryŏ dynasty, mid-12th century AD
Stoneware with celadon glaze, inlaid in
 sanggam technique. H 39.1 cm;
 D (mouth) 6.2 cm, (foot) 15.6 cm
Seo Won-seok Collection

The *maebyŏng* or 'plum vase', with narrow neck and broad shoulders tapering to the base, was a favourite type in the Koryŏ period. The Korean shape is distinguished from that of its Chinese forerunners by the more pronounced arching of the shoulders.

The tall bamboo and plum trees in inlaid black slip, and the white cranes and plum blossoms beneath the celadon glaze, are the work of

a skilled painter. A border of cloud motifs encircles the rounded shoulders, and inlaid borders of wavy lines outline the narrow collar at the mouth of the vessel and the edge of the base. It may be dated among the somewhat earlier pieces with *sanggam* decoration. The glazing is very delicate, and is given a slightly opaque appearance by the bubbles trapped inside. STB

152 *Maebyŏng* and cover with cranes and clouds

Koryŏ dynasty, mid-12th century AD
Stoneware with celadon glaze, inlaid in
 sanggam technique. H (with cover) 39.0 cm.
 (without) 36.3 cm; D (mouth) 6.1 cm,
 (foot) 13.3 cm
National Museum of Korea, Seoul

Flying cranes were a particularly popular motif for Koryŏ celadons decorated in the *sanggam* technique. The fluid arrangement on a broad empty background gives a feeling of unlimited space.

Very few *maebyŏng* vases have been preserved with the original cover, as this one has. The edge of the cover and the foot have a wavy border in inlaid white slip. There is a stylised fringe of cloud motifs in inlaid white slip around the shoulders of the vessel. The bluish-green glaze is broadly crackled, with a brown fleck in places. The glazing technique, and the consistency of the clay, suggest that the vase was produced in the kiln at Yuch'ŏn-ri, North Chŏlla province. STB

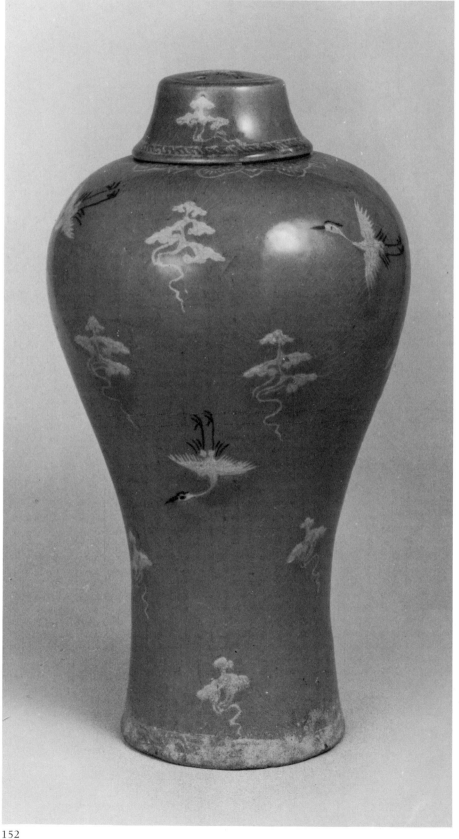

152

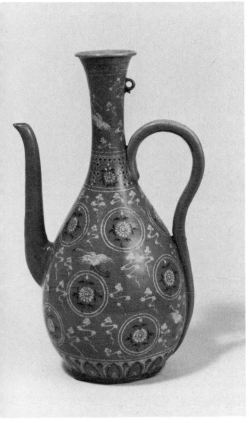

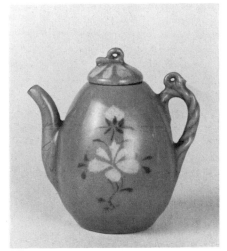

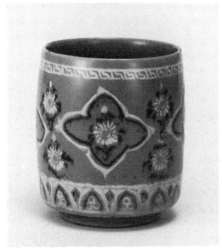

153

154

155

153 Wine ewer with cranes and chrysanthemum medallions

Koryŏ dynasty, mid-12th century AD
Stoneware with celadon glaze, inlaid in
sanggam technique. H 29.8 cm;
D (mouth) 5.6 cm, (foot) 9.0 cm
Horim Art Museum, Seoul

This tall ewer, reminiscent in form of Persian metalwork, has a pear-shaped body and a long trumpet-shaped neck. The narrow spout rises vertically to match the long neck, its end curving slightly outwards. The strap-like handle with a longitudinal furrow is shaped like an ear, and bends downwards with a particularly long stem. The decoration in white and black slip, under a celadon glaze, is copious and covers almost the entire surface of the jug, enhancing its charm. The principal motifs are flying cranes between stylised clouds, and a number of medallions, each containing a spray of chrysanthemum. The neck section is emphasised by pearl pendants and chrysanthemum sprays. There is a border of double lotus petals around the base of the ewer.

The ewer is coated in a greyish-green glaze, finely crackled. STB

154 Melon-shaped wine ewer

Koryŏ dynasty, mid-12th century AD
Stoneware with celadon glaze, inlaid in
sanggam technique. H 8.6 cm;
D (mouth) 1.4 cm, (foot) 3.4 cm
National Museum of Korea, Seoul

This small ewer resembles the classic melon-shaped celadon wine ewers of the first half of the twelfth century. The vessel, with its oval, slightly curving body resting on a broad base, together with its cover, which has a knob in the shape of a short bent stalk, is of a typical Korean melon shape. Two loops in the shape of curved tendrils attach the lid to the cord-type handle. This is an example of an unknown potter attempting to give the ewer a shape in harmony with the natural form. By way of decoration there is a peony spray, with flower and bud in white and black slip under the bluish-green glaze on the sides of the vessel. A lotus leaf is engraved in the spout. STB

Published San Francisco 1979, no. 140;
Choi Sunu 1975: pl. 98

155 Cup with chrysanthemum design

Koryŏ dynasty, mid-12th century AD
Stoneware with celadon glaze, inlaid in
sanggam technique. H 7.7 cm;
D (mouth) 6.5 cm, (foot) 4.8 cm
National Museum of Korea, Seoul

The cylindrical shape of the cup, drawn slightly inwards at the mouth, has a modern appearance. A wavy white line encircles the edge of the vessel under the celadon glaze. On the walls there are four four-petalled cartouches, each containing a chrysanthemum spray. Between them are further inlaid chrysanthemum sprays arranged in pairs one above the other, in white and black slip. The inlaid chrysanthemum decoration is typical of the Koryŏ period, and related to contemporary Korean lacquer. Around the base there is a border of lotus blossom, in inlaid white and black slip. The grey-green glaze of the cup has a slightly opaque appearance, due to the bubbles trapped inside. STB

Published Choi Sunu 1975, pl. 86

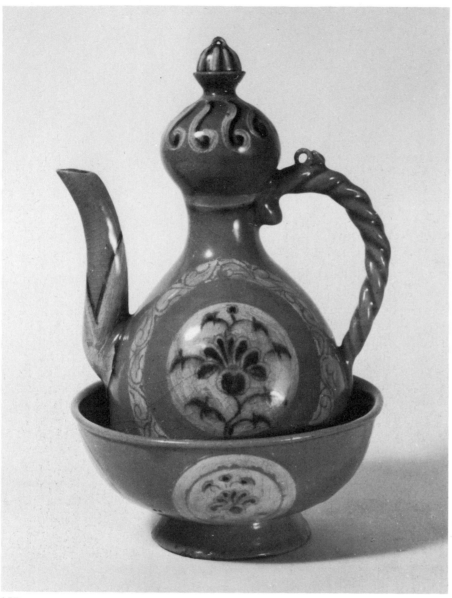

157

156 Wine ewer of double gourd shape with peony scrolls and cranes *(colour ill.)*

Koryŏ dynasty, mid-12th century AD
Stoneware with celadon glaze, inlaid in
sanggam technique. H 34.4 cm;
D (foot) 9.7 cm
National Museum of Korea, Seoul; National
Treasure no. 116

This fascinating gourd-shaped ewer, with its
elegant profile, is one of the most popular designs
of the Koryŏ period for this type of vessel.

The so-called *yŏksanggam* 'reverse inlay' tech-
nique was employed for the luxuriant decoration

of peony sprays which covers the entire lower
part of the body of the vessel. The background,
rather than the decoration, is scraped away and
inlaid with white clay. The earliest datable cela-
don piece displaying this technique is a dish
found in the tomb of Mun Kong-yu, who died in
AD 1159. The onion-shaped top of the ewer is
adorned with white cranes flying through
clouds.

The charm of the jug is further enhanced by
the blue-green glaze, which has collected in the
grooves cut in the narrow neck. STB

Published San Francisco 1979, no. 141;
Choi Sunu 1975, pl. 57; Kodansha 1976, pl. 29;
Sekai Tōji 1978, pl. 70

157 Wine ewer and warming bowl, with chrysanthemum design

Koryŏ dynasty, second half of the 12th
century AD
Stoneware with celadon glaze, inlaid in
sanggam technique. H (ewer) 27.0 cm, (with
bowl) 30.0 cm; D (bowl) 18.4 cm
National Museum of Korea, Seoul

This piece is sturdier in its proportions than the
elegant gourd-shaped ewers, and it has a sharply
everted lip, fitted with a domed black and white
striped stopper with loop. The top of the ewer is
onion-shaped and has black and white simpli-
fied floral decoration. In the centre on each side
there is a chrysanthemum spray painted in black
on a white medallion. Each medallion is encircled
by a band of leaves engraved on a white back-
ground. The lower part of the spout has a white
leaf decoration, with black outlines.

The bowl stands on a high spreading foot. On
the sides there are four white medallions, each
with a black chrysanthemum spray at the centre.
The light-green glaze is finely crackled. Under-
neath, traces of impure minerals in the clay
appear in the burnt body.

The bowl would have been filled with hot
water to keep the wine in the ewer warm. STB

Published Choi Sunu 1975, pl. 102;
Sekai Tōji 1978, p. 79, fig. 90

158 Cup and stand

Koryŏ dynasty, first half of the 12th century AD
Porcellaneous stoneware with underglaze
copper-red. H (cup) 4.4 cm, (stand) 4.6 cm;
D (cup) 8.4 cm, (stand) 10.8 cm
National Museum of Korea, Seoul

This cup and stand is one of a group of ceramics
with underglaze copper-red, not often produced
in Korea (*chinsach'ae-ch'ŏngja*).

The shape of the rounded sides of the upper
section of the stand echoes that of the small
cup. The stand can in fact be compared in shape
with the tenth-century Chinese Yue ceramics,
from Yuyao xian, in the area of Shang-lin Lake,
and with Koryŏ examples in celadon, from the
eleventh century AD.

There are also comparable examples amongst
the lacquered pieces of later periods. Dark
bubbles trapped in the glaze give an uneven
appearance to the light copper colour of the cup
and stand under the celadon glaze. Three spur
marks are visible on the unglazed base of the
thin-walled cup. STB

Published San Francisco 1979, no. 145;
Choi Sunu 1975, pl. 136;
Sekai Tōji 1978, p. 112, fig. 109

159 Round box with floral decoration

Koryŏ dynasty, mid-12th century AD
White porcelain, inlaid in *sanggam* technique.
 H 2.8 cm; D (mouth) 7.4 cm, (foot) 4.4 cm
National Museum of Korea, Seoul

This circular box with cover is the sole example of Koryŏ white ware in this catalogue.

The shape has its origins in the metalwork of the time. The flat surface of the cover is ornamented with blossom and foliage executed in inlaid black lines. The bluish-white colour of the glaze is reminiscent of the Chinese *qingbai* ware made at Jingdezhen, in Jiangxi province. White ware with inlaid decoration was also found in celadon kilns such as those at Yuch'ŏn-ri, North Chŏlla province. This box was excavated in Kaesŏng, Kyŏnggi province, in 1909. There are three spur marks on the base. STB

Published Choi Sunu 1975, pl. 126;
Kodansha 1976, pl. 62;
Sekai Tōji 1978, p. 110, fig. 105

160 Long-necked bottle with fluted body

Koryŏ dynasty, second half of the
 12th century AD
Stoneware with celadon glaze, inlaid in *sanggam* technique. H 38.0 cm;
D (mouth) 2.6 cm, (base) 10.0 cm
National Museum of Korea, Seoul

The Japanese describe this type of bottle as a 'crane's neck bottle' on account of the particularly long neck. Here the spherical body is faceted from top to bottom. In the individual facets there are alternating motifs depicting a single chrysanthemum spray or two peony sprays, one above the other. The blossom is inlaid in white slip underneath the celadon glaze, providing an effective contrast with the leaves, which are inlaid in black.

The neck-piece has a white border of cloud motifs. The long neck is decorated with a stylised cloud formation in white slip. The foot and mouth rims are each encircled with a narrow wavy border of white.

The light greyish-green glaze has a network of crackle. STB

Published Choi Sunu 1975, pl. 72

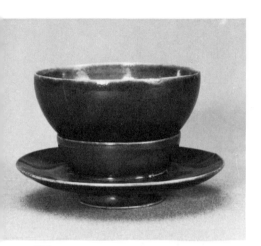

158

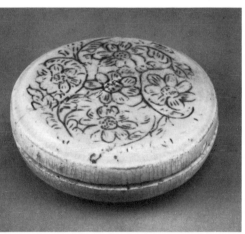

159

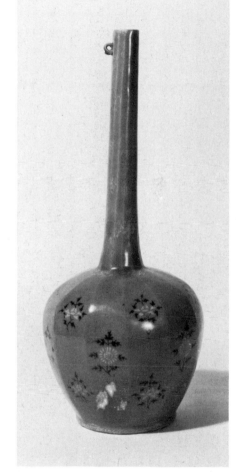

160

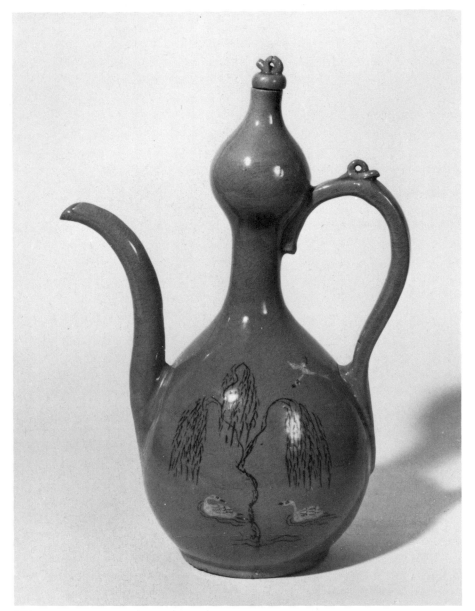

162 Lobed cup and stand with chrysanthemum design

Koryŏ dynasty, second half of the
 12th century AD
Stoneware with celadon glaze, inlaid in
 sanggam technique. H (whole) 9.3 cm,
 (cup) 5.5 cm, (stand) 4.8 cm; D (cup) 7.2 cm,
 (stand) 15.5 cm
National Museum of Korea, Seoul

This cup is in the shape of a melon flower, with a wide, saucer-shaped stand on a high foot with a central support modelled as a lotus. This is one of the most popular shapes for wine cups in the Koryŏ period. According to the phases of development of ceramic production in the Koryŏ period, there is a wide variety of cup shapes and stand heights. The form here, which suggests the Song ceramic style, is individual in its inlaid decoration of chrysanthemum sprays in white and black slip under the celadon glaze. The mouth and foot of the cup are in petal form, with a delicate floral border decoration.

The veins engraved on the individual lotus petals are clearly visible in the centre of the stand. Countless fragments of similar celadon cups have been found in the old kiln sites at Taegu-myŏn in Kangjin district, South Chŏlla province. STB

161

161 Wine ewer of double gourd shape with ducks and willow

Koryŏ dynasty, second half of the
 12th century AD
Stoneware with celadon glaze, inlaid in
 sanggam technique. H 35.5 cm;
 D (foot) 10.7 cm
National Museum of Korea, Seoul

This elegant wine ewer in the shape of a double gourd is typical of the Koryŏ period.

The pictorial inlay, depicting ducks swimming beneath a weeping willow tree on one side and a pair of cranes in a bamboo grove on the other, creates a poetic effect. The duck and willow decoration was often used in the metalwork of the Koryŏ period.

The delicate, blue-green glaze is flecked with brown, and finely crackled. STB

Published Choi Sunu 1975, pl. 59;
Kodansha 1976, pl. 30; Sekai Tōji 1978, pl. 69

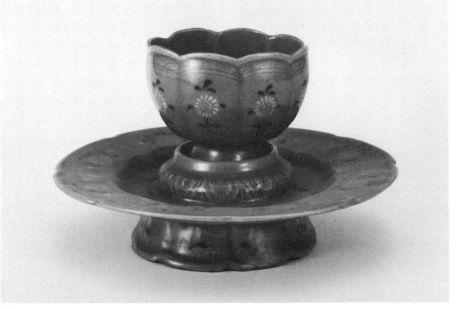

162

163 Box in the form of a chrysanthemum flower

Koryŏ dynasty, second half of the
12th century AD
Stoneware with celadon glaze, inlaid in
sanggam technique. H 6.2 cm; D 11.9 cm
National Museum of Korea, Seoul

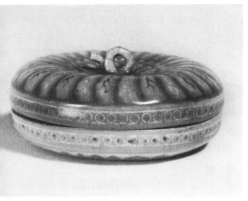

163

A large number of circular celadon boxes with
inlaid decorations of various types have been
preserved from the Koryŏ period. In this one the
cover is modelled as the back of a chrysanthemum
blossom with three rows of petals. The form
was probably derived from Chinese ceramics: a
Southern Song dynasty *qingbai* example from
Jingdezhen is illustrated in *Sōgen no bijutsu*,
Ōsaka 1978, fig. 1–128 (RW). The stem in the
centre forms the knob.

On each of the central petals there are three
white pearls beneath the celadon glaze. The
large outer petals are decorated with an abstract
plant design in white or black slip, under the
celadon glaze.

The vertical sides of box and cover are each
encircled by a string of pearls, with a black dot
at the centre. The base of the box has a border of
lotus petals.

The green glaze has collected thickly between
the petals. STB

Published Choi Sunu 1975, pl. 96.
Cf. Sekai Tōji 1978, p. 169, fig. 183.

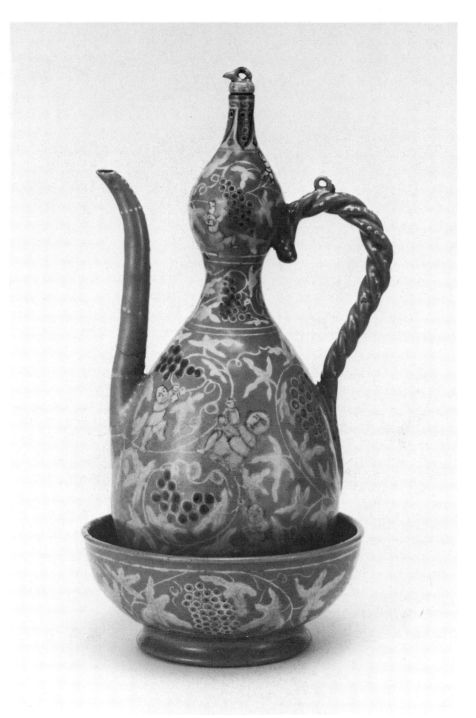

164

164 Wine ewer and warming basin, with design of boys playing among grapes

Koryŏ dynasty, second half of the
12th century AD
Stoneware with celadon glaze, inlaid in
sanggam technique and underglaze
copper-red. H 34.2 cm; D (basin) 17.9 cm
National Museum of Korea, Seoul

This double gourd wine ewer is decorated in a
fashion typical of the Koryŏ period, with vines
and playing children in inlaid white slip under a
celadon glaze. Some of the grapes are copper-
red, others picked out in black and white dots.

The twisted handle and narrow spout are adorned
with a pearl motif in white slip.

The outer surface of the sturdy bowl, standing
on a broad circular foot, is also decorated with
grapes and vine leaves, whilst a large lotus leaf
is finely engraved inside it. Its bluish-green glaze
is crackled, mainly at those points where there
are inlaid vine leaves. The ewer was probably
produced in the kiln at Yuch'ŏn-ri, in North
Chŏlla province.

The basin would have been filled with hot
water to keep the ewer warm. STB

Published San Francisco 1979, no. 149,
pl. XXVIII; Choi Sunu 1975, pl. 120;
Sekai Tōji 1978, pl. 84

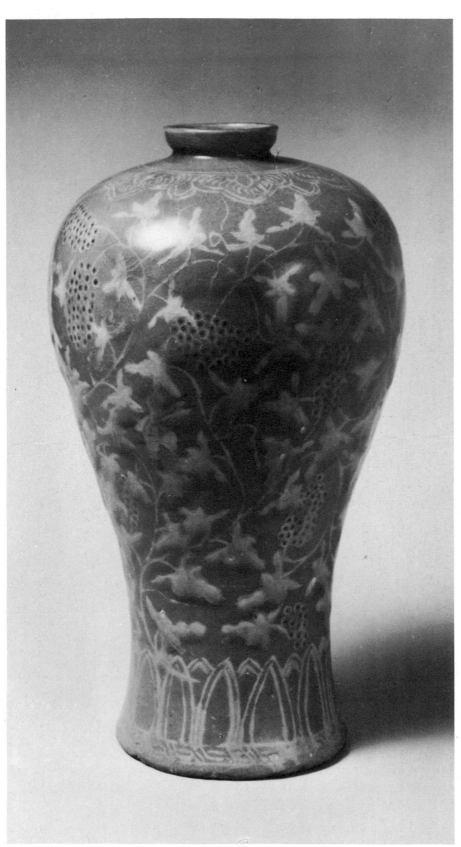

165

165 *Maebyŏng* with design of vine and grapes

Koryŏ dynasty, second half of the
 12th century AD
Stoneware with celadon glaze, inlaid in
 sanggam technique. H 41.5 cm; D (mouth)
 7.5 cm, (foot) 15.8 cm
Kansong Museum of Fine Arts;
 Treasure no. 286

The *maebyŏng* vase is notable for the inlaid decoration of climbing vines, leaves and grapes that covers almost the entire body of the vessel. The individual grapes, executed in white slip with a black dot at the centre, were impressed on the body before it was glazed. The shoulders are festooned with a border of *ruyi*-cloud formations in white slip, inlaid under the glaze. A frieze of meander encircles the edge of the base, topped with a high border of double lotus leaves in inlaid white slip. The grey-green glaze with wide-mesh crackling has collected thickly over the white vine leaves, giving the surface of the vase an uneven appearance. STB

Published Choi Sunu 1975, pl.48;
Sekai Tōji 1978, pl.64

166 *Maebyŏng* with clouds and flying cranes

Koryŏ dynasty, first half of the 12th century AD
Stoneware with iron slip and painted design
 in white slip under a celadon glaze.
 H 35.2 cm; D (mouth) 5.8 cm, (foot) 11.0 cm
National Museum of Korea, Seoul

This *maebyŏng* vase is one of the earlier celadon types, with white slip painting over a blackish-brown slip under the glaze. A feature of these pieces is the lively rustic effect of their decoration, usually applied in a rather careless fashion. The flying cranes depicted here are rather rare, whereas the semi-abstract plants were particularly popular on this type of celadon.

 The base of the vase is flecked with brown in places. STB

Published Sekai Tōji 1978, pl.112.

167 Vase with panels of lotus design

Koryŏ dynasty, mid-12th century AD
Stoneware with brown glaze over white slip.
 H 26.6 cm; D (mouth) 9.4 cm, (foot) 9.7 cm
National Museum of Korea, Seoul

This charming baluster-shaped vase has a long, broad neck and melon-shaped body on a tall foot, fanning out trumpet-wise towards the base. This is a rare example of the iron-glazed ceramic ware of the Koryŏ period.

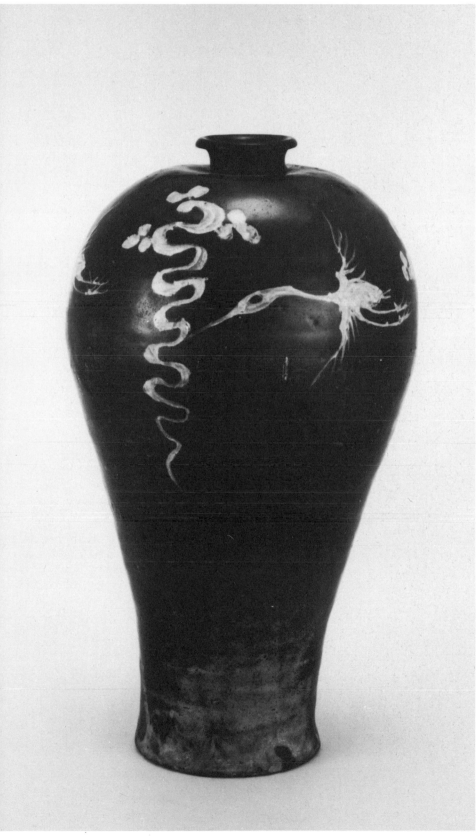

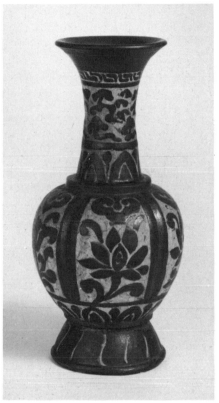

167

The sgraffiato technique derives from the Cizhou ware of the Song period. The heavy iron-brown glaze was applied with a brush to the decorated sections and other areas, and the background of the design was cut away to reveal the white slip beneath (cf. the jar dated AD 1305 in the British Museum; Indianapolis 1980, p. 247).

The tall neck has three different bands of ornamentation, namely a narrow border of pseudo-meander, stylised clouds, and a border of double lotus petals. The melon-shaped, fluted sections of the body of the vessel are divided by brown strips, and there is a lotus spray on each, with a cloud-head pointing downwards.

Fragments of similar pieces have been found at the Sadang-ri kiln in Kangjin district (South Chŏlla province). STB

Published Choi Sunu 1975, pl. 140;
Kodansha 1976, pl. 60; Sekai Tōji 1978,
pl. 114

166

168 Bowl with petalled rim and design of phoenixes and flowers

Koryŏ dynasty, second half of the
 12th century AD
Stoneware with celadon glaze, inlaid in
 sanggam technique. H 8.3 cm;
 D (mouth) 18.8 cm, (foot) 6.0 cm
National Museum of Korea, Seoul

There is a tendency in the thirteenth-century celadon pieces for the inlaid decoration to be over-elaborate, as is the case with this dish. Inside, a band of *ruyi* (stylised cloud-heads) surrounds a medallion with a pair of flying phoenixes in the centre of the narrow base. The rest of the interior is filled by stylised cloud motifs, with four phoenixes in flight.

The outside of the bowl is divided into four different bands of decoration; first a narrow band of semi-abstract plant designs, and beneath it a band of flying cranes between small stylised cloud motifs. Below this comes the main band of decoration, depicting scrolling stems with leaves and flowers alternating with pairs of phoenixes in circular medallions. The lowest band has a garland of double lotus blossom in white and black slip.

The glaze is tinged with blue, grey and green, and is slightly crackled. STB

Published Kodansha 1976, pls 36–7;
Sekai Tōji 1978, p. 85, figs 76–7

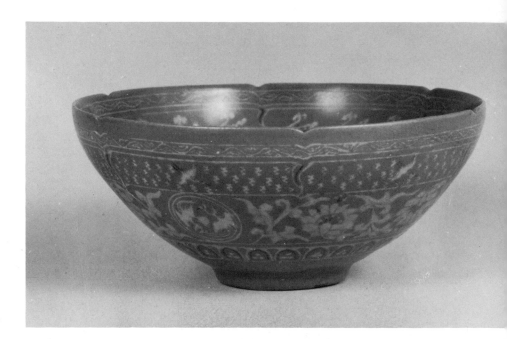

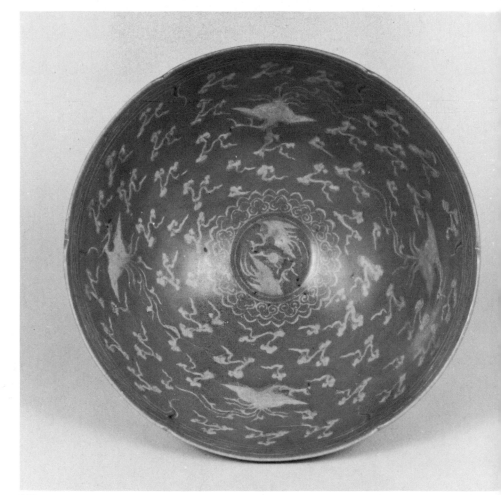

168

169 Covered bowl, with stand and ladle; design of dragons and phoenixes

Koryŏ dynasty, first half of
 the 13th century AD
Stoneware with celadon glaze, inlaid in
 sanggam, with bronze ladle.
 H (whole) 19.3 cm; D (stand) 18.5 cm,
 (foot) 6.8 cm
Hoam Art Museum, Yongin

One seldom finds a set preserved complete, as with this delightful covered bowl, stand and spoon, which were probably used in court circles.

The pattern, executed over the entire surface in the *sanggam* technique, consists of concentric bands of lavish ornament. In the centre of the cover around the knob, which is in the form of a lion, there is a garland of double lotus blossom. The main band of decoration on the cover consists of dragons and phoenixes between clouds, and peony medallions between sprays of blossom and leaves. The stand has a lotus foot and a broad flat rim, and is likewise adorned with a band of dragons and phoenixes between clouds.

The pale-green glaze is slightly crackled, and flecked with brown at intervals. STB

Published Hoam 1982, pl. 6

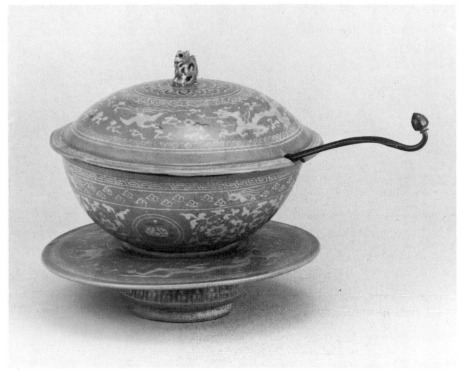

169

170 Oil bottle with flying cranes

Koryŏ dynasty, first half of the
 13th century AD
Stoneware with celadon glaze, inlaid in
 sanggam technique. H 4.4 cm;
 D (mouth) 2.5 cm
National Museum of Korea, Seoul

This small, short-necked bottle with compressed, semicircular body, is of a shape typical of cosmetic oil bottles of the Koryŏ period.

The rounded surface of the shoulder has a wide band of decoration depicting flying cranes between stylised cloud motifs, executed in inlaid white and black slip under a celadon glaze.

The light-green glaze appears slightly opaque, as a result of trapped bubbles, and has collected thickly at the narrow neck. STB

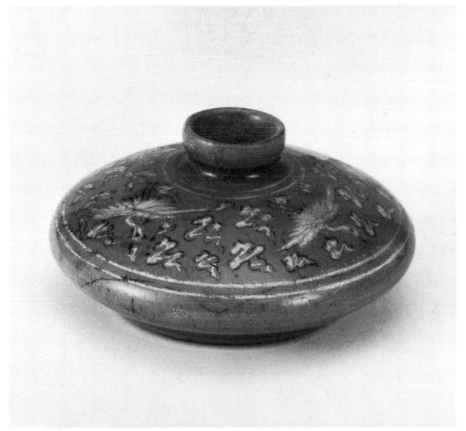

170

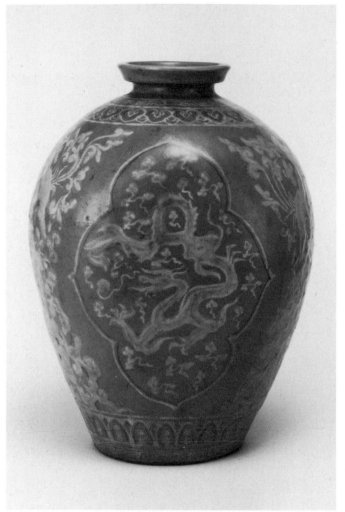

171

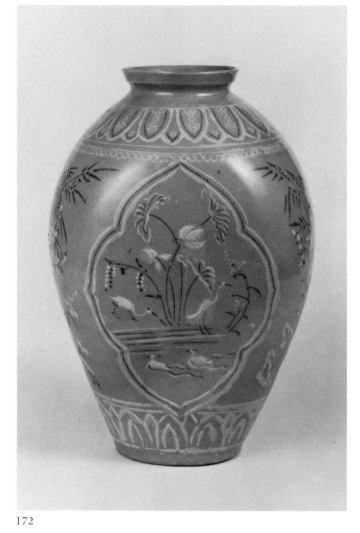

172

171 Storage jar with dragons and phoenixes

Koryŏ dynasty, 13th century AD
Stoneware with celadon glaze, inlaid in
sanggam technique. H 25.0 cm;
D (mouth) 7.2 cm, (base) 9.8 cm
National Museum of Korea, Seoul

This storage jar with flattened body has a copious inlaid decoration.

Each of the flattened sides bears an ogee-shaped panel, containing a flying dragon chasing a god-luck pearl among stylised cloud motifs. The decoration between the panels has flying phoenixes amongst luxuriant foliage. The foot is surrounded with a narrow white border of meanders with a fringe of lotus petals, each petal enclosing small circular motifs. There is a border of meander and stylised *ruyi* cloud formations on the shoulders of the vessel.

The slightly opaque appearance of the bluish grey-green glaze is caused by small bubbles trapped inside.

Fragments of similar inlaid decoration have been found in the kiln at Yuch'ŏn-ri, in Puan district, North Chŏlla province. STB

Published Kodansha 1976, pl. 43.
Cf. Asia House 1968, fig. 73.

172 Storage jar with ducks and egrets

Koryŏ dynasty, 13th century AD
Stoneware with celadon glaze, inlaid in
sanggam technique. H 29.0 cm;
D (mouth) 8.8 cm, (foot) 9.3 cm
National Museum of Korea, Seoul

The interesting feature of this vessel is the pictorial nature of the inlay. Each of its flattened sides displays a panel, enclosing two swimming ducks, and two other waterfowl on the edge of a lotus pond. Tall bamboo shoots and fronds of blossom adorn the remainder of the jar.

The shoulders of the vessel have an inlaid border depicting double lotus petals with pendant, whilst lower down there is a band of pearls, picked out in white slip under a celadon glaze. Around the base is a band of decoration depicting double lotus petals in white slip.

The vessel has a thick bluish grey-green glaze, finely crackled at those points where there is inlaid decoration. STB

Published Choi Sunu 1975, pl. 53

5 Chosŏn Dynasty
(AD 1392–1910)

Korean historians divide the history of the Chosŏn dynasty into two periods: that before the Japanese invasions of AD 1592 and 1597, and the period after the Manchu invasions of some thirty years later. General Yi Sŏng-gye, who had successfully campaigned against the Jurchen in the north and against Japanese pirates on the southern coast, established the capital at a new site, now Seoul, with himself as the first Chosŏn ruler. His posthumous name is King T'aejo.

King T'aejo proceeded to undertake land reforms in order to remove the basis on which Koryŏ power had depended. Because of the corruption and degeneration of Buddhism in the late Koryŏ dynasty, when the abuse of privilege by the monasteries had weakened state finances, Buddhism lost its position as the official state doctrine and was replaced by Confucianism. In accordance with the traditional Confucian relationship between ruler and subject, those who had helped King T'aejo were specially rewarded by being created Merit Subjects, *kongsin*, receiving important grants of land and revenues. Thus the ruling classes, known as *yangban* ('two categories', civil and military officials), continued to be powerful, and competition and even long-standing feuds between hereditary factions was to cause considerable trouble from the late sixteenth century onwards.

In addition to the factional struggles within Korea, Chosŏn was also threatened from abroad, despite enjoying close and friendly relations with Ming China, a policy initiated from the beginning of the dynasty by King T'aejo. In Japan Toyotomi Hideyoshi brought the feudal lords of Kyūshū under control in AD 1587. When the Chosŏn court refused to assist him in the invasion of Ming China he carried out his threat to invade Korea herself. As many as 100,000 Japanese troops penetrated Korea as far as Seoul and P'yŏngyang, but were harassed by Korean irregulars, while in AD 1597 the naval commander Yi Sunsin regained control of the southern seas with his 'turtle ships', the world's first armoured vessels. With only 12 of these, Yi Sunsin forced a Japanese fleet of 133 ships to turn back to Japan, sinking 31 of them.

In AD 1627 and 1636–7 Korea was again invaded, this time by the Manchus who were to bring about the final downfall of the Ming dynasty in AD 1644. They had asked for Korean aid, and had been refused. Both the Japanese and the Manchu invasions devastated the national economy and resulted in great losses of Korean culture. Recovery was only possible gradually. In the eighteenth century, the *silhak* or pragmatic school of thought began to flourish, encouraging commerce and land reform. At the same time in government, King Yŏngjo (reigned AD 1724–76) pursued a policy of impartiality, and talented men of all factions were employed. As a result, this and the reign of King Chŏngjo (reigned AD 1776–1800) was a time of cultural revival and great intellectual activity.

The dominant Confucian policies of the Chosŏn dynasty imparted quite a different character to its culture from that of the preceding Koryŏ dynasty with its Buddhist-oriented aristocratic society. Despite internal struggles and invasions from abroad, the period was one of vigorous activity and especially of the Koreanisation of Chinese elements. The impetus of Confucianism is seen in the compilation of scholarly works such as the *Koryŏ-sa* (History of the Koryŏ dynasty, completed in AD 1451), the *Chosŏn wangjo sillok* (Annals of the Chosŏn Kings, begun in AD 1413), and the *Kyŏngguk taejŏn*, a collection of laws and regulations compiled in AD 1470 and which remained in force for over four centuries until the introduction of legal institutions from the West after AD 1894. Another and most important achieve-

ment of Chosŏn culture is the creation of the *Han'gŭl* phonetic script invented and promoted in AD 1443–6 by King Sejong.

The population was divided into four classes: *yangban* (officials of the two categories – civil and military), *chungin* (middle classes, including professions like medicine, astrology, and law), *sangin* (farmers, artisans and merchants) and *ch'ŏnin* (slaves, entertainers, shamans, and butchers who were the lowest of all). Entrance to official position was by the state examination system. Those who were scholars but did not yet hold official positions were known as *sonbi*. *Sonbi* culture is the hallmark of the Chosŏn dynasty, finding expression in the appearance of *sŏwŏn* or private academies, which had their origin as shrines to the memory of famous scholars, but served also as meeting places and centres of discussion, and produced some of the great Confucian scholars. The several purges of the literati in the course of the sixteenth century caused many Confucian scholars to retreat from political life to their home towns, where they devoted themselves to study and teaching. As a result *sŏngnihak*, or metaphysical Neo-Confucianism, flourished, and scholar-officials such as Yi Hwang (T'oegye, AD 1501–70) and Yi I (Yulgok, AD 1536–84) were of great influence in the development of Neo-Confucianism in Japan as well as Korea. The products of the arts and literature, such as the austere white porcelain, the *sijo* poems, the paintings of actual places by Chŏng Sŏn and his followers, and genre paintings, all owe their origins to the respect for culture and scholarship running throughout the Chosŏn dynasty. RW/YSP

Punch'ŏng wares

It is only in the twentieth century that European potters and collectors have become aware of the austere beauty of Korean Chosŏn ceramics, though connoisseurs in the neighbouring countries of China and Japan have been fascinated by them for centuries. Japanese tea masters and their pupils in particular were captivated from the fifteenth century onwards. The spare designs and techniques appealed to Japanese taste. Apart from porcelain and the occasional black glazed ware, it was presumably in the main the *punch'ŏng* ware, so sought after in Japan, which caused Toyotomi Hideyoshi, after successfully destroying the Korean kilns in the 1590s, to bring hundreds of captured potters to Japan and allow them to settle there. It is to their work that we owe the best-known types of ceramics used in the tea ceremony. The Hideyoshi campaigns were often referred to in the vernacular as the 'ceramic wars' (Akaboshi and Nakamaru 1975, p.13).

While in old Korea ceramics were described by the general term *sagi*, 'clay vessels', in more recent times names have been coined to designate the different types – hence the term *punch'ŏng*, which, literally translated, means 'powder green'. Scholars believe it to derive from the Chinese term *fenqing*, meaning light blue or green, although this colour can only be said to describe a limited number of *punch'ŏng* vessels. Nowadays the Korean term – a contraction of the words *punjang hoech'ŏng sagi* – is used to describe the standard pottery thrown in the fifteenth and sixteenth centuries, in the first half of the Chosŏn dynasty, before the start of the Japanese campaigns. It was produced in a large number of kilns in southern Korea, and was commonly given a light coating of slip, before being painted or decorated by the *sgraffiato* method. Sometimes the pots were first stamped and then these designs were filled with slip. The final process was a transparent glaze, often speckled with green. *Punch'ŏng* ceramics were similar in composition though not in appearance to the older wares, being in the main thick and heavy, grey in body colour, and coated with a glaze of a consistency like that used for Koryŏ celadon, though this was no longer produced after the beginning of the Chosŏn dynasty. The Japanese have known and collected this Korean household ware for centuries. They called it *mishima*, and gave Japanese names to the various types. Mishima ('three islands') being the Japanese name for the port whence the *punch'ŏng* wares were exported to Japan, this term has misleadingly been used both for *punch'ŏng* wares as a whole, and for those with stamped or inlaid millefleur designs.

Korean experts, however, have established a systematic terminology, according to technique, as follows:

sanggam punch'ŏng	inlaid *punch'ŏng* (Japanese, *mishima*)
inhwa punch'ŏng	stamped and filled with slip (Japanese, *mishima*)
pagji punch'ŏng	slip with areas cut away (Japanese, *hori-mishima*)
sŏnhwa punch'ŏng	slip with incised linear decoration, also known as *chohwa punch'ŏng* (Japanese, *horimishima*)
ch'ŏlhwa punch'ŏng	slip and painting with iron oxide (Japanese, *e-hakeme*)
paekt'o punch'ŏng	dipped in slip and left plain (Japanese, *kohiki*)
kwiyal punch'ŏng	slip brushed on and left plain (Japanese, *hakeme*)

(Kim Won-yong 1982, pp.232–5; Chung Yang-mo 1982, p.180)

According to excavated materials, the sequence of development of these techniques seems to be fairly clear. The *sanggam* and *inhwa* techniques were used early

in the Chosŏn dynasty. They were followed soon after in the fifteenth century by the *sŏnhwa* and *pagji* techniques. In the latter half of the fifteenth century *ch'ŏlhwa*, *kwiyal* and *paekt'o* reached a high quality. In the sixteenth century there was an increasing tendency to leave vessels plain. By the time of the Japanese invasions, AD 1592–8, *punch'ŏng* wares had declined, giving way to the white porcelain favoured by the upper classes, and afterwards they were never made again.

The annals of King Sejong, (reigned 1419–50), entitled *Chosŏn wangjo sillok*, 'Veritable Records of the Chosŏn Dynasty', record 139 porcelain kilns and 185 for the production of stoneware. Their exact locations and output are given, and *punch'ŏng* was clearly manufactured in large quantities at that time. The discovery of *punch'ŏng* pottery in the tombs of the aristocracy, for example among the funerary gifts in the tomb of Prince Onyong (Choi Sunu 1963), testifies to its use at all levels of society of the time, including the ceramic urns traditionally used by princes and peasants alike in Korea for funerals (no.173).

Some of the techniques used in the manufacture of *punch'ŏng* ceramics, and in particular the later ones, that is with decoration cut into (*sŏnhwa, pagji*) or painted over (*ch'ŏlhwa*) the slip coating, seem to be related to the Chinese Cizhou wares. Excavations in China have shown that many Cizhou-type kilns existed in the northern provinces of Hebei, Henan and Shanxi. Cizhou wares with floral motifs painted in iron-brown on a cream slip ground were among the consignment of thousands of pieces of Chinese ceramics in a ship sunk off the coast of southern Korea in the early fourteenth century (Sinan 1977). Other Cizhou wares with *sgraffiato* decoration had been produced in north China since the mid-eleventh century, and it is quite likely that the use of similar techniques in Korea in the fourteenth and fifteenth centuries was influenced by them.

Experts believe that some of the top-quality *punch'ŏng* ceramics with painting in iron-brown under a transparent glaze come from the kilns at Kyeryong-san, about half-way between Seoul and Kwangju, South Chŏlla province. Excavations were undertaken here in the 1920s by the Japanese. In the early 1960s a British collector and expert on Korean art, G. St G. M. Gompertz, visited various sites, including the site of the old kilns at Kyeryong-san, and published an account of his travels, along with illustrations of his collection of sherds (Gompertz 1964b).

In recent years, however, more systematic and extensive excavations have been conducted by Korean specialists, and the locations and characteristics of hundreds of kiln sites profusely scattered over the whole of South Korea have been recorded and published (see Chung Yang-mo 1982, pp.195ff). Reconstructions show that the *punch'ŏng* kilns were tunnel-like climbing kilns built of brick and sited on hillsides or man-made mounds. Many dated pieces have been found and provide useful information for the dating of these kilns (*ibid*, pp.180f).

At the turn of the century the great Japanese connoisseur and collector, Yanagi Soetsu, tried to focus attention on the Korean ceramics of the Chosŏn dynasty. Other experts and promoters of Japanese folk art, for example, the potters Shōji Hamada, Kanjirō Kawai and Kenkichi Tomitomo, followed his lead. This was not at first the case in the West. European travellers, including Adolf and Frieda Fischer, the founders of the Cologne Museum, had been to Korea as early as 1909, and acquired celadon wares of the Koryŏ period and painted porcelain from the Chosŏn dynasty in a series of rather speculative purchases, but they remained

unimpressed by the robust beauty of *punch'ŏng* ceramics. However, the ancient Korean and Japanese potter's craft was imitated by potters of the twentieth century – Gerd Knäpper in particular – who acquired an enthusiasm for ash and *temmoku* glazes according to ancient Korean and Japanese traditions, under the guidance of Bernard Leach, whose work *A Potter's Book* was published in 1940 and through whom the beauty of *punch'ŏng* ceramics has been revealed to Western potters and collectors. ED/RW

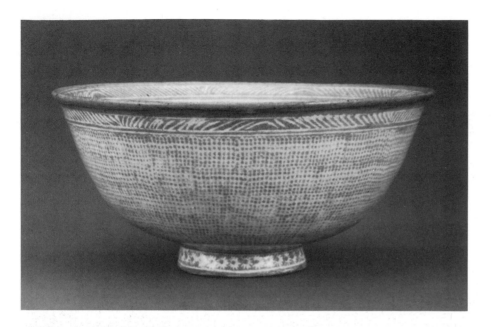

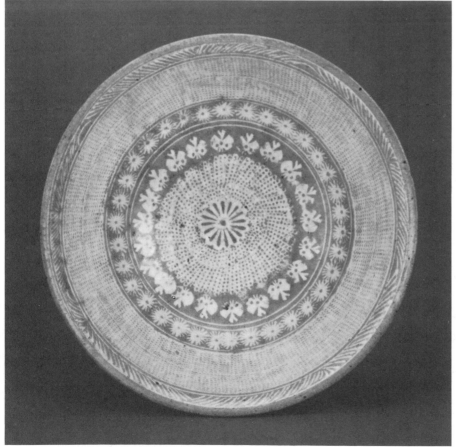

173 Eating bowl

Chosŏn dynasty, 15th century AD
Dark grey stoneware, *inhwa punch'ŏng*.
H 9.6 cm; D (mouth) 20.0 cm, (foot) 6.9 cm
Horim Art Museum, Seoul

This bowl, clearly influenced by the later Koryŏ inlaid celadon wares, is decorated both inside and out with stamped designs filled with white slip, using the *inhwa* technique.

The sides are filled with a 'rope curtain' motif, while a band beneath the rim depicts waving grass. Chrysanthemums surround the foot-ring. The inside has a sixteen-petalled chrysanthemum in the centre, surrounded by concentric bands of dots, butterflies and more chrysanthemums. The white stamped design and grey body are enhanced by the bluish sheen of the transparent glaze.

This is the most common prevailing shape of bowl, found universally in East Asian ceramics. Some Chosŏn examples bear characters, for example *naesŏm*, as part of the decoration inside, indicating the office responsible for supplying dishes for the court (cf. Gompertz 1968, pl. 14). ED/RW

Published Chung Yang-mo 1978, pl. 20

174 Covered placenta jar

Chosŏn dynasty, 15th century AD
Dark grey stoneware with stamped decoration, inlaid in black and white slip,
inhwa punch'ŏng. H 42.0 cm;
D (mouth) 26.5 cm, (foot) 27.6 cm
Korea University Museum, Seoul;
National Treasure no. 177

This impressive jar was discovered only a few years ago in a stone cist on the site of Korea University in Seoul. Inside it was a slimmer jar and cover 26.7 cm high, wrapped in a finely woven rice-straw bag and partly filled with fine earth. Placenta burials were customary in the royal family in Korea until the end of the Chosŏn dynasty; *punch'ŏng* jars were used for this purpose until the mid-fifteenth century, and white porcelain thereafter. An epitaph tablet was occasionally included, but none was found with this example.

Both jars are decorated with stamped and incised decoration filled with slip, in a technique directly related to the Koryŏ *sanggam* inlaid celadons. The decoration consists of repeated elements, especially small chrysanthemums but also including fine 'raindrops', overlapping waves, *wanja* or false meanders, and lotus petals

173

with multiple outlines. Hanging garlands, inlaid in black, accent the shoulder at the widest point. The glaze is pale green, with a greyish-white tinge, typical of *punch'ŏng* wares.

Sherds decorated in similar fashion have been discovered at the Ch'unghyo-dong kiln in Kwangju, South Chŏlla province.　　RW

Published Chung Yang-mo 1982, pl. 34
(see also pp. 202, 206);
San Francisco 1979, no. 163. Cf. Sich 1982.

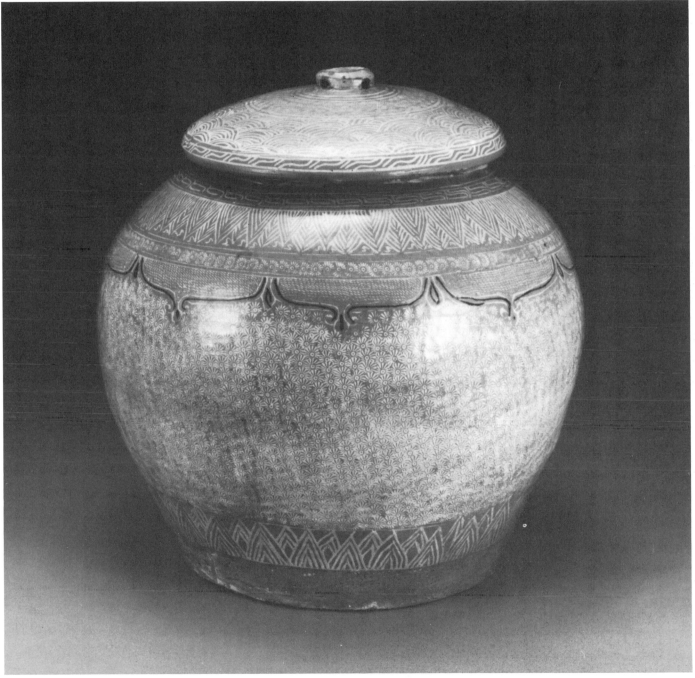

175 Flask with peony-leaf design

Chosŏn dynasty, 15th century AD
Dark grey stoneware, *sŏnhwa punch'ŏng*.
 H 22.4 cm; D (mouth) 4.7 cm, (foot) 8.3 cm
National Museum of Korea, Seoul

This flask is decorated with incised linear decoration, *sŏnhwa punch'ŏng*, of peony leaves. The incising was done after the slip had been applied with a large brush, traces of which are clearly visible. RW

Published Boston 1957, no.139;
Kim and Gompertz 1961, pl.81; Gompertz
1968, pl.17B; Chung Yang-mo 1978, pl.49;
Kodansha 1976, pl.66

176 Wine flask with flattened sides

Chosŏn dynasty, 15th century AD
Dark grey stoneware, *pagji punch'ŏng*.
 H 18.0 cm; D (mouth) 5.0 cm, (foot) 8.1 cm
National Museum of Korea, Seoul

This broad, short-necked bottle is another variation of the pilgrim flask with flattened sides. As is often the case with the *punch'ŏng* wares, the principal motif is made to fill the whole of the available space on one of the large sides, here a single lotus blossom. The narrow panels at the ends are filled with a reversed S motif arranged in columns. After the main lines of the flower were incised, the remaining spaces at the edges of the decoration were cut down through the slip to the body, throwing the large petals of the lotus, and the more stylised floral or leaf motifs between them, into sharp relief. RW/YSP

Published Chung Yang-mo 1978, pl.35;
id. 1982, pl.90

177 Wine flask with lotus, fish and waterfowl

Chosŏn dynasty, 15th century AD
Dark grey stoneware, *pagji punch'ŏng*.
 H 21.7 cm; D (mouth) 4.8 cm, (foot) 8.4 cm
Horim Art Museum, Seoul.
 National Treasure no.179

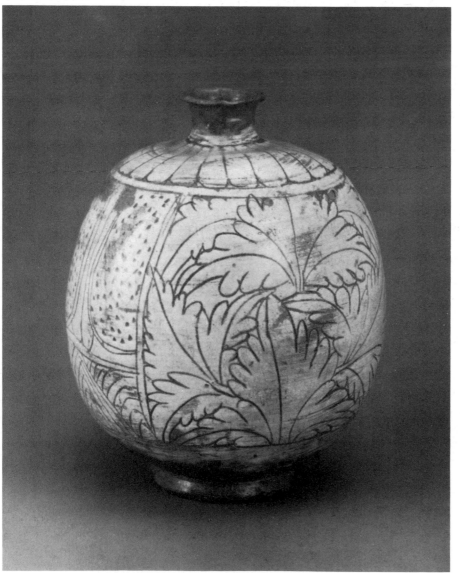

175

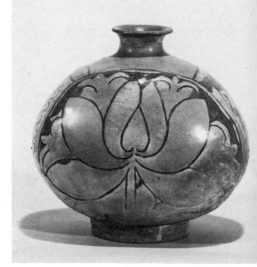

176

The sides of this flask are slightly more flattened than those of no.175, but the shape is still voluminous. According to Chung Yang-mo, it demonstrates the *punch'ŏng* techniques at their best. The main panels are filled with a lively design of lotus leaves, the undersides and rolled edges of which are both visible. Through these a number of lotus buds push up vertically, and one bud and an opening blossom emerge at the top. Below, fish swim among the stems, and waterfowl (one seen on the left in the illustration, two more on the other side) poke among the leaves. The narrow panels at each end are divided into three squares, the upper two filled with lotus leaves, and the lowest with lotus petals.
 The piece displays the virtues of the *punch'ŏng* wares, in its simplified yet realistic depiction of the ordered chaos of an actual lotus pond, with heavy leaves and bent stems. Areas of the background are cut away (*pagji*) to the grey body and

incised lines (*sŏnhwa*) are used for the leaf
veins, scales and feathers. RW

Published Chung Yang-mo 1978, pl. 34;
San Francisco 1979, no. 166, pl.XXIX
(showing other side); Choi Sunu 1979,
pl. 138; Kim Kyong-hi 1980, no. 73;
Chung Yang-mo 1982, pl. 94

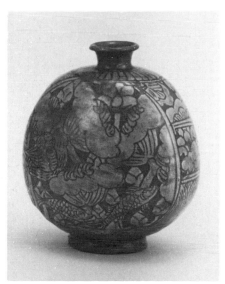

177

178 Jar with peony design

Chosŏn dynasty, 15th–16th century AD
Dark grey stoneware, *sŏnhwa punch'ŏng*.
 H 29.0 cm; D (mouth) 12.2 cm,
 (foot) 21.2 cm
Kyŏngju National Museum

The whole surface of the jar, brushed with a
thin slip, is the field for the design. The surface
had previously been beaten and traces of this
show up clearly as the pattern of depressions
filled with slip. The petals and leaves merge
freely into one another, simply by the omission
of some of the outlines. The *punch'ŏng* artists
were adept at exploiting this technique, achiev-
ing some surprising effects: in one flask in the
Kwangju Museum (Chung Yang-mo 1982,
pl. 82), two fish swim right through each other
by this device. RW

Published Chung Yang-mo 1982, pl. 98

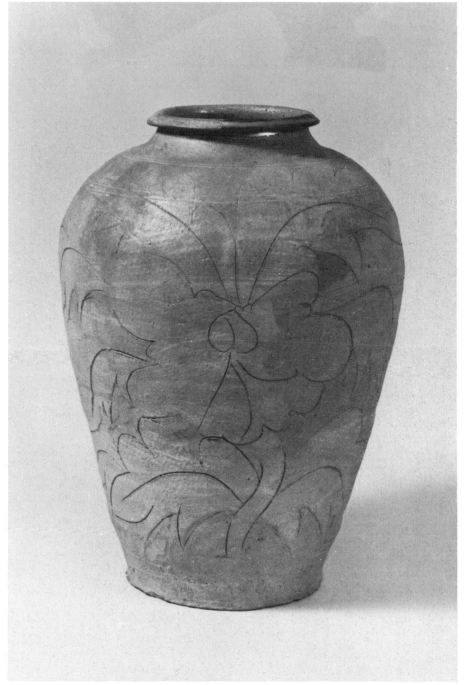

178

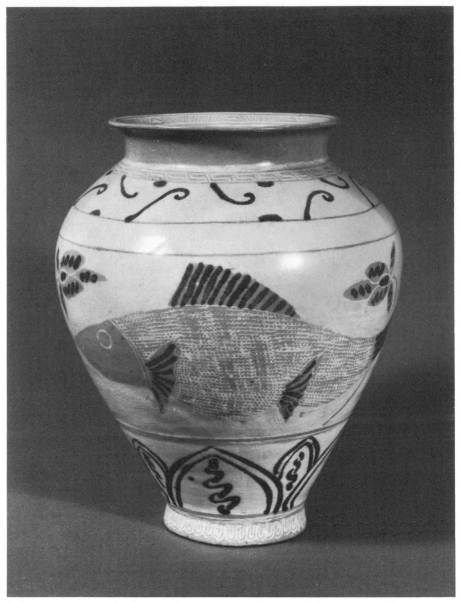

179

179 Wide-mouthed jar

Chosŏn dynasty, 15th–16th century AD
Dark grey stoneware, with pale slip and painted
and stamped decoration, *inhwa* and
ch'ŏlhwa punch'ŏng. H 27.0 cm;
D (mouth) 15.0 cm, (foot) 9.8 cm
Hoam Art Museum Yongin

At least three of the *punch'ŏng* techniques are
combined in the decoration of this handsome
jar. According to Chung Yang-mo, the narrow
borders inside the mouth, at the base of the
neck, and around the foot-ring, are in *sanggam*
inlay technique. But the rest of the decoration is
marvellously spontaneous. The main motif of
the fish was first lightly incised in outline, then
its scales were indicated by stamping (*inhwa*).
The main area, from just above the foot-ring
to just below the neck, was brushed with thin
slip, in the *kwiyal* technique. This slip was wiped
away within the outlines of the fish and lotus
motifs, leaving its traces in the impressed or in-
cised areas. Finally, the broad lines of dark iron-

oxide pigment were painted, before the whole
vessel was coated with a transparent glaze.

The contrast between the large fish of the
central panel, reserved against the pale slip back-
ground, and the lotus motifs beneath, is most
effective in giving the impression that it is swim-
ming in a pond or lake. The *punch'ŏng* potters
were especially skilful at conveying animated
and life-like designs with the relatively simple
means at their disposal. Abstract motifs, such as
those on the shoulder, are ingeniously combined
with real objects. In particular, the bold lotus
petals with scrolling centres give strength and
stability to the vase, which has wide shoulders
and a very narrow foot.

The jar comes from the Kyeryong kiln, which
specialised in *ch'ŏlhwa punch'ŏng*, with large,
almost abstract, painted motifs (see no.180),
but which also produced stamped and incised
punch'ŏng vessels. RW/YSP

Published San Francisco 1979, no.179;
Choi Sunu 1979, pl.136;
Chung Yang-mo 1982, pl.162

180 Wine flask with double fish motif *(colour ill.)*

Chosŏn dynasty, 16th century AD
Dark grey stoneware, with pale slip and
incised decoration, *sŏnhwa* and
pagji punch'ŏng. H 25.0 cm;
D (mouth) 4.5 cm, (foot) 8.7 cm
Park Jun-hyong Collection;
National Treasure no.178

The decoration on the flattened sides of this flask
is done by means of boldly incised outline, with
additional areas pared away in the narrow panels
at the ends. The sureness with which the design
is handled, and the way in which the main
subject almost entirely fills the whole side of
the vessel, is characteristic of the potters of the
Chosŏn dynasty, and of the *punch'ŏng* craftsmen
in particular. The double fish motif stands in
both China and Korea as a symbol of abundance.
 RW/YSP

Published Chung Yang-mo 1978, pl.46;
San Francisco 1979, no.176;
Choi Sunu 1979, pl.140;
Chung Yang-mo 1982, pl.80

181 Wine jar *(changgun)*

Chosŏn dynasty, 16th century AD
Dark grey stoneware *ch'ŏlhwa punch'ŏng*.
H 18.7 cm; L 29.5 cm; D (mouth) 5.6 cm,
(foot) 8.8–10.6 cm
Horim Art Museum, Seoul

This type of bottle is traditionally called *changgun*.
The etymology of the word is not clear, but it is
generally used to refer to a vessel of pottery or
wood used for holding liquids such as rice wine
or soy sauce. Although this example has an
added foot-ring, such vessels were commonly
stood on one end, which was left flattened, and
even, as in this piece, slightly hollowed to provide
a stable ring for standing. The shape is character-
istic for *punch'ŏng*, but is a variation of one that
can in fact be traced back as far as the Western
Han dynasty in China (206 BC–AD 8) (New York
1982, pp.68–9). One *changgun* has even been
found in the excavations at Anap-chi (Anap-chi
1980, fig.83).

The bold, almost abstract decoration of this
piece marks it as having been made at the
Kyeryong kilns, like the next vessel, no.182.
 RW/YSP

Published Chung Yang-mo 1982, pl.141

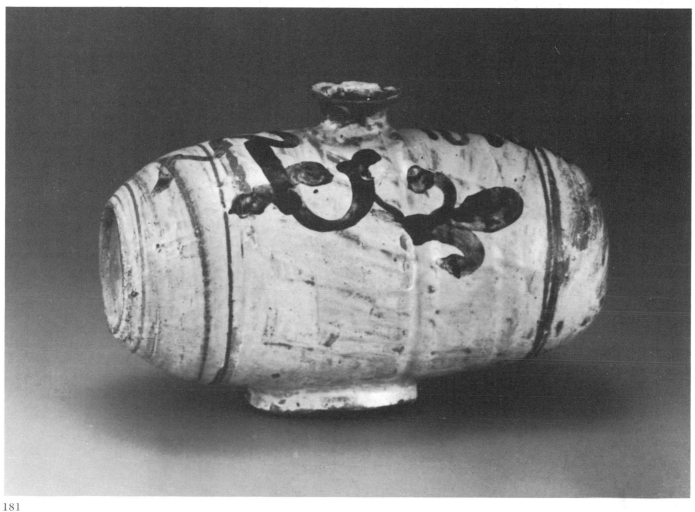

181

182 Small jar

Chosŏn dynasty, 16th century AD
Dark grey stoneware painted in iron oxide,
 ch'ŏlhwa punch'ŏng. H 10.6 cm;
 D (mouth) 9.5 cm, (foot) 6.1 cm
Dong-a University Museum, Pusan

The plant motif on this small jar, painted with a
broad brush, is simplified to a point of complete
abstraction. It has a humorous character typi-
cal of the pieces produced at the kilns on Mt
Kyeryong, near Taejŏn in South Ch'ung-ch'ŏng
province. The Kyeryong pieces commonly have
the slip brushed on *(kwiyal)* on the upper half of
the vessel only, leaving the coarse body exposed
below, with its prominent traces of the throw-
ing process. The iron-oxide pigment, applied
with a very thick brush, is also especially black,
said to be due to the presence of manganese.

RW/YSP

Published San Francisco 1979, no. 177;
Choi Sunu 1979, pl. 131;
Chung Yang-mo 1982, pl. 147

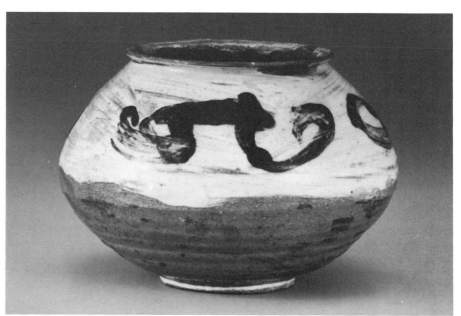

182

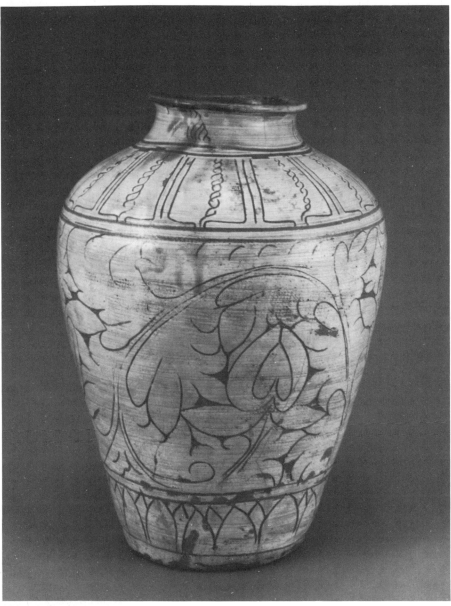

184

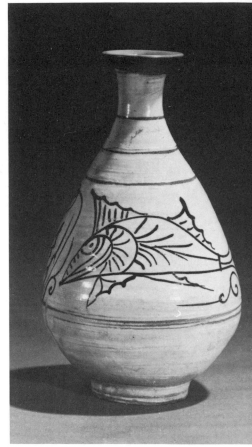

185

183 Wine bottle *(colour ill.)*

Chosŏn dynasty, 16th century AD
Dark grey stoneware, *pagji punch'ŏng*.
 H 34.2 cm
Seo Jae-sik Collection

This pear-shaped bottle is an example of the *pagji punch'ŏng* technique used on its own. The fish, and the lotuses among which they swim, are simply created by paring prominent features down to the grey body, without outlines. The top of the vessel has been repaired; the slip, and the handsome triple collar of inverted lotus petals, would originally have reached close to the rim.
RW/YSP

184 Tall jar

Chŏson dynasty, 15th century AD
Dark grey stoneware, *sŏnhwa* and
 pagji punch'ŏng. H 43.8 cm;
 D (mouth) 15.5 cm, (foot) 16.7 cm
National Museum of Korea, Seoul

This large jar has thick slip applied with the brush. The main design is of a generous lotus scroll, with voluminous foliage, flowers and buds freely incised in sweeping curves. Here and there a small area has been pared down to the body in order to accentuate the lotus blossoms. RW/YSP

Published Chung Yang-mo 1978, pl.48;
1982, pl. 97

185 Wine bottle

Chosŏn dynasty, 16th century AD
Dark grey stoneware painted in iron oxide,
 ch'ŏlhwa punch'ŏng. H 28.6 cm;
 D (mouth) 6.6 cm, (foot) 7.6 cm
National Museum of Korea, Seoul

Fish were a favourite motif on wine bottles of this shape, and several examples are extant in various collections. The fish are drawn with bold lines in underglaze iron and have an idiosyncratic appearance, with few concessions to reality. In some the scales are indicated by dots (Chung Yang-mo 1982, pl.131) or, as in one example in the Ogura collection, turned at right angles to their natural alignment (Gompertz 1968, pl.33). These stylised and even fierce-looking fish are quite different from the more natural-looking ones with which they might be compared on Cizhou wares in north China (Mino 1980, pl.50). RW/YSP

Published Kim Chewon 1964, p.145;
Choi Sunu 1979, pl.137;
San Francisco 1979, no.180

Chosŏn Porcelain

The ceramics of the Chosŏn period reflect a profound change in taste from the luxurious life-style of Koryŏ. In the Koryŏ dynasty Buddhist ceremony and aristocratic taste alike had encourage elaborate and richly decorated wares, many of which have been preserved in burials. In the Chosŏn period, although *punch'ŏng* wares decorated in *inhwa* and *sanggam* technique preserved the traditions of celadon manufacture for a short time in the fifteenth century, the prevailing Confucian ethic demanded wares of an altogether simpler nature.

The material which established itself as the preferred ware in this period was plain white porcelain, which had in fact already been made during the Koryŏ period (cf. Choi Sunu 1981, pls 187–200). Some of these had been decorated in the *sanggam* technique, or carved or moulded, or painted in iron-brown under the glaze. But others (*ibid*, pl. 192) were left entirely plain, one of them dated AD 993 (*ibid*, pl. 187). The white porcelain of the Chosŏn period drew on this tradition to satisfy the needs of the new Confucian élite and court ceremonies.

Porcelain was in demand for daily use as well. Traditionally in Korea a distinction has been made according to season in the vessels used by the upper classes: metal bowls in winter, and pottery in summer. The finds from Anap-chi have recently shown that metal bowls were in common use as early as the Unified Silla period (cf. Lee Nan-young 1983). A shortage of brass for metal vessels may have encouraged the production of ceramics in the early Chosŏn period (Kim Won-yong 1982, p. 231). What is certain is that early in the fifteenth century ceramic production was widespread in Korea, and must have been intended for all classes. In AD 1424–5 a census of kilns was carried out and recorded in the *Sejong sillok* (Annals of King Sejong). The figures, which have often been quoted, listed 139 porcelain and 185 stoneware kilns. The majority of these kilns were not official kilns but were privately operated. Porcelain was sent as annual tribute from the whole country to the court.

Gompertz, in his authoritative *Korean Pottery and Porcelain of the Yi Period* (1968), has cited numerous sources which furnish valuable materials for the history of ceramics in the Chosŏn dynasty. In particular he notes that 'according to a contemporary source, the *Yongjae ch'onghwa* by Sŏng Hyŏn (1439–1504), white porcelain was used exclusively in the royal household of King Sejong' (pp. 15–16). The pieces that have survived of this ware show Korean ceramic taste in its purest form. The monumental covered bowl illustrated in this catalogue (no. 186) is a good example, generous in shape and harmonious in line. Other shapes with typical Korean characteristics include offering stands and jars with faceted sides. Such faceting, especially when it extends from the foot of a piece right to the top, appears uniquely Korean. It is often married to gentle concave curves in the mouth-rim, or with a slightly curved upper surface in the case of offering stands. Some pieces have appliqué ridges of toothed ornament, perhaps inspired by the flanges on Chinese ritual bronze vessels.

Another variety of white porcelain in the fifteenth century was inlaid in black. It is represented here by the bowl, no. 189. A group of white porcelain, including an epitaph plaque and a flattened vase both decorated in this way, has been excavated from the tomb of Lady Chung, dated by the plaque to AD 1466. The group includes a miniature bowl with appliqué wings (Choi Sunu 1963). Such miniature bowls with wings are very distinctive and unique to Korea (Chung Yang-mo 1983, pls 6–7).

In the exchanges between Korea and the Ming court, gifts of porcelain were made on both sides. Gompertz cites an order to the Kwangju kilns for 'large, medium-sized and small white porcelains for presentation to the Emperor' (*ibid*, p. 16). The porcelain received in return from China was of course blue and white and made at Jingdezhen. Great efforts were made in Korea to make blue and white wares, but the scarcity of cobalt, which had to be imported from China at considerable cost, meant that in the fifteenth and sixteenth centuries relatively little porcelain decorated in this technique was made.

As a result, the few pieces that survive with extensive decoration in blue and white, like the large dated vase (no. 198) were probably intended for the exclusive use of the court. In *Tongguk yŏji sŭngnam* (Geographical Survey of Korea, AD 1481), it is recorded that each year the Sa'ong-wŏn, the Office of the Royal Kitchens, obtained the services of painters for the decoration of vessels for the court (Yun Yong-i 1980, p. 51). These must have been decorated in blue and white. After the widespread destruction which occurred in the Japanese invasion of 1592–8 it must have become almost impossible to provide for the needs of the court. In a memorial dated AD 1618 the Sa'ong-wŏn Office advised that all the decorated jars used at royal household festivals were destroyed in the war and that no more could be made as there was no means of importing cobalt. (Gompertz 1968, p. 56.)

Even in the eighteenth century great care was still being taken to produce white wares of a high quality. Korea had an abundance of excellent white clays, which were carried from afar to the central kilns, according to the records of the reign of King Sukjong (AD 1674–1720) (Chung Yang-mo 1983, p. 189). From AD 1752 to 1880 the official kilns for which the Sa'ong-wŏn was responsible were established at Punwŏn-ri in Kwangju district; their actual locations were shifted every ten years to obtain the best wood supply in the district, which is on the Han River south-west of Seoul, but which was unfortunately built over in the period of Japanese occupation after 1910.

Underglaze painting in brown iron oxide (no. 199) was used from the fifteenth century onwards, while underglaze red, which had been pioneered by Korean potters in the Koryŏ period, was revived in the seventeenth century. Both techniques are found in the eighteenth centuries (nos 204, 209, 210), sometimes in combination (no. 218), but from the late seventeenth century greater numbers of pieces were sparingly decorated with elegant flower or grass sprays, in underglaze blue (nos 205–8). Eventually by the nineteenth century cobalt must have been available in sufficient quantity for common use. In China of the eighteenth and nineteenth centuries polychrome enamels, introduced in the Ming dynasty, dominated, but none of them were ever made in Korea, for whose austere taste they may have been too gaudy. Instead, much care went into the creation of delightful water-droppers for the scholar's desk (no. 211), while some of the favourite subjects of popular imagery in folk painting were also rendered in blue and white (no. 214). The distinction between popular and official taste can be seen when these are contrasted with elegant pieces coloured entirely in underglaze blue, like no. 212, where the faceting is carried right through every element from the foot to the mouth-rim. RW

186

186 Covered bowl

Chosŏn dynasty, 15th century AD
White porcelain. H 22.5 cm; D (mouth)
 15.5 cm, (foot) 6.5 cm
Horim Art Museum, Seoul

In shape this rice bowl, with its high domed
cover, echoes the bronze vessels of the Koryŏ
dynasty. The effectiveness of the piece lies in the
monumental form. Its heavy, gently rounded
shape is emphasised by engraved double lines. It
has a thick, soft, flawless glaze, with bluish-
white shading. The cover is crowned with a
conical knob.

The quality of the porcelain suggests that it
was made in one of the official kilns in Punwŏn,
for use in the court. UW

Published Kyōto 1976, no. 180;
San Francisco 1979, no. 168; Chung Yang-mo
1978, pl. 67; 1983, pl. 1

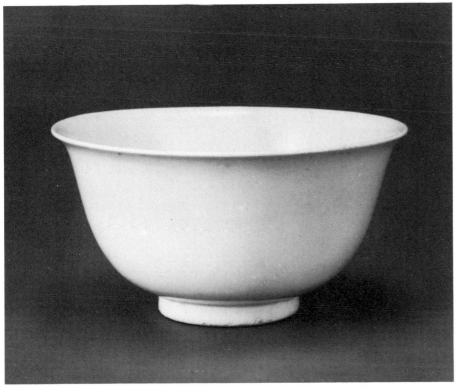

187

187 Bowl

Chosŏn dynasty, 15th century AD
Porcelain. H 11.0 cm; D (mouth) 21.1 cm,
 (foot) 7.3 cm
Horim Art Museum, Seoul

The fifteenth century saw many variants of this
archetypal dish with its flaring rim. Here it is
relatively deep, with taut contours and a flawless
glaze. There is no decoration at all. Such pieces
were produced exclusively for use at the court,
especially in the first half of the century. UW

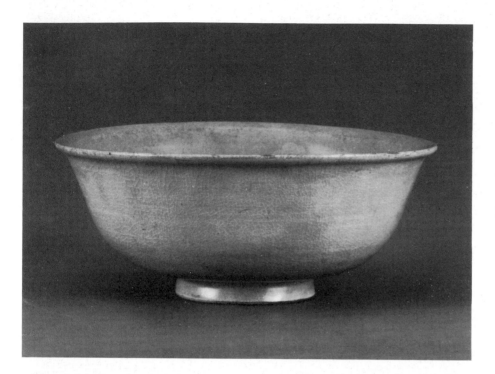

188 Bowl

Chosŏn dynasty, 15th century AD
Stoneware with moulded decoration under a
 celadon glaze. H 7.8 cm;
 D (mouth) 18.5 cm, (foot) 7.1 cm
National Museum of Korea, Seoul

Celadon had already begun to decline in the
late Koryŏ dynasty, and pieces like this – un-
doubtedly from the early Chosŏn dynasty – are
quite rare. Inside the bowl are four cloud motifs,
with a stamped rosette in the centre.

It is likely that this bowl was made in the kilns
at Tochang-kol or Toma-ri, both in Kyŏnggi
province. Clouds were also a common motif in
the *punch'ŏng* ware of the period. UW

Published Chung Yang-mo 1978, pl.6

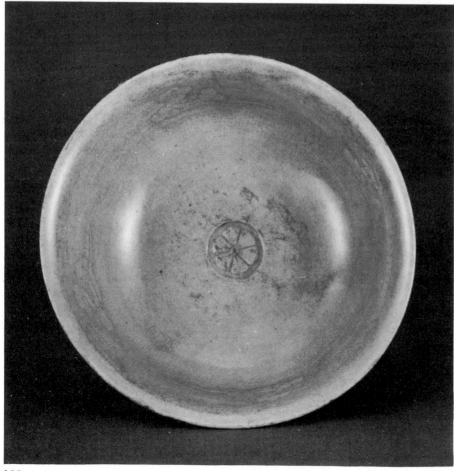

188

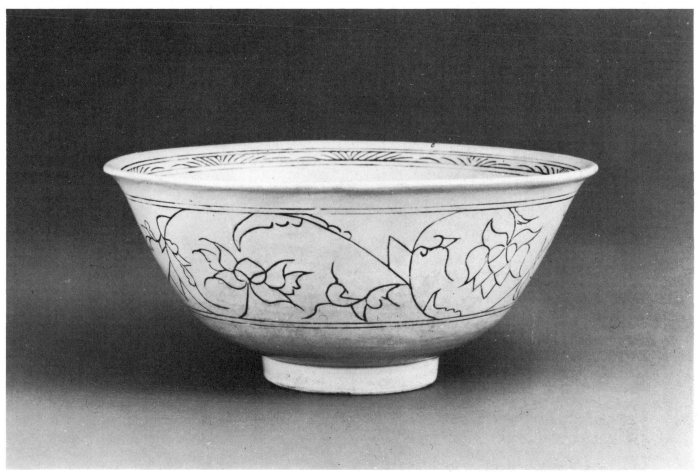

189

189 Bowl

Chosŏn dynasty, 15th century AD
White porcelain with inlaid underglaze
 decoration. H 7.6 cm; D (mouth) 17.5 cm,
 (foot) 6.2 cm
National Museum of Korea, Seoul;
 National Treasure no. 175

This bowl has a broad band of incised lotus
scroll enclosed between double lines. Inside the
mouth is a narrow band with a design of tufts of
grass, a motif also found in the *punch'ŏng* wares
(cf. no. 173) and characteristically Korean. The
precise, clear, engraved decoration is inlaid with
iron-brown, and is entirely appropriate to the
spare form of this thin-walled bowl. UW

Published Chung Yang-mo 1978, pl. 75;
Kyōto 1976, no. 176;
San Francisco 1979, no. 169;
Chung Yang-mo 1983, pl. 40

190 Pear-shaped bottle

Chosŏn dynasty, 15th century AD
White porcelain with inlaid underglaze
 decoration. H 28.8 cm; D (mouth) 7.3 cm,
 (foot) 9.5 cm
Horim Art Museum, Seoul

The arched blossom and leaf decoration that sits
so well on the sides of the vessel serve to comple-
ment its heavy pear-shaped contours. This type
of flask, produced only in the early years of the
Chosŏn dynasty, has its origins in the late Koryŏ
period, as does the technique of engraving and
inlaying the motifs with iron pigment.

We now know of a kiln in Pŏnch'ŏn-ri near
Kwangju in Kyŏnggi province which was pro-
ducing porcelain with inlay decoration in the
early Chosŏn dynasty. UW

Published Chung Yang-mo 1975, pl. 78;
Kyōto 1976, no. 178;
San Francisco 1979, no. 170

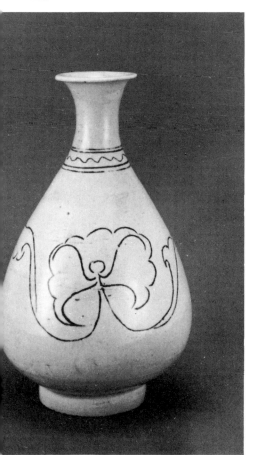

190

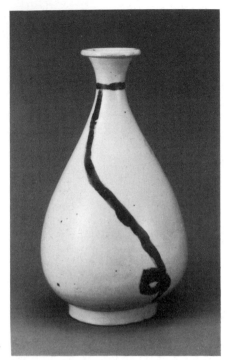

191

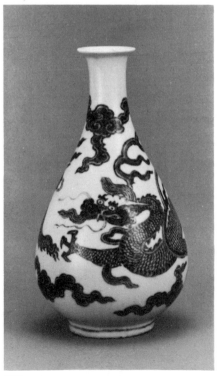

192

191 Pear-shaped bottle

Chosŏn dynasty, 15th century AD
White porcelain with underglaze iron
 decoration. H 31.4 cm; D (mouth) 7.0 cm,
 (foot) 10.6 cm
Seo Jae-sik Collection

This bottle is notable for the originality of its
design. A single thick line encircles the neck at
its narrowest point and continues downwards,
ending in a loop. The brushwork with its differ-
ent degrees of shading is marked contrast to the
clean contours of the vessel, and the shape itself
seems to be distorted by the band of iron pigment.

UW

192 Pear-shaped bottle
with dragon

Chosŏn dynasty, 15th century AD
Porcelain with decoration in underglaze blue.
 H 25.0 cm; D (mouth) 5.3 cm, (foot) 7.7 cm
Hoam Art Museum, Yongin

This bottle has an unusually low base, and its
neck curves only slightly. A single dragon twines
round the whole body chasing a flaming pearl.
Dragons of the middle and late Chosŏn dynasty
are stylised and often caricatured, but this one,
with its realistic and vigorous movement, shows
much of its Chinese ancestry. The piece was
decorated by a professional painter, for use in
the palace, and came from one of the official
kilns at Punwŏn.

UW

193 Water-dropper

Chosŏn dynasty, 15th century AD
Porcelain with decoration in underglaze blue.
 H 7.7 cm; D (foot) 6.3 cm
National Museum of Korea, Seoul

The top of this water-dropper, found in a grave
at Ch'angdong in the suburbs of Seoul, is dec-
orated with a branch of pine and a somewhat
smaller branch of plum. Typical of the cobalt
decoration of the early Chosŏn dynasty is the
metallic blackening of the blue, also found in
early Chinese blue and white porcelain. The
brownish coloration of the glaze is typical of
the period.

Pieces of this kind have been found at Pŏn-
ch'ŏn-ri in Kwangju.

UW

Published Kim and Lee 1974, pl. 158;
Kodansha 1976, pl. 99; Kyōto 1976, no. 188;
San Francisco 1979, no. 174

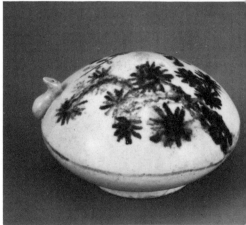

193

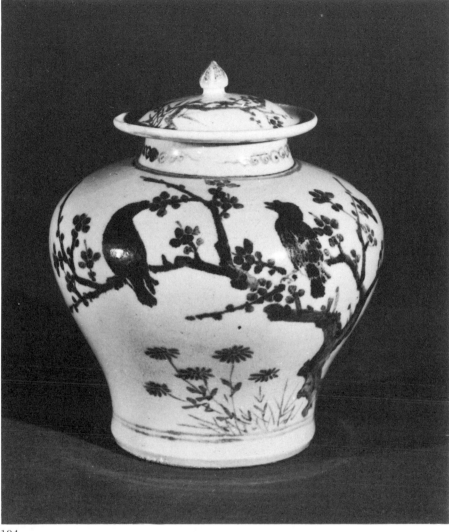

194

194 Covered jar

Chosŏn dynasty, 15th century AD
Porcelain with decoration in underglaze blue.
 H (with cover) 16.5 cm;
 D (mouth) 6.1 cm, (foot) 9.0 cm
National Museum of Korea, Seoul;
 National Treasure no. 170

In a whole series of features, such as the wide shoulder, tapering neck, and the flattened cover with upturned rim, this miniature wine jar epitomises the Korean variations on the standard Chinese theme. The painting covers the whole surface of the vessel. Two birds are chatting on the branches of a flowering plum. A spray of chrysanthemums hints at the landscape beneath. Only on the neck is there a kind of classical garland. The bird motif is direct, indicative of a spontaneous delight in nature, and in keeping with the rather rustic shape of the jar. It contrasts with the more traditional, idealised Chinese designs favoured in court circles.
 Pieces of this kind have been discovered at Toma-ri, near Kwangju, Kyŏnggi province. UW

Published Chung Yang-mo 1978, pl. 79;
Kyōto 1976, no. 182;
San Francisco 1979, no. 173, pl. XXX

195 Covered jar

Chosŏn dynasty, 15th century AD
Porcelain with decoration in underglaze blue.
 H 14.1 cm; D (mouth) 4.0 cm, (foot) 6.9 cm
Hoam Art Museum, Yongin

Published Hoam 1982, pl. 70

196 Covered jar

Chosŏn dynasty, 15th century AD
Porcelain with decoration in underglaze blue.
 H 14.1 cm; D (mouth) 4.1 cm, (foot) 7.1 cm
Seo Won-seok Collection

Both this jar, and no. 195, are miniature versions of large jars. There is no border decoration, and the whole of each vessel is covered with the design of branches of flowering plum, with magpies sitting on them. The magpie was an auspicious bird in both China and Korea, bringing good luck. UW/RW

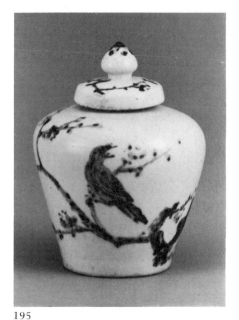

195 196

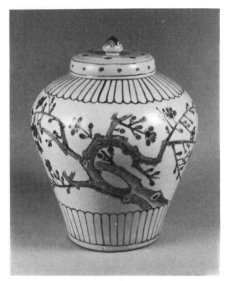

197

197 Covered jar

Chosŏn dynasty, 15th century AD
Porcelain with decoration in underglaze blue.
H (with cover) 29.6 cm; D (cover) 12.7 cm;
(foot) 6.1 cm
Horim Art Museum, Seoul

In this jar the broad centre section bears the
strangely forked and convoluted trunk of a
plum, its branches embracing the vessel, with
bamboo as the counter-motif on the opposite
side. Attempts have been made to vary the trunk
by contoured and graded brushwork. The calm
and ordered decoration of narrow petals form-
ing a border around the foot, on the shoulders,
and enclosing the main design, is in perfect
contrast. The flat cover with its lotus knob is
evenly decorated with dots. The decoration is
most effective, and purely Korean. UW/RW

Published San Francisco 1979, no. 172

198 Vase with bamboo and pine

Chosŏn dynasty, dated second year of
Hongzhi. AD 1489
Porcelain with decoration in underglaze blue.
H 48.7 cm; D (mouth) 13.1 cm,
(foot) 17.8 cm
Dongkuk University Museum;
National Treasure no. 176

This tall vase tells us much about the history
of Korean blue and white porcelain. It is dated
inside the mouth: Hongzhi, 2nd year. This refers
to the Chinese reign, of which the second year
corresponds to AD 1489. The mouth has been
restored, and all that remains of the inscription
is the name of the reign. The slender base of the
vase rises from a projecting foot, the shoulders

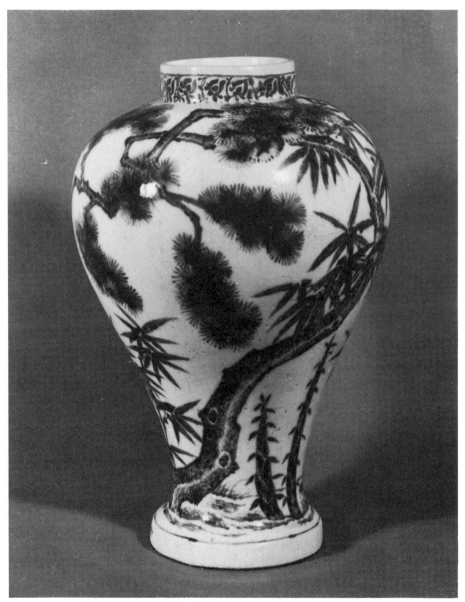

198

curving outwards unusually far. The piece must
originally have had a cover with projecting
flange, but this has been lost, as with other later
jars, and the contour remains incomplete.

There is a broad area between the short vertical
neck and the foot, decorated with sweeping,
asymmetrical swathes of pine and bamboo.
The plentiful use of cobalt, contrasting with its
sparing use on other pieces, the professional
handling of the Confucian theme, the date, and
the solemn, monumental shape suggest that
this unusual vase was designed to fulfil a par-
ticular ceremonial function at the court. UW

Published Chung Yang-mo 1978, pl. 80;
Kyōto 1976, no. 183;
San Francisco 1979, no. 171

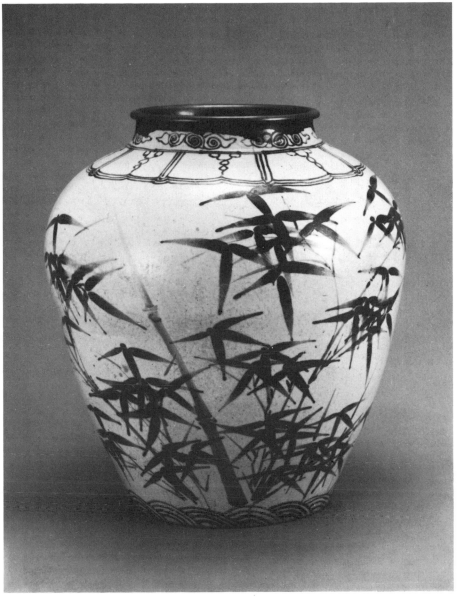

199

200 Cylindrical vase

Chosŏn dynasty, 17th century AD
Porcelain with underglaze iron. H 26.8 cm;
D (mouth) 3.5 cm, (foot) 13.2 cm
National Museum of Korea, Seoul

200

199 Jar with bamboo

Chosŏn dynasty, 16th century AD
Porcelain with decoration in underglaze iron.
H 40.0 cm; D (mouth) 19.0 cm,
(foot) 21.5 cm
National Museum of Korea, Seoul;
National Treasure no. 166

The generous shape of this jar recalls Chinese vessels of the Jiajing reign (AD 1522–66). The petal forms with triple outline are also found on Chinese porcelain of that time. Most of the surface is covered on one side with a dense pattern of bamboo leaves, and on the other with a *Prunus* motif, the two interlacing and linked at the base by a row of overlapping concentric arcs. Con-trasting brush techniques are used: contour lines for the *Prunus* branches, but for the bamboo the 'boneless' technique, without contours. As in ink-painting, the bamboo and *Prunus* are executed on a white background.

The body is greyish-white, with the decoration in iron-brown, at times verging on a yellowish-green, under a light, bluish glaze. The highly atmospheric painting and the confident brush-work are probably the hallmarks of a professional painter, working at one of the official Punwŏn kilns to produce vessels for the court. UW

Published Chung Yang-mo 1978, pl. 111;
Kyōto 1976, no. 193; Kodansha 1976, pl. 75;
San Francisco 1979, no. 175

This vessel, constructed from individual pieces, has straight sides, flaring slightly at the bottom. The porcelain vessel has been painted with clearly visible, broad, uneven brush-strokes of iron-bearing slip, with a transparent glaze over it. On the base, the glaze has been applied directly to the body. The uneven application of the iron slip gives the orderly shape a vivid, rich surface, not at all monochromatic in its effect.

Sandy deposits on the base show that the piece stood directly on the kiln floor. The texture of the glaze suggests that this piece was produced in one of the official kilns at Punwŏn. UW

Published Chung Yang-mo 1978, pl. 134;
Kodansha 1976, pl. 104

201 Wine container (*changgun*)

Chosŏn dynasty, 17th century AD
Porcelain with decoration in underglaze iron.
 H 8.5 cm; D (flat end) 16.0 cm
National Museum of Korea, Seoul

This container has a rustic appearance reminiscent of a rice bale. One end is flattened (cf. no. 181). The whole of the remaining surface of the container is available for painting. The subject is a three-clawed dragon, uncurling itself among clouds. The painting, in iron-brown, is spontaneous and powerful, very thickly applied in places, with metallic discolorations blurring the motif. Both the painting and the shape of the container have a naive charm which is often the hallmark of privately operated kilns.

Similar vessels have been found on Mt Kwanak near Seoul, at Mt Kyeryong, and at other sites. This ancient type of container can be traced back to the Three Kingdoms period, and was also popular in *punch'ŏng* ware (see no. 181) and in white porcelain during the Chosŏn dynasty. UW

Published Kodansha 1976, pl. 78

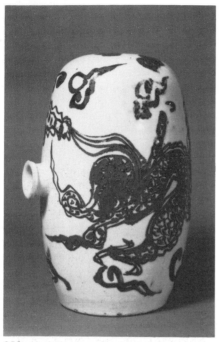

201

202 Jar with dragon

Chosŏn dynasty, 17th century AD
Porcelain with decoration in underglaze iron.
 H 28.2 cm; D (mouth) 18.5 cm,
 (foot) 13.4 cm
National Museum of Korea, Seoul

The solid, convex body of this piece is set off by a low, narrow foot-ring and a wide mouth with no neck.

A caricatured, iron-brown dragon rushes right round the sides, its scales roughly blotched by way of enhancement. Dragons like this are a standard form of decoration on this type of vessel, and are often abstract to the point of being unrecognisable. The irregularities of shape, marks of throwing and the design are all indicative of the fact that this piece was produced for ordinary use, in one of the unofficial kilns. UW

Published Seoul 1982, p. 288

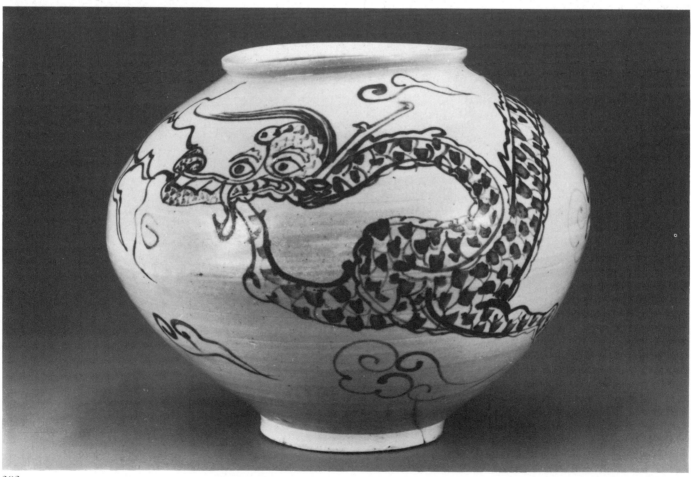

202

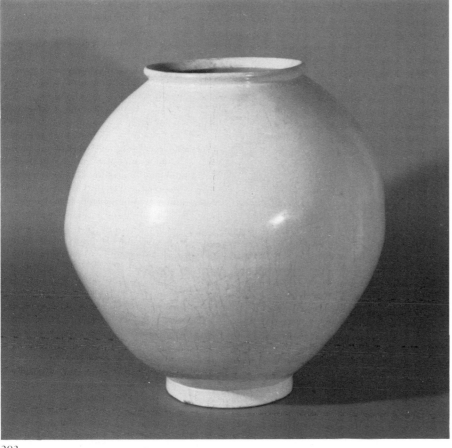

203

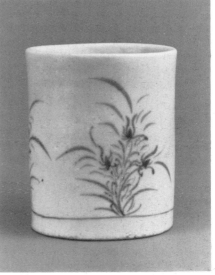

205

203 Large jar

Chosŏn dynasty, 17th century AD
Porcelain. H 42.8 cm; D (mouth) 19.8 cm,
(foot) 15.8 cm
National Museum of Korea, Seoul

This almost spherical storage jar is made up of two bowl-shaped halves joined together. The resulting luted seam and asymmetrical shape give character to the simple, self-enclosed container shape. The milky white soft glaze is crackled, and the piece probably originated from one of the official Punwŏn kilns, which at this time were located at Kuman-ri in Kwangju district, Kyŏnggi province. This shape was popular in the seventeenth and eighteenth centuries. UW

Published Kodansha 1976, pl. 74;
San Francisco 1979, no. 200

204 Large jar with grape vine *(colour ill.)*

Chosŏn dynasty, 17th century AD
Porcelain with decoration in underglaze iron.
H 53.8 cm; D (mouth) 19.5 cm,
(foot) 19.2 cm
Ewha Woman's University Museum, Seoul;
National Treasure no. 107

This jar is regarded by many as the largest and most beautiful of its kind. In contrast to the abstract painting in iron-brown of the private kilns, this vessel is painted in a courtly and very naturalistic style. A vine hangs from the neck over the shoulders, the large grapes so realistically depicted that they seem to move. The depiction is in deliberately contrasted gradations of colour, from light to dark brown, in rich washes.

The shape is typical of the middle of the Chosŏn dynasty, with a straight, vertical neck, high, wide shoulders tapering sharply to a narrow foot. There can be no doubt that the jar originally had a cover, now missing. As with simpler storage jars, this one consists of two sections luted together: the line of the join is easily visible.

This jar, fired in one of the official Punwŏn kilns at Kwangju for palace use, was decorated by a professional painter. UW

Published Gompertz 1968, pl. 70;
Chung Yang-mo 1978, pl. 120;
San Francisco 1979, no. 198

205 Brush pot

Chosŏn dynasty, 18th century AD
Porcelain with decoration in underglaze blue.
H 16.0 cm; D 13.1 cm
Hoam Art Museum, Yongin

The straight sides of this plain, cylindrical brush pot have no separate mouth or foot. The sparingly painted cobalt-blue decoration is composed of individual sprays of orchid, plum and bamboo, linked by a single base line. The simple shape, with its soft, lyrical painting, is an example of the refined taste of this period for the implements of the scholar's writing desk. It is probably a product of one of the official Punwŏn kilns, possibly from Kŭmsa-ri in Kwangju. UW

Published Kyōto 1976, no. 189;
San Francisco 1979, no. 202;
Hoam 1982, pl. 104

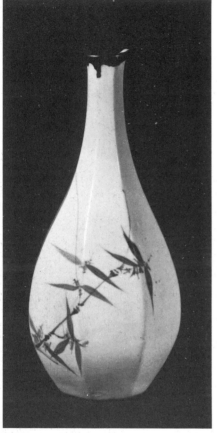

206

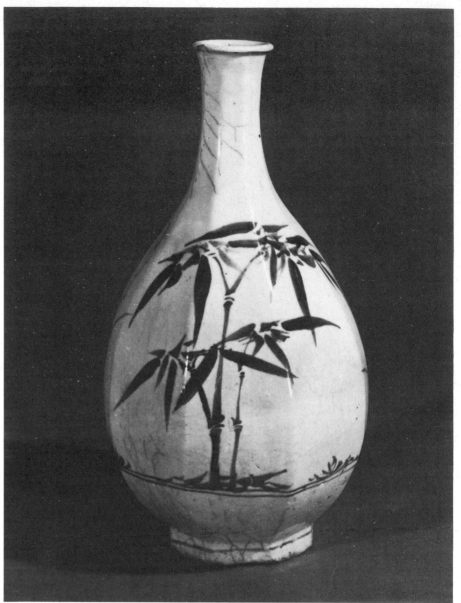

208

206 Octagonal bottle

Chosŏn dynasty, 18th century AD
Porcelain with decoration in underglaze blue.
 H 27.4 cm; D (mouth) 4.4 cm, (foot) 6.1 cm
National Museum of Korea, Seoul

This slender octagonal bottle has a symmetrical decoration of wild orchid on one side, and a bamboo leaning to the right on the other, the latter sharp and well defined in contrast to the vague and undefined way in which the orchid is painted. Potters strove to achieve their effects as economically as possible because of the considerable difficulty experienced in importing cobalt.

The method of enhancing a simple, basic ceramic form by giving it faceted walls is an increasing tendency in the porcelain of the late Chosŏn period. This early vase in the group is remarkable for the fact that is has no foot. It comes from one of the Punwŏn kilns in Kwangju. UW

Published Kyōto 1976, no. 184;
Kodansha 1976, pl. 82;
San Francisco 1979, no. 199

207 Octagonal bottle *(colour ill.)*

Chosŏn dynasty, 18th century AD
Porcelain with decoration in underglaze blue.
 H 40.3 cm; D (mouth) 7.7 cm, (foot) 11.2 cm
Hoam Art Museum, Yongin

This tall, octagonal bottle has a sturdy foot, also octagonal, contrasting with the circular mouth and rounded lip. This type of bottle was thrown with thick walls which were then faceted by being cut with a knife from top to bottom. The design is on opposite sides of the bottle, with a large clump of bamboo at the front and a smaller one behind, both emerging from the encircling base line. This piece, with a pale bluish glaze, comes from a kiln in Kuman-ri, in the district of Kwangju. UW

Published Chung Yang-mo 1978, pl. 82;
Hoam 1982, pl. 73

208 Octagonal bottle

Chosŏn dynasty, second half of the 18th
 century AD
Porcelain with decoration in underglaze blue.
 H 35.0 cm; D (mouth) 5.4 cm, (foot) 10.2 cm
Hoam Art Museum, Yongin

This late example of a bottle fashioned into an octagonal shape has a tall, heavy body, a short neck, and virtually no lip at all. The decoration is on two sides, and consists of bamboo and plum above an encircling double line, with suggestions of further vegetation below it. The quality of the glaze, and the blue shading, are typical of the period after the mid-eighteenth century.
UW

Published Chung Yang-mo 1978, pl. 103;
Kyōto 1976, no. 186;
San Francisco 1979, no. 203, pl. XXXII

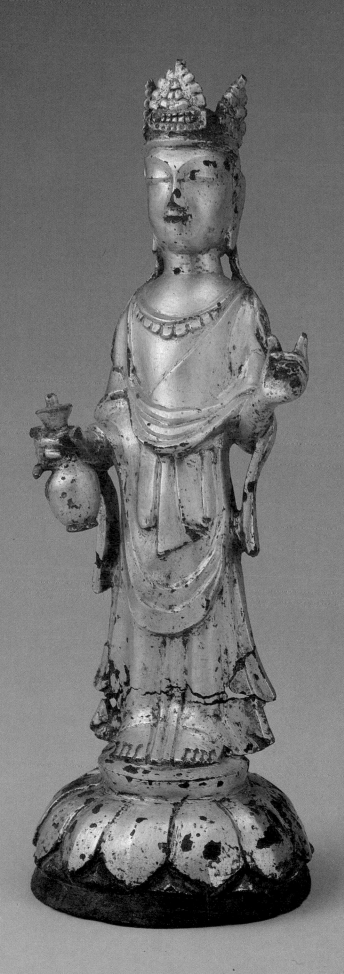

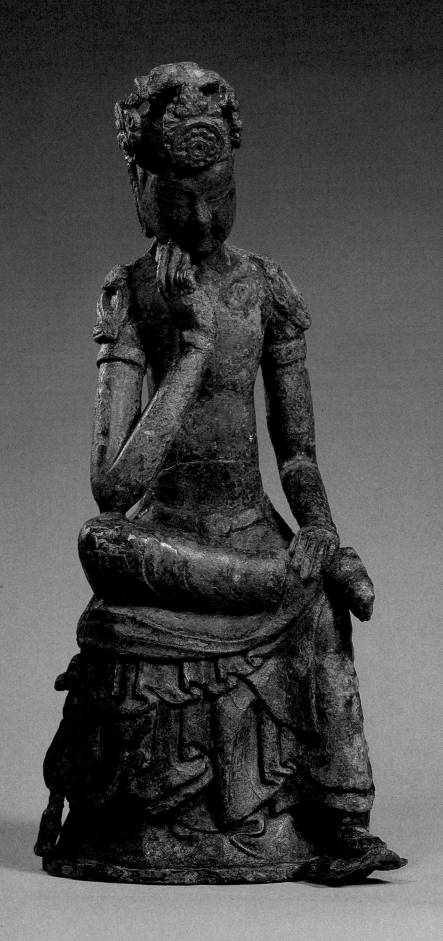

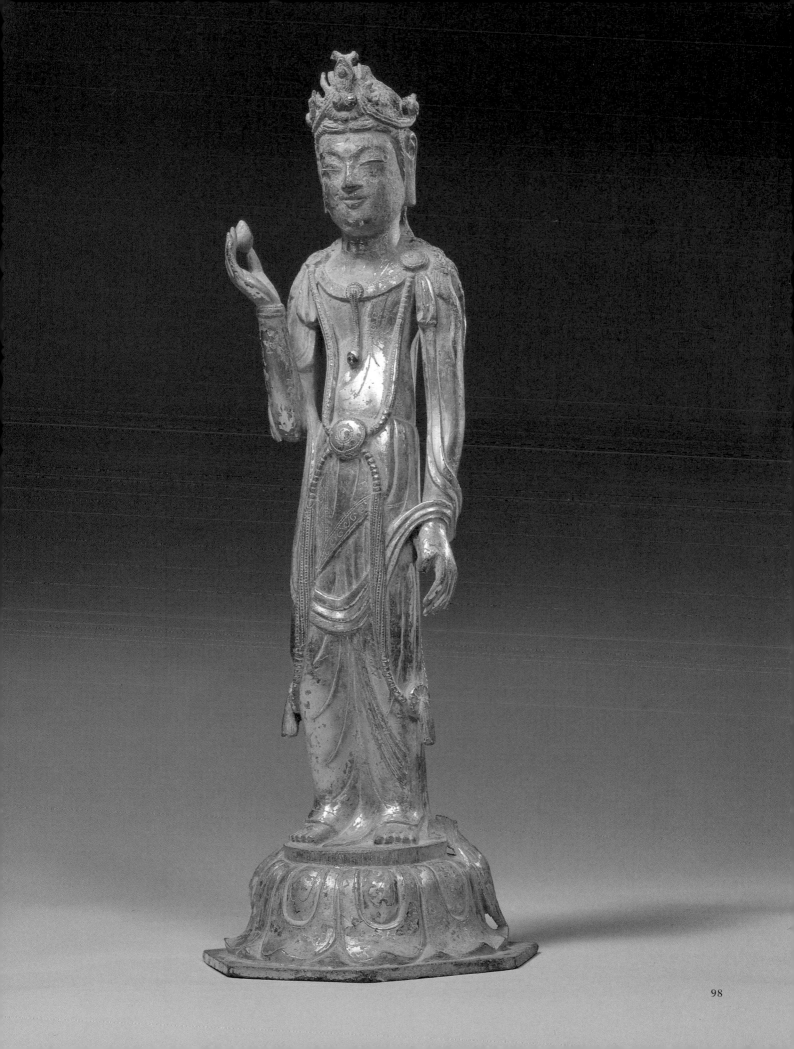

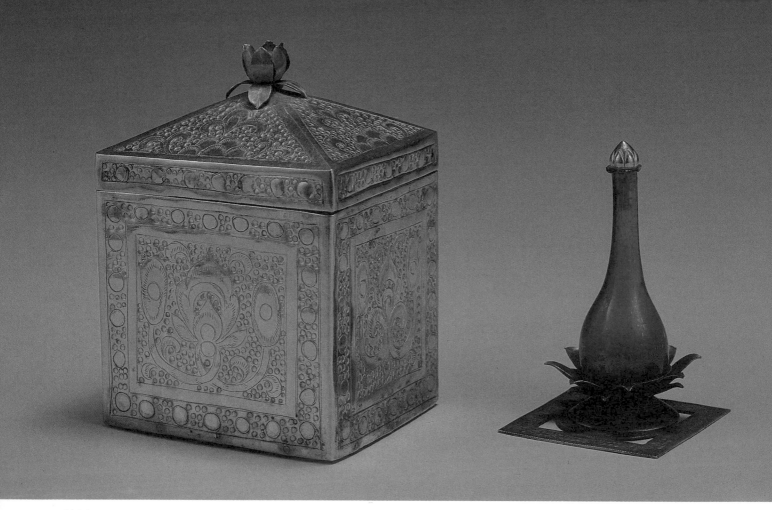

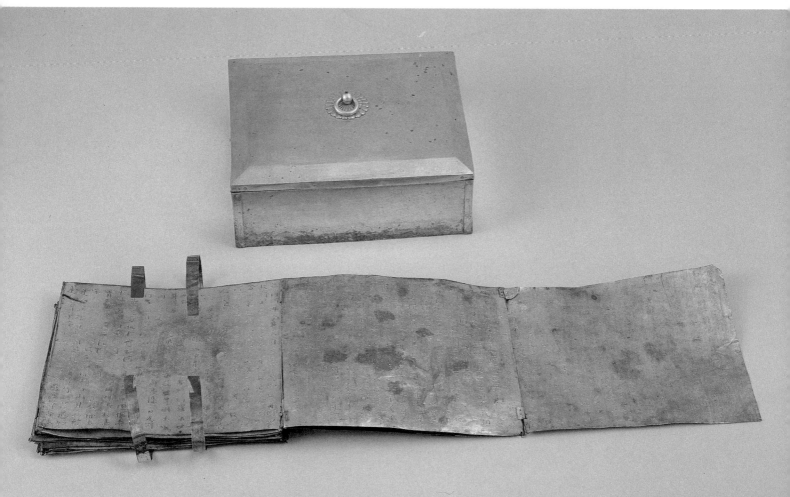

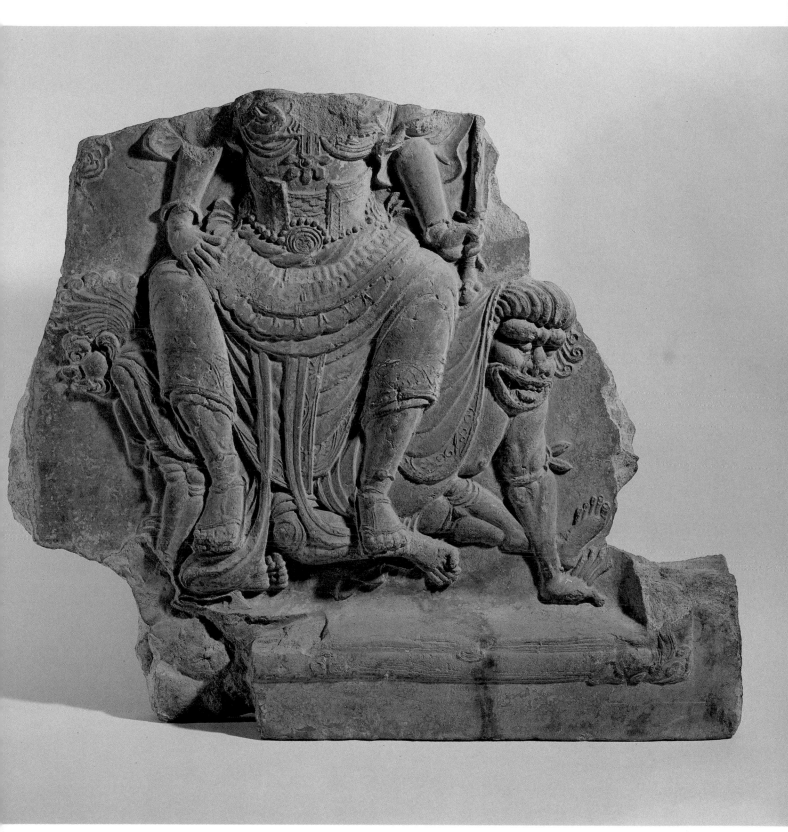

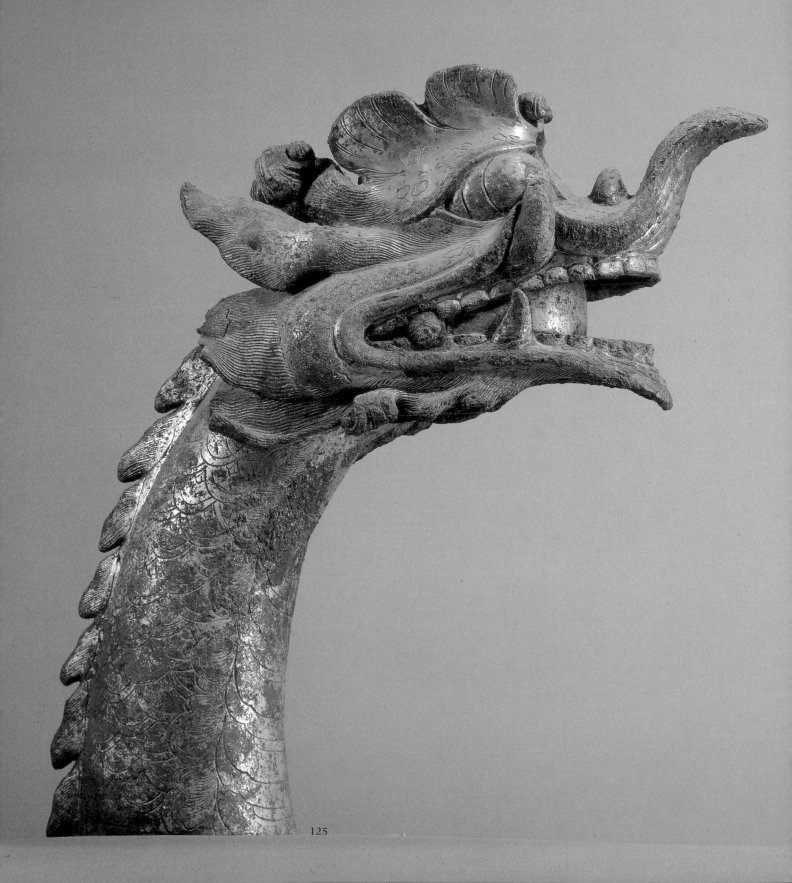

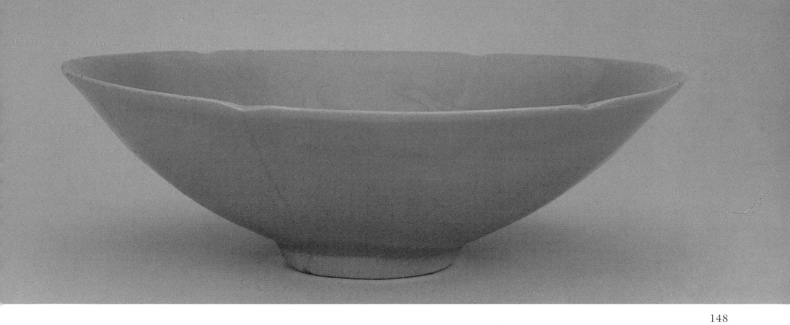

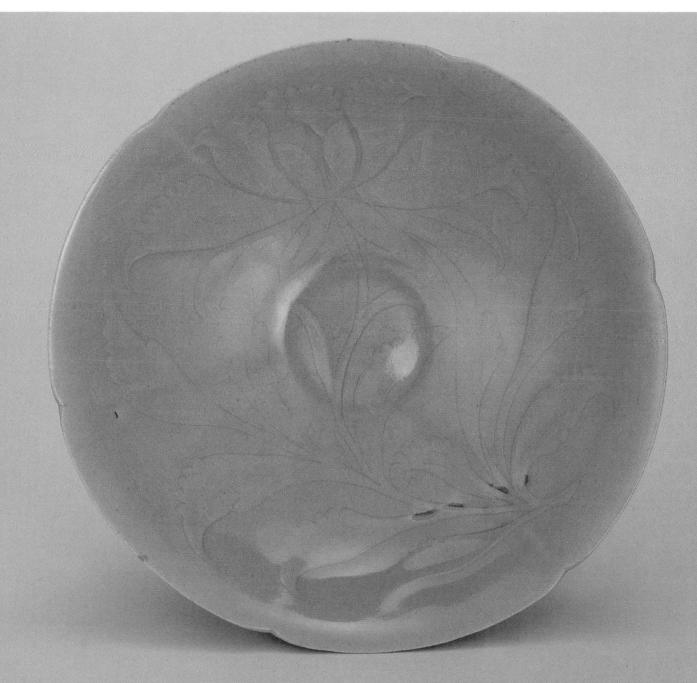

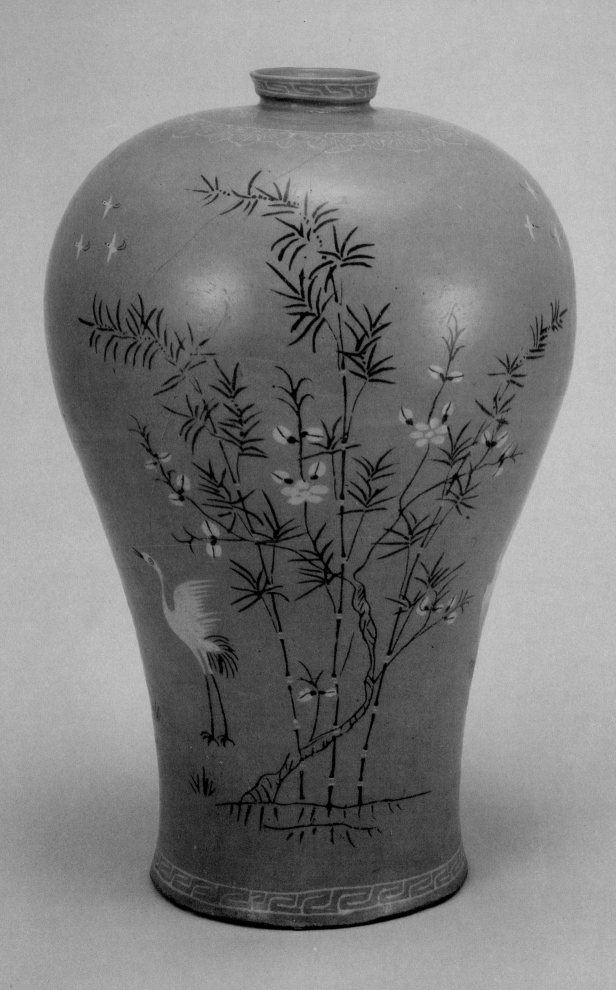

151

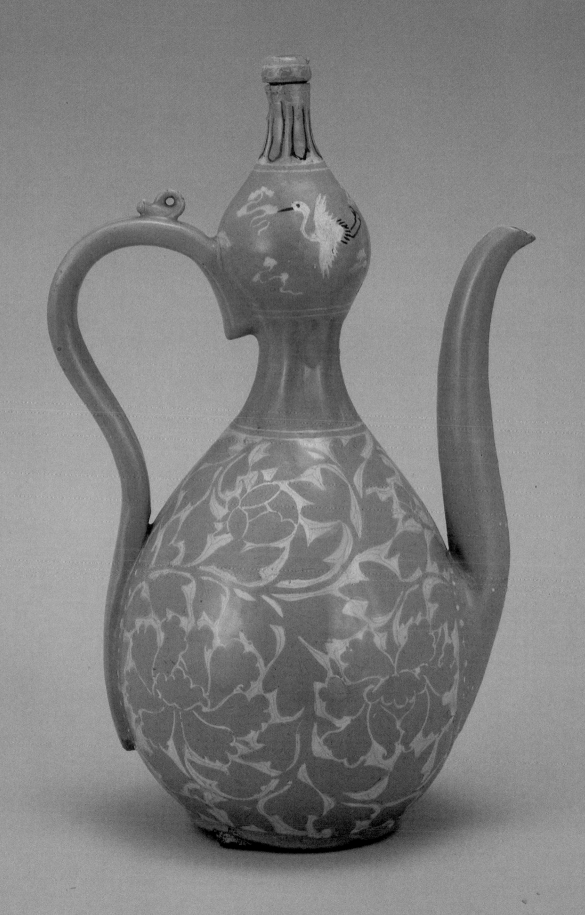

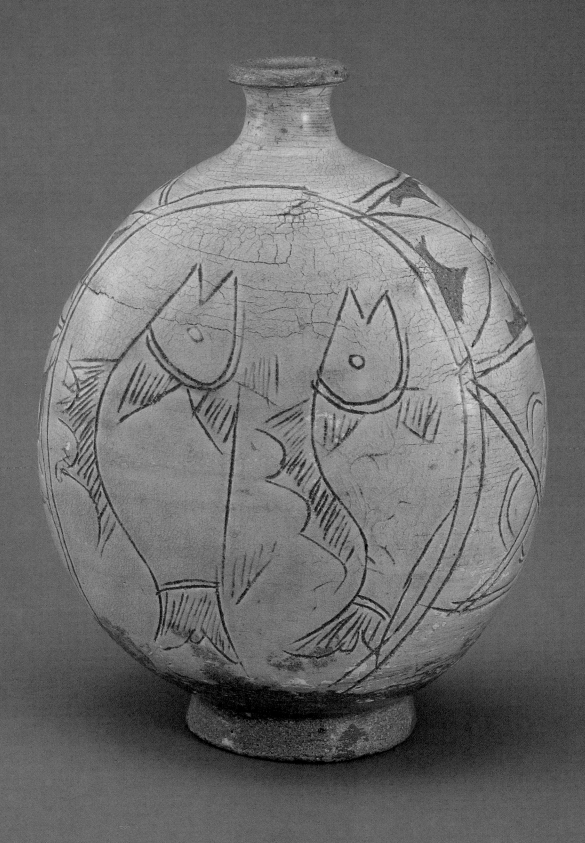

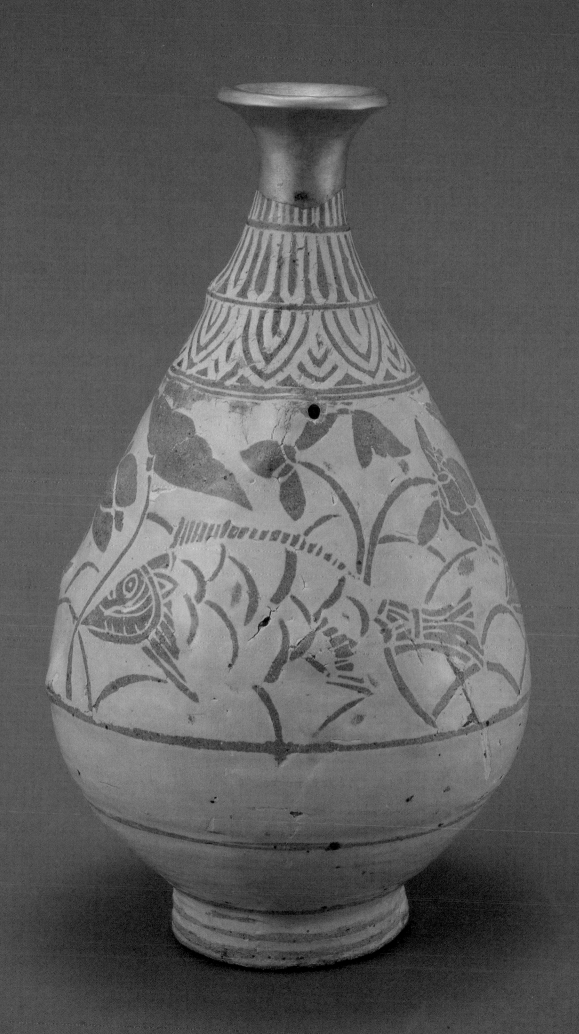

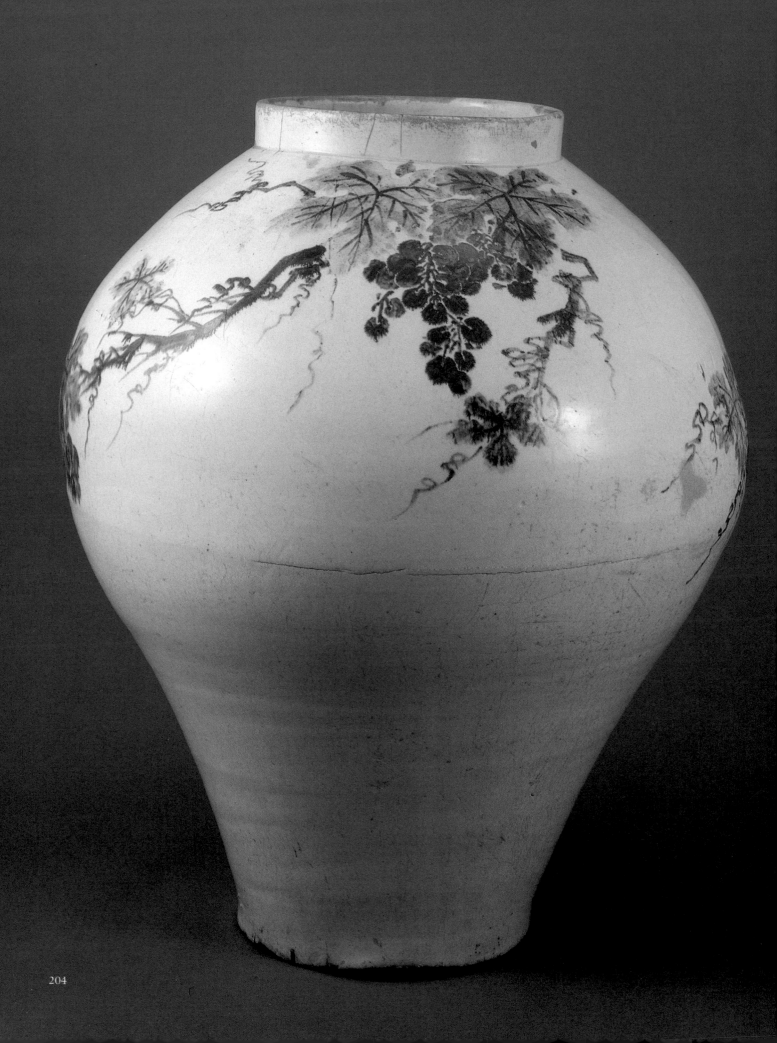

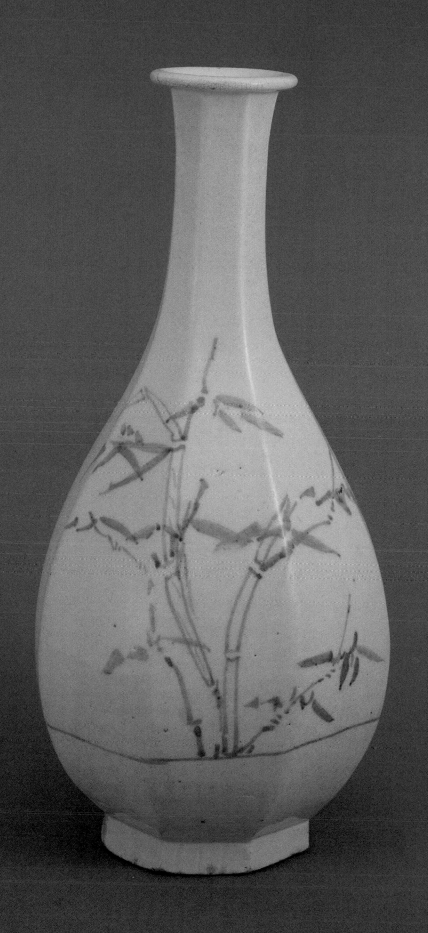

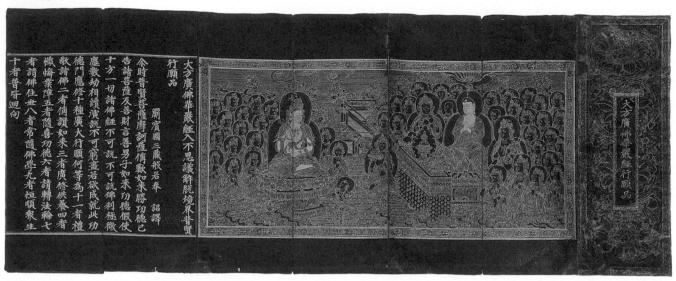

219

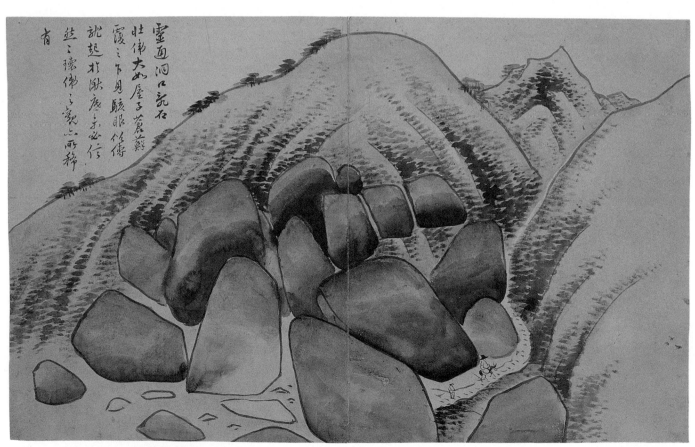

236b

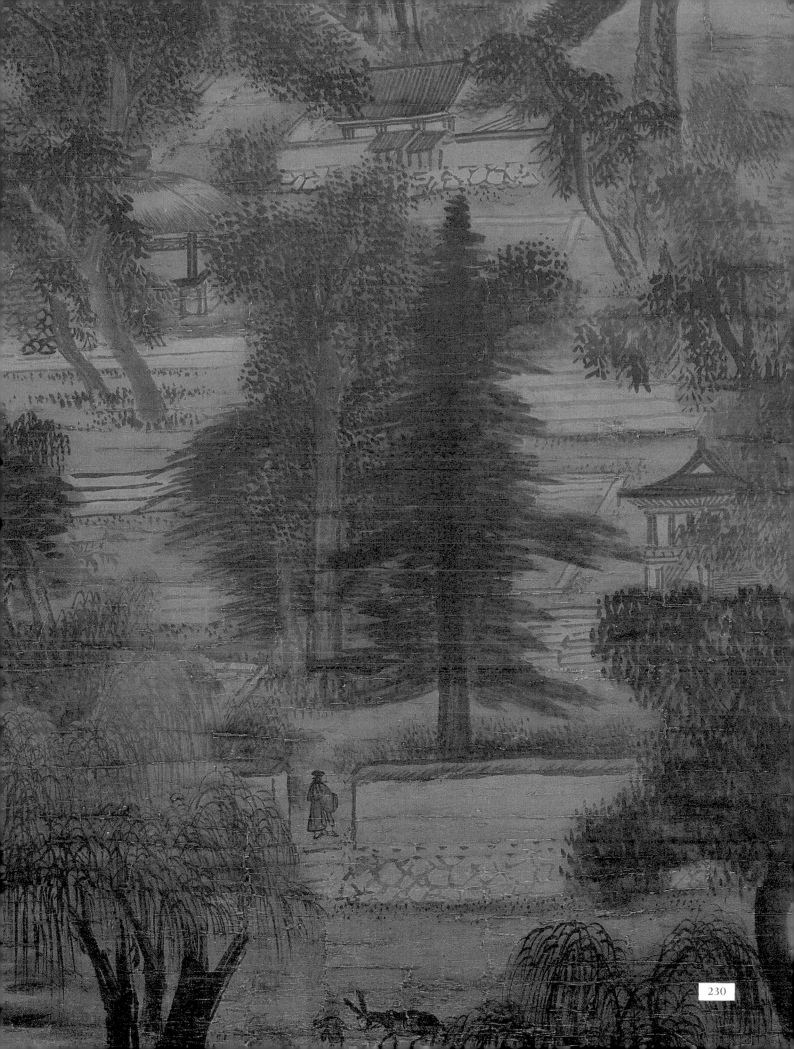

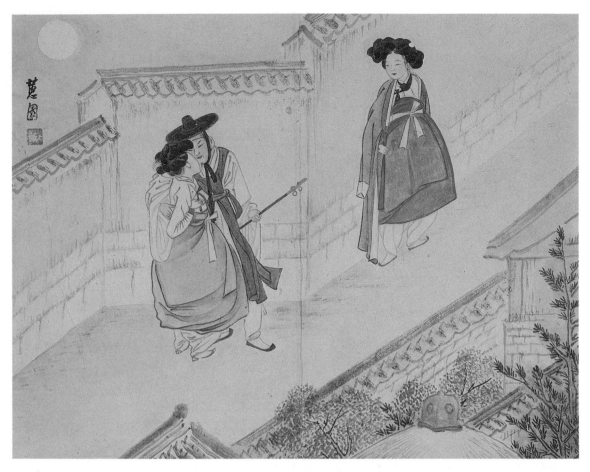

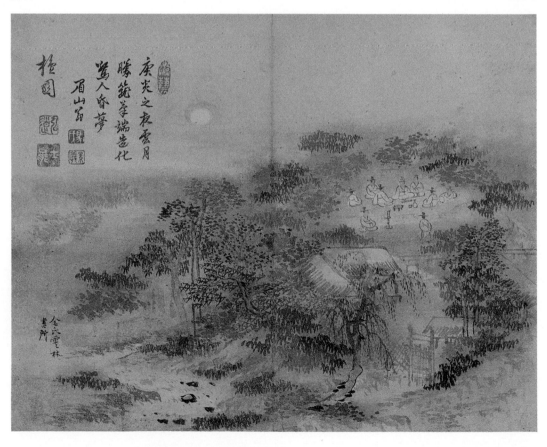

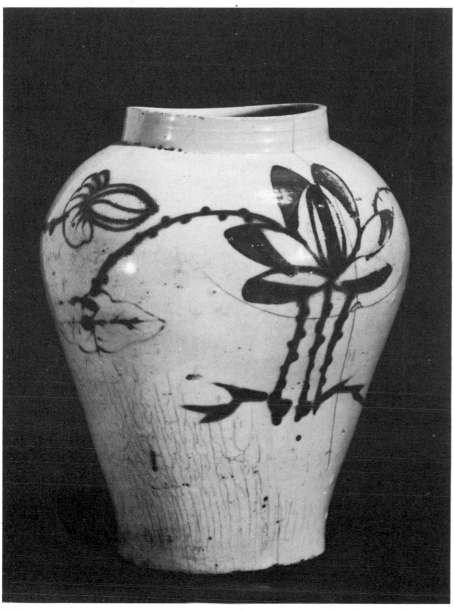

209

210 Jar with melon vines

Chosŏn dynasty, 18th century AD
Porcelain with underglaze copper-red
 decoration. H 27.8 cm; D (mouth) 13.4 cm,
 (foot) 13.3 cm
National Museum of Korea, Seoul

The austere lines of this spherical jar are accentuated by the double profile of the rim curving obliquely downwards. A double line runs round the shoulder but, typically, the painter has used it as part of the design rather than just as a frame. A vine clambers around the jar, its stem and tendrils curling around the double line as a support. It has three large, star-shaped leaves, their copper-red colour shot through at intervals with bright green, giving the piece a fluid, unpretentious beauty. The glaze is greyish-blue in colour, crackled in the lower part. Imperfections such as the marks of throwing, the irregular shape, puckering of the glaze and finger-nail marks show that the piece was made quickly, without the technical perfection required of vessels for use at the court. UW/RW

Published Kim and Lee 1974, pl. 160;
Kyōto 1976, no. 194;
Kodansha 1976, pl. 94;
San Francisco 1979, no. 206;
Chung Yang-mo 1983, pl. 134;

209 Large jar with lotus

Chosŏn dynasty, 18th century AD
Porcelain with underglaze copper-red
 decoration. H 29.5 cm; D (mouth) 13.6 cm,
 (foot) 14.2 cm
National Museum of Korea, Seoul

Porcelain with the decoration in underglaze copper-red originated in Korea in the twelfth century under the Koryŏ dynasty. In the Chosŏn dynasty it was not made until the eighteenth century, except for one fifteenth-century piece in Chinese style. The technique was a difficult one to control, but became quite popular.

This large jar from a private kiln has a decoration of lotus painted over a large area in the folk-art style. Spots in the crackled glaze are caused by metallic residues in the body. UW/RW

Published Chung Yang-mo 1978, pl. 135;
Kodansha 1976, fig. 296

210

211 Water-dropper in the form of a peach

Chosŏn dynasty, second half of the 18th
 century AD
Porcelain with underglaze blue and copper-red
 decoration. H 10.3 cm; D (foot) 6.5 cm
Hoam Art Museum, Yongin.

This water-dropper is a charmingly natural peach
shape, resting on a base of branches, one of
which curves upwards around the fruit to form
the tiny spout. A cicada crouches in the de-
pression under the tip of the fruit. The peach has
been left white, and the leaf picked out in blue
under the glaze, and the cicada stands out on
this background. The branches are in copper-
red, and have acquired a yellowish-green tinge.

UW

Published Chung Yang-mo 1978, pl. 137;
San Francisco 1979, no. 208, pl. XXXIII;
Hoam 1982, pl. 79

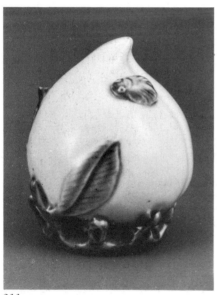

211

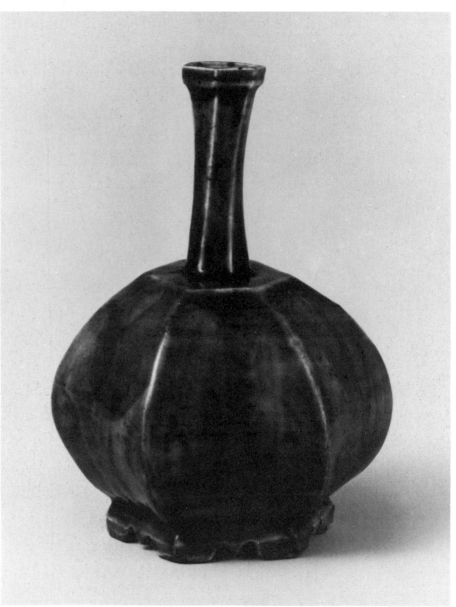

212

212 Hexagonal bottle

Chosŏn dynasty, 18th century AD
Porcelain with underglaze blue. H 14.5 cm;
 D (mouth) 2.5 cm, (foot) 7.2 cm
National Museum of Korea, Seoul

This small bottle is composed of sharply con-
trasting parts. The full-bellied hexagonal body
rests on a foot, also hexagonal, with semi-
circular indentations. The neck rising from the
flat shoulder is long and slender, slightly twisted.
The mouth is straight, projecting a little from
the neck. The whole of the body is covered with
broad, visible brush-strokes in cobalt-blue. The
uneven application of the colour, and the paler
areas at the corners, all add vitality to the struc-
ture. The high quality of both body and glaze,
and the clear pure cobalt-blue all suggest that
this is a piece originating from one of the official
kilns at Punwŏn.

UW

Published Kodansha 1976, pl. 103

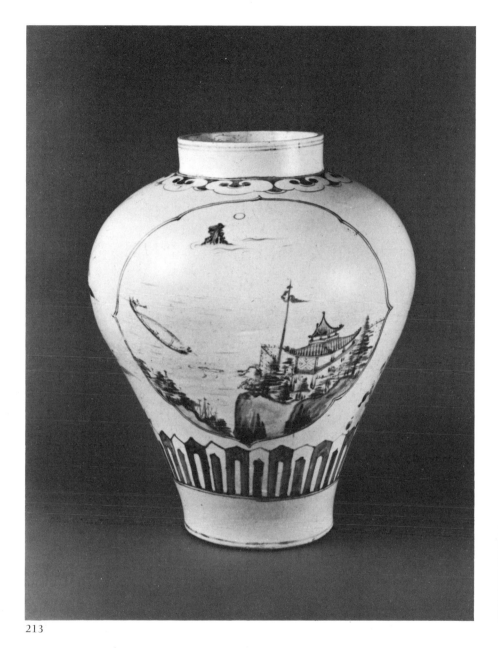

213

214 Jar with cranes and tortoises

Chosŏn dynasty, 19th century AD
Porcelain with decoration in underglaze blue.
H 33.0 cm; D (mouth) 13.5 cm,
(foot) 14.2 cm
Sim Sang-jun Collection

This simple jar has a generous spherical shape and a tall, straight-sided mouth and low base. The motifs depicted in the four circular medallions are a dragon-like tortoise and a crane, each repeated, standing freely against the white background. Both are symbolic of longevity. Above each is an area of cloud, representing the heavens (on some pieces waves or ground are shown beneath the tortoises to represent earth).

UW/RW

Published Chung Yang-mo 1978, pl.85;

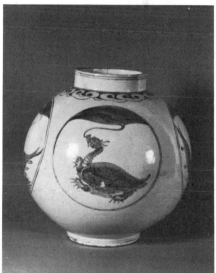

214

213 Jar with landscape panels

Chosŏn dynasty, 18th century AD
Porcelain with decoration in underglaze blue.
H 36.9 cm; D (mouth) 13.5 cm,
(foot) 14.5 cm
National Museum of Korea, Seoul

Using a type of decoration popular in the late Chosŏn period, the sides of this jar have large four-pointed ogee panels as windows looking out over landscapes. Their shape suits this type of high-shouldered jar, with ornamental bands at the base of the neck and around the foot, made up of alternate contrasting bands of blue and white. The accomplished landscape work,

frequently found on porcelain, could have been painted by a professional painter. UW

Published Kodansha 1976, fig.233;
San Francisco 1979, no.204

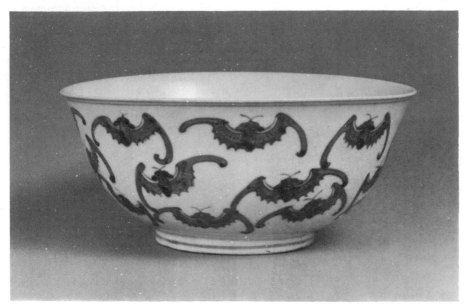

215

215 Bowl with decoration of bats

Chosŏn dynasty, 19th century AD
Porcelain with decoration in underglaze blue.
H 11.0 cm; D (mouth) 24.9 cm,
(foot) 10.9 cm
Hoam Art Museum, Yongin

The outside of this large, deep rice bowl is densely filled with flying bats, irregularly spaced between the encircling lines around the rim and foot. The Chinese character for bat, *fu*, is phonetically the same as the one for luck. A decoration of bats was therefore regarded as lucky. The connection is made explicit by the character *fu* itself, drawn in the centre of the bowl in underglaze blue. The potting is of very high quality, and the bluish-white glaze is uncrackled. This piece was produced in one of the official kilns at Punwŏn, and several identical ones have been found. UW

Published Chung Yang-mo 1978, pl. 95;
Hoam 1982, pl. 108

216 Offering dish with leaping carp

Chosŏn dynasty, 19th century AD
Porcelain with decoration in underglaze blue.
H 3.7 cm; D 16.7 cm, (foot) 8.7 cm
National Museum of Korea, Seoul

This flat, spreading dish rests on a high, sturdy base. The decoration is on the upper surface, within a circular medallion, and shows a leaping carp, the symbol of success in the state examinations. Mountains are depicted in folk style around the edges and in the background. It is said that the mountain represents Mt Pukhan, the holy mountain believed to protect the capital, Seoul. Other similar dishes have as motifs cranes, chrysanthemum, and the Chinese symbol for long life. The dish is from the official kilns at Punwŏn. UW

Published Kodansha 1976, pl. 90

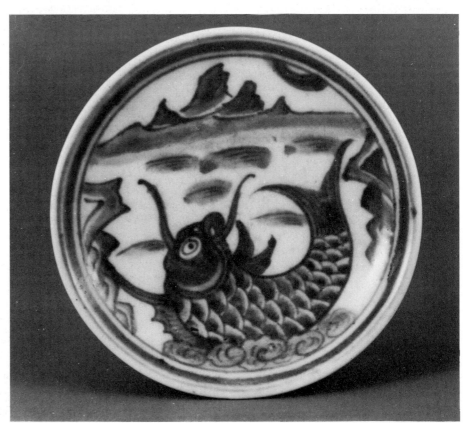

216

218

217 Square dish

Chosŏn dynasty, 19th century AD
Porcelain with decoration in underglaze blue.
 H 3.0 cm; L 15.2, 14.8 cm
National Museum of Korea, Seoul

This square, tray-shaped dish has bevelled corners, and low edges rising from a circular foot. The decoration inside depicts an imaginary landscape in which individual stylised rock formations, each with a scroll motif, point like fingers from the outer edges into the centre. They have pine-like branches, standing at right angles. A border of pseudo-meander lies just inside the rim.

Square trays of this kind are fairly rare, and were used in the royal household, or by members of the aristocracy. They come from the official kilns at Punwŏn. UW

Published Kodansha 1976, pl. 87

218 Brush-washer

Chosŏn dynasty, 19th century AD
Porcelain with decoration in underglaze blue and copper-red. H 7.5 cm;
 D (mouth) 12.3 cm, (foot) 10.1 cm
National Museum of Korea, Seoul

The sides of this brush-washer are shaped like a range of mountains, with peaks and valleys alternating. Scattered about the hilly landscape are towers and pavilions, with monks and monuments. The mountains surround a lake in which a crested four-clawed dragon is swimming. This is a utensil for a scholar's desk. Its shape, despite its fantastic appearance, is designed for practical use, and combines that of an ordinary brush-washer with the kind of *bishan* or 'brush mountain' commonly used in China as a brush-rest. The outside is painted in cobalt-blue and copper-red, while the dragon inside is in blue, with very little shading in copper-red. The piece comes from Punwŏn. UW/RW

Published Chung Yang-mo 1978, pl. 127;
Kodansha 1976, pl. 98

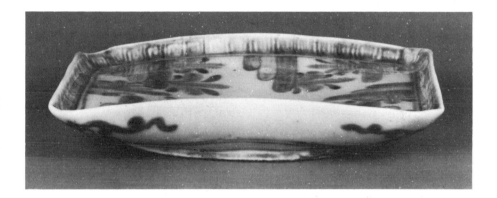

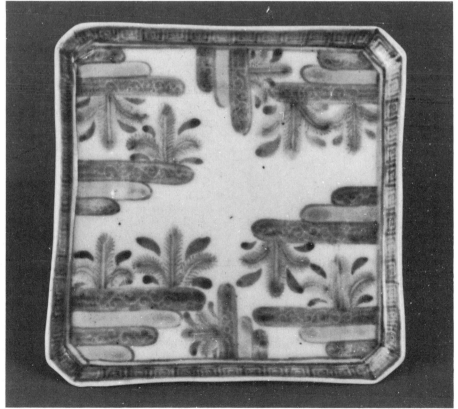

217

6 Painting

Though little is known of Korean painting in the West, it held an important place in Korea from an early date, and in all the principal historical periods. A tradition of painting had existed in the area of Lelang (founded 108 BC) since the time of the Western Han dynasty. The painted lacquer basket from Lelang, now in the P'yŏngyang museum, with numerous figures associated with filial piety, shows the advanced level of accomplishment in painting found there. When the colony fell in AD 313 its traditions and some of its population and craftsmen must have been absorbed into Koguryŏ. Of the Three Kingdoms Koguryŏ, with its painted tombs, has the largest corpus of painting, but there is evidence also of paintings decorating tombs in Paekche, and of painted objects in Silla.

The wall-paintings of the Koguryŏ tombs are in the north of the peninsula, near the Koguryŏ capitals (present-day Tong'gou and P'yŏngyang). The tombs are large stone-built structures with several chambers, with paintings on the walls and ceilings. The scenes from the lives of the deceased, the guardian animals of the four directions, and celestial bodies are all themes that have their origin in Han tomb decoration, like the architecture of the tombs themselves. The Koguryŏ tombs, however, continued to refine the wall-painting decoration long after the Han dynasty: the earliest tombs in Koguryŏ date from the third and fourth centuries AD, the latest from the sixth and seventh centuries AD. Particularly in these later tombs, such as the Great Tomb of Kangsŏ (Kim Won-yong 1978b, pls 68–74), the tomb at Naeri with landscape paintings (ibid, pl. 100), and the tomb of Chinp'ari, with its gracefully waving tree and scudding clouds either side of a large tortoise and snake (ibid, pl. 95), new elements were added to the traditional subjects. Buddhist influence brought the lotus and floral scrolls, used as borders or as ceiling patterns. The treatment of the Four Guardian Animals becomes increasingly fluent, and the Takamatsu tomb at Nara in Japan shows the transmission of the tradition of tomb wall-paintings to that country from Korea.

From Paekche, one of the royal tombs from the Sabi period (AD 538–660, when the capital was at Puyŏ), each wall a single slab of polished stone, is decorated with the animals of the four directions, in similar fashion to the tombs of Koguryŏ. The tomb of King Munyŏng and his queen, from the early sixth century, is built of brick, but the queen's head-rest of lacquered wood painted with animals, flowers and birds is evidence for the existence of a flourishing decorative tradition at this time.

In Puyŏ itself there have also been discovered a number of tiles, each about 29 cm square, with landscape designs. In the foreground these have flattened rocks and sheer vertical pinnacles, above which rise tall rounded summits with fine grass around their edges and crowned by stands or clumps of trees. Clouds scroll across the top of these tiles, two of which are in the form of pure landscape, while in two more the landscape is a foreground element, dwarfed by the figure of a huge monster (Puyŏ 1977, pls 73–6). These masterpieces of the tilemaker's art are not simply among the finest surviving examples of early landscape in East Asia, they also contain Buddhist elements which both help to fix their date and suggest the appearance of lost paintings on other materials. One of the two monsters stands on a large lotus pedestal; but the Buddhist elements are even more explicit in surviving examples of one of the two landscape designs, and especially in a fragment, now in the Seoul National Museum, where the figure of a Buddhist monk and a shrine or hermitage high in the hills above him, both in fine

crisp outline relief, appear especially clear (Ōsaka 1980, no. 97). The landscape forms can be paralleled in Chinese landscape art of the Six Dynasties, such as the famous 'Filial Piety' sarcophagus in the Nelson Gallery, Kansas City, but their Korean character becomes evident when we witness the reappearance of similar foreground pinnacles in An Kyŏn's masterpiece of the early fifteenth century, *Dream Visit to the Peach Blossom Land* (Richō 1977, pls 4–5).

Silla tombs were of a different character from the brick or stone-built structures of Koguryŏ and Paekche, and therefore contained no wall-paintings. Paintings on birch-bark survive from the Tomb of the Heavenly Horse, and depict birds, horse-men riding, as well as two examples of the horse in a flying gallop that have given the tomb its name. Both the flying horse and the floral border of the saddle-flap on which it is painted find parallels in Koguryŏ mural paintings of the sixth to seventh centuries AD.

From Unified Silla almost nothing remains in the way of actual painting, with the single exception of an illuminated fragment of the Avataṁsaka sutra on purple paper, recently discovered in Korea. Painted in gold and silver, it is dated in the period AD 754–5 and is evidence of a high level of accomplishment in painting. This is also suggested by the remains of richly ornamented tiles for architectural decoration and by Buddhist figurative plaques cast in bronze, such as the abundant finds from Anap-chi and from the great Hwangryong-sa temple. Silla interest in painting is also borne out in Chinese written accounts: for instance, in *Tangchao minghua lu* Zhu Jingxuan records in the section on Zhou Fang that 'at the end of the Zhenyuan reign [AD 785–805] a person from Silla came to the Jiang and Huai region and for a good price bought some tens of scrolls to take back to that country. These included Buddhist images, immortals, figures of men and women, all fine works.'

In the Koryŏ period, Buddhism enjoyed the patronage of the royal house and the aristocracy, circumstances which favoured an even greater outpouring of paintings and artefacts. Almost none of the paintings remain in Korea, due to the devastations of the successive Mongol, Japanese and Manchu invasions, but a large number of Koryŏ Buddhist paintings are preserved abroad, principally in Buddhist temples and collections in Japan (a similar state of affairs exists with respect to Korean bronze bells of the Unified Silla and Koryŏ periods, large numbers of which are now in Japan since they have always been highly prized there).

Koryŏ Buddhist paintings were made for use at innumerable rites, many of which are recorded in the *Koryŏ-sa*, History of the Koryŏ dynasty. They included dharma meetings (*pŏbhoe*) and memorial rites on the anniversaries of the deaths of kings or queens. The richness and delicacy of colour of these Buddhist images make Koryŏ painting one of the marvels of East Asian art, although one that remains largely unknown outside Japan. Among its characteristics is the abundant use of gold in patterns for garments, and the use of transparent effects, giving a lightness and delicacy hardly matched elsewhere. The skill of Koryŏ Buddhist scribes and illustrators in the making of sutras was also appreciated in China and Japan, and the example illustrated here (no. 219) gives an idea of their achieve-ments and the linear conventions used for the depiction of drapery folds and other details of the illustrations.

We have very little idea of the appearance of Koryŏ secular painting, though historical records continue to make it clear that there were painters of distinction

and that Koreans often came to China to buy paintings. Guo Ruoxu's *Tuhua jianwenzhi*, written in the eleventh century, has a section on Korea which praises Korea for the way in which, alone among other countries in contact with China, it had absorbed Chinese manners and culture:

In refinement of artistic skill, other lands have seldom [produced anything] comparable to its marvels of painting. Ch'ien Chung-i owned a coloured landscape in four scrolls [by a Korean]; and Li . . . owned two scrolls depicting eight old men of that country . . . [The Korean] envoys on arrival in the Middle Kingdom have sometimes made use of folding fans as personal gifts. These fans are made of blue-black paper; the paintings on them show persons of quality of the country of their origin, diversified by ladies and saddle horses. There may be streams with banks indicated in gold, or lotus blossoms, trees and waterfowl of various sorts, all most ingeniously worked out with decorative touches. Sometimes they have effects of mist and moonlight, done with silver paint; these can be extremely attractive. (Soper 1951, p.103.)

Guo Ruoxu identifies this type of fan as having originally come from Japan, but we may recognise the subject-matter, and the predilection for painting in silver and gold, as being characteristic of the Koryŏ period, and we may note also that the depiction of gentlemen, ladies and horses provides an interesting precedent for the genre paintings of Sin Yun-bok and Kim Hong-do in the eighteenth century.

Few Koryŏ painters are known by name. In the *Koryŏ-sa* it is written that Yi Nyŏng visited Song China and that Emperor Huizong commanded a number of court painters to learn from him (O Se-chang 1928, p.17). None of his works survive, however. Yi Je-hyŏn (no. 220) visited China together with his father and met Zhao Meng-fu (AD 1254–1322), the leading painter and calligrapher of his day. Guo Ruoxu's record, already quoted above, notes that in AD 1074 one Kim Yanggam who had come as an envoy with tribute 'was on the lookout for Chinese pictures. He was a very keen buyer, and purchased some three hundred works, although only one or two out of every ten had any degree of refinement' (Soper, *loc. cit.*).

In the later Koryŏ period members of the Korean royal family who lived in Peking under the Mongol Yuan dynasty must also have had the opportunity to see and probably to collect paintings which were taken back to Korea. One collection formed in the early Chosŏn dynasty is recorded in Sin Suk-ju's *Hwagi* (Records of Painting), published in AD 1445. The complete list has been studied and published by Ahn Hwi-joon: the collection, apparently formed between AD 1435 and 1445, was that of Prince An-p'yŏng (AD 1418–53), the patron of the fifteenth-century Korean master An Kyŏn (see no. 221).

The composition of the collection is most interesting: naturally, there are a large number of paintings by An Kyŏn, but no works by other Koreans, nor by any contemporary Ming painters. It would therefore seem that Prince An-p'yŏng's selection was made from Chinese paintings which had already been brought to Korea before his time. Beginning with a rubbing after the fourth-century master Gu Kaizhi, it included one work each by the Tang masters Wang Wei and Wu Daozi, and paintings by six Song masters, Guo Zhongshu, Li Gonglin, Su Dongpo, Wen Tong, and Guo Xi, the last-named with no fewer than seventeen paintings. Apart from these earlier paintings the collection was naturally very strong in works of the Yuan period, beginning with twenty-six pieces of Zhao Mengfu's running-script calligraphy, and numerous paintings by some twenty other artists, besides a handful of uncertain period. Thirty works by An Kyŏn complete this

remarkable list. Thus it is no surprise to find the brushwork and complex compositional organisation of Guo Xi prominent in An Kyŏn's work, as in the seasonal compositions, four of which are illustrated (no. 221).

The adoption of Confucianism as the state doctrine in the Chosŏn dynasty had a profound effect on Buddhist painting, since there was no longer either need or support for elaborate and costly paintings of Buddhist deities. Although Buddhism remained popular and even enjoyed a degree of royal support, it was never able to recover the position of artistic pre-eminence that it had enjoyed in Koryŏ.

Despite the lack of contemporary Chinese paintings in the collection of Prince An-p'yŏng, the Chosŏn policy of friendly relations with the Ming court must have afforded further opportunities for exchange of works of art beyond the end of the Yuan period. It was the painting of court artists, still working in the Southern Song academy tradition, that seem to have been known to the Koreans, rather than the scholar-painters of the Wu school: indeed it is noticeable that none of the Four Masters of Late Yuan (in whose works lay the origins of the Wu school) were included in Prince An-p'yŏng's collection. It was therefore the case that Korean landscape masters of the sixteenth century evolved their own versions of the classical landscape tradition, keeping the elements of far distance in their compositions rather than confining attention to the foreground as often happened in Ming China. Some of these landscapes, with a light texture of finely detailed motifs in a grandiose setting, were to be influential on the ink painting of Muromachi Japan.

Professional artists of the Zhe school (named after the coastal province of Zhejiang which had a long painting tradition and from which many Chinese court artists of the early Ming came) also had their influence on Korean painting, so much so that Ahn Hwi-joon has coined the term 'Korean Che [Zhe] School' for artists working in this manner, with bold ink washes, vigorous brushwork, and compositions featuring silhouetted rocks or cliffs. Kang Hŭi-an's *Sage at rest on a rock* (no. 222) is the archetypal example of a 'Korean Zhe school' painting, and the album leaves attributed to Yi Kyŏng-yun also qualify. The landscape also attributed to him seems more typical of the Korean elaboration of the academic tradition followed at the Ming court by artists such as Li Zai, before the Zhe style had assumed its final character.

While Korean officials and Confucian scholars at the Chosŏn court undoubtedly appreciated and collected paintings, their contacts must have been mainly through the court, and the paintings of the literati remained largely unknown to them. No doubt because of the successive Japanese and Manchu invasions, the seventeenth-century revival of classical styles had little effect in Korea until much later (cf. no. 263), and Korean painters were free to pursue their own development. Thus it was in the eighteenth century, when painting in China was beginning to lose momentum, that the intellectual and cultural revival in Korea led to new developments in painting as well. These developments were purely Korean and have no parallels in Chinese painting: indeed they occurred at a time when Chinese painters, after a period of intense study and revival of ancient styles, were settling into a more routine style, offset by the deliberate eccentricities of those who were catering to a new affluent class of merchants.

The first of the new developments is the appearance of *chingyŏng sansu* or 'real landscape' pioneered by Chŏng Sŏn (nos 230–32). Chŏng Sŏn's *Summer Land-*

scape (no. 229) is still in the vein of Korean landscapes in the ideal manner, though already coloured by Chŏng Sŏn's own brush techniques involving repetition and overlaying of strokes to obtain denser textures. This is a valley scene with a large country retreat in the foreground, secluded among dense trees and overshadowed by huge peaks rising on the right. To the left a valley view stretches to the far distance. Here already we find a clue to Chŏng Sŏn's practical interests, for this distant view is not a sheet of water, lake or river, as in Chinese landscapes in this tradition, but level fields regularly laid out. Others of Chŏng Sŏn's paintings describe the scenic areas of Korea like the Diamond Mountains, and the connoisseur and scholar-painter Kang Se-hwang followed suit with his album of views of the former Koryŏ capital at Songdo. Topographical paintings, including albums of different views of a single area, had had their place in China since early in the Ming dynasty in the paintings of the scholar-painters, but in Korea the new subject-matter was accompanied by a new brush manner as well, suited to the particular forms of the Korean landscape.

The other genre with a special Korean flavour in the eighteenth century is the painting of scenes from daily life, exemplified in the work of two artists, Sin Yun-bok and Kim Hong-do (nos 246, 248). Although Sin Yun-bok painted the upper classes only, both his work and that of Kim Hong-do relies on close observation of Korean daily life. So the results are refreshingly direct, distinct from those of China, where in the Ming and Qing dynasties the choice was between Qiu Ying's genteel depictions of the activities of Ladies in the Palace, on the one hand, and Huang Shen's rustic fishermen on the other.

The works of Kim Tu-ryang afford another example of direct observation which probably has its origins in the *silhak* (pragmatic) school of thought. Kim Tu-ryang (see no. 243) is an artist whose work deserves to be reassessed as several unsigned works seem to show characteristics of his hand, as it is known both from a landscape in the National Museum, Seoul, and from a study of an oxherd and his ox, in the P'yŏngyang Museum. Two unsigned album leaves (in addition to the leaf shown illustrated here) are studies of dogs, painted with an attention to character and habit which is truly remarkable. The dogs depicted by Kim Tu-ryang are of foreign breeds rather than the Korean dogs and puppies painted with great affection by Yi Am in the fifteenth century. There are signs of possible Western influence in Kim's paintings, notably in the use of chiaroscuro, but the means of depiction continues to be based on fine brush lines in the Oriental manner.

The appearance of new and inventive forms in painting of the eighteenth century in Korea seems to have provided the inspiration for further innovation in the nineteenth century. The work of Kim Chŏng-hŭi, better known in Korea as Ch'usa or Wandang, was inspired by his contacts with Chinese scholars and calligraphers, but he seems to have been able to go beyond them in intensity of feeling and originality of form (see no. 256). Intellectually and aesthetically, he was a paramount figure in the literary scene of the late Chosŏn dynasty, and there were none who could match his attainments. But if his pupils, such as Cho Hŭi-ryong (nos 258–9), were unable to reach the same high standards, others such as Hong Se-sŏp (nos 261–2) continued to be inventive and innovative, so that painting remained a lively art throughout the nineteenth century in Korea.

In Korea there is not the very considerable literature of connoisseurship and

criticism that has existed in China since the sixth century AD. Many Korean paintings, especially those of the Koryŏ dynasty, are no longer in their country of origin, so that only in recent years have some fields begun to be studied in depth. Nevertheless, it is possible to see a pattern of relationship between China and Korea which is the more fascinating since the periods of greatest creative activity did not always coincide, so that Korean painting pursued its own path with substantially different results from developments on the mainland. Several such periods can be identified: they include the Koguryŏ wall-paintings, Buddhist paintings in the Koryŏ period, landscape painting in the first half of the Chosŏn dynasty, the landscapes of actual Korean places in the eighteenth century, and genre paintings. Thus distinctive Korean styles of painting were created throughout the centuries, and even when on the face of things there was a fairly close adherence to Chinese models, this was always tempered by a reworking and further development, made possible since the fabric of Chinese institutions had been thoroughly absorbed at an early date in Korea and remained an integral part of Korean life until the end of the Chosŏn dynasty and even beyond it. RW/YSP

219 Illuminated Avataṁsaka sutra *(colour ill.)*
Koryŏ dynasty, dated AD 1341–67

Folding book of ten leaves, written and painted
 in gold on indigo-dyed paper.
 Each leaf: H 26.4 cm; W 9.5 cm
Cho Myong-ki Collection

The writing of Buddhist scriptures was one of
the most important meritorious deeds, and
therefore great care was lavished on their cre-
ation. The essence of each chapter is illustrated
in the frontispiece before the actual text. Illum-
inated Buddhist sutras in gold and silver on blue
or purple paper were already in circulation dur-
ing the Silla dynasty, and one example from this
period still survives (Hoam 1982, pls 189–90).
During the Koryŏ dynasty, the refinement and
sumptuous decoration of sutra manuscripts place
them among the most distinctive artistic creations
of the period. At this time special bureaux were
established for the illumination of sutras in gold
and silver. In addition to the royal patronage
within Koryŏ, it is recorded in the *Koryŏ-sa*
(History of the Koryŏ Dynasty) that sutra manu-
scripts and those who could write them were
sent to Yuan China.

The text of the Avataṁsaka or Garland sutra
exists in three different translations into Chinese
from the Sanskrit: in sixty volumes by Buddhab-
hadra (AD 422), in eighty volumes by Śikṣānanda
(AD 699) and in an extracted version containing
only the chapters concerning the fifty-five stages
of the journey of the boy Sudhana, Sŏnjae Tongja
and his enlightenment (cf. Fontein 1967), in
forty volumes by Prajña (AD 778). The manu-
script shown here is the last chapter of the third
translation. Most other surviving manuscripts
of the sutra, now in Japanese collections, are of
Śikṣānanda's translation in eighty volumes (see
Kōrai Butsuga 1981, pls 74–9).

The title *Mahāvaipulya Buddha Avataṁsaka
(or Gaṇḍhavyūha) sutra. On entering the immeasur-
able realm of enlightenment: the actions and vows of
Samantabhadra* is written in full to the left of the
frontispiece, and in abbreviated form on the
cover. The chapter concerns Sudhana's final
enlightenment following his arrival before the
Bodhisattva Samantabhadra, as depicted in the
frontispiece. On the inside of the cover is an
inscription in gold, *Illustrations to the chapter on
actions and vows. Painted by Mungyŏng.* Nothing
is known of Mungyŏng, but he was probably a
monk painter.

In the frontispiece Buddha Śākyamuni with a
numerous assembly of Bodhisattvas, is seated
on the right on a lotus throne. Before it is an

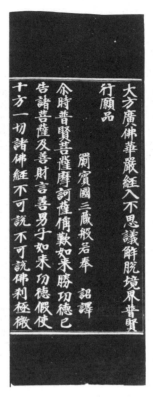

219

altar table with flower bowls and a splendid
censer of Koryŏ type with a lotus cover (cf.
no. 137). On the left the Bodhisattva Samantab-
hadra is seated on an octagonal lotus throne.
Sudhana is seen standing in a posture of ador-
ation before him. The whole frontispiece is drawn
in extremely fine linear technique, with draperies
characterised by concentric or spiral lines, in
the manner typical of manuscripts of the first
half of the fourteenth century, such as the folding
booklet dated AD 1341 recently acquired by the
British Museum (Pak 1982). It is framed by a
border of vajras and wheels, as in most manu-
scripts of the Koryŏ period. The text that follows
is written in regular script. Both front and back
covers of the manuscript are ornamented with
large lotus flowers with scrolling stems.

The last page of the folding booklet carries a
colophon which is partially obscured but which
gives the names of Prince Yŏng'in, son of King
Kongmin (reigned AD 1351–74), who caused
to be written this chapter, together with
the Diamond Sutra (Kŭmganggyŏng), the Sutra
of Long Life (Changsugyŏng), the Amitābha
sutra (Amitagyŏng), the Sutra of the Requite-

ment of Blessings received from Parents (Pumo
ŭnjunggyŏng) and the chapter on Avalokiteśvara
vara (Pomunp'um) from the Lotus Sutra, in order
to acquire merit, making a number of additional
personal wishes. This dedication reveals the
nature of late Koryŏ Buddhism which was
primarily concerned with personal well-being
and salvation. YSP

Published Choi Sunu 1978, pl. 11

220 Attributed to Yi Je-hyŏn
(AD 1287–1367)

Hunting scene in winter

Album leaf, ink and colours on silk
H 28.8 cm; W 43.9 cm
National Museum of Korea, Seoul

Examples of Koryŏ painting are extremely
scarce, apart from Buddhist paintings, now
mainly in Japan. Yi Je-hyŏn, known for his
excellence in calligraphy and poetry as well as
painting, is one of the few artists of whom one or
two works survive.

At the age of 33, Yi Je-hyon accompanied
King Ch'ungsŏn (reigned 1275–1308) to
China, where he met Zhao Mengfu and Zhu
Derun. His portrait, still preserved in the Seoul
National Museum, was painted by Wu Shoushan
(Yu Pok-yol 1969, pp.1017ff; Seoul 1979, pl.
78).

With such eminent contacts, Yi Je-hyŏn's
visit to China gave him the opportunity to see
famous paintings, as reflected in this work,
damaged though it is. Zhao Meng-fu was the
leading painter in both landscape and figure
painting, and was especially known for his
horses. This painting shows a hunting party
crossing a frozen river; some of the horses shy
away from the unfamiliar experience. The snow-
covered landscape is suggested by the trees,
banks and cliffs around the edges, but the centre
of the painting is left clear, so that the two riders
and horses on the ice are seen against a plain
ground, recalling Zhao's studies after Tang
dynasty masters.

The painting bears the signature *Ikje*, and seal
Yi Je-hyŏn in. RW/YSP

Published Seoul 1977, no. 3; Ahn Hwi-joon
1980a, pl. 21; 1980c, fig. 12; 1982a,
pl. 3; O Se-chang 1928, p.29; Choi Sunu 1979,
pl. 248

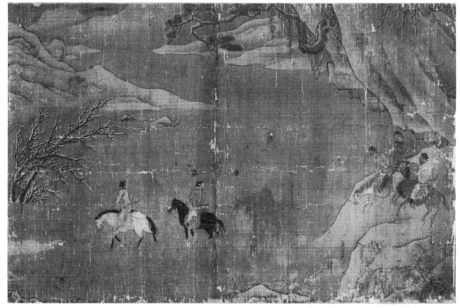

220

221a–d Attributed to An Kyŏn
(AD 1418–?)

Early Summer, Late Autumn, Early Winter, Late Winter

From a set of eight album leaves, ink and
colours on silk. Each leaf: H 35.8 cm;
W 28.5 cm
National Museum of Korea, Seoul

An Kyŏn is one of the most eminent painters of
the early Chosŏn dynasty. His most famous and
authentic painting, now in the Tenri Library,
Japan, is *A Dream Visit to the Peach Blossom Land*
(Ahn Hwi-joon 1980b) which was commissioned
in AD 1447 by his royal patron and exact con-
temporary Prince Anp'yŏng (AD 1418–53), the
third son of King Sejong (reigned AD 1419–50).
As the prince had a very considerable collection
of Chinese paintings of the Tang, Song and
Yuan periods (Ahn Hwi-joon 1980a, pp.93–6)
as well as thirty works by An Kyŏn, the latter
had exceptional opportunities to study fine
Chinese paintings. In particular, the collection
included no fewer than sixteen works by the
Northern Song painter Guo Xi (c. AD 1001–90),
among them a pair of landscapes of spring and
autumn.

It is the Guo Xi style that is the basis of these
leaves. They come from an album of eight (two
additional leaves from a different set are also
contained in the album). All eight have been
studied in detail by Ahn Hwi-joon (1978). Two
leaves are devoted to each of the seasons, and
the compositions are so arranged that they form
matching pairs.

In composition the landscapes still recall
Song principles, as set forth by Guo Xi in his
Essay on Landscape Painting. In each painting
there is clear distinction between foreground
and far-distant elements, with motifs contrast-
ing in scale to give a sense of distance and
height from the foreground rocks to the heights
of the mountains. Though small in size, the
scenes evoke some of the complexity and vast-
ness of larger landscapes. The outlines of rocks
and trees likewise recall the works of Guo Xi,
famous for his cloud-like rocks and crab's claw
branches.

Seasonal landscapes in sets of four or more
were common in Chinese painting. Like the
subject of landscape itself, they evoke the
passing of time. Mountains and water remain,
clothed anew each year with fresh foliage, while
human activities are dwarfed by their surround-
ings. Not only the seasons, but, as in Southern
Song painting, atmospheric effects play their
part in these paintings. In *Late Summer* (not
shown here) the dense foliage of the trees on the
bluff is shaken by gusts of wind; even the peaks
seem to share in the movement (Ahn Hwi-joon
1982a, pl. 10). The two *Winter* leaves show, in
the darkened sky and the bare branches, the
deepening hold of winter on the landscape.

In these works it is not easy to define the elements that are specifically Korean. Perhaps they should be sought in the combination of climatic effects with the motifs of a landscape still close to the classical ideal of Northern Song. In particular, the high cliffs or peaks rising in the middle ground are brought close to the viewer. Mist or water flows around each of them. The combination was to prove successful in Muromachi ink-painting in Japan, in the works of masters like Shūbun, not far removed in time from An Kyŏn. RW

Published San Francisco 1979, no.181;
Ahn Hwi-joon 1978, figs 3,6,7,8;
Richō 1977, pls 35,34,33

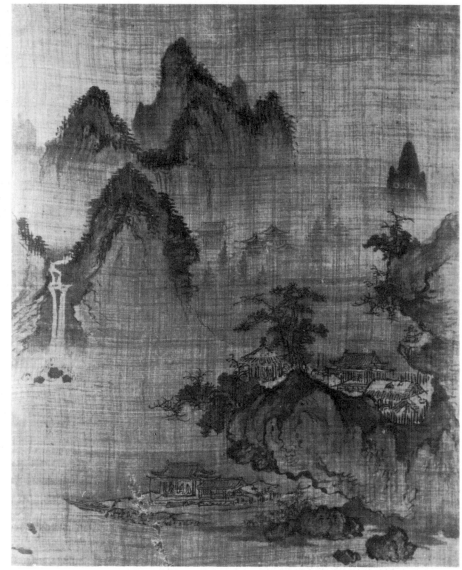

221a

221d

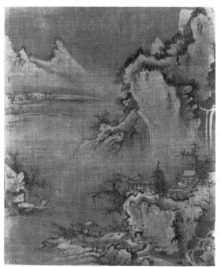

221c

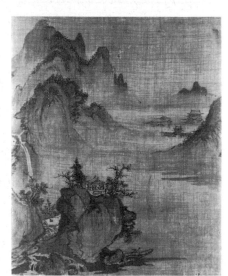

221b

222 Kang Hŭi-an (AD 1419–64)

Sage at Rest on a Rock

Album leaf, ink on paper. H 23.4 cm;
 W 15.7 cm
National Museum of Korea, Seoul

Kang Hŭi-an and his brother Kang Hŭi-maeng both achieved high rank as Confucian scholar-officials in the early Chosŏn dynasty. Kang Hŭi-an was a member of the Chiphyŏn-jŏn, Hall of Worthies, which was responsible for the creation of the *Han'gŭl* phonetic system of writing Korean. He himself was accomplished in the arts of calligraphy, poetry and painting. In AD 1455, as the head of an official delegation, he made the first of three visits to China.

Several works by or attributed to Kang Hŭi-an and his brother still exist (Yu Pok-yol 1969, nos 18–23; Nara 1973, pls 19–20), mainly album leaves with figures in landscape or garden settings, close to paintings by Li Zai and his contemporaries at the Ming court. All of them display confident and vigorous brushwork, especially in the drapery of the figures. In the leaf shown here the effect is enhanced by the strong silhouetting of rocks and overhanging foliage against a pale ground. RW/YSP

Published Ahn Hwi-joon 1977b, fig. 5; 1982a, pl. 15; Richō 1977, pl. 6

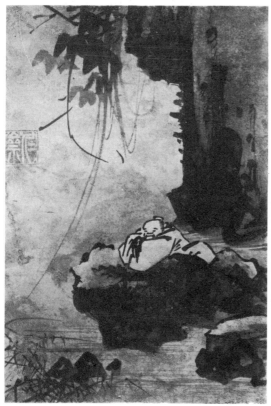

222

223

223 Attributed to Yi Kyŏng-yun (AD 1545–?)

Landscape

Hanging scroll, ink and light colours on silk.
 H 91.1 cm; W 59.5 cm
National Museum of Korea, Seoul

Yi Kyŏng-yun and his younger brother Yi Yŏng-yun (AD 1561–1611) were scholar-painters and members of the royal family. Yi Kyŏng-yun was enfeoffed as Haknim-su (Keeper of Crane Forest) and promoted to Haknim-chŏng. His illegitimate son Yi Ching (AD 1581–after 1645) became a court painter (Richō 1977, pls 67–8).

The subject of this painting has much in common with the work of artists like Tang Yin (AD 1470–1523) in Ming China. The grandiose autumn landscape is the setting for the meeting of two friends, accompanied by their servants to brew tea and carry equipment to the chosen spot, carefully prepared with a low railing at the cliff edge and a flat rock for both seat and table. The crane, bamboo and pine are all associated with Confucian virtues. In the distance a pagoda rises above the buildings of a Buddhist temple. The painting is remarkable for the subtle application of light colouring to the figures and tree leaves against the prevailing monochrome ink washes of the rock and mountain forms. RW

Published San Francisco 1979, no. 186; Ahn Hwi-joon 1982a, pl. 72; Richō 1977, pl. 11

224a,b Attributed to
Yi Kyŏng-yun (AD 1545–?)

Scholar dipping the feet,
Fisherman playing the flute

From a set of ten album leaves, ink on silk.
 Each leaf: H 31.2 cm; W 24.9 cm
Korea University Museum, Seoul

The theme of dipping the feet alludes to the song
of the Fisherman in the *Chuci* [Songs of Chu]:

> The fisherman, with a faint smile, struck his
> paddle in the water and made off.
> And as he went he sang: 'When the Ts'ang-
> lang's waters are clear, I can wash my
> hat-strings in them;
> When the Ts'ang-lang's waters are muddy, I
> can wash my feet in them'
> (David Hawkes (trans.), *Songs of the South*,
> Oxford 1957, p. 91)

Wen Zhengming (AD 1470–1559) and others
painted the same theme of the scholar in retire-
ment, washing his feet instead of his official hat-
strings.

 As in the large landscape by the same painter
(no. 223), the focus of attention in these album
leaves is on the figures who appear prominently
in the foreground. On another leaf two scholars
play chess on a table set beneath a pine tree. In
one of the leaves of a similar album in the Seoul
National Museum (Yu Pok-yol 1969, nos 85–6)
Yi Kyŏng-yun has repeated the motif of the
scholar dipping his feet, with the addition of an
attendant bringing wine in a ewer. Other leaves
show scholars watching the moon rise, or the
fall of a mountain cascade. Some, like the fisher-
man playing the flute, have an unselfconscious
lyrical quality enhanced by crisp brushwork.
The fisherman faces the misty distance from
his boat moored among the reeds, in complete
anonymity. RW

a *Published* San Francisco 1979, no. 187a;
Richō 1977, pl. 51

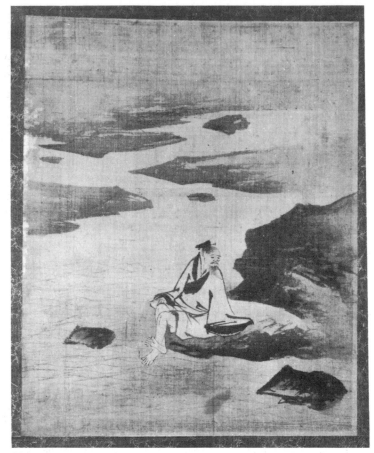

224a

224b

192

225 Yi Chŏng
(AD 1541–?)

Bamboo

Hanging scroll, ink on silk. H 148.8 cm;
 w 69.8 cm
National Museum of Korea, Seoul

Yi Chŏng, T'anŭn, was the great-grandson of
King Sejong, and Korea's most celebrated painter
of bamboo. A superb album of bamboo, painted
in gold on black silk and with seals and in-
scriptions dating it to the *kabo* year of Wanli
(AD 1594) is now divided between the Kansong
Museum and a private collection in Japan (Kan-
song, 1976, pls 11–12; Yu Pok-yol 1969,
nos 79–80). His painting here has the majesty
seen in paintings of plum blossom by Ŏ Mong-
yong (AD 1566–?) and grapes by Hwang
Chipjung (AD 1533–?) (cf. Richō 1977, pl. 57;
Yu Pok-yol 1969, no. 70).

Such subjects were symbolic of Confucian
virtues, particularly uprightness of character
sustained through times of difficulty. While some
of Yi Chŏng's works such as *Bamboo in the Wind*
in the National Museum display clear parallels
with the bamboos painted by Zhu Duan in China,
this painting shows great originality in compo-
sition with an upright soaring bamboo stem in
the middle of the picture. The stems have been
broken off a short way up, so that only the
sturdy stumps and a few twigs and leaves remain.

The painting is signed *T'anŭn*, with one seal
T'anŭn (relief) and a second seal of unusual
design (square relief within an intaglio circle in
a square) which has not been read. RW/YSP

Published San Francisco 1979, no. 189;
Richō 1977, pl. 9; Choi Sunu 1978, pl. 24

225

226 Anonymous,
early 17th century AD

Portrait of Yi Hang-bok
(AD 1556–1618)

Album leaf, ink and colours on paper.
H 59.3 cm; W 35.2 cm
Seoul National University Museum

The purpose of the portrait in East Asian countries was to record the character of the individual, especially where a character had great merit, in order to serve as an example to others. This preparatory sketch shows how this was accomplished. The finished portrait would have included the whole figure seated and wearing official robes (see no. 264), but as these varied little there was no need to include them in the preparatory study. Instead this concentrates on every nuance of the facial expression. Later, in the finished painting, the seat, robes and footstool with all their elaborate detail could be added, if necessary by another painter.

226

Yi Hang-bok came from a scholar family famous since the Koryŏ dynasty and was a descendant of Yi Je-hyŏn (see no. 220). He held various high official posts and finally rose to be Prime Minister. He was brilliantly active during and after the time of the Hideyoshi invasions (1592–8), and in AD 1604 was recognised as a Merit Subject (*kongsin*), but in the end fell victim to factional strife, and died in his place of banishment. After his death, he was reinstated. This portrait, whether made during his lifetime or

after his death, shows him in a thoughtful, even worried mood, which the facts of his life serve to explain. RW/YSP

Published Seoul 1972, pl. 1;
San Francisco 1979, no. 193;
Choi Sunu 1978, pl. 27; 1979, pl. 259

227 Kim Myŏng-guk
(AD 1600–after 1662)

Landscape in snow

Hanging scroll, ink or ramie. H 101.7 cm;
W 54.9 cm
National Museum of Korea, Seoul

This winter landscape with its jagged brushwork, dark sky and narrative composition is a good example of what Ahn Hwijoon has termed the Korean Zhe school. The Zhe school, named after Zhejiang province in China, comprised numerous professional painters, among them Wu Wei,

227

Jiang Song and Zhang Lu, active in the later fifteenth and the sixteenth centuries. Their paintings are characterised by the use of bold ink washes and compositions set in the near and middle ground, with minimal indication of the far distance. They almost always include figures, so that the landscape provides a setting for a story, but there is rarely any inscription other than a brief signature and seal of the painter.

Kim Myŏng-guk was a professional painter who taught at the Tohwasŏ, the Painting Bureau. He is said to have been a bold and extremely energetic character, which is seen in his brushwork. The scene here shows a scholar and his attendant carrying his belongings, setting off on a journey, leaving his wife standing at the gate of his country retreat. The winter cold, and the sorrow of parting, are well conveyed in the attitudes of the figures as they look towards each other. Many such farewell scenes are found in Chinese Zhe school paintings and in those of their Korean followers. RW

Published Richō 1977, pl. 13; Choi Sunu 1979, pl 266; Ahn Hwi-joon 1982a, pls 120–1

228 Kim Myŏng-guk
(AD 1600–after 1662)

Bodhidharma

Ink on paper. H 82.8 cm; W 57.5 cm
National Museum of Korea, Seoul

Kim Myŏng-guk went twice to Japan as a member of Korean delegations in 1636 and 1643, and several of his works are still found there. They show that he must have seen a number of Zen paintings. This painting shows Bodhidharma, the first patriarch of Chan (Korean: Sŏn; Japanese: Zen) Buddhism, with his marked foreign appearance and thick beard. Bodhidharma came to China from India early in the sixth century and died there in AD 528. According to legend, in order not to sleep when meditating, he cut off his eyelids, and shoots from them grew into tea plants. Accordingly, tea remained associated with the Chan sect (Seckel 1957, p. 238).

The painting is signed *Yŏndam*, with two of the artist's seals, *Yŏndam* and *Kim ssi Myŏng-guk*.
YSP

Published Richō 1977, pl. 71

229 Chŏng Sŏn (AD 1676–1759)

Summer landscape

Hanging scroll, ink and light colours on silk.
H 179.7 cm; W 97.3 cm
National Museum of Korea, Seoul

The painting is unsigned but bears an inscription dated AD 1773 signed *P'yoam* by Kang Se-hwang (AD 1713–91, see no. 236), beginning with a poem in four lines:

In the picture hills and rocks, dark, strange, hidden
Streams drip from high falls, willows grow thickly
The thatched hut has a woven fence to obstruct enquiry
Lost in clouds and mist, and dark frosts.

228

With its freely dripping [ink] and luxuriance of vegetation, this is the best of Kyŏmjae's works of his middle years . . .

The inspiration for a large painting like this is still taken from the Song tradition, as we can see from the majestic scale of the mountains and the view stretching into the far distance. Although P'yoam's inscription goes on to quote the Chinese connoisseur Dong Qichang (AD 1555–1636), who had a profound influence on all later Chinese painting, this Korean work of the 1730s shows less of his influence than one would expect. The main structural elements of the composition are juxtaposed, divided by areas of mist or water. The pattern of dark and light ink is related to that seen in the works of early Ming painters like Li Zai and Dai Jin, but Chŏng Sŏn's own genius emerges in the dense repeated strokes that form rocks and the luxuriant and wet foliage admired by Kang Se-hwang.　　RW

Published Kim and Lee 1974, pl. 253; Ahn Hwi-joon 1982b, pl. 11; Yu Joon-yong 1976, p. 92; Richō 1977, pl. 15; Yi Dong-ju 1981b, pp. 168ff

229

230 Chŏng Sŏn (AD 1676–1759)

Ch'ŏngp'ung-gye (Cool Breeze Valley), dated AD 1739 *(colour ill.)*

Hanging scroll, ink and light colours on silk.
H 132.0 cm; W 58.8 cm
Kansong Museum of Fine Arts

Like the *Summer Landscape* (no. 229), this paint-
ing shows Chŏng Sŏn's predilection for areas of
bluish wash overlaid by strong ink accents in
repeated strokes. Here, however, Chŏng Sŏn has
completely abandoned the classical formula
of the ideal landscape, with its view past
foreground rocks, middle-distance bluffs and
high cliffs to a distant lake shore. Instead, the
painting is a very real description of a spacious
country residence. Like the figure in the painting,
who has dismounted in the lane outside, we
enter through an opening in the well-built wall.
Inside, though great trees dominate the scene,
the grounds are laid out in an orderly manner,
with lotus ponds enclosed by stone banks in
straight lines. A pavilion on the right, a thatched
hut on the left under a zelkova tree, lead to the
main house in the centre, well hidden behind
another enclosure. Behind it steps rise at
the foot of a pine-clad cliff. A stream plunges
down beside it from the mist-filled valley above
them. There is no distant lake view: instead the
scene is closed off with another massive cliff
crowned with pines.

Chŏng Sŏn frequently painted this spot and it
must have been close to his own home. Accord-
ing to Choi Wan-su, the main building was the
ancestral hall of Kim Sang-yong (1561–1637),
a scholar-official who visited Ming China and
who helped the royal family to take refuge in
Kanghwa Island at the time of the Manchu
invasions; sooner than surrender, he committed
suicide. As a result, numerous shrines were
erected in Korea to his memory. The mountain
at the top of the painting is Mt Inwang, in Seoul;
the stream plunging from it in the painting feeds
the ponds in the foreground. The repeated layers
of dark ink strokes used for the rocks are Chŏng
Sŏn's way of describing the character of the
massive granite cliffs of the mountain, and the
pattern of light areas and dark elements is his
unique contribution to a distinctive Korean style
of landscape painting.

At the top right, the painting bears the sig-
nature *painted in the spring of ŭlmi* [AD 1739] *by
Kyŏmjae,* with a relief seal *Wŏnbaek.* Chŏng Sŏn
was aged 64 in this year. Apparently the title
Ch'ŏngp'ung-gye (Cool Breeze Valley) was also
inscribed at the extreme right, but has almost all
been lost in remounting. Another version of the
painting, clearly titled, is in the Korea University
Museum (Kyŏmjae 1981, pl. 8). RW/YSP

Published Kim-Lee 1968; San Francisco 1979,
no. 219, pl. XXV; Choi Wan-su 1982, pl. 2

230

231 Chŏng Sŏn (AD 1676–1759)

The rock gate at T'ongch'ŏn

Hanging scroll, ink on paper. H 131.6 cm;
W 53.4 cm
Kansong Museum of Fine Arts

This scene is one of the *Eight Views of the Eastern Pass* (Kwandong p'algyŏng), on the east coast of Korea. Here huge basalt pillars rise on the shore: evidently at low tide it was possible to pass between them. No less impressive than these pillars is the depiction of the sea, in a huge swell rising in the composition high above the tops of the cliffs. No fewer than three versions of this scene are in the Kansong Museum, and Chŏng Sŏn painted many other variations of it (Kyŏmjae 1981, pls 31–4).

In the depiction, Chŏng Sŏn has worked with carefully controlled ink washes to outline the shapes of the cliffs, continuing with darker ink lines, vertical or sharply angled, and finished with intense black strokes for moss dots or foliage. Smoothly curved lines describe the waves, running across the picture and breaking only in paler curls on the shore. Above, tighter but sparser reversed-s curves hint at racing clouds. The party on the shore are in Korean costume.

The inscription gives the title, *The Cliff Gate at T'ongch'ŏn. Kyŏmjae*, with seal *Wŏnbaek* (relief). Choi Wan-su considers that this painting was not necessarily executed on the spot, and that it dates towards the end of the artist's life, when he was in his eighties. RW/YSP

Published Richō 1977, pl. 83;
Choi Sunu 1978, pl. 47; Choi Wan-su 1982,
pl. 4

231

232 Chŏng Sŏn (AD 1676–1759)

Manp'okdong (Ravine of a Myriad Falls)

Album leaf, ink and light colours on paper.
H 33.0 cm; W 21.9 cm
Seoul National University Museum

Despite the fantastic appearance of this landscape, this is also the depiction of an actual place, described in *Tongguk yŏji sŭngnam* (A Geographical Survey of Korea, first compiled in AD 1481), as a valley in the Diamond Mountains where a hundred different streams meet together, dominated by a peak known as Five Persons Summit, said to be the dwelling of a blue crane. Now in North Korea, this is one of Korea's most famous scenic spots.

Like other versions of this subject (Kyŏmjae 1981, pl. 26; Choi Wan-su 1982, pl. 7), the scene revolves around the pillar rising in the centre. In this idealised view from his later years, it has become more like a pillar, to distinguish it from the massive cliff behind, than it is in actuality. Beneath it a large shelving rock provides open space for the visitors, gathered to watch the cascades that meet in the foreground pool. The serried ranks of the inner Diamond Mountians (Kŭmgang, close the view at the top of the painting.

As the perfect complement to his subject, Chŏng Sŏn has added a famous verse by the fourth-century Chinese master Gu Kaizhi:

A thousand cliffs compete in elegance,
Innumerable streams strive to flow,
Grass and trees thrive luxuriantly,
Clouds well up in coloured splendour.

The leaf is titled and signed *Manp'ok-dong. Kyŏmjae*, with one intaglio seal, *Kyŏmjae*.

RW/YSP

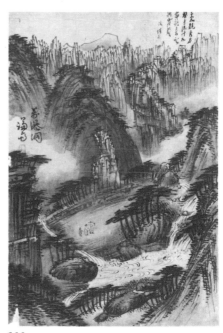

232

Published Kim-Lee 1968; Kyŏmjae 1981, pl. 25;
Kim and Lee 1974, pl. 256; Richō 1977, pl. 85

233 Chŏng Sŏn (AD 1676–1759)

Old Juniper, c. AD 1730–40

Hanging scroll, ink and light colours on paper.
H 131.6 cm; W 55.6 cm
Hoam Art Museum, Yongin

This painting shows the monumental qualities
of Chŏng Sŏn's brushwork and composition,
applied to a single motif. Like the landscapes of
his later years, it is an idealised view, but firmly
based on reality. We can readily see the source
of his inspiration in another painting of his, the
Sajik Pine in the collection of the Korea University
Museum, which depicts an actual pine tree,
its trunk contorted and all its branches sup-
ported by struts, for all the world like a specimen
tree in Kew Gardens (cf. Lee 1968, p. 87; Kyŏmjae
1981, p. 173). The Hoam painting, by contrast,
simplifies the foliage to areas of blue wash over-
laid by dense ink dots, and articulated by the
curving trunk and branches, rendered in parallel
curving brush-strokes. Three or four bare
branches emerge near the top of the tree.

The painting is signed *Kyŏmjae* at the top
right with two seals, *Chŏng Sŏn* (intaglio) and
Wŏnbaek (relief). At the top left, a brief inscription
records that the painting was given to Yebaek
by Taerae: neither has been identified. The in-
scription at the bottom is by An Jung-sik (1861–
1926), who was himself a painter (cf. Hoam
1982, pl. 211), and who gave this painting to
Kim Yun-sik (AD 1835–1922, writer, official
and Foreign Minister) for his sixtieth birthday.

RW

Published Kyŏmjae 1981, pl. 98; Hoam 1982,
pl. 227

234 Attributed to Chŏng Sŏn
(AD 1676–1759)

Greeting Japanese Envoys in Tongnae

Folding screen, ink and light colours on paper.
Each panel: H 85.0 cm; W 46.0 cm
National Museum of Korea, Seoul

This screen painting in ten panels is a historical
document which has been studied in detail by
the historian Choi Yong-hi (1976), on whose
work these notes are based.

The whole painting is laid out as a panorama
reading from right to left. In the first panel the
walled city of Tongnae is seen with its main gate
to the south and protected by mountains to the
north. The second panel is dominated by a beacon
hill overlooking Pusan bay, with buildings of
the town in the foreground; adjacent to these
are three Korean ships in Pusan harbour, this
being the most convenient port for travel to
Japan. Here, and on the next several panels,
is the official procession of the magistrate of

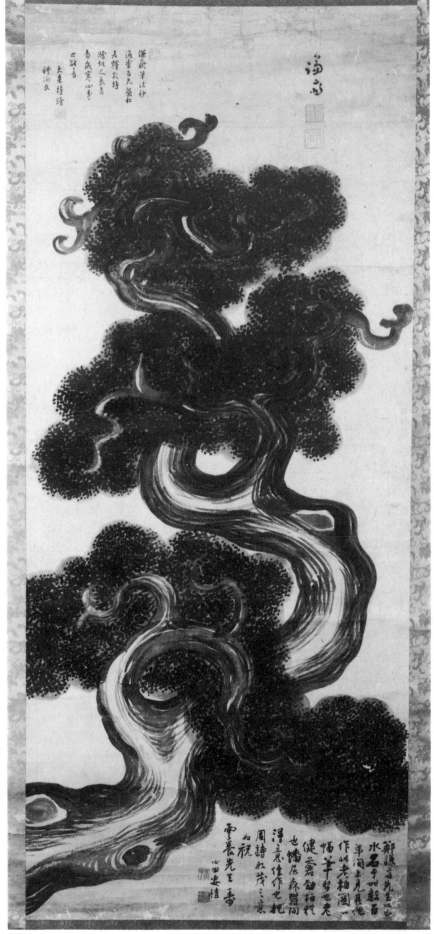

233

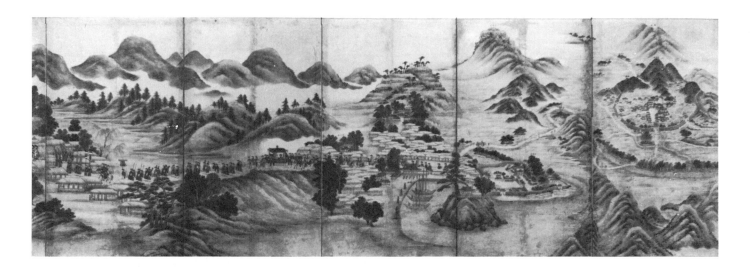

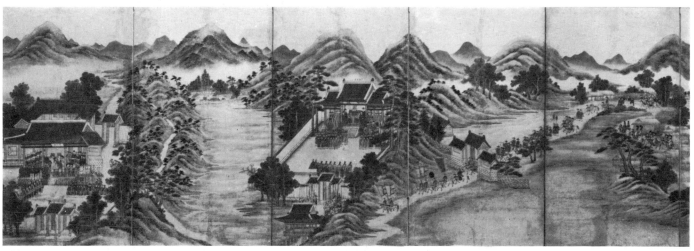

234

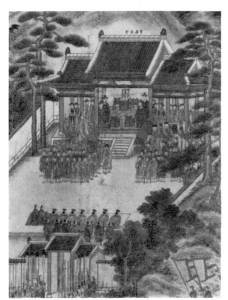

234 (detail of eighth panel)

Tongnae, on his way in a large palanquin to greet the Japanese envoys. A numerous guard precedes him in order to impress his importance on the visitors. Farther ahead, on the sixth panel, ride a party of *kisaeng* who will entertain them.

The seventh panel shows the head of the procession passing through the gate to the Japanese compound. The stone walls were built in AD 1710 and the whole compound was rebuilt in 1758; this painting dates before the rebuilding. Panel 8 shows the Japanese envoys kneeling to pay their respects in the detached tablet hall to the Chosŏn king, who remained in Seoul and is represented by the magistrate and the empty chair. Guest quarters and the long road to the banquet hall are seen in the ninth panel. The tenth features the Hyangdae-ch'ŏng, Great Banquet Hall, with the entertainment in progress. The magistrate of Tongnae and the commissar of Pusan are seated on the right, the Japanese envoys on the left, while the *kisaeng* and the musicians occupy the centre.

The painting shows the large size of delegations between the two countries and the importance attached to protocol. The Ch'oryang or diplomatic office for the Japanese was built near Pusan in AD 1678; previous embassies had had to travel all the way to Seoul. Originally the welcoming dances were performed by boys; they were replaced by *kisaeng*, women entertainers, by special request of the Japanese in AD 1612.

This scene is unsigned, but the topographical accuracy and the style of the landscape elements all confirm the statement in the label that it is the work of the painting master Chŏng Sŏn, who was especially renowned for his *chingyŏng sansu* (landscape of actual places). It may have been painted by him as an official commission when he was a member of the Painting Bureau, to which he was recommended when he was aged 30.
YSP

Published San Francisco 1979, no. 221; Choi Young-mi 1976

235

235 Sim Sa-jŏng (AD 1707–66)

Watching the waterfall

Album leaf, ink and light colours on paper.
 H 30.0 cm; W 46.0 cm
Kang Su-yang Collection

Sim Sa-jŏng was a scholar-painter and pupil of
Chŏng Sŏn, but also studied Ming paintings of
the Wu and Zhe schools. An album leaf of sea-
birds on sea-girt rocks, in the Kwangju National
Museum, shows him in relation to Chŏng Sŏn,
perhaps taking an actual scene on the coast of
Korea (Ahn Hwi-joon 1982b, pl.43). This album
leaf, on the other hand, is in the vein of Ming
paintings showing scholars in the romantic sur-
roundings of a wild landscape. The brushwork
is in Sim Sa-jŏng's large, 'axe strokes', here
combined with light colours.

The leaf bears the artist's signature *Hyŏnjae*
and one seal, *Ch'ŏng song chi hu* (descendant of
the Ch'ŏng song branch [of the Sim family]).

RW

236a–c Kang Se-hwang
(AD 1713–91)

Scenic Spots of Songdo (Kaesǒng)

Three album leaves, ink and light colours on
paper. Each leaf: H 32.8 cm; W 53.4 cm
National Museum of Korea, Seoul

Kang Se-hwang was born of a literati family and
became the greatest connoisseur and critic of
painting of his time. His comments on the
paintings of his contemporaries and predecessors
are usually signed with his studio name, P'yoam
(see no.229) and provide valuable source ma-
terials for the history of Korean painting. Kang
Se-hwang's own paintings are firmly rooted in
the scholar-painting tradition of the Ming Wu
school, exemplified by Shen Zhou (1427–1509)
and his followers. The three paintings shown
here are in keeping with that tradition, since
Shen Zhou painted many albums of scenic spots
around Suzhou, but they display purely Korean
characteristics in execution as well as in the
topography.

The album has sixteen leaves, two of which
are descriptions by the artist, and a further leaf
with a later colophon. The fourteen painted
leaves show sixteen views, of which the first is a
general view of Kaesǒng, the former capital of
the Koryǒ dynasty, and the rest are beauty spots
identified by name in the artist's inscriptions, as
follows:

236a Paeksǒk-dam, 'White Rock Pool'

White Rock Pool, too, is on the Yǒngt'ong road.
Its rocks are white as snow, and as square as a
chess board. A clear flow spreads over them, the
mountains all around are so green that they
seem about to drip. When I was there there was
a fine rain which suddenly cleared. The scenery
was incomparably beautiful, and quite unfor-
gettable.

236b Yǒngt'ong tonggu, 'Yǒngt'ong Grotto' (colour ill.)

At the mouth of the Yǒngt'ong Grotto is a
jumble of rocks, boulders as large as houses.
They are covered in green moss. When I first
saw them I was startled. People say that a
dragon rises out of the pool, but one doesn't
have to believe it. But the grandeur of the view
is something rarely seen.

236c Ch'ǒngsǒk-dam, 'Clear Rock Pool'

Kang Se-hwang's paintings here are a match for
the portrayals of scenes in the Diamond Moun-
tains by Chǒng Sǒn (cf.no.232), in their obser-
vation of the characteristic features of the Korean
landscape. In particular, the huge granite boul-

236a

236c

ders, dwarfing the figures riding beside them,
are in fact realistic despite their amazing appear-
ance. P'yoam's instinct was right when he wrote
that it was not necessary to believe in the legend
of a dragon to realise the grandeur of the place.

P'yoam has used finely graded ink and pale
colour washes, with fine ink outlines. Effects of
light and shade are used to give substance to the
boulders of the Yǒngt'ong Grotto (see colour
illustration), but the main effect comes from the
composition, focused on the central elements
which are enlarged until they almost fill the
whole available surface. The result is an extra-
ordinarily modern appearance in each of the
paintings, due to the abstraction seen in the
principal motifs.

The whole of this album and its inscriptions,
making a total of seventeen pages, has been
reproduced in an article in Oriental Art (Cox
1973). The leaves shown here are nos 3, 4, and
7 in the sequence. RW

Published Cox 1973; San Francisco 1979,
no.232a–c, pls XXXIV–XXXV;
Ahn Hwi-joon 1982b, pls 111–14

237 Yun Du-sŏ (AD 1668–1715)

Self-portrait

Hanging scroll, ink and light colours on paper.
 H 38.5 cm; W 20.5 cm
Yun Young-son Collection

Self-portraits are almost entirely unknown in the Far East. That Yun Du-sŏ should have chosen to paint this one is perhaps due to the philosophy of *silhak* ('practical learning') current in the early eighteenth century, as a result of contact with Qing China where the Jesuits had brought knowledge of Western science. Yun Do-sŏ came from a distinguished family and passed the state examinations as *chinsa* (doctorate) at the age of 26 in 1693.

Even more than in the sketch for the portrait of Yi Hang-bok (no.226), the painter concentrates exclusively on the close study of the head and the rest of the body is not even indicated. The drawing is sensitive and meticulous, using light and shade in a most subtle way. It is surely one of the masterpieces of portrait-painting in any country. RW/YSP

Published Choi Sunu 1978, pl.42; Richō 1977, pl.80

238 Anonymous

Portrait of Yi Chae (AD 1680–1746)

Hanging scroll, ink and light colours on silk.
 H 97.0 cm; W 56.5 cm
National Museum of Korea, Seoul

This formal portrait shows Yi Chae, also known as Toam, in the white robes worn by Confucian scholars and officials until this century. The robes, as suggested by their name, *hakch'ang-ŭi*, or 'crane robes', are white with black borders, resembling the plumage of the Oriental crane. A touch of colour in the fastening ribbon of silk finely woven in a floral pattern adds to the elegant effect. The facial rendering is detailed and realistic, successfully conveying the benevolent spirit of the sitter.

Yi Chae was a leading Neo-Confucian scholar who served in high official positions during the reigns of King Sukjong (reigned AD 1674–1720) and King Yŏngjo (AD 1724–76). In his later years, on account of factional struggles, he withdrew from official life and devoted himself to scholarship. RW/YSP

Published San Francisco 1979, no.223; Choi Sunu 1978, pl.89

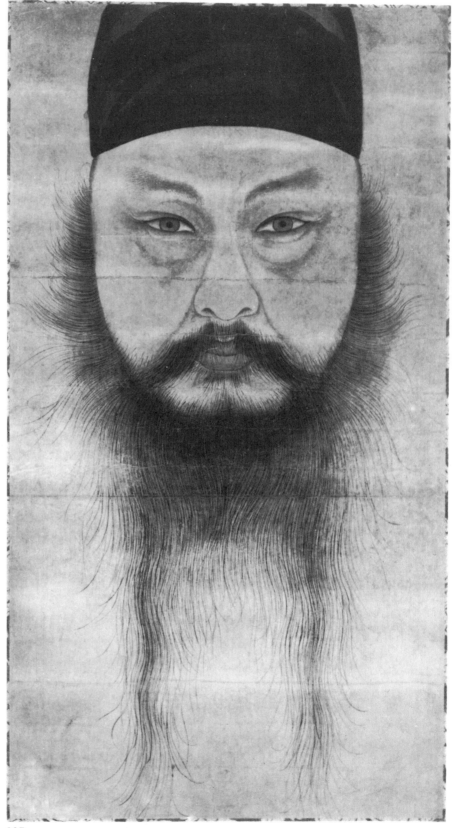

237

239 Anonymous, dated AD 1807

Portrait of Yi Ch'ae (AD 1745–1820)

Hanging scroll, ink and light colours on silk.
H 99.2 cm; W 58.0 cm
National Museum of Korea, Seoul

Yi Ch'ae was the grandson of Yi Chae (no. 238), and like him held various high official positions. He is shown here wearing the same *hakch'ang-ŭi* but with a *tongp'a-gwan* or Confucian scholar's headgear as worn by the Song dynasty scholar Su Dongbo, of gauze woven with horse-hair, more formal than the scarf fastened at the back in his grandfather's portrait. The front part of the headgear is lower than the back.

The portrait consciously evokes that of his grandfather, as explained in the important inscriptions by contemporary scholars and calligraphers. On the left at the top is a eulogy originally composed much earlier by Wŏn'gyo, Yi Kwang-sa (1705–77) saying that Yi Ch'ae's spiritual appearance was very similar to that of his grandfather. This was copied out here by another calligrapher, Songwŏn, in AD 1807, the date of the painting.

The long inscription on the right is a poem composed by Yi Ch'ae himself and written on the painting by Kyŏngsan Yi Han-jin (1732–?) who was particularly famous for his calligraphy in seal script. Finally on the left is an inscription composed by Choam, Yu Han-jŏn (AD 1732–1811), one of the best writers of his time, and written in formal script by the calligrapher Yu Han-ji (AD 1760–?). RW/YSP

Published Seoul 1979, pl. 53; Choi Sunu 1979, pl. 278

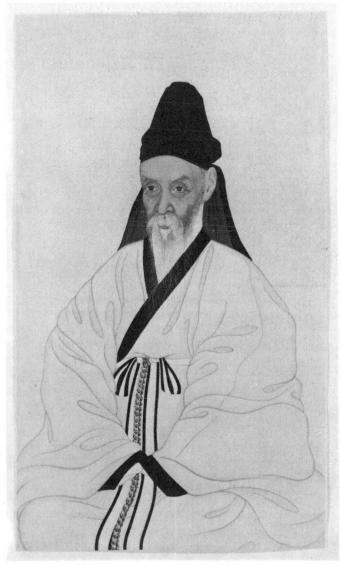

238

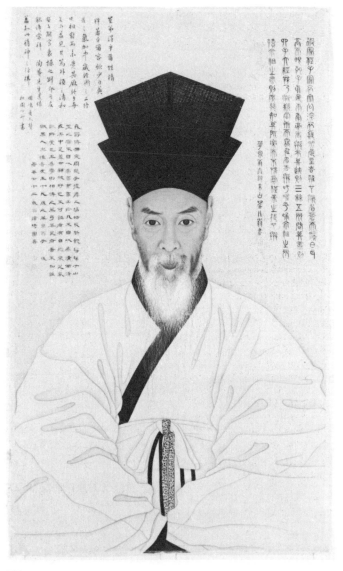

239

240

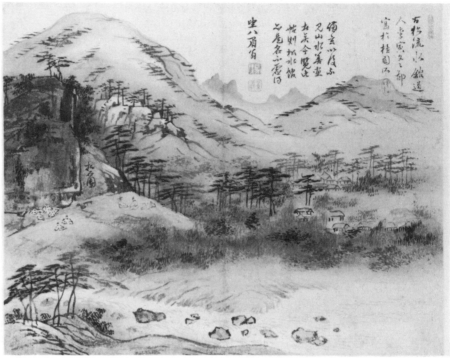

241

240 Yi In-sang (AD 1710–60)

Pine tree in snow

Hanging scroll, ink on paper. H 117.2 cm;
W 52.6 cm
National Museum of Korea, Seoul

The strong brushwork and unconventional
composition of this painting display Korean schol-
arly taste. Yi In-sang was a scholar who obtained
the *chinsa* degree in 1735; he was known for his
calligraphy and seal-carving, all traditional
accomplishments of the literati painters. Choi
Sunu has quoted the judgement of Pak Kyusu
(AD 1807–76) who wrote on an album: 'Yi had
a very clear and upright character, a lofty taste,
and was indeed one of the foremost scholars of
his time. He enjoyed calligraphy and painting as
a hobby, without attaching too much import-
ance to them. Loving landscapes, rivers and
lakes, water and rocks, he wanted to be distant
from the daily dust'. Such a character is amply
borne out in this painting, with one pine trunk
rising vertically in the centre, and another cros-
sing at right angles. Brush-strokes and ink washes
are used to suggest a bleak snow-covered land-

scape. Yi In-sang's own brush manner stands
out clearly but unassertively, so that no inscrip-
tion or signature, but only a single seal, *Yi In-
sang in*, in the lower left corner, is all that is
needed to identify his work. RW

Published Richō 1977, pl. 101

241 Yi In-mun (AD 1745–1821)

Poetry meeting at Pine
Rock Garden

Album leaf, ink and light colours on paper.
H 25.6 cm; W 31.8 cm
Kim Shin-kwon Collection

Yi In-mun was a member of the Painting Bureau,
and is said to have been as renowned as Kim
Hong-do (see nos 247–50). A handscroll by him
in the National Museum, *Mountains and Streams
Without End*, is as its title suggests a vast pan-
orama, 8.5 m long, drawing inspiration from
Northern Song landscape but painted according
to the principles of the Qing dynasty Orthodox
school and their followers (Richō 1977,

pls 112–15). Other works of his show a command
of colour washes and of light and shade which
justify his reputation (Ahn Hwi-joon 1982b,
pl. 75).

The scene is a meeting of gentlemen in Korean
costume in a scenic spot, the name of which is
actually inscribed on one of the rocks: Songsŏk-
wŏn, 'Garden of the Pine Rock'. The trees and
rocks are drawn with repeated brush strokes
which create their own rhythms. Figures and
houses are tiny by comparison with the land-
scape.

The painting is signed: *Painted by Munuk, Yi
In-mun, Kosong Yusukwan toin* ('Hermit of the
Old Pine and Flowing Water Lodge'), with
an oval seal. Like the companion leaf by Kim
Hong-do from the same collection (no. 250, see
colour illustration), the painting also has an
inscription and two seals of Misan (Ma Sŏng-
rin, *cha* Sŏnghi), a calligrapher known during
the reign of King Yŏngjo (AD 1724–76) for his
regular script but otherwise obscure (O Se-chang
1928, p. 202). RW

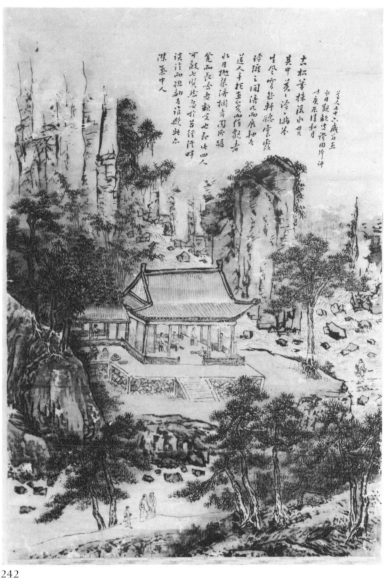

242

243

242 Yi In-mun (AD 1745–1821)

Gathering of Friends
dated AD 1820

Hanging scroll, ink and light colours on paper.
H 86.5 cm; w 57.8 cm
National Museum of Korea, Seoul

The inscription, written by Kim Yŏng-myŏn (Chugyŏng, a famous player of the *qin*), reads:

A few aged pines, running water between them, green and cool, filling the valley with breezes. Suddenly in the pavilion, rosy clouds appear through the lattice windows. Next to the table, unrolling a scroll, is Toin [the painter Yi In-mun]; holding an album in his hand and looking at it is Suwŏl [Im Hui-ji]; abandoning his *qin* and sitting on the railing is Chugyŏng [the writer]; sitting on a stool and reciting is Yŏngsu [Sin Wi ?, a famous painter]. These four gentlemen may compare with the Seven Sages. And here on the mossy path along the bank, engrossed in conversation, who are they? They must also be men of noble character.

Three shorter lines give the cyclical date, con-firmed by the fact that Yi In-mun was aged 76 when he painted the work.

Unlike the more Korean gatherings seen in nos 241 and 250, the participants in this elegant gathering all wear Chinese dress, in keeping with the tradition which, as Kim's inscription suggests, goes back to the meetings of the Seven Sages of the Bamboo Grove, of the fourth century AD, in which the *qin* player Xi Kang was a prominent figure. RW

Published San Francisco 1979, no. 239; Richō 1977, pl. 117

243 Attributed to
Kim Tu-ryang (AD 1696–1763)

A dog scratching

Album leaf, ink on paper. H 23.0 cm; w 26.3 cm
National Museum of Korea, Seoul

Kim Tu-ryang was a talented painter whose best painting is a landscape in moonlight in the Seoul National Museum. He is also known for his animal paintings, which rank almost as portraits in their sensitive depiction of character. One of the best, now in P'yŏngyang, is an ox with its keeper, important in Kim's oeuvre since it bears an inscription by his famous contemporary, Kang Se-hwang (see no. 236), who was himself both painter and connoisseur.

A second album leaf in the National Museum also portrays a scratching dog (Seckel 1979, fig. 5, n. 7). Neither bears a signature or seal of the artist, but it is the second leaf that appears closest in style and execution to Kim Tu-ryang's other works, especially the *Ox and Herdboy* in P'yŏngyang. RW

Published San Francisco 1979, no. 222.
Cf. Seoul 1977, pl. 191

244 Pyŏn Sang-byŏk
(18th century AD)

Cats and Sparrows

Hanging scroll, ink and light colours on silk
H 93.7 cm; W 42.9 cm
National Museum of Korea, Seoul

Next to Yi Am in the fifteenth century, Pyŏn Sang-byŏk is Korea's most famous painter of animals. Yi Am is celebrated for his mother dogs and playful puppies, but Pyŏn's speciality was cats, to the extent that he earned the nickname of Pyŏn Koyang or Pyŏn the Cat. He was a member of the Painting Bureau and portraitist of high repute as well. Given the keen observation needed in portraiture, it is perhaps no wonder that Pyŏn Sang-byŏk's depiction of cats (and of hens and chickens, which were another favourite subject of his) is so detailed and minute. In this painting the fine work devoted to the textures of patterns of fur and feathers is contrasted with the bold patterning of the bark in the tree trunk and the soft green of the grass and plants, which are organised in small repetitive motifs.

The same care and attention is lavished on the composition. The two cats, one hardly more than a kitten, the other more sedate, balance each other in the foreground, but the sparrows above, far from being perturbed at the intrusion of the kitten, seem absorbed in their own petty quarrels, displaying with half-opened wings and pouted chests. The whole painting moves in fluent rhythms, most conspicuously in the contours and markings of the two cats, but also in the tree-trunk and the movements suggested by the birds.

The painting is signed *Painted by Hwaje* on the right. RW

Published Seoul 1972a, pl. 49;
Choi Sunu 1979, pl. 279;
San Francisco 1979, no. 196

244

245 Sin Yun-bok
(mid-18th century AD)

Woman by a lotus pond

Album leaf, ink and light colours on silk.
H 29.6 cm; W 24.8 cm
National Museum of Korea, Seoul

Sin Yun-bok painted exclusively scenes from the daily life of the *yangban* or upper classes and of those who provided them with entertainment. His paintings give glimpses of the customs and surroundings of his time. A pretty young woman is seated on the open verandah of a Korean house, overlooking a lotus pond. Her fashionable hair-style and attributes, a long pipe and a *saeng* or mouth organ, and even her seating posture, show that she is no ordinary lady but a *kisaeng*, a high-class entertainer. In order to sit comfortably she has hitched up her skirt, worn by *kisaeng* with the opening on the right, under her right arm. She wears a short jacket, long ample trousers, white cotton socks and low-cut Korean shoes. Her hair is braided up in two long thick plaits and fastened with ribbons on the side of the head.

The large green lotus leaves and pink flowers are in harmony with the soft blue of the skirt. The building, drawn in broad ink strokes, has a wooden floor raised on stone supports, and lattice windows lined with paper. YSP

Published Seoul 1972a, pl. 54

246a-d Sin Yun-bok
(mid-18th century AD)

Midnight meeting, Travelling, Moonlight dalliance, Going Home

Four album leaves, ink and colours on silk.
Each leaf: H 28.3 cm; W 35.2 cm
Kansong Museum of Fine Arts;
National Treasure no. 135

These colourful scenes are from an album of thirty leaves in the Kansong Museum of Fine Arts, all illustrating the life of the wealthy *yangban* classes and the *kisaeng* who were allowed the freedom to meet them, while ladies of good family led secluded lives. The paintings provide fascinating glimpses of clothing and customs in Korea in the eighteenth century. Not all of the scenes are inscribed, but in each case the narrative content is clear through the behaviour of the characters so that explanation is hardly necessary.

246a Midnight meeting

Here the young man with a red lantern is apparently bidding farewell to his sweetheart, who wears a *ssŭgae-ch'ima* or cloak to cover her head

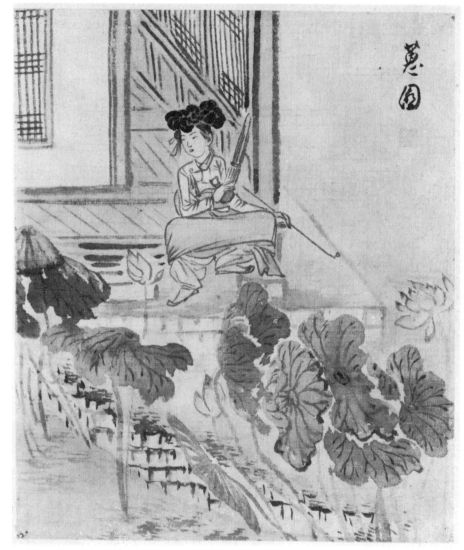

245

and shoulders. Women commoners, and not only the *kisaeng*, wore the *ssŭgae-ch'ima* when they went out as they were not able to show their faces; it also had a practical function in protecting from the cold. The poem reads:

> The moon sinks low, it is past midnight
> What is in the hearts of two people only two
> people know

The scene is subtle and romantic, with a touch of poignancy as the girl turns her head away from the young man, and draws the cloak around her face. There are two seals of the artist, one reading *Ippu*, another reading under the signature, *Hyewŏn*.

246b Travelling

The woman in the sedan-chair wears the same *ssŭgae-ch'ima* cloak and holds a long pipe. The reason for the contrite expression of the young man in this painting is apparent from the inscription which reads: 'The talented youth from Luoyang, how much does he really know?' The allusion is to a Tang poem by Bao He (mid-eighth century AD): 'The southern beauty has gone and will not return; the brilliant youth from Luoyang must seek another wife'. So the young man is left standing wondering what to do as his lover leaves. The leaf is signed *Hyewon*, and bears three seals of the artist, *Ippu*, *Ch'ihwa-ssi* and *Ilp'yŏnun*. The leaf has not been published before.

246c Moonlight dalliance (colour ill.)

The third leaf shows another street scene under a full moon. A young man in military apparel boldly embraces a *kisaeng*, while another *kisaeng* spies on them from around the corner of a compound wall. She wears a green *chang'ot* with sleeves, which she has let fall to her shoulders. She wears a *kach'e*, or false hairpiece, much in vogue in the eighteenth century, so much so that royal prohibitions were necessary on the expense involved in procuring even larger ones. The fashion is to be seen in all of Sin Yun-bok's paintings. The leaf is signed *Hyewŏn*, with one seal.

246d Going Home

The night watchman, in the red cloak, checks on the gentleman who has been to a party and is on the street after curfew. His *kisaeng* companion is totally unconcerned. The boy carries a lantern and also the woman's fur-trimmed *nambawi*, worn with ribbons in winter. As in the travelling scene, the man's gesture in holding the edge of his hat denotes embarrassment.

RW/YSP

Published P'ungsok 1977, vol. 2, (a) pl. 28; (d) pl. 18.

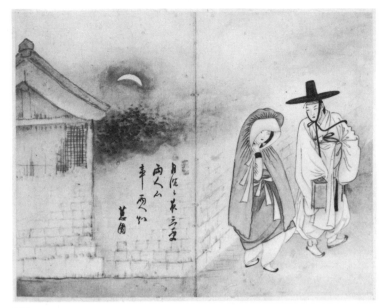

246a

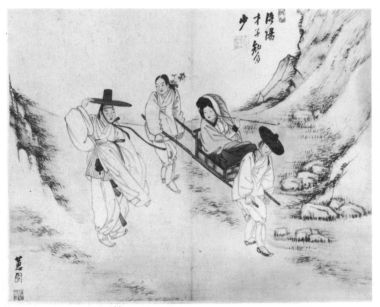

246b

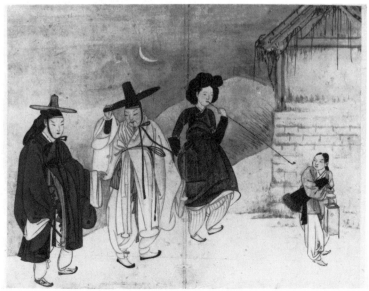

246d

247 Kim Hong-do
(AD 1745–after 1814)

Gathering of Elders, dated AD 1804

Hanging scroll, ink and light colours on silk.
H 137.0 cm; W 53.3 cm
Yi Dong-ju Collection

This is representative of a uniquely Korean type of painting, dating back to the early Chosŏn dynasty, while the kind of gathering it portrays has its origins even earlier in the Koryŏ dynasty. According to the inscription at the top, written by Hong Kanje in AD 1805, Kim Hong-do, the best painter of his time, was commissioned to paint this scroll in 1804.

The occasion is the gathering of gentleman aged over 70 for an open-air feast at the Manwŏl-dae or Terrace of the Full Moon, the former site of the Koryŏ palace, located at Mt Song'ak in Kaesŏng. The names of the sixty-four principal participants are all listed at the bottom of the picture. They are seated around the centre of a hollow square, under a tented roof, each with an individual tray-table. In the centre of the square is a red lacquer table bearing a number of white porcelain jars and vases with flowers. All around stand the younger gentlemen who commissioned the painting. More trays of food are brought by women, and served by boys, some of whom also dance.

The title, Kirose ryŏnkedo (Picture of the Gathering of Elders) is written at the upper left in clerical script, with the signature Tanwŏn and two seals, one reading Kim Hong-do yin (intaglio).

RW/YSP

Published Richō 1977, pl.128;
Yi Dong-ju 1981b, p.105

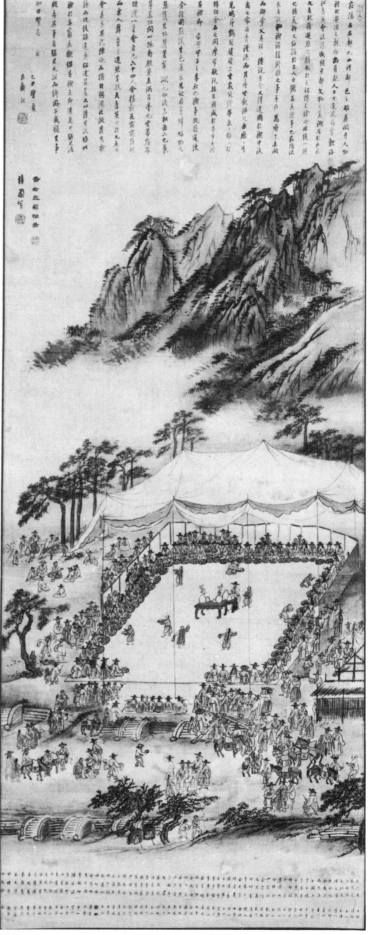

247

248a-c Kim Hong-do
(AD 1745–after 1814)

Schoolroom, Wrestling, Boy Dancing

Three album leaves, ink and light colours on
 paper. Each leaf: H 28.0 cm; W 24.0 cm
National Museum of Korea, Seoul;
 Treasure no. 527

Kim Hong-do, like Sin Yun-bok (nos 245–6) is
famous for his scenes from daily life. However,
while Sin Yun-bok painted almost exclusively
the life and pleasures of the upper classes, Kim
Hong-do took his subjects from ordinary people.
These three leaves are from an album of twenty-
five (six are shown in Kim and Lee 1974,
pls 269–74).

Each of the leaves is organised in a circular
composition, with the focus on a single figure or
group, which gives the paintings a striking
narrative content in addition to the touching
sympathy of observation. In the schoolroom
scene the tearful schoolboy has to turn his back
to the teacher (so as not to see the textbook)
while he tries to recite, and his classmates
suppress their mirth. The schoolmaster wears
the *t'anggŏn* or indoor headgear. On the right
the other half of the class are reading in unison.

A second leaf shows *ssirŭm* or Korean wrest-
ling, with a large circle of spectators and a
hopeful hawker with a tray of *yŏt*, sticky rice
sweets. The contestants have removed their
shoes. Several of the men watching have removed
their hats and one can see their top-knot and
mangŏn or cap worn beneath it.

The leaf with the dancing boy shows a number
of the traditional Korean popular musical in-
struments: suspended drum, *puk*, *changgo* drum,
tangp'iri and *hyangp'iri* oboes, *taegŭm* or large
flute, and *haegŭm*, two-stringed fiddle. In the
lower left corner is an intaglio seal reading *Kim
Hong-do yin.* RW/YSP

Published Richō 1977, pls 124–6;
San Francisco 1979, no. 228a-b, pl. XXXVI

248a

248b

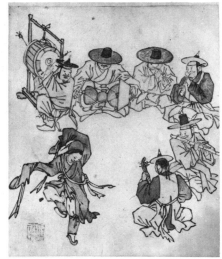

248c

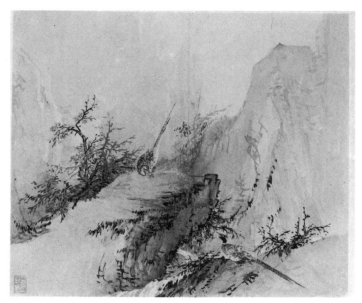

249a

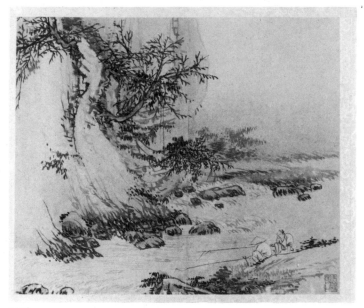

249b

249a-c Kim Hong-do
(AD 1745–after 1814)

Pheasants, Fishermen, Bird on a flowering branch

Three album leaves, ink and light colours on
 paper. Each leaf: H 27.0cm; W 31.5cm
Hoam Art Museum, Yongin

These three leaves come from an album
apparently dated AD 1796, the year after Kim
Hong-do retired from his post as a local magis-
trate. They show lyricism and a lightness of
touch and texture, and refreshing use of colour,
besides an accomplished landscape style. The
charming bird on a flowering branch is close to
an ink sketch on which Kim Hong-do wrote that
he was following the Ming painter Lin Liang
(cf. Richō 1977, fig.65). At least one of the
scenes in the album is of a peak in the Diamond
Mountains (Hoam 1982, pl.186), a subject
which he also painted for King Chŏngjo. Besides
this royal patron, Kim Hong-do received con-
siderable praise from the connoisseur and
painter, Kang Se-hwang (no.236). Each leaf
has a relief seal of a collector, *Kim Yong-jin ga
chinjang*, treasured by Kim Yong-jin family.

<div align="right">RW/YSP</div>

Published Hoam 1982, pls 201, 222, 223

249d Kim Hong-do
(AD 1745–after 1814)

Coin-bearers beside a castle wall

Album leaf, ink and light colours on paper.
 H 27.0cm; W 38.5cm
Hoam Art Museum, Yongin

This leaf is from a different album from the three
last. The painting shows Kim Hong-do's concern
for ordinary people like these two porters with
their heavy loads of strings of copper cash. It is
signed *Tan'gu*, a signature used by the artist in
his later years.

 There are two of Kim's seals, *Kim Hong-do yin*
(intaglio) and *Sanŭng* (relief). RW/YSP

Published Hoam 1982, pl.213

249d

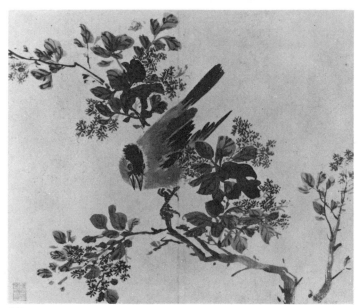

249c

250 Kim Hong-do
(AD 1745–after 1814)

Moon-viewing party *(colour ill.)*

Album leaf, ink and light colours on paper.
H 25.6 cm; W 31.8 cm
Kim Shin-kwon Collection

In this romantic scene a number of gentlemen in Korean costume have gathered to drink wine and admire the full moon from a sheltered rise behind a rustic retreat. On such occasions poems or *sijo* (see Introduction, p. 17) would be composed and recited, with the accompaniment of wine.

This is a companion to the leaf by Yi In-mun (no. 241), and has an inscription and three seals of the calligrapher Ma Sŏng-rin:

At the peak of midnight
The full moon pierces the fence
The creation of the brush
Startles men in their dreams.

The delicate brushstrokes and light colour are in harmony with the romantic atmosphere.

Kim Hong-do's signature is on the left, with seals *Hong-do* (relief) and *Sanŭng* (intaglio). At the lower left, there is another brief inscription, *Kimssi unnim sŏso*, which seems to imply that the scene is set in the artist's own studio, named Unnim (Yunlin) after Ni Zan (1301–74), the famous Yuan dynasty painter. RW

251 Anonymous

Tiger, dated AD 1714 or 1774

Hanging scroll, ink and light colours on paper.
H 96.0 cm; W 55.1
National Museum of Korea, Seoul

The tiger was native to Korea, and Korean popular literature and legend is full of stories about tigers. In these stories the tiger is not necessarily fierce in character, but is thought of as a *sansin* or mountain spirit, worshipped for its strength and protective powers. In folk paintings, where it is a recurrent motif, it is often whimsically portrayed and not frightening at all. In this painting, however, the depiction is realistic, and the tiger's coat is described with meticulous precision without loss of character and inner spirit. The pose of the tiger shows that it is just coming down from the mountains; the artist has used the vertical format of the painting to great dramatic effect in this respect, as the movement flows continuously from the curving tail through the arched back down to the head which turns again to the front with staring eyes. Each of the paws is placed with weight and balance, so that the whole composition implies the tiger's motion in space. The keen observation of movement and sense of power makes this

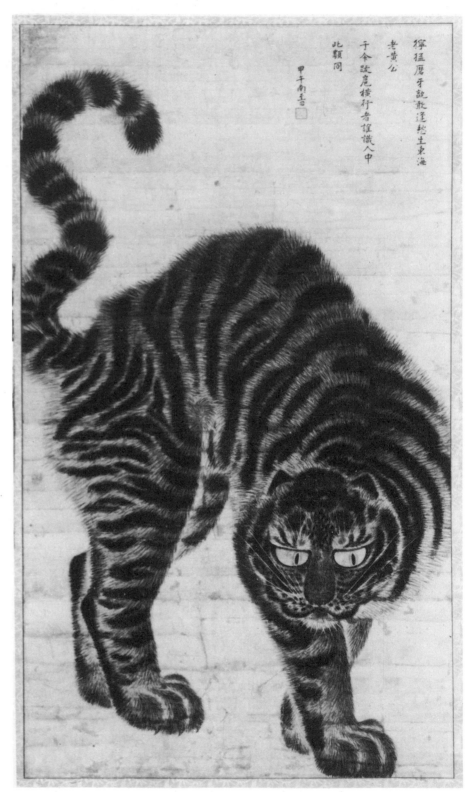

251

painting one of the masterpieces of Korean animal paintings.

The poem inscribed at top right affords some valuable clues to the interpretation of the painting:

Fierce and sharp-fanged, who dares to meet
 him?
Tragedy befell old Master Huang of the
 Eastern Sea.
Nowadays there are some who stride
 uncontrollable
Who knows whether there are such now
 among men?
[Written in the] *kabo* [year] at the winter
 solstice.

Master Huang was a legendary figure of the Han dynasty, who in his prime had the skill to tame tigers and serpents, but in his old age met his death by a white tiger which his red sword was unable to kill. The third and fourth lines may imply an element of political criticism in the writer's intention, which accords well with the troubled circumstances caused by factional struggles in the later Chosŏn dynasty.

The painting bears a seal but no signature. The seal reads *Hyŏnjae*, one of the names of Sim Sa-jŏng (AD 1707–69, see no.235), but Sim Sa-jŏng's dates do not accord with either AD 1714 or 1774, to which the *kabo* year corresponds, and it is generally agreed that the seal should be regarded as a later addition. More pertinent to the date of the painting is the existence of another tiger in a similar pose painted by Kim Hong-do, in a joint work with Kang Se-hwang, now also in the National Museum, and which must be dated before Kang Se-hwang's death in 1791. RW/YSP

Published San Francisco 1979, no.231

252 Kim Sŏk-sin (AD 1758–?)

Mt Tobong

Album leaf ink and light colours on paper.
 H 36.6 cm; W 53.7 cm
Yi Dong-ju Collection

Kim Sŏk-sin and his brothers Kim Dŭk-sin and Kim Yang-sin all were professional painters in the Painting Bureau. While his elder brother Kim Dŭk-sin followed Kim Hong-do and specialised in genre paintings, Kim Sŏk-sin was more influenced by Chŏng Sŏn (see nos 229–33) as can be clearly seen in this painting of Tobong, a mountain now in the northern suburbs of Seoul. The large characters of the title read *Tobong Album*, as this was the frontispiece to a collection of poems written on excursions in the area (Yi Dong-ju 1981b, pl.189). Two columns beneath the title explain that Ch'owŏn Kim Sŏk-sin painted the landscape for the noted scholars

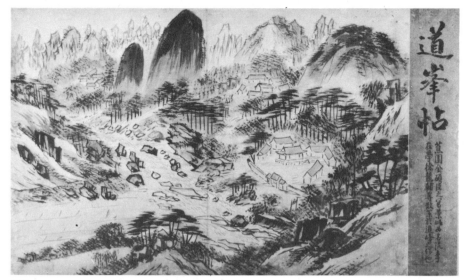

252

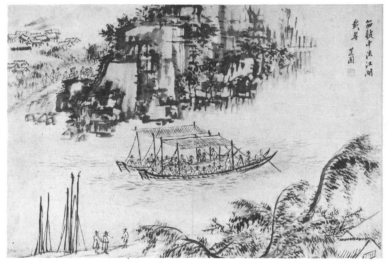

253

Yi Jac-hak (AD 1745–1806), Inspector General and Minister of the Board of Punishments, Sŏ Yong-bo (AD 1757–1824), later Prime Minister, and others, for their rambles around Mt Tobong. The calligrapher has not been identified, nor has his seal been read.

The composition is arranged in such a way as to show a number of points of interest in a wide valley, including fields, temple compounds, stands of pine trees, rock-strewn rivers, the dominant summits of the mountain, and serried distant peaks. The main summits are executed in the repeated ink strokes pioneered by Chŏng Sŏn. RW/YSP

Published Richō 1977, pl.132; San Francisco 1979, no.233; Ahn Hwi-joon 1982b, pl.84

253 Kim Sŏk-sin (AD 1758–?)

Boating scene

Album leaf, ink and light colours on paper.
 H 31.6 cm; W 46.9 cm
Son Seki Collection

This painting by Kim Sŏk-sin is one of four album leaves illustrating scenic spots on the Han River, near Seoul (cf. Ahn Hwi-joon 1982b, pl.86). Canopies are stretched over the two boats, with musicians playing instruments including a red *changgo* (drum) on one boat.

Both the occasion and the manner of celebration, as well as the style and composition of the painting, are essentially Korean. Other groups wearing white costumes and black hats are seen on both banks of the river. The focus is on the light structure of the pleasure boats and the sheer falls of the cliff opposite. The gentle greens of the foreground foliage, the pink flushes of the azaleas on the cliff, and the branches of peach blossom near the house at the right, all suggest that it is a warm spring day. The delightful atmosphere is borne out by the title, which reads *Pipes and drums in mid-stream; lakes and rivers bearing gaiety*. This is followed by Kim Sŏk-sin's signature, *Ch'owŏn*, and one relief seal, *Kunik*. RW/YSP

Published Richō 1977, pl.133; Yi Dong-ju 1981b, pp.225f; Ahn Hwi-joon 1982b, pl.85

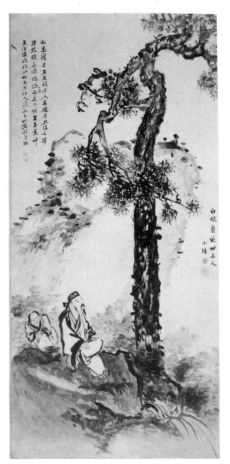

254

254 Yi Chae-gwan
(AD 1783–1837)

Hermit under a pine tree

Hanging scroll, ink and light colours on paper.
H 138.0 cm; W 66.2 cm
National Museum of Korea, Seoul

The long inscription at the left praises the 'bone' quality of Yi Chae-gwan's painting. The writer says that if he were to be asked by Sodang (Yi Chae-gwan) to paint this, he would merely paint the forms: an old pine, a strange rock, an eccentric figure, no more. But Sodang's pine is emaciated bone, his stone wayward bone, his man arrogant bone, capturing the spirit of his subjects. And indeed Yi Chae-gwan's rock is so wayward that in reproduction at least it almost disappears, merging with the branches of the pine.

The composition has been compared to the work of Yi Yin-sang (Ahn Hwi-joon 1982b, pl. 121); however, the subject only is comparable and not the treatment. Much closer in composition and style, as well as in subject-matter, are some of Kim Hong-do's paintings (cf. Korea University 1971, p. 56). The figure also, with its narrow features and sharply defined folds, is close to Kim Hong-do's figure style. Like Kim Hong-do, Yi Chae-gwan held a post in the Painting Bureau, but painted in literati style. He was a student of Ch'usa (Kim Chŏng-hŭi, cf. no. 256).

The painting bears on the right the title phrase, *Gazing with disdain on the rest of the world*, fol-lowed by the artist's signature *Sodang* and two of his seals, *Ch'agun sanbang*, *Hermitage of This Gentleman* (intaglio) and *Sodang* (relief). RW/YSP

Published Richŏ 1977, pl. 27; Ahn Hwi-joon 1982b, pl. 151

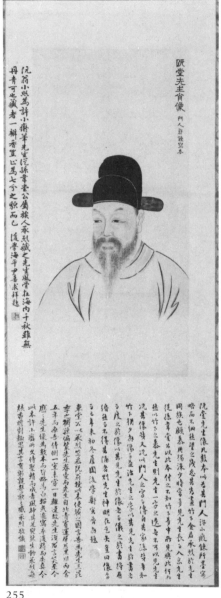

255

255 Hŏ Yu (AD 1809–92)

Portrait of Kim Chŏng-hŭi (Ch'usa)

Hanging scroll, ink and light colours on paper.
H 51.9 cm; W 24.7 cm
Hoam Art Museum, Yongin

This is one of several portraits of Kim Chŏng-hŭi, also known as Ch'usa and as Wandang, who was Korea's most eminent calligrapher. One of his masterpieces, combining painting and calligraphy in his own highly original style is shown in the next item. His considerable influence on Korean literati painting has been discussed by Yi Dong-ju (1973).

Kim Chŏng-hŭi obtained the *chinsa* degree in 1809, and visited Peking in the same year with his father. There he met and was encouraged by the great scholar and collector Weng Fanggang (AD 1733–1818), and his son. From them and from other Qing dynasty connoisseurs and collectors, Kim Chŏng-hŭi must have acquired his love of epigraphy, and the knowledge of calligraphy and of painting, which is evident in his own paintings (see no. 256).

The portrait is titled *Portrait of Master Wandang, by his disciple Hŏ Ryŏn* [Hŏ Yu] in the upper right. The inscription on the left is by the sinologist Yun Hŭi-gu (AD 1867–1926). Of the two inscriptions at the bottom, the one on the right is by Chŏng Yin-bo (AD 1892–?), one of the most distinguished scholars of Korean studies in this century, and father of Chung Yang-mo, the present Chief Curator of the National Museum of Korea, Seoul. That on the left is by Kim Chŏng-hŭi's descendant Kim Sŭng-yŏl.

Hŏ Yu's sketch for the portrait, which is also still extant, has been described as follows by Yi Dong-ju (1973, p. 72):

> This is a portrait of Wan-dang in his declining years. By the effective use of delicate lines and well-fleshed touches in accordance with the traditional method of portraiture, Hŏh Soh-ch'i could represent a generous face wearing 'pheonix's eyes' (an attribute of the aristocrat according to Chinese physiognomy) and the beautiful gray beard and whiskers. At a casual glance, the wide space between his two eyebrows, large and thick earlobe, which maintain a good harmony with his refined presence, seem to convey the impression that such a generous and moderate look cannot have belonged to such a fastidious person, and therefore he might have passed through a comfortable life. However, inscrutable is the nature of man, for our inferences as to the disposition of Wan-dang are contrary to the fact.

From 1840, Kim Chŏng-hŭi spent nine years in exile on Cheju island, and a further year in the north from 1851. In painting and calligraphy, however, this was his most productive period.

RW

Published Hoam 1982, pl. 233; Yi Dong-ju 1981b, p. 240

256 Kim Chŏng-hŭi
(AD 1786–1857)

Orchid, nan

Album leaf, ink on paper
H 55.0 cm; W 30.6 cm
Son Seki Collection

This painting is a masterpiece combining calligraphy and painting into a single creation. The trembling leaves of the *nan* break all the rules of brushwork, yet arrive at its essential spirit. Ch'usa (Kim Chŏng-hŭi) himself wrote that *nan* could only be painted after acquiring a literary mind; to paint it, all methods of painting must be forgotten. Painting by the book, one might waste a thousand sheets of paper in vain. He was even critical of his pupil Cho Hŭi-ryong (nos 258–9), unable to transcend method in his painting and so unable to reach the inmost spirit of his subject (Choi Wan-su 1976, pp 35–6).

The inscriptions, which have not been fully translated before, are presented here in the sequence in which they were written by the artist.

The first begins in the top left corner, continuing in short columns from left to right across the top of the painting:

For twenty years I have not painted *nan*
[orchid].
Now by chance I have brought out its heavenly
nature.
Shutting one's door, searching and seeking
constantly
This is Vimalakirti's Chan of non-duality.

Should there be someone who forcibly wanted to define it, then Master Vi[malakirti] would have no words to answer him.
Manhyang (with relief seal *Ch'usa*).

Filling the space in the lower left corner is a second inscription, beginning near the flower, with the irregular intaglio seal *Mukjang* (Ink Cottage):

If I start to let my brush go the result can only be one and not two. Sŏngak noin [Aged Guest of Immortals].

As a footnote he adds in a column of smaller characters:

O So-san saw [this] and was seized with a fit of laughter.

The relief seal reads *Nagu ch'ŏnhasa* (Scholar who delights in the world) and the intaglio one *Kim Chong-hui in*.

The last inscription is in small characters reading in columns from right to left:

I have painted this in the strange *ch'oye* writing style. But who today will understand or appreciate it? Kugyŏng again inscribed (with intaglio seal *Koyŏnje*).

The analogy of the sudden intuition or enlightenment of Chan Buddhism (Korean Sŏn, Japanese Zen), was often used in painting. Asked to define non-duality, the rich Indian layman Vimalakirti remained silent, to be praised by the Bodhisattva Manjusri: 'Well done, well done, ultimately not to have any letters or words, this is indeed to enter into the doctrine of non-duality'. Ch'usa's opening line 'For twenty years I have not painted *nan*' may be literally true, or may contain its opposite: after painting *nan* [without success] for twenty years, only now, in this work that defies explanation, has he finally succeeded.

Ch'usa's calligraphy, which no doubt owes as much to Chinese individualist or eccentric painters such as Shitao, Zhu Da and Zheng Xie as it does directly to Chan Buddhism, is indeed a mixture of the formal *ye* (*li* or clerical script of the Han dynasty) with *ch'o* (*cao*, draft or 'grass' script) with characters of irregular size and strongly contrasted thick and thin strokes, written directly without any attempt to hide the traces of the brush tip as in more conventional styles.

Two or three more of Ch'usa's seals are associated with the orchid, near the base of the stems (intaglio, *Yon ? je*) and possibly also the two half-seals in the lower right corner. The remainder of

256

the seals on the right side are said to be those of Japanese collectors. On the left one small gourd-shaped relief seal reads 'Divine class'. RW

Published Richō 1977, pl. 22; Choi Suni 1978 pl. 111; San Francisco 1979, no. 240; Bae 1982, no. 83; Choi Sunu 1979, pl. 319

257 King Chŏngjo
(AD 1752–1800)

Plantain tree and rock

Hanging scroll, ink on paper. H 84.6 cm; W 51.1 cm
Dongkuk University Museum; Treasure no. 743

King Chŏngjo (reigned AD 1776–1800) was the twenty-second king of the Chosŏn dynasty, the grandson of King Yŏngjo. He was active in the promotion of academic studies, establishing a Royal Library, Kyujanggak, now in Seoul National University. His reign thus represents a time of cultural renaissance, and he himself was a calligrapher and painter.

The painting, in typical *muninhwa* or literary men's style, is an ink play composed of broad ink washes and nervous finer lines. Rock and plantain or banana achieve a stable balance. The painting bears two large and well-cut seals of the king, *Hongje* (intaglio) and *Mangi* (relief). RW/YSP

Published Choi Sunu 1978, pl. 67; San Francisco 1979, no. 234

257

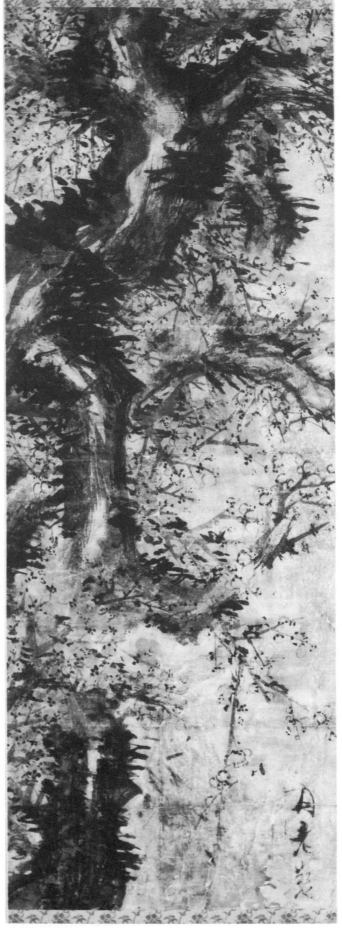

258

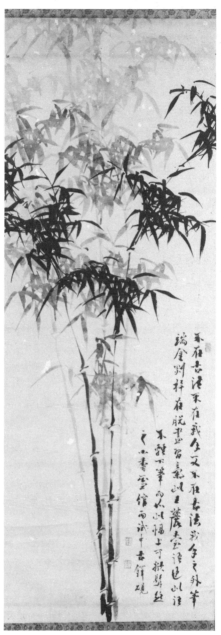

259

new shoots are borne on aged branches and trunks, so that a variety of textures challenge the endless capabilities of brush and ink. This painting falls clearly into the category of 'Aged Plum,' as the massive, even top-heavy, trunk fills the left side of the picture from bottom to top, overlaid by dense black strokes to show the peeling bark.

Cho Hŭi-ryong is said to have painted plum trees on all the walls of his studio. In the lower right corner is the signature *Tanno*, this being one of his names. RW

Published Yu Pok-yol 1969, p.718

258 Cho Hŭi-ryong
(AD 1797–1859)

Plum Blossom

Hanging scroll, ink and light colours on paper.
H 113.5 cm; W 41.2 cm
Korea University Museum

Plum blossom, like bamboo, was one of the favoured subjects for the scholar-painter in China and Korea. The time for *maehwa* or plum flowers is at the end of winter, and so it is the first flower to bring a touch of colour to the year, often while snow is still on the ground. Smooth

259 Cho Hŭi-ryong
(AD 1797–1859)

Bamboo

Hanging scroll ink on paper. H 27.0 cm;
W 44.8 cm
National Museum of Korea, Seoul

The painting bears an inscription by the artist as follows:

'Not through ancient method, not in my hand, Nor outside ancient method, nor out of my hand, For the brush point to be like a diamond pillar, one must completely remove any common habit'. These are the words of Wang Lutai [Wang Yuanqi, 1642–1715]. This means that one should not lightly take brush [to paper]. But as far as this painting is concerned, this is simply written as a joke [literally: to shake the beard]. In the So-hyangsŏl-gwan [Little Fragrant Snow Hall], trying out an old bell-shaped inkstone.

Cho Hŭi-ryong's meaning is that he does not claim that his own painting matches the standards set by the Qing master Wang Yuanqi; he is simply being modest. His robust calligraphy, close to that of his teacher Kim Chŏng-hŭi (see no.256), is a foil for the delicate ink washes of the bamboo.

The inscription is followed by three intaglio seals: *Mugyŏn* (Source of Ink); *Yangyŏn sanbang* (Hermitage to Nourish the Spirit); and *Ilso sŏksil* (One Flute Stone Shelter). Like his teacher, Cho Hŭi-ryong had a great number of seals (cf. Sŏhwaga 1978, pp.77–80) RW/YSP

Published Seoul 1977, no.145; Kwon Yong-pil 1983

260 Kim Su-ch'ŏl
(mid-19th century AD)

Flowers

Pair of hanging scrolls, ink and light colours on paper. H 27.9 cm; W 29.1 cm
National Museum of Korea, Seoul

This pair of scrolls, with a scattering of gold and silver leaf flakes on the surface of the paper, tends towards the decorative. Kim Su-ch'ŏl specialised in flowers, and was also known for landscape. Here the flowers, peonies on the right and mallow or hibiscus on the left, grow from the rocks at the sides of the scrolls. In this style of painting, light colour washes play a more important part than ink outlines.

The left scroll bears the artist's signature, *Puksan*, with two relief seals, *Kim Su-ch'ol yin* and *Saik*. RW/YSP

Published Richō 1977, pls 143–4; Choi Sunu 1978, pl.110

260

261

262

263 Chang Sŭng-ŏp
(AD 1843–97)

Landscapes, dated AD 1890

Pair of hanging scrolls, ink and light colours
on silk. H 136.5 cm; W 32.5 cm
Kansong Museum of Fine Arts

In both composition and brush style, this pair of
hanging scrolls from a set of eight reveal the
direct influence of the Orthodox school of Chin-
ese painting, which in the seventeenth century
had examined the works of Song and Yuan
dynasty masters, and had produced new ver-
sions of their brush manners, using particular
brush-strokes and motifs to render each of them.
The compositions, which rise from the fore-
ground through successive stages to distant and
high peaks, within a narrow format, are also
those of the mainstream followers of the Ortho-
dox school, such as the pupils of Wang Hui (AD
1632–1717). Chang Sŭng-ŏp also painted
figure-paintings in the manner of the late Ming
master Chen Hongshou (AD 1599–1652).

The title written on one of the paintings shows
that the subject, as well as the composition and
the brush style, is Chinese: it reads *Returning
Home*, a reference to the famous poem by the
poet Tao Yuanming. Following it is the date,
corresponding to AD 1890. The title of the second
painting reads: 'After Huang lao Shanqiao's
Wind in the Pines and Running Waters. Owŏn'
The reference is to the famous Yuan painter
Wang Meng (AD c. 1308–1385), whose densely
filled landscapes and noble pines are echoed
in the composition. Both paintings are signed
Owŏn, Chang Sŭng-ŏp's studio name, and
followed by two seals with the artist's name.

RW

Published Richō 1977, pl. 150;
Ahn Hwi-joon 1982b, pl. 194, p. 201

261–2 Hong Se-sŏp
(AD 1832–84)

Swimming ducks, Cormorants

Hanging scrolls, ink on paper. H 119.5 cm;
W 48.0 cm
National Museum of Korea, Seoul

These two paintings are from a set of eight
panels of a folding screen. A third panel was
shown in 1977 at the exhibition of paintings
shown for the first time to the public (Seoul
1977, pl. 167). A similar but narrower pair
of bird paintings is in the Hoam Art Museum
(Hoam 1982, pl. 225).

In all of these paintings of birds Hong Se-sŏp,
who came from a scholar family, seems to have
discovered an original and exciting theme and
compositional scheme. Each panel has two birds
in an abbreviated landscape setting. Both the
brushwork and the composition are extremely
bold and innovative, and seem to recapture cer-
tain essentially Korean themes seen afresh. The
pair of ducks recall the boldness of the designs
on the *punch'ŏng* ceramics, in the way that the
lines of the ripples spreading in their wake
merge with the pine branches from the right,
and the filling of the whole surface with the
design. The two cormorants stand on a shelving
rocky shore, just out of reach of the foaming
crests of a wild sea. The three pillars are the
basalt pillars that were a feature of Chŏng Sŏn's
depictions of actual places on the eastern coast
(cf. no. 231). RW/YSP

Published Richō 1977, pl. 30;
San Francisco 1979, no. 249;
Ahn Hwi-joon 1980a, pls 138–9

264 Anonymous
Portrait of Taewŏngun,
Yi Ha-ŭng (AD 1820–98)

Hanging scroll, ink and colours on silk.
H 132.1 cm; W 67.6 cm
National Museum of Korea, Seoul

Yi Ha-ŭng was a key figure in the political scene
in the second half of the nineteenth century. As
the father of King Kojong (reigned AD 1863–
1907), and as Prince Regent, he exerted formid-
able power. Despite his early reforms which
helped to rid the country of factionalism, he was
instrumental in operating the 'closed door'
policy towards Western contacts, so that his

263

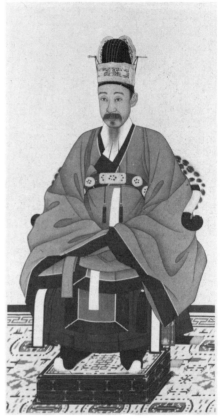

264

later actions delayed modernisation in Korea.

The eminence of the subject is reflected in the technical brilliance of the painting. The sitter is seated facing slightly to one side wearing a *yanggwan* official head-dress with five *yang* (vertical lines) to denote the highest rank. His hands are hidden in the voluminous folds of his robe. His feet rest on a separate footstool, which has a matting top-surface woven to form the 'double happiness' character between his feet. The floor of the room is also made of matting woven in elaborate decorative patterns. RW/YSP

Published Seoul 1979, pl.62

265 Anonymous
(18th century AD)

Crane and pine tree

Hanging scroll, ink and colour on paper.
H 167.5 cm; w 86.0 cm
Hoam Art Museum, Yongin

Cranes and pine trees, both renowned for their
long life, were part of the popular imagery
in Korea, constantly appearing as decorative
themes on ceramics, lacquer and furniture as
well as in the colourful folk paintings or
minhwa, which have been rediscovered in
recent years, but which do not form part of the
history of painting as a fine art, since they were
created in a popular context and were not
intended to last. This painting, frankly decora-
tive in its bright colours and meticulous atten-
tion to detailed technique, must have been
intended as an elegant birthday present in a rich
household. RW

Published Hoam 1982, pl. 220

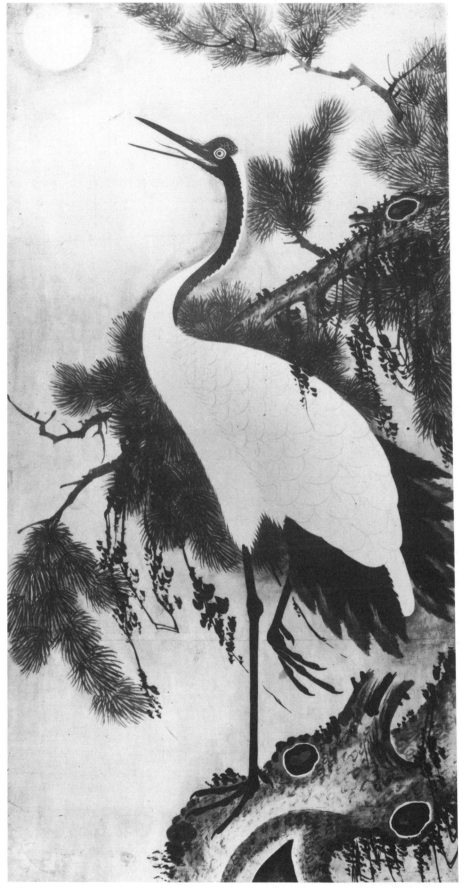

265

Glossary

Abiji	阿非知	architect from Paekche
am-maksae	암 막 새	female end-tile
Anap-chi	雁鴨池	Lake of Wild Geese and Ducks
An Kyŏn	安堅	painter (AD 1418–?); no.221
An P'yŏng	安平	prince and collector (AD 1418–53); no.221
banga-sayu	半跏思惟	posture of Maitreya
cha	字	personal name
Chajang	慈藏	Silla priest, mid-7th century AD
changgun	강군	rice-bale shaped bottle; nos 181, 201
Chang Sŭng-ŏp	張承業	painter (AD 1843–97); no.263
chang'yuk-sang	丈六像	sixteen-foot image
Ch'ilburam	七佛庵	temple name
ch'imi	鴟尾	'owl's tail' ridge finial
chingol	真骨	'true bone' in kolp'um system
chingyŏng sansu	真景山水	real landscape
chinsach'ae ch'ŏngja	辰砂彩青磁	celadon with underglaze copper-red
Chinul	知訥	Koryŏ priest (AD 1158–1210)
Chogye-jong	曹溪宗	Korean Meditation School
Cho Hŭi-ryong, Tanno	趙熙龍	painter (AD 1797–1859); nos 258–9
chŏksŏk mokgwak bun	積石木槨墳	tomb with wooden chamber covered with stones and earth
ch'ŏlhoe ch'ŏngja	鐵繪青磁	celadon with underglaze iron decoration
ch'ŏlhwa	鐵畫	decoration painted in iron oxide; no.179
Ch'ŏmsŏng-dae	瞻星臺	Terrace for the Contemplation of the Stars
ch'ŏnin (bich'ŏn)	天人 飛天	apsaras, flying celestial figure
Chŏngjo	正祖	Chosŏn king (AD 1752–1800); no257
Chŏngnim-sa	定林寺	temple name
Ch'ŏng Sŏn, Kyŏmjae	鄭敾謙齋	painter (AD 1679–1759); nos229ff
Chŏngt'o-jong	淨土宗	Pure Land School
Ch'ŏnmach'ong	天馬塚	Tomb of the Heavenly Horse
Ch'ŏntae-jong	天台宗	Tiantai School
Chosŏn	朝鮮	morning freshness; Korea Chosŏn dynasty
Chosŏn wangjo sillok	朝鮮王朝實錄	Annals of the Chosŏn Dynasty
chusim	柱心	main columns
gongp'o (pojak)	貢包 包作	bracket system
gŭn	斤	weight measure, approx. ½ kg.
Hae'in-sa	海印寺	Temple of the Ocean Symbol
Hanguk	韓國	State of the Han; Korea
Han'gŭl	한글	Korean script
ho	號	studio name
Hong Se-sŏp	洪世燮	painter (AD 1832–84); nos261–2
horang'i	호랑이	tigers
Hŏ Yu	許維	painter (AD 1809–92); no.255
Hunmin chŏng'ŭm	訓民正音	Correct Sounds for the Instruction of the People
hwagum ch'ŏngja	畫金青磁	celadon with gold decoration
Hwangryong-sa	皇龍寺	Temple of the Imperial Dragon (Kyŏngju)
Hwangnam daech'ong	皇南大塚	Hwangnam Great Tomb
Hwaŏm-gyŏng	華嚴經	Avataṁsaka sutra or Garland Sutra; no.219
hwarang	花郎	flower squires (Silla)
hyangga	鄉歌	native songs
Hyech'o	慧超	Silla priest (AD 704–87)
idu	吏讀	writing system with Chinese characters
ilgwang samjon-bul	一光三尊佛	triple image with one mandorla; no.26
Imhae-jŏn	臨海殿	Hall by the Sea (Anap-chi detached palace)
inhwa	印花	stamped decoration; no.173
Inwang-gyŏng	仁王經	Sutra of the benevolent king
Iryŏn	一然	Koryŏ priest (AD 1206–89), author of Samguk yusa
Kamsan-sa	甘山寺	temple name
Kamŭn-sa	感恩寺	temple name
kangdang	講堂	Lecture Hall
Kang Hŭi-an, Inje	姜希顏仁齋	painter (AD 1419–64); no.222
Kang Se-hwang, P'yoam	姜世晃豹庵	painter (AD 1713–91); nos229, 236
kasa	歌辭	lyrical poems
Kaya	伽倻	kingdom (AD 42–562); nos 37–43
kayagŭm	가야금	twelve-stringed zither
kidan	基壇	raised terrace for building
Kim Chŏng-hŭi, Ch'usa	金正喜秋史	painter (AD 1786–1857); nos255–6
Kim Hong-do, Tanwŏn	金弘道檀園	painter (AD 1745–after 1814); nos247ff
Kim Myŏng-guk, Yŏndam	金明國蓮潭	painter (AD 1600–after 1662); nos227–8
Kim Pu-sik	金富軾	Koryŏ scholar-official, compiler of Samguk sagi
Kim Sŏk-sin	金碩臣	painter (AD 1758–?); nos252–3
Kim Su-ch'ŏl, Saik	金秀哲 士益	painter (mid-19th century AD); no.260
Kim Taesŏng	金大成	minister (AD 700–74)
Kim Tu-ryang	金斗樑	painter (AD 1696–1763); no.243
Kim Yusin	金庾信	general (AD 595–673)
kisaeng	妓生	courtesans
kogok	曲玉	curved jade; no.52
Koguryŏ	高句麗	kingdom (37 BC–AD 668)
Kolgul-am	骨窟庵	temple name
kolp'um	骨品	'bone lineage' of Silla
kongsin	功臣	merit subject
kopsae kiwa	곱새 기와	ridge-end tile; no.102c
Koryŏ	高麗	dynasty (AD 918–1392)
Koryŏ-sa	高麗史	History of the Koryŏ dynasty
Koryŏ taejang-gyŏng	高麗大藏經	Koryŏ edition of entire Buddhist canon
kukhak	國學	state university (in Three Kingdoms)
Kulbul-sa	掘佛寺	Temple of the Sculptured Buddha
kŭmdang	金堂	Golden Hall
Kŭmgangsan	金剛山	Diamond Mountains
Kŭmsŏng	金城	Golden Fortress (former name of Kyŏngju)
kut	굿	shaman ceremony
kwangbae	光背	mandorla; no.26
Kwanggaet'o	廣開土	Koguryŏ king (d. AD 413)
kwimyŏn	鬼面	demon-mask; no.18
kwiyal	귀얄	broad brush for applying slip; no.179

kyŏngdang	經堂	private Confucian schools
Kyongguk taejŏn	經國大典	compilation of Chosŏn laws, AD 1470
Kyŏngju	慶州	capital of Silla
maebyŏng	梅瓶	'plum vase'
Milgyo	蜜教	Esoteric Buddhism
Mirŭk-sa	弥勒寺	Maitreya temple
mosŏri am-maksae	모서리 암 막새	corner or edge female tile; no.104
mudang	무당	shaman
muninhwa	文人畫	literary men's painting
Munyŏng	武寧	King of Paekche (AD 501–23); nos 29–36
naesŏm	内贍	Royal Household office in Chosŏn
Nangnang (Naknang)	樂浪	Chinese colony of Lelang
ogye	五戒	five commandments of Silla *hwarang*
Paegyul-sa	栢栗寺	temple name
Paekche	百濟	kingdom (18 BC–AD 660)
paekja	白磁	white porcelain
paekt'o	白土	slip applied by dipping
pagji	剝地	areas of slip pared away; nos 176–7
Palhae	渤海	state in northern Korea
pisaek-ch'ŏngja	秘色青磁	secret colour ware; no.148
Pŏbju-sa	法住寺	temple name
Pongdŏk-sa	奉德寺	temple name
pŏphoe	法會	dharma meeting
Pŏpsang-jong	法相宗	Dharmalaksana School
Pŏpsŏng-jong	法性宗	School of Absolute Being
Pori-sa	普提寺	temple name
posanghwa	寶相華	'precious visage' floral designs; nos 105–6
P'osŏk-jŏng	鮑石亭	Pavilion of the Abalone-shaped stones
Puin-sa	符仁寺	temple name
Pukhan-san	北漢山	mountain north of Seoul
Pulguk-sa	佛國寺	Temple of the Buddha Land
pulgyo	佛教	Buddhism
punch'ŏng	粉青	'powder green'; nos 173ff
pungdang	朋黨	factions in Chosŏn dynasty
Punhwang-sa	芬皇寺	Fragrant Imperial Temple
punjang hoech'ŏng sagi	粉粧灰青砂器	powdered grey-green pottery
Pusŏk-sa	浮石寺	temple name
Puyŏ	扶餘	capital of Paekche
pyŏlgung	別宮	detached palace
P'yŏngyang	平壤	capital of Koguryŏ
Pyŏn Sang-byŏk	卞相璧	painter (18th century AD); no.244
Sach'ŏnwang-sa	四天王寺	Temple of the Four Heavenly Kings
sahwa	士禍	literati purges in Chosŏn
Samguk sagi	三國史記	Historical Records of the Three Kingdoms
Samguk yusa	三國遺事	Reminiscences of the Three Kingdoms
Samnon-jong	三論宗	School of Three Treatises
sanggam	象嵌	inlay (designed filled with slip); nos 150ff
Sa'ong-wŏn	司饔院	office in charge of kitchen vessels in Chosŏn period
sibi-ji	十二支	twelve zodiacal signs
sijo	시조	three-line poems
silhak	實學	practical learning
Silla	新羅	kingdom (57 BC–AD 935)
Sim Sa-jŏng, Hyŏnjae	沈師正玄齋	painter (AD 1707–66); no.235
Sinsŏn-am	神仙庵	temple name
Sin Yun-bok, Haewŏn	申潤福蕙園	painter (mid-18th century AD); nos 245–6
sipch'ŏn-gan	十天干	ten celestial stems
sip-hyunyo	十訓要	Ten Admonitions of Wang Kŏn
sŏkkarae-maksae	석가래 막새	plaques for the ends of beams
Sŏkkuram	石窟庵	granite shrine on Mt T'oham
sŏkt'ab	石塔	stone pagoda
Sŏngdŏk	聖德	Silla king (reigned AD 702–36); no.129
sŏnggol	聖骨	'sage bone' in *kolp'um* system
sŏnhwa (chohwa)	線畫 雕畫	incised linear decoration; no.175
Sŏn-jong	禪宗	Meditation School (Chan, Zen)
sŏwŏn	書院	Confucian academy of Chosŏn
sud-maksae	슷 막새	male end-tile
t'ab	塔	pagoda
t'aehak	太學	state university (in Koguryŏ)
tang (chŏn)	堂 殿	hall
T'oham-san	吐含山	mountain near Kyŏngju
Tonggu (Tong'gou)	通講	northern capital of Koguryŏ
Tongguk yŏji sŭngnam	東國輿地勝覽	Geographical survey of Korea, AD 1481
Ŭich'ŏn	義天	Koryŏ priest (AD 1055–1101)
Ŭisang	義湘	Silla priest (AD 625–702)
Ungjin	熊津	capital of Paekche (AD 475–538)
Wang Kŏn	王建	founder of Koryŏ
Wang-o ch'ŏnch'uk kukjŏn	往五天竺國傳	Travels to Five Indian Countries, by Hyech'o
Wŏn'gwang	圓光	Silla priest (d. AD 630)
Wŏnhyo	元曉	priest (AD 617–86)
yangban	양반	two classes (military and civil)
Yi Ch'ae	李采	official (AD 1745–1820); no.239
Yi Chae, Toam	李縡 陶庵	scholar (AD 1680–1746); no.238
Yi Chae-gwan, Sodang	李在覺 小塘	painter (AD 1783–1837); no.254
Yi Chŏng, T'anŭn	李霆 灘隱	painter (AD 1541–after 1622); no.225
Yi Hang-bok	李恒福	official (AD 1556–1618); no.226
Yi Ha-ŭng	李昰應	Prince Regent (AD 1820–98); no.264
Yi In-mun, Munuk	李寅文 文郁	painter (AD 1745–1821); nos 241–2
Yi In-sang	李麟祥	painter (AD 1710–60); no.240
Yi Je-hyŏn, Ikje	李齊賢 益齋	painter (AD 1287–1367); no.220
Yi Kyŏng-yun	李慶胤	painter (AD 1545–?); nos 223–4
yŏksanggam	逆象嵌	reverse inlay (ground filled with slip); no.156
Yongjang-sa	茸長寺	temple name
yugyo, yuhak	儒教 儒學	Confucianism
yukdup'um	六頭品	six ranks of Silla
Yun Du-sŏ	尹斗緖	painter (AD 1668–1715); no.237
Yusik-jong	唯識宗	Dharmalakṣaṇa School

Bibliography

AHN HWI-JOON 1974. *Korean Landscape Painting in the Early Yi Period: The Kuo Hsi Tradition*. Inaugural dissertation, Harvard University, Harvard.

AHN HWI-JOON 1977a. 'Korai oyobi Richō shoki ni okeru Chugokuga no ryunryu' (The Influence of Chinese Painting in the Koryŏ and Early Yi Dynasties), *Yamato Bunka*, 62, pp. 1–17.

AHN HWI-JOON 1977b. 'A study on Korean Painting of the Che School Style', *Misul Charyo*, 20, pp. 24–62.

AHN HWI-JOON 1978. 'On the Eight Views of the Four Seasons attributed to An Kyŏn' (in Korean), *Kogo misul*, 136–9, pp. 72–8.

AHN HWI-JOON 1980a. *Hanguk hoehwa sa* (History of Korean Painting). Seoul.

AHN HWI-JOON 1980b. 'An Kyŏn and "A Dream Visit to the Peach Blossom Land"', *Oriental Art*, vol. XXVI, no. 1, pp. 59–71.

AHN HWI-JOON 1980c. 'Development of Korean Landscape Painting' (in Korean), *Misul Charyo*, 26, pp. 12–38.

AHN HWI-JOON 1982a. *Sansu hwa* (Landscape painting), vol. 1. *Hanguk ŭi mi*, vol. 11. Seoul.

AHN HWI-JOON 1982b. *Sansu hwa* (Landscape painting), vol. 2. *Hanguk ŭi mi*, vol. 12. Seoul.

AHN HWI-JOON 1982c. 'Koryŏ mit Chosŏnwangjo ŭi munin kehoe hwa' (Literati Gatherings and their pictorial representation in the Koryŏ and Chosŏn Dynasties), *Komunhwa*, 20, p. 3

AHN HWI-JOON 1982d. 'Chinese Influence on Korean Landscape Painting of the Yi Dynasty'. International Symposium on the Conservation and Restoration of Cultural Property – Interregional Influences in East Asian Art History – Tokyo.

AKABOSHI and NAKAMARU 1975. Goro Akaboshi and Haiichiro Nakamaru, *Five Centuries of Korean Ceramics*. New York–Tokyo–Kyoto.

ANAP-CHI 1978. Munhwajae kwalliguk (ed.), *Anap-chi palgul chosa pogosŏ* (Report on the excavation of Anap-chi). Seoul.

ATAKA 1980. *Masterpieces of Chinese and Korean Ceramics in the Ataka Collection*. Tokyo.

BAE 1982. Soon-taek Choi-Bae, *Kalligraphie und Kunsttheorie des Kim Chonghŭi (1776–1857)*. Inaugural dissertation, University of Köln, Köln.

BOSTON 1957. *Masterpieces of Korean Art*. Exhibition Catalogue, Museum of Fine Arts, Boston.

BRINKER and GOEPPER 1981. Helmut Brinker and Roger Goepper, *Kunstschätze aus China*. Exhibition Catalogue, Zürich.

CH'EN 1964. K. K. S. Ch'en, *Buddhism in China, A Historical Survey*, Princeton.

CHIN HONG-SOP 1975. *Kyŏngju ŭi kojŏk* (Historical sites in Kyŏngju). Seoul.

CHIN HONG-SOP 1978a. *T'ogi, t'ou, wajŏn* (Pottery, figurines, tiles), *Hanguk misul chŏnjip*, vol. 3. Seoul, 2nd edn.

CHIN HONG-SOP 1978b. *Kŭmsok kongye* (Metalwork), *Hanguk misul chŏnjip*, vol. 8. Seoul, 2nd edn.

CHO HUNGYOU 1982. *Koreanischer Schamanismus: Eine Einführung*. Hamburg.

CHOI SUNU 1960. 'Two Early Yi Porcelains with Inscription' (in Korean), *Misul Charyo* 1, pp. 15ff.

CHOI SUNU 1963. 'Inlaid White Porcelains found in the Tomb of the Lady Chung of Chin-yang' (in Korean), *Misul Charyo* 8, pp. 23–6.

CHOI SUNU 1971. 'Kang Pyo Am, Painter' (in Korean), *Ko misul* 110, pp. 8–10.

CHOI SUNU 1975. *Koryŏ ch'ŏngja* (Koryŏ celadon), *Hanguk misul chŏnjip*, vol. 9. Seoul.

CHOI SUNU 1978. *Hoehwa* (Painting), *Hanguk misul chŏnjip*, vol. 12. Seoul.

CHOI SUNU 1979. *Five Thousand Years of Korean Art*. Seoul.

CHOI WAN-SU 1976a. *Kim Ch'u-sa yŏnguch'o* (Study on Kim Ch'u-sa). Seoul

CHOI WAN-SU 1976b. *Ch'u-sa myŏngp'umch'ŏp* (Famous Albums of Ch'usa). Seoul.

CHOI WAN-SU 1982. *Kyŏmjae myŏng pum* (Famous works of Kyŏmjae [Chŏng Sŏn]). Seoul.

CHOI YONG-HI 1976. 'Chŏngsŏn ui Tongnae Pusa chŏp woesa-do' (The reception of the Governor of Tongnae for Japanese Diplomatic Representatives, painted by Chŏng Sŏn), *Kogo misul*, 129–30 pp. 168–74.

CH'ŎNMA-CH'ONG 1974. Munhwajae kwalliguk, *Ch'ŏnma-ch'ong palgul chosa pogosŏ* (Report of the excavation of the Tomb of the Heavenly Horse). Seoul.

CHONG YONGHO 1982. *Sŏkt'ab* (Stone Pagodas), *Hanguk ŭi mi*, vol. 9. Seoul.

CHŌSEN 1980. *Chōsen bijutsu hakubutsukan* (The Chosŏn Art Museum [P'yŏngyang]). Tokyo.

CHUNG YANG-MO 1978. *Yijo doja* (Chosŏn dynasty ceramics), *Hanguk misul chŏnjip*, vol. 10. Seoul, 2nd edn.

CHUNG YANG-MO 1982. *Punch'ŏng sagi* (Punch'ŏng ceramics), *Hanguk ŭi mi*, vol. 9. Seoul, revised edn.

CHUNG YANG-MO 1983. *Paekja* (White porcelain), *Hanguk ŭi mi*, vol. 2. Seoul, revised edn.

COX 1973. Susan Cox. 'An Unusual Album by a Korean Painter, Kang Se-whang', *Oriental Art* XIX, no. 2, pp. 157–68.

EWHA 1979. *Chosŏn sidae ŭi gŭrim* (The Paintings of the Chosŏn Dynasty). Exhibition Catalogue, Ewha Woman's University Museum.

FONTEIN 1967. Jan Fontein, *The Pilgrimage of Sudhana. Study of Gandhavyūha Illustrations in China, Japan and Java*. The Hague.

FORMAN 1962. Werner Forman and Jaroslav Barinka, *Alte Koreanische Kunst*. Prague.

GARDINER 1969. K. H. B. Gardiner. *The early history of Korea: the historical development of the peninsula up to the introduction of Buddhism in the fourth century AD*. Honolulu.

GOMPERTZ 1964a. G. St G. M. Gompertz, *Korean celadon and other wares of the Koryŏ period*. London.

GOMPERTZ 1964b. G. St G. M. Gompertz, 'A trip through Southern Korea', *Transactions of the Oriental Ceramic Society*, vol. 36 (1964–6) pp. 1–20.

GOMPERTZ 1968. G. St G. M. Gompertz, *Korean Pottery and Porcelain of the Yi Period*. London.

GREIFENHAGEN 1974. Adolf Greifenhagen, *Schmuck der Alten Welt*. Berlin.

GYLLENSVÄRD 1971. Bo Gyllensvärd, *Chinese Gold, Silver and Porcelain: The Kempe Collection*. The Asia Society, New York.

HAMADA and UMEHARA 1934. Kosaku Hamada and Sueji Umehara, *Study on the Ancient Tiles of the Silla Dynasty, Korea*. Report upon Archaeological Research in the Department of Literature, Kyōto Imperial University, vol. XIII (1933–4). Kyōto.

HAN BYONG-SAM 1978. *Kobun misul* (Ancient Tomb Art), *Hanguk misul chŏnjip*, vol. 2. Seoul, 2nd edn.

HAN BYONG-SAM 1981. *T'ogi* (Pottery), *Hanguk ŭi mi*, vol. 5. Seoul

HAN and KOH 1963. Han Inyong and Koh Chongkun, 'Gamma Radiography of the Ancient Arts', *Misul Charyo* 8, pp. 1–5.

HARADA 1951. Harada Yoshito, 'A Cut-glass Vessel excavated from the Tomb of Emperor Ankan (in Japanese), *Museum*, 5, pp. 29–30.

HASEBE 1977. Hasebe Gakuji, *Kōrai no seiji* (Koryŏ celadon), *Tōji taikei*, vol. 29. Tokyo.

HA TAEHUNG 1972. Ha Taehung and Grafton K. Mintz (translators), *Samguk Yusa, Legends and History of the Three Kingdoms of Ancient Korea*. Seoul.

HENTHORN 1971. William E. Henthorn, *A History of Korea*. New York.

HOAM 1982. *Hoam misulkwan myŏngp'um torok* (Masterpieces of the Hoam Art Museum). Yongin.

HONOLULU 1963. Center for East Asian Cultural Studies (ed), *A Short History of Korea*. Tokyo – Honolulu.

HWANGNAM DAECH'ONG [1975]. Munhwajae kwalliguk (ed), *Kyŏngju Hwangnam-dong 98 ho kobun palgul yak pogo* (Summary report on the excavation of Tomb no. 98 at Hwangnam, Kyŏngju). Seoul.

HWANGNAM DAECH'ONG 1976. Munhwajae kwalliguk (ed), *Kyŏngju Hwangnam-dong che 98 ho kobun (nambun) palgul yak pogo* (Summary report on the excavation of Tomb no 98 at Hwangnam, Kyŏngju, South Mound). Seoul.

HWANG O-GUN 1976. *Hanguk changsingu misul yŏngu* (Studies in Korean costume and ornaments). Seoul.

HWANG SU-YONG 1963. 'New National Treasure: Standing Gilt Bronze Buddha dated 7th year of Yŏn-ga' (in Korean), *Misul Charyo* 8, pp. 30–42.

HWANG SU-YONG 1968. 'A Gilt Bronze Standing Avalokiteśvara Discovered from Seoul' (in Korean), *Misul Charyo* 12, pp. 1–3.

HWANG SU-YONG 1972. 'Gilt Bronze Epitaph of Hwangryong-sa Nine-storey Wooden Pagoda, Silla Kingdom' (in Korean), *Kogo misul* 116, pp. 2–7.

HWANG SU-YONG 1973. *Hanguk pulsang ŭi yŏngu* (Studies in Korean Buddhist Images). Seoul.

HWANG SU-YONG 1974a. *Pulsang* (Buddhist Images), *Hanguk misul chŏnjip*, vol. 5. Seoul.

HWANG SU-YONG 1974b. *Shiragi no sekibutsu* (Stone Buddhas of Silla). Tokyo.

HWANG SU-YONG 1976. *Hanguk kŭmsŏk yumun* (Korean Inscriptions in Metal and Stone). Seoul, 2nd edn.

HWANG SU-YONG 1978. *Sŏkt'ab* (Stone Pagodas), *Hanguk misul chŏnjip*, vol. 6. Seoul, 2nd edn.

HWANG SU-YONG 1979. *Hanguk pulgyo misul, Pulsangp'yŏn* (Korean Buddhist Art, Images of Buddha), *Hanguk misul chŏnjip*. Seoul, 2nd edn.

HWANG SU-YONG 1983. *Pulsang* (Buddhist Images), *Hanguk ŭi mi*, vol. 10. Seoul, 3rd edn.

IM HYO-JAE 1983. 'Study of the dating of Palaeolithic culture in Korea according to Carbon-14 tests', in *Kim Chol-jun paksa hwagak kinyŏm sahak nonch'ong*. Seoul.

ITOH 1980. Itoh Ikutaro, *Masterpieces of Chinese and Korean Ceramics in the Ataka Collection: Korea, Koryŏ Dynasty*. Tokyo.

KAMŬN-SA 1961. Kim Chewon and Youn Moo-byong, *Kamŭn-sa: A Temple Site of the Silla Dynasty* (in Korean with an English summary). Special Report of the National Museum of Korea, vol. II. Seoul.

KANG WOO-BANG 1973. 'Analysis and Interpretation of the Silla-Twelve Animals' (in Korean), *Pulgyo Misul*, 1, pp. 75–115.

KANG WOO-BANG 1979. 'Syncretic phenomena in ancient Korean art between [the gods of] the Five Directions and the Four Guardians: Metamorphoses of Gods – in connection with [the] restoration of Four Guardians from the temple site, Sach'ŏnwang-sa' (in Korean), *Misul Charyo*, 25, pp. 1–46.

KANG WOO-BANG 1982. 'Gilt-bronze Pensive Image with the crown combined with the Sun and Moon – Study on the styles of the Three Kingdoms period . . .' (in Korean), *Misul Charyo*, 30 (1982) pp. 1–36 (pt 1), 31 (1982) pp. 1–21 (pt 2).

KANSONG 1972. 'Wan-dang [Kim Chŏng-hŭi]'s Calligraphy' (in Korean), *Kansong Munhwa* 2–3. Seoul.

KIM and GOMPERTZ 1961. Kim Chewon and G. St G. M. Gompertz, *Korean Arts II–Ceramics*. Seoul.

KIM and KIM 1966. Kim Chewon and Kim Won-yong, *The Arts of Korea*. London.

KIM and LEE 1974. Kim Chewon and Lena Kim-Lee, *Arts of Korea*. Tokyo.

KIM CHEWON 1959. 'Treasures from the Songnim-sa temple in southern Korea', *Artibus Asiae* XXII, nos 1–2, pp. 95–112.

KIM CHEWON 1964. 'Korea', in A. B. Griswold *et al, Burma, Korea, Tibet*. London.

KIM CHONG-BAE 1971. 'Bronze Artefacts in Korea and their Culture-Historical Significance'. Unpublished draft for the Conference on Traditional Korean Society and Culture (June 7 11).

KIM CHONG-KI 1980. *Kŏnch'uk* (Architecture), *Hanguk misul chŏnjip*, vol. 14. Seoul, 2nd edn.

KIM JEONG-HAK 1978. *The Prehistory of Korea*, ed. and trans. by Richard and Kazuo Pearson. Honolulu.

KIM KIUNG 1980. *Chōsen hanto no hekiga kofun* (Tombs with wall-paintings in the Korean peninsula). Tokyo.

KIM KYONG-HI 1980. *Hanguk misul chŏnghwa* (Masterpieces of Korean Art). Seoul.

KIM TAI-JIN 1976. *A Bibliographical Guide to Traditional Korean Sources*. Asiatic Research Center, Korea University, Korea University.

KIM WON-YONG 1958. *Studies on Silla Pottery*. Inaugural dissertation for New York University, New York.

KIM WON-YONG 1968. *Hanguk misul sa* (History of Korean Art). Seoul.

KIM WON-YONG 1971. 'On the Gold Crown said to be from Koryŏng' (in Korean). *Misul Charyo*, 15, pp. 1–6.

KIM WON-YONG 1973. *Hanguk kogohak kaesŏl* (Introduction to Korean Archaeology). Seoul.

KIM WON-YONG 1978a. *Wŏnsi misul* (Early Art), *Hanguk misul chŏnjip*, vol. 1. Seoul, 2nd edn.

KIM WON-YONG 1978b. *Pyŏkhwa* (Wall-painting), *Hanguk misul chŏnjip*, vol. 4. Seoul, 2nd edn.

KIM WON-YONG 1982. *Hanguk komisul ŭi ihae* (Introduction to Ancient Korean Art). Seoul.

KODANSHA 1976. *National Museum of Korea*. Oriental Ceramics, The World's Great Collections, vol. 2. Tokyo.

KO YU-SŎP (compiler) 1965. *Chosŏn hwaron chipsŏng* (Collection of Korean writings on painting). Seoul (reprint).

KŌRAI BUTSUGA 1981. Kikutake Jun'ichi and Yoshida Hiroshi (eds), *Kōrai Butsuga* (Koryŏ Buddhist Painting). Tokyo.

KOREA UNIVERSITY 1971. *Guide to Korea University Museum*. Seoul.

KWON YONG-PIL 1983. *Die Entstehung der 'koreanischen' Bambusmalerei in der Mitte der Yi-Dynastie (1392–1910) – Ihre gedankliche Begründung und Stilfragen*. Inaugural dissertation for University of Köln, Köln.

KYŎMJAE 1981. *Kyŏmjae Chŏng Sŏn, Hanguk ŭi mi* vol. 1. Seoul, 2nd edn.

KYŎNGJU n.d. *Catalogue of the Kyŏngju National Museum* [1974]. Kyŏngju.

KYŌTO 1976. *Kankoku bijutsu gosen-nen ten* (Five Thousand Years of Korean Art). Exhibition catalogue, Kyōto.

LEE NAN-YOUNG 1978. 'The Metal Bottles of Ancient Korea' (in Korean), *Misul Charyo* 23, pp.15–30.

LEE NAN-YOUNG 1983. 'Metal bowls and dishes of Unified Silla period – with emphasis on Anap-chi pond artefacts' (in Korean), *Misul Charyo* 32, pp.1–18.

LEE 1969. Peter H. Lee, *Lives of Eminent Korean Monks*. Harvard Yenching Institute Studies, xxv. Cambridge (Mass).

LIAONING 1982. *Ryōnenshō hakubutsukan* (The Liaoning Museum), *Chūgoku no hakubutsukan*, 3. Tokyo.

LIN YUN 1980. 'Bronze swords of the North-eastern type in Ancient China' (in Chinese), *Kaogu xuebao* no. 2, pp.139–62.

MATHESAN 1980. Susan B. Mathesan, *Ancient Glass in the Yale University Art Gallery*. Yale.

MATSUBARA 1972. Matsubara Saburo, 'Shiragi-butsu ni okeru tōyō shiki no jūyō futatsu no mondai ni tsuite' (Two important questions in Far Eastern History concerning Silla Buddhas), *Bukkyō Geijutsu* 83, pp.41–52.

MEDLEY 1972. Margaret Medley, *Metalwork and Chinese Ceramics*. Percival David Foundation of Chinese Art, Monograph Series no. 2. London.

MEDLEY 1975. Margaret Medley, *Korean and Chinese Ceramics from the 10th to the 14th century*. Loan exhibition mounted jointly by the Fitzwilliam Museum, Cambridge, and the Percival David Foundation of Chinese Art in the Fitzwilliam Museum, Cambridge.

MEDLEY 1977. Margaret Medley, 'Korea, China and Liao in Koryŏ Ceramics', *Oriental Art* XXIII, no.1, pp.80–6.

MINO 1980. Yukata Mino, *Freedom of Clay and Brush through Seven Centuries in Northern China: Tz'u-chou type wares, 960–1600AD*. Indianapolis.

MIZUNO 1960. Mizuno Seiichi, *Chūgoku no chokoku* (Bronze and Stone Sculpture of China, from the Yin to the Tang Dynasty). Tokyo.

MOON MYONG-DAE 1978. 'Silla Inwang sang' (Silla Images of Dvarapālas), *Pulgyo Misul* 4, pp. 37–103.

MOON MYONG-DAE 1979. 'Avataṁsaka Sutra painting in Silla dynasty' (in Korean), *Hanguk hakpo* 5, pp.27–64.

MUNYŎNG 1974. Munhwajae kwalliguk, *Munyŏng wangnŭng*. Official Report on the excavation of the tomb of King Munyŏng of the Kingdom of Paekche. Seoul.

NAN CHŌSEN 1925. *Nan Chōsen ni okeru Handai no iseki* (Han dynasty (sic) relics found in Southern Korea), *Taishō juichi nendō koseki chōsa hōkō*, vol. 2. Kyōto.

NARA 1973. *Chōsen no kaiga* (Exhibition of Korean paintings of the Koryŏ and Yi Dynasties). Yamato Bunkakan, Nara.

NARA 1978. *Nihon bukkyō bijutsu no genryū* (The Origins of Japanese Buddhist Art). Nara National Museum, Nara.

NEW YORK 1968. *The Art of the Korean Potter—Silla, Koryŏ, Yi*. Exhibition at the Asia Society, New York.

NEW YORK 1982. *Significant Aspects of Early Chinese Ceramic Arts*. The China Society, New York.

NOMORI KEN 1944. *Kōrai tōji no kenkyū* (Studies on Koryŏ ceramics). Tokyo.

ŌSAKA 1978. *Sōgen no bijutsu* (Song and Yuan Art). Ōsaka.

ŌSAKA 1980. *Ni Kan bunka koryū ten* (Cultural Exchange between Korea and Japan). Ōsaka Municipal Museum. Ōsaka.

O SE-CHANG 1928. *Kŭnyŏk sŏhwajing* (Dictionary of Korean Calligraphers and Painters). Seoul.

PAIK SYEUNG-GIL 1982. Paik Syeung-gil (ed), 'Romanization of Korean', *Korea Journal* 22, 8 (August 1982) (special issue with several articles).

PAK YOUNG-SOOK 1981. *The Cult of Kṣitigarbha: an apect of Korean Buddhist painting*. Inaugural dissertation for University of Heidelberg. Heidelberg.

PAK YOUNG-SOOK 1982. 'Illuminated Manuscript of the Amitābha Sutra', *Orientations*, vol. 13, no. 2, pp.46–8

PAK YOUNG-SOOK 1984. 'Internationalism in Korean Art', *Orientations* vol. 15, no. 1.

PEARSON 1982. Richard Pearson. 'The Archaeological Background to Korean Prehistoric Art', *Korean Culture*, vol. 3, no. 4, pp.18–29.

PINDER-WILSON 1970. Ralph Pinder-Wilson, 'Glass in Asia during the T'ang Period', in W. Watson (ed), *Pottery and Metalwork in T'ang China*. Colloquies on Art and Archaeology in Asia, no. 1, pp.62–71. London.

PRINCE YI 1933. *Yi Wangga pangmulkwan sojangp'um sajinch'ŏp. Hoehwa* (Illustrated Catalogue of Works in the Prince Yi Household Museum. Paintings). Kyōto.

PROPYLÄEN 1968. *Propyläen Kunstgeschichte*, vol. 18, 'China, Korea, Japan', Berlin.

P'UNGSOK 1977. Kim U-jong (ed.) *Yijo p'ungsok hwach'ŏp* (Albums of Chosŏn Genre Painting), vols 1–2. Seoul.

PUYŎ 1977. *Puyŏ pangmulgwan chinyŏl p'um togam* (Selected Treasures of the Buyeo National Museum). Puyŏ.

RHEE 1978. Rhee Byung-chang, *Masterpieces of Korean Art*, 3 vols. Tokyo.

RICHŌ 1977. Matsushita Takaaki and Choi Sunu, *Richō no suibokuga* (Ink Paintings of the Yi Dynasty). *Suiboku bijutsu taikei*, suppl. vol. 2. Tokyo.

SAMGUK SAGI. Kim Pu-sik (1075–1151), *Samguk sagi* (Historical Records of the Three Kingdoms). Chosŏn sahakhoe edition. Kyŏngsŏng (Seoul), 1928.

SAMGUK YUSA. Iryŏn (1206–89). *Samguk yusa* (Reminiscences of the Three Kingdoms). Chosŏn sahakhoe edition. Kyŏngsŏng (Seoul), 1929.

SAN FRANCISCO 1979. *5000 Years of Korean Art*. Exhibition at the Asian Art Museum and other museums in the United States, 1979–81. San Francisco.

SAOTOME 1982. Saotome Masahiro. 'Silla and Kaya Crowns – study of the Ogura Collection – I' (in Japanese), *Museum* 372, pp.4–14.

SECKEL 1957. Dietrich Seckel, *Buddhistische Kunst Ostasiens*. Stuttgart.

SECKEL 1964. Dietrich Seckel, *The Art of Buddhism*. New York/London.

SECKEL 1977. Dietrich Seckel, 'Some Characteristics of Korean Art,' *Oriental Art* 23, no. 1, pp.52–61.

SECKEL 1979. Dietrich Seckel, 'Some Characteristics of Korean Art. II. Preliminary Remarks on Yi Dynasty Painting', *Oriental Art* vol. xxv, no. 1 (Spring 1979), pp.62–73.

SECKEL 1980. Dietrich Seckel, 'Stūpa Elements Surviving in East Asian Pagodas', in *The Stūpa, Its Religious, Historical and Architectural Significance*. Wiesbaden, pp. 249–59.

SEIAN HIRIN 1966. *Seian Hirin* (The Beilin at Xian). Tokyo.

SEKAI TŌJI 1978. *Sekai Tōji zenshu* (World Ceramies), vol. 18, Koryŏ Period. Tokyo.

SEOUL 1972a. *A Hundred Treasures of the National Museum of Korea*. Seoul.

SEOUL 1972b. *Masterpieces of 500 Years of Korean Painting*. National Museum of Korea, Seoul.

SEOUL 1977. *Korean Paintings Selected from the Collection of the National Museum – to be shown for the first time to the public*. National Museum of Korea, Seoul.

SEOUL 1979. *Hanguk ŭi ch'osanghwa* (Korean Portraits from the Collection of the National Museum), Seoul.

SEOUL 1980. *Special Exhibition of artefacts excavated from Anap-chi Pond*. National Museum of Korea, Seoul.

SEOUL 1981. *Special Exhibition from the Lee Hong-kun Collection*. National Museum of Korea, Seoul.

SEOUL 1982. *Chosŏn period ceramics in the Lee Hong-kun Collection*. National Museum of Korea, Seoul.

SHŌSŌIN 1965. *Shōsōin no garasu* (Glass Objects in the Shōsōin). Tokyo.

SHŌSŌIN 1976. *Shōsōin no kinkō* (Metalwork in the Shōsōin). Tokyo.

SICH 1982. Dorothea Sich, 'Bräuche zur Beseitigung der Geburtsanghänge im ländlichen Korea und einige Überlegungen über moderne geburtshilfliche Ausbildung,' *Curare*, vol. 5, pp.245–9.

SINAN 1977. *Sinan haejŏ munmul* (Relics from the Sinan seabed). National Museum of Korea, Seoul.

SOHWAGA 1978. *Hanguk sŏhwaga yinbo* (Seals of Korean Calligraphers and Painters). Seoul.

SOPER 1951. Alexander C. Soper, *Kuo Jo-hsü's Experiences in Painting (T'u-hua chien-wen chih)*. Washington, D.C.

TAKAMATSU-ZUKA 1973. *Takamatsu-zuka kofun hekiga chosha hokoshu* (Mural Painting in the Tumulus Takamatsu-zuka). Kyōto.

TOKYO 1983. *Kankoku kodai bunka ten* (The Ancient Korean Arts; Quintessence of 1000 Years of Silla). Tokyo National Museum, Tokyo.

TONKŌ 1980–2. *Chūgoku Sekkutsu: Tonko Makkōkutsu* (Chinese Cave Temples: The Mogaoku of Dunhuang), 5 vols. Tokyo.

TSUDOI 1974. Tsudoi Ryohei, *Chōsen kyō* (Korean Bells). Tokyo.

VOS 1977. Fritz Vos, *Die Religionen Koreas. Die Religionen der Menschheit*, vol. 22, 1. Stuttgart.

WAGNER 1974. Edward W. Wagner, *The Literati Purges: Political Conflict in Early Yi Korea*. Harvard East Asian Monographs 58. Cambridge (Mass).

WAKIMOTO 1934. Wakimoto Sokuro, *Nihon suibokuga-dan ni oyoboseru Chōsenga no eikyō* (Influence of Korean Painting on Japanese Ink Painting), *Bijutsu kenkyū* 28, pp.159–67.

WENHUA 1972. *Wenhua dageming qijian chutu wenwu* (Antiquities excavated during the Cultural Revolution). Peking.

WHITFIELD 1982–3. Roderick Whitfield, *Paintings from Dunhuang* I–II. *The Art of Central Asia*, vols 1–2. Tokyo.

YI DONG-JU 1973. Lee Dong-ju, 'Wan-dang's Influence on Korean Literati Painting', *Upper-Class Culture in Yi-Dynasty Korea*. Korea Culture Series 2. Seoul.

YI DONG-JU 1981a. *Koryŏ pulhwa* (Koryŏ Buddhist Painting), *Hanguk ŭi mi*, vol. 7. Seoul.

YI DONG-JU 1981b. *Uri nara ŭi yet kŭrim* (Studies in Korean Painting). Seoul, 2nd edn.

YI DONG-JU 1982. *Hanguk hoehwa sosa* (Brief History of Korean Painting). Seoul, 2nd edn.

YI KA-WON 1963. 'Wan Dang ch'osang sogo' (A Portrait of Wan-dang), *Misul Charyo* 7, pp.1–4.

YI KANG-CHIH 1972. *Hanguk myŏng'in ch'osang daegam* (Portraits of Historic Koreans). Seoul.

YI KI-BAEK 1976. *Hanguksa sinnon* (New theories of Korean History). Seoul, revised edn.

YI YONG-BOM 1969. 'Study on the Legend of Ch'oyong – Islamic Tradesmen in Tang Period and Silla Dynasty' (in Korean with English summary), *Chindan Hakpo* 32.

YI YONG-BOM 1973. 'Trade items of Islamic Merchants found in *Samguk sagi*', *Collection of Theses on Korean History* (in Korean), pp.95–104. Seoul.

YI YONG-GAE 1971. *Chōsen koshoga sōran* (Compendium of Korean Calligraphy and Painting). Kyōto.

YOSHIDA 1977. Yoshida Hiroshi. 'Richō no kaiga' (Yi dynasty painting), *Kobijutsu* 52, pp.83–91.

YU HI-KYŎNG 1977. *Hanguk poksiksa yŏngu* (Studies in Korean Costume). Seoul.

YU JOON-YONG 1676. *Chŏng Sŏn (1676–1759): Ein koreanischer Landschaftsmaler aus der Yi-Dynastie*. Inaugural dissertation for University of Köln, Köln.

YU POK-YOL 1969. *Hanguk hoehwa taekwan* (Pageant of Korean Painting). Seoul.

YUN YONG-I 1980. 'Paekja' (White Porcelain), *Kansong Munhwa* 20.

ZHANG HUAI 1974. *Tang Li Xian mu bihua* (Wall-paintings from the tomb of Prince Li Xian [Zhang Huai] of Tang). Shaanxi Provincial Museum, Xian.

kun Collection. National Museum of Korea, Seoul.